# MASQUERADING POLIT

# MASQUERADING POLITICS

*Kinship, Gender, and Ethnicity in a Yoruba Town*

John Thabiti Willis

Indiana University Press

This book is a publication of

Indiana University Press
Office of Scholarly Publishing
Herman B Wells Library 350
1320 East 10th Street
Bloomington, Indiana 47405 USA

iupress.indiana.edu

⊗ The paper used in this publication meets the minimum
requirements of the American National Standard for Information
Sciences—Permanence of Paper for Printed Library Materials,
ANSI Z39.48-1992.

Manufactured in the United States of America

Library of Congress Cataloging-in-Publication Data

Names: Willis, John Thabiti, [date] author.
Title: Masquerading politics : kinship, gender, and ethnicity in a
    Yoruba town / John Thabiti Willis.
Description: Bloomington, Indiana : Indiana University Press, 2018. |
    Series: African expressive cultures | Includes bibliographical
    references and index.
Identifiers: LCCN 2017009278 (print) | LCCN 2017011919 (ebook) |
    ISBN 9780253031457 (e-book) | ISBN 9780253031440 (cloth) |
    ISBN 9780253031464 (paperback)
Subjects: LCSH: Yoruba (African people)—Rites and ceremonies. |
    Yoruba (African people)—Nigeria—Otta—History. | Otta
    (Nigeria)—History. | Yoruba (African people)—Politics and
    government. | Masks, Yoruba—Nigeria—Otta—History. |
    Masquerades—Nigeria—Otta—History. | Egungun (Cult)—
    Nigeria—Otta. | Gelede (Yoruba rite)—Nigeria—Otta.
Classification: LCC DT515.45.Y67 (ebook) | LCC DT515.45.Y67 W55
    2018 (print) | DDC 305.896333—dc23
LC record available at https://lccn.loc.gov/2017009278

1 2 3 4 5   23 22 21 20 19 18

*To our parents, elders, and ancestors—*
*on whose shoulders we stand as we reach for the stars—*
*and to our children, we pray we have made this world*
*a better place than we found it*

# Contents

# Acknowledgments

THE MOST REWARDING aspects of writing this book are the wide-ranging, deep, and meaningful relationships that made it possible. I am incredibly grateful for the ways in which people opened their minds, hearts, spirits, and homes to me.

The University of Lagos (UniLag) provided an initial intellectual and institutional home in Lagos, Nigeria, and it was from there that I was able to conceive and conduct my field and archival research. I am particularly grateful to Professor Ayodeji Olukoju (now the vice chancellor at Caleb University), as well as the faculty members and administrative assistants who comprise the Department of History and Strategic Studies at UniLag, along with its graduate students, particularly Paul Osifodunrin and Gboyega Adebayo, and the Department of Psychology, especially Olufemi Lawal. It was with the guidance of these individuals at UniLag that I developed strategies for how best to begin my research of Otta.

I am thankful to the residents of Otta for supporting this work. Among the individuals who were instrumental in helping me get my research started in Otta are Dr. Adeboyega Salami (the chairman of the Ado-Odo/Ota Local Government), Dr. Isaac Ayinde Adalemo (Professor Emeritus of Geography at the University of Lagos), Mr. Yinka Dada and his family, Prince Waidi Ogunleye (the secretary and personal assistant of the king of Otta), and Oba Moshood Adetoro Oyede III (the *Olota* of Otta). Prince Kunle Andrew and Mr. Egi Ogbe introduced me to many of the masquerade chiefs and their families. I am most indebted to the Egungun chiefs, particularly Chief S. Asanbe (the *Oloponda*) and members of the *Iya Agba Oje* (most notably the Elesho), as well as the families that mask as Egungun at Otta: the Ajofoyinbo, Arogunmola, Ayoka, Itimoko, Lebe, and Owolafe families. Prince Wasiu Ashola Ojugbele (the Aru Efe Egbe Alase Otta), Mr. Salawu Abioru Olaniyan (the Olori Gelede), and other Gelede chiefs and performers provided an opportunity for me to experience the spectacle that is Gelede. Other residents of Otta who deepened my understanding of this town's rich history and culture include Chief Sikiru Anibere Matoro Aso Akiolo (the *Onikosi* of Otta), Alaji Fatusi (son of the former *Oloponda* of Otta), Chief Solomon Adebiyi Isiyemi (the *Baale* of Atan), Chief R. S. O. Ojolowo, and Ruholla Ajibola Salako.

Residents of other Yoruba towns also enhanced my knowledge of Egungun and gender in Yoruba history and culture. They include Dr. Remi Ajala and Mrs. Toyin Ajala of Ibadan, Chief (Mrs.) Adedoyin Talabi Faniyi (the Yeye Aresin Alabola Masifa Lano), and Chief Muraina Oyelami (the *Esa* of Iragbiji). My

experience at Oshogbo was made particularly sweet by the conversation and play with many of the children living at the house of Adunni Olorisha on Ibokun Road. I am also grateful to Omolola Olarinde and other members of her family for their hospitality and assistance with my research in Ibadan. Moreover, Mr. Gbamidele Ajayi has been a most faithful friend, companion, and guide since 2005, and I am privileged to call him a brother.

I also developed a lifelong relationship with two families in Nigeria: the Adelekes and the Animashawuns. The Adeleke family includes Deola, Shade, Shofi, Shonola, Tinu, and Wole, while the Animashawun family includes Abi, Reverend (Mr.) and Mrs. Aishida, Bukky, Dele, Fela, Femi, Kehinde, Segun, Shubumi, and Taiwo. Both families have exhibited exceptional generosity and love toward me and my visitors (including family and friends from the United States) during our time in Nigeria. Taiwo Animashawun and Wole Adeleke have treated me like a brother, and their collegial and diplomatic natures have shown me new ways to engage and resolve the conflicts that often occur during cross-cultural encounters. I am also grateful to the Farunkmi family (Seye in particular).

A contingent of scholars based in the United Kingdom provided critical support for this project. The late J. D. Y. Peel not only produced pioneering research on the encounter of nineteenth-century Yoruba speakers and Christian missionaries but also first directed me to the work of James White. The scholars based at the Centre of West African Studies at the University of Birmingham have played a significant role in my development. Karin Barber has provided a model of groundbreaking research into African oral traditions and performance culture, and her warmth, humility, and charisma have been both inspiring and welcoming. Insa Nolte has been a gem from our first conversations in Nigeria to our repeated encounters in England. I am thankful to Insa as well as her husband, Simon, and her three children—Ana, Taiwo, and Kehinde—for welcoming me into their home and hearts. William Rea of the University of Leeds has been producing a body of scholarship on the masquerades of Ikole Ekiti that has has been very formative in my thinking, and it is for his work and collegiality that I am grateful.

Faculty, staff, administrators, and students from Emory University and Spelman College have offered support that has been pertinent to my intellectual and professional development during my years of graduate study at Emory. They include Chante Baker, Rudolph Bird, Stacy Boyd, Leroy Davis, Zakiya Farris, Kharen Fulton, Akeba Harper, Kamili Hayes, Sherice Henry, Rosemary Hines, Ada Jackson, Denise James, Theresa Cox Kinney, Miriam Petty, Virginia Shadron, Cynthia Spence, Brenda Tindal, Shirley Toland-Dix, Queen Watson, and Ulrica Wilson. The late Kharen Fulton was a mother figure and mentor from the beginning of my graduate years at Emory, and the depth of my gratitude for her life and legacy is immeasurable.

This book also has been realized with the endless support of Jean DeSilva, Carrie Crompton, Jeri Neuman, and William Barnet. Other individuals whose assistance with the writing was critical include Yvette Wing and Jennifer Miller. Leah Lewis and Maurita Poole have been dear friends and colleagues, and their support has been vital.

My advisers from Emory were the backbone of this work. Sidney Kasfir's course Masks and Theory, and her research on masquerades, provided my initial introduction to West African masquerade traditions. It also was in this course that I first learned of the need for historians to study masquerades and other African art forms. Similarly, in Randall Packard's African Historiography course, I first encountered Edna Bay's work on Dahomey. Her book spoke to my interests in African ritual traditions. Dianne Stewart served as a great mentor in understanding the place of Yoruba ritual practices within the study of Afro-Atlantic religious traditions and practices. I hope that this book realizes the standard of scholarship befitting of someone who has had the pleasure of learning from them.

Kristin Mann has been an exceptional steward of my intellectual maturation. She supported me as I initially struggled to envision, create, and carve out an original and sustainable research project. She has been gracious in sharing her knowledge of African history in general and of Yoruba historiography, as well as of nineteenth-century archival sources. She has worked tirelessly to ensure that I received the best training that Emory has to offer, and for her excellent efforts, I am eternally appreciative. My prayer is that I not only realize but also exceed the standards that she and Sidney, Edna, and Dianne set for me.

The faculty, staff, students, and researchers affiliated with the University of Virginia's Carter G. Woodson Institute for Afro-American and African Studies have played a key role in this project. It was during the two years I spent at the Woodson Institute that I began work on this book manuscript. Deborah McDowell, Cynthia Hoehler-Fatton, Roquinaldo Ferreira, and Marlon Ross along with the Woodson fellows provided insightful comments on early drafts. Many other scholars based in Charlottesville also helped support me as I prepared to enter the professoriate.

To Nwando Achebe, Hilary Jones, and Harry Odamtten—my mentors, colleagues, and friends at the *Journal of West African History* (JWAH)—I also owe a debt of gratitude. Their scholarship, guidance, support, and collegiality have been inspiring.

I also must mention the staff, editorial board, and reviewers for Indiana University Press. I am grateful for their belief in this project and for the patience and care with which Dee Mortensen, the editorial director of the Press, and her staff have guided and supported me through the publication process. My work has found an ideal home in Indiana University Press, and I am sure that all the people who have supported this work join me in this expression of gratitude.

Two individuals have made tremendous contributions that deserve special attention. Daniel Black is an example of a scholar and activist who inspired me to consider a career in the academy and to connect my life's study to the spiritual traditions of my ancestors. It is only fitting that my first book focuses on masquerade traditions that honor ancestors. He also embodies a steadfast character and magnetic persona that have made him an ideal role model. Marlon Bailey is another exemplary scholar, activist, and friend whom I met at the beginning of my Ph.D. journey. Marlon's mentorship and scholarship have been paramount for my work. Both of these scholars have inspired me to find my own voice as an intellectual and to be patient as my ideas mature.

I am grateful beyond measure for the intellectual home I have found at Carleton College. Dean Beverly Nagel and President Steve Poskanzer have been instrumental in providing the financial and institutional resources that have made this book possible. The Faculty Endowment Grant provided the year of financial support that I needed to write the manuscript. The College's Visualities Initiative provided the support needed to photograph some of the masquerades depicted in a statue and wall art in Otta. Financial support for the printing of color images in this book comes from the Office of the Dean of the College and my mother, Carol Willis.

Colleagues in the History Department have provided support via comments on public presentations and drafts, as well as mentorship and other forms of affirmation of my work. They include Cliff Clark, Andrew Fisher, Annette Igra, Adeeb Khalid, Amna Khalid, Victoria Morse, Bill North, Susannah Ottaway, David Tompkins, George Vrtis, Harry Williams, Seungjoo Yoon, and Serena Zabin. Other colleagues affiliated with the African and African American Studies Program (newly renamed as Africana Studies) have been essential in making Carleton home. They include Anita Chikkatur, Pamela Feldman-Savelsberg, Andy Flory, Cherif Keita, Kofi Owusu, Noah Salomon, and Kevin Wolfe.

Two interrelated elements of a graduate student's life are a purpose and community. These factors converged for me through my ongoing participation in the Ndugu-Nzinga Nation, a rite-of-passage community based in the Atlanta University Center. There I learned that to be an intellectual means always seeking wisdom, knowledge, and personal fulfillment, even in social endeavors. This community reinforces something that academics often assume—that the personal is political. The leading members of this community include Akua, Azikiwe, Bahati, Chitope, Edima, Ifetayo, Mawu, Nazapa, Njemile, Ofetalo, Oluiyapo, Osizwe, and Tchseseret. Many other members of Ndugu-Nzinga, too numerous to name, have reminded me that I should always strive to clear a path for those coming behind me. Without them, this book would not have been completed.

My family saw long ago that this day would come. Ms. Lucy started calling me "the professor" when I was five years old. My family members from New

Jersey—Aunt Mary and Uncle Stan as well as their children and grandchildren (Janaya, John, Monique, Rene, Shawn, Tallia, and Wayne) made their home one of my favorite places to visit. My Uncle Bobby, Aunt Shirley, and my grandparents, Robert and Mammie Chapman, were pillars of support. My stepmother, Madre, and my sister, Valerie, provided me with role models as I looked to pursue graduate education.

My partner, Nada Othman, and our family based in Saudi Arabia and Bahrain offered crucial emotional, psychological, and spiritual support while I completed this book. Her belief in my work and eagerness to nurture a home life conducive to academic writing have been vitally important. Nora, my sister-in-law, sacrificed more than two months of her time to care for my daughter, Lana, during her toddler stage and helped around the home while I worked in my office on the last drafts of the manuscript. Lana also exhibited great patience while her father worked around the clock during her toddler years. Nada demonstrated an unshakable belief in my work, even as it required more time and energy than either of us could have imagined. May she and Lana reap the benefits of their daily support. For this vital support, I treasure what Nada has brought to my life and work.

It is to my parents that I am most indebted. My mother is at the heart of this work. She has nurtured me in ways that only she knew and loved me in ways that only a mother intimately knows. She has inspired me to realize the presence of mothers in all of my travels and everywhere that I have found a home. Those who internalize the insights I gained through my fieldwork in Nigeria will appreciate the extent of my mother's influence on this book and the journeys that made it possible. Furthermore, my father and stepmother have been essential to my work; through their support and example, they instilled a work ethic, professionalism, character, and a set of values that I strive to uphold in all that I do. I am so proud of them for all that they have become in their professional and personal lives, and I pray that this book reflects the expectations that they first set for me. It is not possible to fully do justice to what they have done for me.

May my life, the way that I treat people, and live do them justice.

# MASQUERADING POLITICS

# Introduction

In 1848, a young warrior from the West African town of Otta consulted a diviner because he was unable to conceive a child with his wife. The diviner told him that his ancestors were punishing him for his failure to honor them properly. To rectify the situation he needed to organize an ancestral masquerade figure and organization known as an Egungun. Otta's chiefs had banned his father's Egungun a little more than a year earlier. His father, the highest-ranking chief in the town—second in authority only to the king of Otta—was responsible for punishing criminals and leading the town's defenses in battle. When it was called for, the father would appoint a new Egungun, a masked and costumed figure revered as an incarnate ancestor, to perform executions, and it was this violent use of Egungun that the chiefs had banned.

When performing an Egungun, the warrior wore elaborately decorated fabrics that covered it from head to toe. The feathers of birds, the fur of cows and hyenas, the shells of turtles and snails, and the bones of animals were attached to sections of cloth covering the arms, chest, and back of the Egungun. Bloodstains were visible on its sleeves and chest. The warrior's father and other relatives used the blood and remains of animals to consecrate the mask, channeling the spirits of the ancestors into the Egungun.

The young warrior adhered to the diviner's prescription, creating an Egungun masquerade named Ajofoyinbo, Yoruba for "we dance for the white man." This name symbolized his father's status as the chief who, in his capacity as a foreign relations officer, hosted and entertained guests, including white men, before they visited the king. The white men would bring gifts to his father, and the new Egungun that his son created was named in their honor. This Egungun masquerader, more entertaining than the violent Egungun that had been banned, danced in the presence of the whites with appropriate adornments. Then the chief took the Egungun cloth to the nearby village of Iyesi, the home of his mother, where his childless son further adorned the new Egungun with the hope of pleasing the ancestral spirits. He and his wife subsequently had two children, one boy and one girl. That Egungun became known thereafter as Ajofoyinbo Iyesi.

This episode reveals the power of masquerades in West Africa, in both civil society and political life. Using a range of historical sources and methods, I argue that such masquerades played critical roles in West African history. I center my

analysis on the town of Otta (now part of Nigeria), whose strategic location made it a focal point of trade. Otta was vulnerable to the imperial ambitions of its more powerful neighbors, including the kingdom of Oyo in the eighteenth century and the warrior state of Abeokuta and the British colonial presence based at the port kingdom of Lagos from the middle of the nineteenth through the early twentieth centuries. Contrary to traditional depictions of the masquerades as ceremonial practices through which ancestors were remembered and honored—as the story of the young warrior might suggest—I argue that they also developed into effective tools of statecraft and warfare, shaping population movements, rivalries over trade routes, military maneuvers, and royal succession throughout the region in which Otta is located.

My research yielded several findings that challenge conventional wisdom about the masquerade societies. I argue, for example, that economic trends helped enhance their role in West African society and culture, because those with access to certain manufactured goods were better able to stage influential masquerade performances to advance their political and cultural interests. Owning a masquerade and having the wherewithal to put on impressive performances enhanced political and military power and extended the function of masquerades beyond that of performing ritual or ceremonial obeisance to ancestral spirits. Masquerade performers were political actors who enacted the politics of their constituents, and the creation of new masks and modes of performance constituted shifts in the policies of the families and factions that vied for dominance over kingdoms. I also show how the role of gender in masquerades, and in West African society more generally, differs from traditional assumptions—often made by missionaries and colonial observers—that women were subservient to men and rarely participated in or achieved influence in masquerade societies. Building on recent scholarship that has revealed a far more nuanced role for women in the region, I trace the growing levels of participation and power that women forged within unfolding political and military movements throughout the region.

This book, then, places at the center of West African political history a coalition of masquerade practitioners and organizers that evolved over a period extending from the height of the transatlantic slave trade at the end of the eighteenth century (although the origins of masquerades date back several centuries before that) to the formal establishment of European colonial policies in the first quarter of the twentieth century. Treating masquerade as a historically contingent cultural component of state power, this book shows how the authority invested in masquerade performers enabled them to play key roles in forging alliances, consolidating state power, incorporating immigrants, executing criminals, and, ultimately, projecting individual and group power. It also demonstrates how transformations in performers, performances, and the institutional structure of

masquerades reflect links between changes in gender, kin, and ethnic identities and practices; the expansion and decline of the slave trade; the rise and fall of an empire; the outbreak of warfare; the growth in the overseas commercial trade; and the establishment of Christian missions and colonial rule in the second half of the nineteenth century. The story of masquerades in this region of West Africa is as complex as the political, cultural, and social histories in which it is set.

Masquerades, as the episode with which the book begins suggests, are ritualized spectacles that feature masked figures dressed in cloth, raffia, or wooden attire. These figures, revered as incarnate spirits, are accompanied by a procession of devotees—drummers, singers, dancers, and other supporters. Today these performances are sponsored by organizations of individuals and by groups, regarded as kin, at family compounds, shrines, and public markets. Historically, masquerades were also performed on battlefields and in criminal proceedings. The performances enact characteristics or achievements of revered spirits or gods and goddesses, marking seasonal changes, marriages, deaths, and births, as well as political events. When all the elements—spiritual, aesthetic, performative, emotional, and social—come together, a masquerade becomes a complex and powerful event, an attempt to harness the goodwill of ancestral spirits to shape social and political relations within the material world.[1] Through a study of the medium of masquerades, this book demonstrates how evolving factions have responded to and transformed historical events, movements, and processes and shaped notions of kinship, gender, and ethnicity among the Yoruba.

Yoruba speakers claim a common tradition of origin, whether at Ile-Ife or Oyo. A particular group of Yoruba speakers identifying themselves as Oyo, Awori, Egbado, or Gun constitute a subethnic group, henceforth simply an ethnic group. This study assumes that ethnicity, kinship, and gender are mutually and historically contingent, not fixed, and that my sources and I do not share the same working definition of these categories. I draw on Sandra E. Greene's definition of ethnicity to shed light on patterns of social organization and classification of precolonial West African communities. In *Gender, Ethnicity, and Social Change on the Upper Slave Coast: A History of the Anlo-Ewe* (1996), Greene writes, "Ethnicity is defined here as a system of social classification embraced by groups of individuals who identify themselves and are identified by others as distinct on the basis of their shared putative or real cultural, ancestral, regional, and/or linguistic origins and practices, and where the identities of the groups and individuals so classified are also subject to periodic reinvention."[2]

In the remainder of this introduction, I provide an overview of the historical setting that shaped and was shaped by masquerades and describe masquerade practices in detail, using photographs to show contemporary masquerades in Otta. I then explain my approach to understanding gender in the context of the

complex relationships among masquerades, ethnicity, and kinship that have played out over the centuries I cover in the book. Because my approach to gender reflects, in part, my research methodology, I then explain how I marshaled a diversity of historical and contemporary sources to inform my analysis.

## Historical and Cultural Background: Situating Masquerades

### *The Oyo Empire and Otta's Place in It*

Yoruba speakers trace their origins to migrations to and from the towns of Ile-Ife and Oyo. As early as the tenth century, these settlements were established as trading centers for glass and stone beads, iron, and cloth. Yoruba communities at Ile-Ife established new ruling dynasties that controlled commodity production, often in tension with existing Yoruba and non-Yoruba groups.[3] In the sixteenth century, a new dynasty seized power at Oyo, the capital of a lowland savanna kingdom located in a frontier zone. This dynasty developed large-scale horse-trading posts at desert ports to the north. They then developed a cavalry with which to wage warfare on their neighbors and thus began building an empire. This dynasty validated its claims over material and human resources by forging alliances through masquerades performed or patronized by various ethnic and linguistic groups and affiliated with earlier ruling dynasties. In the early seventeenth century, Oyo began to consolidate power along trade routes that connected it to the south coast, gaining control of the overseas slave trade at Atlantic ports. During the eighteenth century, royals wielded unprecedented power as Oyo dominated its neighbors in the savanna and seized control over trade routes passing through the forest region in the south and terminating at port towns, where the captured entered ships bound for slavery in the Americas on the other side of the Atlantic Ocean. This dynasty appointed masquerade performers and organizers/officials as imperial administrators in provincial communities to promote the royal family's political and economic supremacy over its subjects and rivals. Over time, the dynasty that ruled the town of Oyo incorporated Otta—a Yoruba-speaking, predominantly Awori town and kingdom near the coast—into its imperial domain.

The Awori tell a story about how they settled in their ancestral place. A leader named Oduduwa directed his son, Olofin, to lead the Awori people to a new homeland. He further instructed Olofin to float a wooden plate on a river, follow its path, and stop where it sank. Olofin followed his father's instructions. The plate sank three times (at Isheri, Otta, and Lagos), and a small contingent settled at each location. (Awori stands for Awo-ti-ri, meaning "the plate sank.") Yet because of the location of all of their settlements—where the plate sank—Awori identity came to involve resistance to their more aggressive neighbors—Dahomeyans to the west and the Egba (who settled at Abeokuta in the early nineteenth century) to the north.

The descendants of an Oyo administrator claim that, during the last quarter of the eighteenth century, their ancestor established the practice and priesthood of Egungun, an Oyo-styled ancestral masquerade, in Otta, which served as a center of commerce and supplier of goods from interior markets for the port towns of Badagry and Lagos. Dissent in the Oyo capital and rebellion in other provincial communities weakened the power of Oyo royals during the last decades of the eighteenth century and the first quarter of the nineteenth century. At Otta, the family claiming Oyo royal blood forged alliances with Oyo and Gun refugees from Gun-populated Badagry and together acquired land and authority, which enabled it to better defend and police the town. New chiefs emerged, established new compounds and wards with representation in the town's government, and mobilized new masquerades, at first to punish invaders and criminals.

Another wave of refugees in the 1830s, this time Egbado ethnics, arrived, acquired land, founded a new ward, and mobilized a new group of masquerades, known as Gelede, to consolidate their community, ridicule foreign threats, and satirize residents. Clashes between Otta's warrior chiefs and merchants from new regional powers led to the abovementioned attack on Otta that largely destroyed the town in 1842. During this era, British missionaries and colonial officials began to intervene in regional affairs in ways that enabled these foreigners to emerge as enduring mediators in Otta's relationship with its more powerful neighbors during the rest of the nineteenth century. The British increasingly threatened the power and authority invested in secret organizations—including Egungun and Gelede masquerades and other spirit-possession groups, whose members were bound by ritual oaths—and were crucial allies in power struggles between royals, chiefs, warriors, and merchants. European intervention, which culminated in the transition to colonial rule around the turn of the twentieth century, was met with the rise of a new generation of elites who created new masquerades depicting, placating, or targeting Westerners and their African collaborators. These early colonial elites enhanced their reputations and garnered support through their identification with Egungun as an Oyo cultural practice in a colonial regime that increasingly appropriated Oyo's status and imperial legacy.

Awori identity developed further as they welcomed waves of Gun, Oyo, and Egbado refugees fleeing attacks on former Oyo strongholds in southwestern Yorubaland in the 1830s and 1840s. Identification with the Oyo offered temporary relief from Dahomey's attacks on the Gun community of Badagry in 1789 and on the Egbado communities of Ilaro and Iganna in the 1830s. The Oyo had dominated the Egbado and Awori areas during the era of Oyo imperialism, keeping Dahomey in check, and Oyo-affiliated warriors harnessed powerful Egungun masquerades to assert their power; the Egbado enacted an alternative masquerade practice known as Gelede to sound the alarm when Dahomeyan soldiers approached to attack these invaders.

Following Oyo's collapse in the 1830s and the rise of other regional powers that began to threaten Otta's stability during the middle decades of the nineteenth century, these chiefs enslaved or killed law-abiding travelers and residents of other wards and threatened the legitimacy of the monarchy and of the leaders of the town's oldest wards. Wars began to break out across the region, inspiring the proliferation of violent Egungun masquerades controlled by warriors such as the new chiefs at Otta and their followers. British missionaries had first arrived in the town in 1842, the same year in which Otta had suffered a crushing defeat at the hands of forces from another town, Abeokuta. In that battle many of Otta's inhabitants were killed, enslaved, or forced to seek refuge in nearby communities. Missionaries working with the king of another nearby town, Lagos, negotiated the terms of resettlement, albeit under the authority of representatives from Abeokuta.

Oyo warriors residing in Otta turned tyrannical in the 1840s and 1850s before being checked by the same Egba forces. The creation of the Ajofoyinbo masquerade that I describe in the book's opening episode reflected a new era in the politics of the region as the warrior chief, his son, and their followers attempted to maintain their prominence in Otta's affairs. The town's Egungun masquerades were pivotal in this effort, but soon enough coalitions of rival chiefs, missionaries, and officials from Abeokuta deployed a variety of strategies, which included engaging in their own masquerade politics, to remake the town in their own image. Abeokuta repeatedly threatened the stability and existence of Otta from the 1860s until the formal establishment of colonial rule in the 1890s.

It was during the second half of the nineteenth century, I contend, that the memory of the warrior or group of warriors known as Iganmode became fused with Awori resistance to Dahomeyan and Egba attacks. Otta's praise song and anthem link Iganmode and the Gelede mask with Otta's defense against those forces. Whereas many people in Otta claim that Iganmode was a historical warrior, a few contend that he was a mythical figure created to represent the unity of Otta's inhabitants (men and women, indigenes and immigrants) in defense of their community.[4] Iganmode was promoted in part to counter the challenge posed by the Gun and Oyo warriors from the Ijana ward to the Awori wards of Otun and Osi for control of the internal affairs of the town. The invention of Iganmode offered a figure that Otta's diverse populations—Awori, Gun, Oyo, and Egbado—could embrace to support claims that some had introduced specific masquerades—Egungun by the Oyo people and Gelede by the Egbado people.

During the ascendancy of the Oyo Empire, Egungun represented the authority of the king, while it came to signify the warlords who appropriated that power in times of strife as the empire declined. The creation of an Egungun named Oya Arogunmola signaled the transition from warfare to peacetime and from precolonial life under the Oyo Empire and its successors to British colonial rule. It was

during the colonial period that many new Egungun *alagbada* masquerades were created (I explain this term later), often after irreconcilable rifts opened between families that had once jointly performed a given masquerade.

The eighteenth century marked the height of the transatlantic slave trade, when large numbers of Yoruba speakers sold by the Oyo Empire were forced to travel to what are now known as Benin and Togo in West Africa and from there to Brazil, Cuba, and Haiti in South America and the Caribbean. Although the slave trade was outlawed in the early 1800s, a robust and illegal slave trade moved approximately 200,000 Yoruba speakers to Brazil and Cuba over the course of the first half of the nineteenth century. Nevertheless, many slaves on board slave ships bound for the Americas were intercepted by British Royal Navy patrols and redirected to the British colony of Sierra Leone in West Africa.[5] In that colony, many Yoruba speakers—including the Egba, who settled in 1825 at Abeokuta to the north of Otta and southwest of Oyo—were converted and agreed to spread the Christian gospel and promote British commerce; they then boarded British ships that returned them to their homeland to fulfill these promises. The Oyo people distinguished themselves among early Yoruba converts by creating a Yoruba grammar book and dictionary based on the Oyo dialect, promoting this dialect as the standard spoken Yoruba, and then translating the Christian Bible into this dialect and calling it the Yoruba Bible. The writings of these individuals in the 1840s and 1850s reflected in complex ways the mutual assimilation of British Victorian and Christian ideals into Yoruba ethnic or tribal identities.[6] The production and circulation of these writings inspired the codification of a Yoruba ethnic identity based on the Oyo dialect, culture, and traditions of origin.

Given the large-scale movements of Yoruba people in both directions across the Atlantic and within the African continent, modern Yoruba identity encapsulates the complex and wide-ranging historical experiences of those who have come to identify with Yoruba language and cultural elements. One body of oral traditions identifies Ile-Ife as the origin of the Yoruba people and the dynasties that govern their kingdoms. Another identifies Oyo. Together, these traditions inform how Yoruba speakers identify the origins of their beliefs and practices.[7]

In subtle ways, missionary accounts from the second half of the nineteenth century—which I present in detail later—reflect an awareness of the unique status of the Oyo in Yoruba history and culture. For instance, James White, a British-trained missionary of Yoruba descent based in Otta, occasionally hinted at a link among Yoruba groups—Awori, Egba, Oyo, and Egbado—and the practices and institutions that they maintained. To supplement these missionary accounts, I engaged in my own ethnographic research over the course of twenty months from 2004 through 2006. The oral traditions that I documented and the masquerade practices, participants, and sponsors that I observed all shed light on the dynamic power struggles at work in these enactments.

In both public and secret deliberations and performances, masquerades have long been central to the political culture of West African societies. They have informed and reflected struggles for power, authority, and resources, especially during periods of extreme turmoil or rapid change. During significant moments in the era of the slave trade and the early years of colonial rule, shifting coalitions of royals, chiefs, warriors, and merchants enacted or sponsored masquerade performances. These ritual performance spectacles featured masked figures who were revered as incarnate spirits with the capacity to bless or to curse, to legitimize or to punish. A procession of drummers, singers, and dancers accompanied masked performers and—together with the society of priest-chiefs—formed a masquerade organization that worked in concert with elites (their patrons) to shape and enforce policy.

## The Origins of the Egungun and Gelede Masquerade Traditions

Although the Egungun masquerade society was introduced to Oyo before the empire was formed, its masquerades and chiefs gained greater prominence in Oyo political life during the imperial period. Oral traditions contend that the Nupe kingdom, Oyo's northern neighbor, used a masquerade as it invaded Oyo during the sixteenth century, ultimately causing Oyo's ruler to flee into exile and the people of Oyo to reorganize themselves politically in alignment with the invaders. Oyo's new leadership subsequently introduced and spread the Egungun society in Oyo's governmental administration to centralize its power.[8]

There is strong evidence that, shortly after Oyo consolidated control over its trade routes in the southwest in the 1770s, a Ketu prince who founded the royal dynasty in the ancient town of Ilobi introduced the Gelede masquerade. To resolve a Ketu succession dispute, the prince is said to have commissioned and dispatched a masquerade from Ilobi to Ketu to terrorize the population of the town. Thereafter, the Ilobi residents taught the Ketu the secrets of Gelede. This masquerade tradition flourished along the trade corridor in the southwest from 1774 to 1830, passing through Ketu and Egbado areas and connecting Oyo to the coast. Unlike the Gelede masquerades used to terrorize Ketu's inhabitants, other, less menacing Gelede masquerades were mobilized to appeal to market women, Oyo administrators, Hausa traders, and European travelers; these Gelede were associated with prosperity and the promotion of peace in the region.[9]

When metropolitan dissent and provincial rebellion caused the Oyo Empire to collapse in the 1830s, tens of thousands of refugees fled into southern and western Yorubaland. Within a decade, they established new states organized around independent warlords, not kings. In the process of reconstituting their governments and communities, Yoruba speakers drew on cultural institutions and practices from their past, including masquerades. But the empire's collapse left a

power vacuum that precipitated rivalries between these new states, as well as struggles to control trade routes linking the coast with the interior. These conflicts sparked a half-century of warfare that destroyed many communities and destabilized a wide region.[10] And just as masquerades contributed to the centralization of power in Oyo during the imperial period, they were also involved in the shifting political orders that characterized the period between Oyo's collapse and the imposition of British colonial rule into the early twentieth century.[11]

## Otta, Its Masquerades, and a Town's Struggle for Survival among Oyo's Ambitious Successors

The Yoruba town of Otta in Nigeria is an ideal place on which to focus my investigation of the relationship between masquerades and political, economic, and social transformations during the period between 1770 and 1928.[12] Strategically located just south of an area where the main conflicts between Oyo and its provinces played out, Otta enjoyed relative peace during the height of Oyo's imperial dominance, between 1770 and 1789, when an Oyo administrator brought an Egungun mask to Otta and became the leader of its Egungun priesthood in the town.[13] However, as metropolitan dissent and provincial unrest weakened Oyo, ambitious warriors sought freedom from its yoke and pursued their own imperial aims.[14] Many refugees settled in Otta, created their own Egungun and Gelede masks, and used them to entrench themselves and these masquerade institutions in the town's political culture. At the same time, Otta's inhabitants were caught between three regional powers vying for dominance in southwestern Yorubaland throughout much of the nineteenth century: the Fon kingdom of Dahomey to the west, the new Egba settlement of Abeokuta to the north, and the major coastal trading center of Lagos to the south.[15]

In the early nineteenth century, Otta's leaders mobilized many masquerades, in some cases transforming them, as they struggled to regain their economic footing in the face of a declining transatlantic slave trade and new European commerce in palm produce. In 1842, Otta was, as noted, subjugated by Abeokuta; in that same year, British evangelists began establishing a Christian mission in Otta.[16] After the establishment of a British Crown Colony at Lagos in 1861, the British became increasingly involved in Otta's unstable political, economic, and social life until 1893, when Great Britain formally imposed colonial rule throughout the region. In 1901, the last king to have been installed at Otta in the precolonial period died.[17] By then, masquerades had become so deeply entrenched in Otta's political culture that the constraints imposed by British colonial rule, along with Britain's limited reach into local politics, inspired a new generation of enterprising patrons who organized a new style of Egungun masquerade performance,

the abovementioned *alagbada* ("the owners of long flowing gowns"), in ways that shaped and reflected complex new alliances between colonial elites and subjects.

## Yoruba Masquerades

Although there have been a number of masquerade organizations among the Yoruba, Egungun and Gelede are the most extensively documented—by James White in Otta in the nineteenth century and by contemporary residents in the town.[18] To understand Egungun and Gelede, we must understand the beliefs, practices, and performances associated with them while bearing in mind that masquerade performances permit wide-ranging representations and interpretations.[19] In the most general sense, the term *egungun* has many meanings: bones, ancestors, a burial shroud, a mask, or, by extension, to any masked figure or masquerade. The mask conceals the identity of its wearer, who embodies a supernatural force, the spirit of an ancestor. More specifically, when I apply it to specific masquerade societies and performances, *Egungun* refers to a masked spirit whose name, attire, and ritual enactment are associated with an Oyo masking tradition. For the purposes of this study, *Egungun* may refer to a single Egungun masquerade or to a specific Egungun organization or society, which includes all of the masquerade chiefs and initiated members who may or may not don the mask in a town. An Egungun masquerade named Oya, for instance, includes the person wearing the Oya mask, as well as the drummers, singers, and other ritual specialists who accompany Oya during outings or performances.

In terms of their primary functions, Egungun masquerades honor ancestors and promote the reputations of their living descendants, which include the mask's sponsors.[20] An individual, male or female, may come to own or possess an Egungun mask by creating, inheriting, or seizing it by force. If the owner is male, he may carry or wear the mask, or he may enlist the help of another individual who possesses certain skills that are desirable in a performer. A female must rely on a male to wear her Egungun mask.[21] But despite conventions that prevent females from wearing an Egungun mask—and in some instances, from viewing certain masks and the process of a male robing a mask—many adult females do own Egungun masks (see figure I.1). Such conventions have not, however, been consistently upheld; sometimes women in their marital or birth homes or in ritual spaces watch the performer of a masquerade robe and disrobe even if they are typically barred from viewing that masquerade during its performances. And men and women commonly perform songs and dance steps alongside the man who adorns the Egungun. At the same time, some Egungun performers don a cloth costume in a way that makes the "assumed" male body underneath visually indeterminate, which adds to the masquerader's mystery. In the next section I discuss the approach to gender I developed over the course of this study.

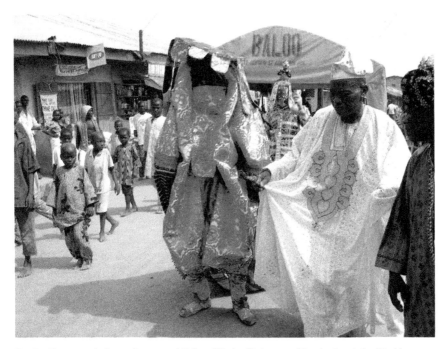

Fig. I.1. Egungun *baba muko*, named Babaa ("father"), is owned by the *Iya Agba Oje* (the elderly women chiefs of Egungun) in Otta. This Egungun performs on special days during the festival period, including one day, seen here, set aside for Babaa. It honors deceased Egungun chiefs and initiated members. 2004–2005 Egungun Festival, Otta. Photograph by author, December 26, 2004.

Although many studies of Egungun focus on gender, in some instances kinship and ethnicity are equally if not more important elements of regional culture and history. Kinship refers to people who identify themselves as members of the same marital or birth lineage; gender and age determine their rank and obligations. Through Egungun performances, participants create and expand kinship through actions that identify themselves as children or loyal followers of the same ancestor and oblige other "followers" or observers to meet the demands of deference, labor, money, and so on, required by the ancestor. In essence, Egungun performances redefine kinship beyond biology and marriage to include all of humanity as the descendants of the deceased. The notion that Egungun has been used to punish witches reflects a policing of gender and kinship norms in ways that overhaul daily social identities.

In the dialect of the masquerade names and songs and in the mythology that explains the origin of the practice and of its performers and organizers,

Egungun is identified most closely with Yoruba speakers from the kingdom and empire of Oyo. Egungun performances, I argue, have in certain contexts also been about harnessing and enacting the power ascribed to Oyo and its people. As mentioned, an Egungun's mask may include a headdress made from animal bones or skin, netting, mirrors, or wooden carvings. If a headdress is worn, below it a layer of fabric, palm fronds, or animal skins covers the body of the wearer from head to toe, including all limbs. The cloth costume may take the shape of a large sack, with swirling panels of damask, velvet, lace, or other fabrics. The arrangement of materials in an Egungun's costume gives it an appearance that ranges from distinctly human to animal to supernatural. To complement the visual disguise of the Egungun, the performer speaks in an unrecognizable, often guttural voice.[22]

Egungun differ in name, form, and function, both within and between communities. Today at Otta, for instance, the following types appear in the annual festival: *baba muko, alagbada, alabala, oloogun, wariwo,* and *soja. Baba muko* are elders who honor Egungun chiefs upon their deaths. An *alagbada,* true to its name (as mentioned earlier), is the owner of an *agbada,* a long, flowing robe resembling Muslim attire worn by men of status and the Egungun that promote them. During the evening performance of the Egungun *alagbada,* the masquerader removes the *agbada* (gown) costume at one stage of the performance to reveal another type of costume underneath—animal or human—known as an *onidan* (a possessor of magic), which represents various animals in the local cosmology.[23] An *oloogun* and *wariwo* (medicine man and warrior) remind the town of a time when its warriors were men trained in the use of medicines with spiritual properties. An *alabala* is mythically and visually associated with the nimble and acrobatic patas monkey. A *soja* refers to a soldier, one who controls the crowd and serves as an intermediary between the Egungun performers or ancestors and the audience of human beings. There are also separate categories for some Egungun, identified by their name and attire, such as Ege, Apaje, Apaje Ishorun, and Amuludun.[24]

The second masquerade tradition called Gelede honors the power of women. Three elements make up the Gelede attire: a carved wooden headdress depicts the masquerade figure, large metal anklets rattle during the dancing, and panels of fabric, associated with women's skirts or baby sashes, cover the body of the performer (see figure I.2).[25] Through Gelede masquerade performances, communities have petitioned human and spiritual forces to act harmoniously, reminding them that they are children of the same archetypal mother, Iya Nla. Gelede has also placated Iya Nla, asking that she promote human and agricultural fertility and discourage her children from using force to resolve conflicts (see figure I.3). Gelede also often satirizes social misfits.[26]

Both Egungun and Gelede involve elements of ritual and play. Egungun honors and incarnates the ancestors, and Efe (the night performer who precedes a

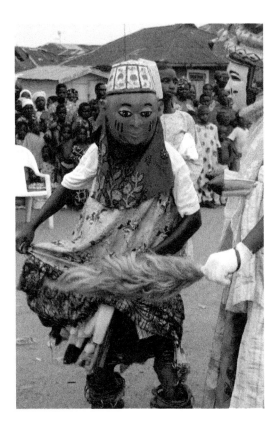

Fig. I.2. Gelede mask depicting a Hausa, or Yoruba, Muslim man. A woman's blouse, cloth used for a baby sash, and metal anklets—all of which are visible in this figure—make up the three distinguishing elements of a Gelede masquerader's attire. 2006 event honoring the king of Otta's late mother, Otta. Photograph by author, April 7, 2006.

daytime Gelede performer and is part of the Gelede masquerade tradition) venerates the Iya Nla, the *aje* (female mystical power associated with witchcraft), *orisha* (deity), his own ancestors, and retired performers (see figure I.4). Egungun uses the threat of and actual violence to police social and ritual actors. Efe uses social commentary to both praise and critique. Gelede as well as some Egungun use play to regulate individual behavior and societal norms.[27] Also, contrary to the predominant scholarly view, some Gelede masquerades also engage in acts of violence.

Male performers don Egungun and Gelede masks. In the case of Egungun masks that completely conceal the identity of the person underneath, performers shed their everyday identities and undergo a transformation into spirit mediums who are not held responsible for their actions.[28] However, Egungun does not involve spirit possession or trances, in which another consciousness associated with a spirit displaces the consciousness of the human performer. Conversely, Gelede masks and performances do not conceal the identity of the male masqueraders during nighttime Efe performances or daytime Gelede performances. Neither nighttime nor daytime Gelede actors are spirit mediums, although their status is

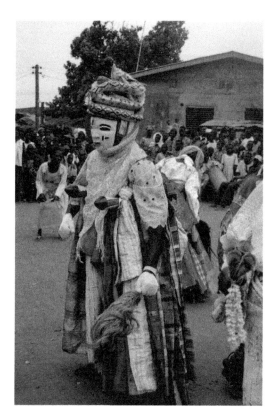

Fig. I.3. A bird and a snake appear atop the headdress of a Gelede mask depicting a female form. Both animals are among the forms taken by the nocturnal spirits associated with Iya Nla, the matron spirit of Gelede. 2006 event honoring the king of Otta's late mother, Otta. Photograph by author, April 7, 2006.

ambiguous. Efe performers maintain their human identities while engaged in acts of ritual devotion and speaking in the voice of Iya Nla. Gelede performers maintain their daily identities while playing other social and ritual actors. Some Egungun and Gelede performers wear wooden headdresses that depict feminine hairstyles and makeup or even chest plates depicting breasts along with women's clothing.

This introduction to the masquerade tradition provides an apt pivot to a discussion of the approach to gender that I developed during my research, which, as I suggested earlier, departs from conventional wisdom in the literature. To understand why male ritual performers such as Egungun and Gelede masqueraders and *orisha* possession priests take on feminine attributes—even performing gender identities typically ascribed to women such as the bride, the wife, and the pregnant woman—we must adopt an intersectional approach. Although being male serves as one criterion of a person's candidacy for donning an Egungun or Gelede mask, other determining factors include membership within a family in possession of the mask and individual skill. Masqueraders who take on the

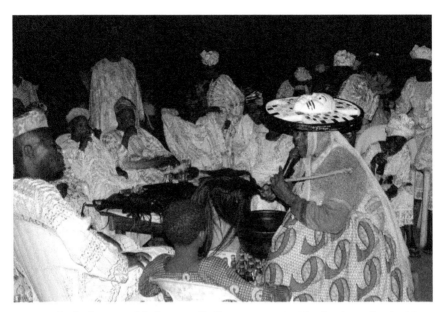

Fig. I.4. Efe, also known as "the humorist," offers prayers to Iya Nla, the *aje*, *orisha*, the Efe performers' own ancestors, and retired performers, along with social commentary (ranging from humor and satire to ridicule) during a night concert while using a microphone to project its voice. Efe is the nighttime counterpart to the daytime Gelede performance; Efe and Gelede performances make up the entire Gelede masquerade tradition. The mask worn on top of the head of the Efe performer is known as the *oriji*. 2006 event honoring the king of Otta's late mother, Otta. Photograph by author, April 6, 2006.

persona of brides should be interpreted not only as "playing" female wives-to-be but also as representing individuals undergoing the process of initiation into an *orisha* priesthood because the Yoruba term for "bride" is also used to refer to some *orisha* priests.

Similarly, masqueraders who depict wives may also be referring to devotees of particular *orisha* priests; both male and female priests of the deity Shango are known in the Yoruba language as (ritual) "wives" of the deity and of the *Alaafin* of Oyo, who like Shango priests during possession is also the living embodiment of the deity.[29] The gender identity of a Shango devotee is ambiguous: he is both a "wife" of the deity and, during possession rituals, the spirit of Shango incarnate. Male masqueraders and priests who perform gender categories typically ascribed to women reflect a Yoruba awareness of the distinction between sex and gender that is all too often absent in scholarship.[30] Thus Western-trained scholars need to acknowledge how gender functions as a metaphor for a range of other social identities and structural relations.

There are sexual metaphors in masquerade performances as well. Possession priests and priestesses are receptacles for the deity honored in a particular performance. As the performance ethnographer and Yoruba ritual specialist Margaret Thompson Drewal astutely observes, "The male is contained during intercourse, just as he is by the spirit's cloth in masking. . . . In contrast, the female contains during intercourse and pregnancy."[31] In the case of Egungun depicting pregnant women, "the play on the idea of mask as womb and womb as mask is the primary theme in performances of miracle worker masks [a particular genre of Egungun performer] whose form and performance allude simultaneously to a pregnant womb that 'gives birth' and to the dress of Muslim women in Purdah."[32] A pregnant woman in essence *is* a mask, suggesting metaphorically that a woman was the original mask. The metonymic conjunction between a pregnant woman and a mask may explain the existence of myths that attribute the origins of masking to women.

Pregnant women and spirit possession priests share a quality of Egungun masqueraders insofar as both serve as temporary homes for spirits, the former as expectant mothers and the latter as spirit mediums of ancestors. While in a trance, possession priests reincarnate the spirits of family deities in the bodies of living members (the descendants), in response to prayers, offerings, drumming, dancing, and singing on the part of priests and other devotees. Possession priests lose consciousness during a trance, it being temporarily displaced by spirits or deities.[33]

The ritual context, music, and audience involved in a masquerade performance inspire dramatic changes in the behavior of Gelede masqueraders. The ritual context heightens awareness of the sacred aspects of ritual performance. The performer's awareness of the audience fuels a desire to put on a captivating performance.[34] There is thus no dividing line between the sacred and the secular in performance, as masqueraders play with gender in ways that lie at the heart of this book's agenda.

## Gender in Precolonial West Africa

In this book I view and use gender as a social category, an analytic instrument, and a performance. As a category of analysis, gender highlights the ways in which bodies, male or female, have behaved according to a set of social practices and group norms. This focus differentiates the experiences of males and females and of men and women in various contexts.[35] As an analytic instrument, this focus on gender demonstrates how social categories have been constructed and reproduced, how inequalities have been maintained, how power has been wielded, and how historical processes such as the rise and fall of the slave trade and empires have played out and been experienced.[36] Enacting, commenting on, or revising a

gender identity in everyday life or in masquerade and other ritual practices constitutes a gender performance.[37]

Several important texts on gender in precolonial African history inform the way I link fluctuations in the participation of women as high-ranking political and ritual authorities in West Africa societies to shifting models of gendered chiefly and royal power during the era of the transatlantic slave trade. Preeminent among these studies is Greene's abovementioned *Gender, Ethnicity, and Social Change on the Upper Slave Coast.* She argues that evolving encounters between "insiders" (early Ewe residents) and "outsiders" (refugees and immigrants) on the Gold Coast during the slave trade spawned an Anlo-Ewe (Anlo) ethnic identity around clans. Male elders in patrilineal Anlo society regulated young women's marriage choices and access to land. Yet women's efforts challenged the social marginalization that resulted from Anlo identity formation. Greene powerfully demonstrates how the appropriation and blending of ritual ideas, practices, and institutions were linked to changing gender relations.[38] Following on her analysis, I link the history of masquerades in the Yoruba kingdoms of Oyo and Otta to the development of local mutually constitutive ethnic and gender identities as well as masquerades.

Portraits of royal women and their shifting functions within states that interacted with Oyo and Otta are critical to the argument I advance regarding gendered expressions of power and authority in local and regional politics. A royal woman occupied multiple gendered identities: as the wife, sister, mother, or daughter of the king and as a diplomat or representative of the king beyond the palace walls, such a woman could harness to varying degrees the royal masculinity of the monarch.[39] Edna Bay's *Wives of the Leopard* (1998) describes the monarchy in the Fon kingdom of Dahomey as including royal women, who comprised the majority of palace personnel.[40] She chronicles the rise of an administrative system within the palace that included female bodyguards, "queen-mothers," and other bureaucrats who worked with their male counterparts to influence politics and economics outside the palace. Bay notes the connections between the roles and meanings of particular religious systems and their appropriation into the Dahomeyan political system, as well as their effects on gender relations within the political culture of the state. Her study inspired me to look for connections between masquerades and the efforts of state actors (kings and chiefs at Oyo and Otta in particular).

This book is also in dialogue with Lorelle D. Semley's *Mother Is Gold, Father Is Glass: Gender and Colonialism in a Yoruba Town* (2011), which challenges the assumption that women's power derived from their biological status as mothers. She grapples with the historical and symbolic power associated with motherhood in the Yoruba kingdom of Ketu, focusing on a number of subject positions that Yoruba women have historically embodied in a range of relationships.[41] She does

not observe women who bear masculine (and men who bear feminine) titles and subjectivities in masquerade and other organizations. Here I address this absence and broader issues of gender, kinship, and ethnicity in African political culture during and immediately after the transatlantic slave trade.

Among Yoruba speakers, only males, with few exceptions, have been known to wear masks during ritual performances, and masquerade organizations or groups have long been domains that adult males dominated, according to missionaries and subsequent generations of scholars. Yet this view of the practice and of masquerade performance overlooks the gender fluidity that I confirmed through my research: males and females occupy diverse and shifting gender categories while engaging in a range of gendered practices.[42]

Gender reflects the various social roles and obligations placed on and ascribed to men and women and on male and female social groups, including the roles of postmenopausal women as compared with those of child-bearing women, those of senior wives as compared with those of junior wives, those of fathers as compared with those of mothers, and those of elderly men as compared with those of young, unmarried men. Gendered practices and institutions constitute actions and organizations that limit one gender's options while creating greater opportunities that enable another gender to dominate.[43] This book offers an array of evidence that I use to complicate and contest this predominant view of gender in masquerade performances and organizations by demonstrating that adult females sometimes perform masculinity in ways that have been historically associated with adult males; conversely, adult men sometimes perform aspects of femininity.

## Research Methodology

### Reconceptualizing Masquerades

To date, most of our knowledge about masquerades in Africa has come from art historians and anthropologists, who view them both as practices involving dance, performance, ritual, or possession and as institutions whose aims included social control and ritual subversion or validation. Historians, by contrast, have by and large overlooked the place of masquerades within African history, treating them as peripheral to the political, economic, and cultural forces that have shaped the past. In addition, historians have tended to rely heavily on written documentation as source material, rather than examining the artifacts of material culture or collecting oral histories regarding the masquerade tradition.

My thinking about masquerades as encompassing a fluctuating group of individuals with wide-ranging interests and resources is indebted to the work of Africanist scholars from a range of disciplines. From *Wives of the Leopard*, I draw on Bay's view of the monarchy as an evolving coalition of individuals whose membership and motives changed with respect to the hierarchy of spirits, ritual

specialists, and devotees.[44] Similarly, I view individual Egungun and Gelede masquerades as comprised of small but fluid groups of political, ritual, and commercial elites, with one man wearing the mask for which the masquerade was named and other members and their associates marshaling their resources to advance individual and collective interests. Building on Bay's work, I observed that these masquerade members and their associates sometimes included chiefs and members of the monarchy.

I also find inspiration in the work by the anthropologist, Insa Nolte, on precolonial Yoruba speakers in the town of Remo. In *Obafemi Awolowo and the Making of Remo* (2010), Nolte develops the idea of Yoruba towns as "pacted" communities brought into existence by the consent of individuals and groups who submit to a town's (or kingdom's) authority and enable it to survive physical destruction and resettlement, which both Oyo and Otta experienced at various times. She views masquerade organizations, *orisha* priests, chiefs, families, compounds, and wards that comprise towns as deeply implicated in dynamic struggles for community control and that reinterpret its institutions, narratives, and practices in ways that promote a particular vision and set of actors. She describes how diverse forms of ritual and political enactments—such as installation ceremonies, festivals, and rituals—reaffirm the notion of a town as a unified whole.[45]

Ritual performers do not simply garner agency by adhering to a preset ritual structure and mode of performance, however. As Margaret Thompson Drewal skillfully demonstrates in *Yoruba Ritual* (1992), performers identify precedents from myths and fashion them to create a double dynamic that simultaneously refers to the past and ancestral spirits while renegotiating the present through improvisation. Mythical and otherworldly elements are brought to bear on ongoing circumstances just as tradition or legal precedents become referenced, interpreted, and represented.[46]

## Sources of Evidence and Methodology

Yoruba communities are among the few places in sub-Saharan Africa where we can find a large body of written, oral, and visual evidence and scholarship for reconstructing local politics from the eighteenth century through the early twentieth century. Samuel Johnson, a Yoruba Christian clergyman, offers the most comprehensive text of Yoruba precolonial history in general and of the origins of Egungun in particular. Between the 1870s and the 1890s he collected a wide range of oral evidence from *arokin*, Oyo oral court historians whose principal function has long been to recite the *oriki* (praise poems) of Oyo kings on ceremonial occasions. Johnson, however, did not simply narrate what he heard. He interpreted and transformed historical traditions into his *History of the Yorubas*, written in 1897 and published posthumously by his brother in 1921. The text may more accurately be understood as the "history of Oyo," framed through a chronology of

the reigns of the *Alaafin* (the title for the king of Oyo). It focuses on events and personalities associated with the rule of Oyo kings, rather than with the history of predynastic Oyo settlement and state formation.[47] Thus the book ignores many details of the origins and early history of Egungun, and it reinforces many gender stereotypes by focusing on men and portraying women as marginal players and victims. Gelede makes a brief appearance in Johnson's work, but only as an Egbado imitation of Egungun.[48]

Otta provides an excellent site for this investigation because of its rich masquerade traditions and the fact that it experienced the upheavals that plagued the broader region in a way that can be clearly seen. It also is the subject of historical sources of exceptional quality. Nineteenth-century missionary journals, letters, and reports from the archive of the Church Mission Society (CMS) offer an unmatched account of Otta's ritual and political life and the individuals and groups that animated it. Early twentieth-century records from Nigeria's National Archives at Ibadan and Nigeria's National Archives at Abeokuta, otherwise known as the Egba Archives, include intelligence reports, district council meetings, and other assorted documents created by colonial officials; these records document the development of local government institutions and colonial policies for provincial administrators based at Abeokuta, the headquarters of the province in which Otta existed as a district during the colonial period. Alongside written sources that offer first- and secondhand accounts of events as they unfolded or were recalled are oral traditions narrated by chiefs, royals, and masquerade performers and officials and visual sources that document twenty-first-century actors, events, and material culture. Together these sources offer a range of overlapping and alternative accounts of Otta's history and politics and the prominence of masquerades therein from the vantage points of a range of narrators of and actors within this history: missionaries, masquerade participants, royals, local chiefs, and colonial administrators.

CMS missionaries, some of Yoruba origin, arrived in the town in 1842 and lived there from 1852 through the end of the century. Their journals, letters, and reports to their leadership in London as well as a number of traveler accounts provide vivid written descriptions of Otta's nineteenth-century masquerades, along with much information about local politics and warfare. These sources yield rich data indicating how masquerade performers and organization members, on the one hand, and politics, on the other, shaped each other.

The most important missionary evidence pertaining to Otta comes from the writings of Reverend James White, a CMS agent of Yoruba parentage.[49] Born in the late 1820s in Charlotte Village, Sierra Leone, a British colony to which, as noted earlier, some would-be slaves were returned by the British after it abolished the slave trade, he was educated by the British in mission schools. Thus, although

White grew up outside of the Yoruba homeland (in what later became Nigeria) and was educated in British mission schools, he was raised by his Yoruba parents in a heavily Yoruba Christian mission community.[50] During White's formative years, many former Yoruba slaves lived in and around Freetown, the capital of Sierra Leone. He likely observed Africans receiving apprenticeships through their interactions with European settlers, merchants, sailors, carpenters, doctors, and missionaries.

White was sent to Otta in 1854 as an evangelist with arguably as much knowledge of European culture as of Yoruba culture. His understanding of both cultures evolved over the course of the twenty-five years he spent in Otta. Fluent in both English and Yoruba, White regularly wrote texts in English documenting life in the town. Of the many Yoruba agents who served in their homeland, he evidenced the greatest interest in local cultural practices, including masquerades.[51]

White produced vivid accounts of the activities of masquerades and other ritual practitioners and leaders. He compared Egungun performances that he observed in Freetown with those he witnessed in Otta. He chronicled a range of situations in which various individuals and factions mobilized Egungun and Gelede in Otta to intervene in evolving conflicts within the town. His accounts offer insightful commentary about the underlying causes and consequences of attitudes, practices, actions, and events; he also provides detailed descriptions of the ritual attire, instruments, and settings in which these groups operated. His writings reveal the politics and economics of these groups and, to the extent of his understanding, how these actors fit into the history of the town as it grappled with larger regional and global forces.

White's journal was a formal document, in which he often wrote several times a week and that he forwarded to his London superiors, along with quarterly, semiannual, and annual reports.[52] He wrote about masquerades as if they were "heathen" spectacles. Readers may infer that White, born to Christian converts and a newcomer to Otta, was unfamiliar with many of the subtleties of masquerade practices. Even if he was at times inclined to view masquerades as serious, complex, and worthwhile institutions, his awareness of the audience for which he wrote prevented him from freely expressing such views.

The information that CMS documents contain must be read with a "hermeneutic of deep suspicion," according to the anthropologist J. D. Y. Peel, author of the monumental work *Religious Encounter and the Making of the Yoruba* (2000), because the missionaries' primary aim was to supplant local religious beliefs and practices and replace them with Christianity.[53] Missionaries competed with the leadership of masquerade organizations for the loyalty of local elites and laypeople. This competition led missionaries to miss many details of the myths, traditions, and practitioners linked to masquerades that later ethnographers have

endeavored to capture. The missionaries simply could not see them, or at least could not acknowledge such in their writings, because of their training and aims.[54] I interpret the sources that missionaries produced as pitched to a particular audience, as Peel aptly elucidates.

In varying ways, missionaries and other narrators often failed to recognize cultural change through time. This inattention, I argue, led nineteenth-century missionaries to overlook the ways in which the outbreak of warfare and the fluctuating statuses of old and new towns affected how patrons and performers harnessed the violent elements of masquerades. Women who were without the protection of natal or marital kin or access to considerable financial resources were particularly vulnerable. These women tend to appear as flat, one-dimensional characters in many sources, instead of as agents whose status was shaped not only by their gender but also by their age, wealth, and the social and political standings of their birth, marital, and ritual lineages. Missionaries were not alert to or ignored how cultural institutions were changing in response to the demands of warfare. Nor were they aware of the influence of their own presence on institutions such as masquerades. Yet still, missionary sources are critically important as records of events, people, and practices about which other evidence does not exist or provides few details.

A number of written texts produced by local historians of Otta have also proved useful. Dada Agunwa wrote during the colonial period and produced accounts that supplement British colonial sources and missionary writings. R. A. Salako and Dele Kosebinu are contemporary writers who discuss the history of Otta, providing detailed narratives of the reigns of its kings.[55] Kosebinu produced the brochures for the 2000 and 2004 Egungun festivals at Otta, in which he included some of the praise songs (*oriki*) that accompany masquerades belonging to the *alagbada* group. These songs reference elements of ritual practice and of the history of the families that enact masquerades; they also highlight the achievements of individual family members.[56]

Finally, oral data are critical to this study, because they provide an essential indigenous perspective and address issues on which the written records are silent. Oral data include historical narratives, poems, and songs that have long served as indigenous historical records and are recognized as such by scholars.[57] Asiwaju, a historian, contends that Efe songs, recited during Gelede performances, express the views of the masses by narrating and commenting on events and individuals.[58] Peel has shown that *itan*, or oral stories, represent self-contained or limited episodes from the past related to individuals, lineages, communities, or religious groups.[59] Although these oral traditions are, for the most part, transmitted by men, another genre, the *oriki*, is transmitted mostly by women. *Oriki* narrate attributes of individuals, lineages, towns, and mythological figures as well as events surrounding them.[60]

Together, these oral sources provide histories of masquerades from the perspective of local men and women, both elite and common. Drawing insights from the work of Bolanle Awe and Karin Barber on *oriki*, Wande Abimbola on Ifa divination poetry and narratives, and A. I. Asiwaju on Efe songs, I probe these oral texts alongside the written sources to reconstruct the history of masquerading in Otta.[61] These sources provide much-needed detail regarding the origins and development of masquerades, their role in implementing policy and buttressing royal and chiefly power, and the relationship of masquerades to important historical figures and events. Although *oriki* mix historical and mythological narratives, scholars recognize them as the most fixed and reliable of oral traditions because of the intense training their transmitters undergo. In addition, the emphasis on accuracy in reciting these oral texts gives them a level of integrity that leads Yoruba people to lean heavily on them for information regarding Yoruba history.

I use performance as a conceptual framework for analyzing the production of knowledge about Yoruba history and culture reflected in the narratives constructed by missionaries, as well as by colonial writers, local historians, and other patrons of and participants in masquerades. This approach helps me evaluate the extent to which discrepancies in the accounts rendered by my sources reflect divergent agendas. I endeavor to historicize performance by analyzing the prevailing conditions during or in the aftermath of the moments at which my sources observed historical phenomena, provided their accounts in oral or written form, or performed a given set of actions.

The stage is now set to tell the story of how masquerade societies and practices in Otta—particularly Egungun and Gelede masquerades—shaped and were shaped by the region's dynamic, sometimes violent, social, political, and cultural history. I show that many leaders, both in and out of royal lineages, harnessed beliefs about and devotion to ancestral spirits to challenge, consolidate, or defend their power and prestige. As I trace the evolution of masquerade practices, I show that masquerades have played—and continue to play—a critical role in processes of migration and assimilation as waves of people representing a range of Yoruba speakers of varying ethnicities moved into and expanded Otta's wards; these migrants introduced new (or transformed existing) masquerades that they mobilized to help them forge alliances or protect their interests against invading forces from the west and the north. Egungun and Gelede masquerades were and remain essential elements of Yoruba identity and of the identities of ethnic groups and towns over the course of the centuries during which the events I chronicle unfolded. Along the way I also show that a fuller understanding of masquerades enables me to challenge traditional views of gender in these societies, because women have played significant roles throughout the history of masquerades and continue to do so in the present day.

## Notes

1. Elizabeth Tonkin, "Cunning Mysteries," in *West African Masks and Cultural Systems,* ed. Sidney L. Kasfir (Tervuren: Musée Royal de l'Afrique Centrale, 1988), 241, 244.

2. Sandra E. Greene, *Gender, Ethnicity, and Social Change on the Upper Slave Coast: A History of the Anlo-Ewe* (Portsmouth, NH: Heinemann, 1996), 12.

3. Samuel Johnson, *History of the Yoruba: From the Earliest Times to the Beginning of the British Protectorate* (Lagos: C. M. S. Bookshop, 1921); Robert S. Smith, *Kingdoms of the Yoruba* (London: Methuen, 1969).

4. Dada Agunwa, *The First Book on Otta: In Memory of King Aina and King Oyelusi Arolagbade* (Otta, 1928).

5. Yorubaland refers to southwest Nigeria and southern Benin and Togo.

6. W. E. B. Du Bois, *The Souls of Black Folk: Essays and Sketches* (Chicago: A. C. McClurg, 1903).

7. Andrew H. Apter, *Black Critics and Kings: The Hermeneutics of Power in Yoruba Society* (Chicago: University of Chicago Press, 1992), chapter 1.

8. Peter Morton-Williams, "The Egungun Society in South-Western Yoruba Kingdoms," in *Proceedings of the Third Annual Conference of the West African Institute of Social and Economic Research* (Ibadan: University College, 1956), 90–103; Robert Smith, "The Alaafin in Exile: A Study of the Igboho Period in Oyo History," *Journal of African History* 6, no. 1 (1965): 57–77; Joel Adedeji, "The Alarinjo Theatre: The Study of a Yoruba Theatrical Art from Its Earliest Beginnings to the Present Times" (PhD diss., University of Ibadan, 1969); S. O. Babayemi, *Egungun among the Oyo Yoruba* (Ibadan: Board Publication, 1980).

9. Henry John Drewal and Margaret Thompson Drewal, *Gelede: Art and Female Power among the Yoruba* (Bloomington: Indiana University Press, 1983), 234–236.

10. J. D. Y. Peel, *Religious Encounter and the Making of the Yoruba* (Bloomington: Indiana University Press, 2000), 35–38.

11. See Adedeji, "The Alarinjo Theatre," 166–207; Babayemi, *Egungun among the Oyo Yoruba,* 27–29.

12. B. A. Agiri, "Kola in Western Nigeria, 1850–1950: A History of the Cultivation of Cola Nitida in Egba-Owode, Ijebu-Remo, Iwo and Ota Areas" (PhD diss., University of Wisconsin, 1972), 18–24.

13. R. A. Salako, *Otta: Biography of the Foremost Awori Town* (Otta: Penink Publicity, 2000), 61–65.

14. Robin Law, *The Oyo Empire, c. 1600–c. 1836: A West African Imperialism in the Era of the Atlantic Slave Trade* (Oxford: Clarendon, 1977), 261–277; J. F. Ade Ajayi, "The Aftermath of the Fall of Old Oyo," in *History of West Africa,* ed. J. F. Ade Ajayi (London: Longman, 1987), 174–214.

15. Agiri, "Kola in Western Nigeria," 19–20, 56–57.

16. S. O. Biobaku, *The Egba and Their Neighbours, 1842–1872* (Oxford: Clarendon, 1957), 27.

17. Salako, *Otta,* 65.

18. J. R. O. Ojo, "Epa and Related Masquerades among the Ekiti Yoruba of Western Nigeria" (MPhil diss., University of London, 1974); Babayemi, *Egungun among the Oyo Yoruba;* Nwanna Nzewunwa, ed., *The Masquerade in Nigerian History and Culture* (Port Harcourt, Nigeria: University of Port Harcourt, 1980); Drewal and Drewal, *Gelede;* Benedict M. Ibitokun, *Dance as Ritual Drama and Entertainment in the Gelede of the Ketu-Yoruba Subgroup in West Africa* (Ile-Ife: Obafemi Awolowo University Press, 1993); Babatunde Lawal, *The Gelede Spectacle:*

*Art, Gender, and Social Harmony in an African Culture* (Seattle: University of Washington Press, 1996).

19. Henry John Drewal and Margaret Thompson Drewal, "The Arts of Egungun among Yoruba People," *African Arts* 11, no. 3 (1978): 18; Margaret Thompson Drewal, *Yoruba Ritual: Performers, Play, Agency* (Bloomington: Indiana University Press, 1992).

20. Drewal and Drewal, "The Arts of Egungun among Yoruba People," 18.

21. Babatunde Lawal, "The Living Dead: Art and Immortality among the Yoruba of Nigeria," *Africa* 47, no. 1 (1977): 51, 59.

22. Interview with Oba M. A. Oyede III, *Olota* of Otta, Otun ward, Otta, 2005.

23. Deji Kosebinu, Dele Adeniji, and Rasheed Ayinde, *Millennium Egungun Festival in Ota Awori: Special Program Brochure* (Otta: Bisrak Communications, 2000).

24. The Amuludun of Otta is not the same as the Amuludun referenced in Oyo oral traditions that chronicle the origin of the first Egungun masquerader, even though they have the same name.

25. Ulli Beier, "Gelede Masks," *Odu: Journal of Yoruba and Related Studies* 6 (1958): 5–23; Drewal and Drewal, *Gelede*; Ibitokun, *Dance as Ritual Drama*; Lawal, *The Gelede Spectacle*.

26. Beier, "Gelede Masks"; Drewal and Drewal, *Gelede*; Ibitokun, *Dance as Ritual Drama*; Lawal, *The Gelede Spectacle*.

27. Drewal, *Yoruba Ritual*; Lawal, *The Gelede Spectacle*.

28. Lawal, *The Gelede Spectacle*.

29. Drewal, *Yoruba Ritual*, 110–111; James Matory, *Sex and the Empire That Is No More: Gender and the Politics of Metaphor in Oyo Yoruba Religion*, 2nd ed. (Minneapolis: University of Minnesota Press, 2005).

30. John Thabiti Willis, "Bridging the Archival-Ethnographic Divide: Gender, Kinship, and Seniority in the Study of Yoruba Masquerade," *History in Africa: A Journal of Method* 44 (2017), doi.org/10.1017/hia.2016.12.

31. Drewal, *Yoruba Ritual*, 185.

32. Ibid.

33. Pierre Verger, "Trance and Convention in Nago-Yoruba Spirit-Mediumship," in *Spirit Medium and Society in Africa*, ed. J. Beattie and J. Middleton (London: Routledge and Kegan Paul, 1969), 50–66.

34. Lawal, *The Gelede Spectacle*, 269.

35. There is a difference between the biological categories of male and female and the social categories of men and women. Acknowledging this difference is essential to understanding Yoruba discourses about witchcraft. One factor that complicates these discourses is that some writers and speakers assume that these biological and social categories are interchangeable, whereas others do not. Whether a witch is a female or a person who deviates from conventional gender norms is a key factor in discussions of witchcraft. I believe the same factor informs discussions of Egungun; for example, regarding participation based on biology, gender-based social categories, or other factors such as kinship and wealth. At the same time, unless I indicate otherwise, I treat these biological and social categories as the same.

36. Lisa A. Lindsay and Stephan Miescher, "Introduction: Men and Masculinities in Modern African History," in *Men and Masculinities in Modern Africa*, ed. Lisa A. Lindsay and Stephan Miescher (Portsmouth, NH: Heinemann, 2003), 3–6.

37. Marlon M. Bailey, *Butch Queens up in Pumps: Gender, Performance, and Ballroom Culture in Detroit* (Ann Arbor: University of Michigan Press, 2013).

38. Greene, *Gender, Ethnicity, and Social Change*.

39. I draw on Lindsay and Miescher's notion of masculinity as the assortment of norms, values, and behavior patterns that reflect expectations of how men should act and represent themselves to others. Lindsay and Miescher, "Introduction," 4.

40. Edna G. Bay, *Wives of the Leopard: Gender, Politics, and Culture in the Kingdom of Dahomey* (Charlottesville: University of Virginia Press, 1998).

41. Lorelle D. Semley, *Mother Is Gold, Father Is Glass: Gender and Colonialism in a Yoruba Town* (Bloomington: Indiana University Press, 2011), 12.

42. Lisa A. Lindsay and Stephan Miescher, eds., *Men and Masculinities in Modern Africa* (Portsmouth, NH: Heinemann, 2003); Nwando Achebe, *The Female King of Colonial Nigeria: Ahebi Ugbabe* (Bloomington: Indiana University Press, 2011).

43. I draw from historian Marjorie McIntosh's clear and succinct definition of gender and patriarchy. Marjorie Keniston McIntosh, *Yoruba Women, Work, and Social Change* (Bloomington: Indiana University Press, 2009), 17.

44. Bay, *Wives of the Leopard*, 7.

45. Insa Nolte, *Obafemi Awolowo and the Making of Remo: The Local Politics of a Nigerian Nationalist* (Edinburgh: Edinburgh University Press, 2010), 32–46.

46. Drewal, *Yoruba Ritual*, 91–94.

47. Many historians agree that individual *Alaafins* (assumed to have been men, assisted by their supporters) revised the history of previous eras to such a degree that there is little trace of what actually occurred before these rulers seized power. Furthermore, Johnson's official version, which privileges the *Alaafins'* role in Oyo history, has been so widely circulated that it appears to have influenced subsequent accounts. B. A. Agiri, "Early Oyo History Reconsidered," *History in Africa* 2 (1975): 1–16; Robin Law, "How Many Times Can History Repeat Itself? Some Problems in the Traditional History of Oyo," *International Journal of African Historical Studies* 18, no. 1 (1985): 33–51.

48. Johnson, *History of the Yoruba*, 30–31, 158–160.

49. James White, *CA2/087 Original Papers—Missionaries: Church Mission Society—Yoruba Missions* (Birmingham: University of Birmingham, 1879).

50. Ibid.; Christopher Fyfe, *A History of Sierra Leone* (London: Oxford University Press, 1962); Jean Herskovits Kopytoff, *A Preface to Modern Nigeria: The "Sierra Leonians" in Yoruba, 1830–1890* (Madison: University of Wisconsin Press, 1965); John Peterson, *Province of Freedom: A History of Sierra Leone, 1787–1870* (London: Faber, 1969).

51. Peel, *Religious Encounter*.

52. Ibid., 9.

53. Ibid., 12.

54. Ibid.

55. Agunwa, *The First Book on Otta*; Dada Agunwa, *Iwe Itan Bi Esin Imale Ti Se De Ilu Otta Ati Ilosiwaju Ninu Esin Imale*, trans. Gbamidele Ajayi (Otta, 1947); Salako, *Ota*; Ruhollah Ajibola Salako, *Oba Moshood Oyede, the Olota of Ota: So Far So Good* (Otta: Penink Publicity, 2004); Deji Kosebinu, *Alani Oyede: The People's Monarch* (Otta: Bisrak Communications, 2000); Kosebinu et al., *Millennium Egungun Festival*; Deji Kosebinu, Dele Adeniji, and Rasheed Ayinde, *Odo Oje Otta: Launching and Commissioning of "Ege" Statue* (Otta: Bisrak Communications, 2000); Deji Kosebinu, Dele Adeniji, and Rasheed Ayinde, *2004 Egungun Carnival in Otta Aworiland* (Otta: Bisrak Communications, 2004).

56. Karin Barber, *I Could Speak until Tomorrow: Oriki, Women and the Past in a Yoruba Town* (Washington, DC: Smithsonian Institution Press, 1991).

57. I collected this material during semistructured and open-ended interviews and conversations with representatives of Otta's masquerade lineages and royal and chieftaincy lineages,

as well as through my own observations of masquerade performances. Bolanle Awe, "Praise Poems as Historical Data: The Example of the Yoruba Oriki," *Africa* 44, no. 4 (1974): 331–349; Barber, *I Could Speak until Tomorrow*.

58. A. I. Asiwaju, "Gelede Songs as Sources of Western Yoruba History," in *Yoruba Oral Tradition: Poetry in Music, Dance, and Drama*, ed. Wande Abimbola (Ile-Ife: Department of African Languages and Literature, University of Ife, 1975), 199–204.

59. J. D. Y. Peel, "Making History: The Past in the Ijesha Present," *Man*, n.s., 19, no. 1 (1984): 111–132.

60. Awe, "Praise Poems as Historical Data"; Bolanle Awe, "Notes on Oriki and Warfare in Yorubaland," in *Yoruba Oral Tradition: Poetry in Music, Dance, and Drama*, ed. Wande Abimbola (Ile-Ife: Department of African Languages and Literature, University of Ife, 1975), 267–292; Barber, *I Could Speak until Tomorrow*.

61. Wande Abimbola, "Ifa Divination Poems as Sources for Historical Evidence," *Lagos Notes and Records* 1 (1967): 17–26; Awe, "Praise Poems as Historical Data"; Awe, "Notes on Oriki and Warfare in Yorubaland"; Barber, *I Could Speak until Tomorrow*.

# 1 The Early History of Otta and the Origins of Egungun and Gelede

OTTA IS THE capital of a precolonial Yoruba kingdom and a modern-day local government area, as well as the home of the second-largest concentration of industries in Nigeria. Geographically, this community lies at the convergence of a flat, low-lying savanna and a forest belt with well-watered soil that has nurtured agricultural, commercial, social, and political activities. Before the sixteenth century, a group of Awori people moved from Isheri to settle in Otta, where early economic activity included farming and trading. Otta is located to the north and west of another Awori settlement, Lagos, where a large lagoon that opens onto the Bight of Benin in West Africa proved conducive to fishing, water navigation, and canoe-based warfare (see map 1.1). To the west of Otta's early residents were Gbe speakers (Aja, Fon, and Gun people) and to the northwest and east were Yoruba speakers (Egbado and Ijebu people, respectively). People from near and far have made important contributions to Otta's political and cultural institutions.

This chapter reconstructs the early history of Otta and links the migration of Awori and other Yoruba speakers to the development of its political and cultural institutions. It draws on oral traditions documented by missionaries from the nineteenth and twentieth centuries and unearthed archeological evidence to reconstruct the origin of the Egungun and Gelede masquerade practices and organizations. An analysis of this evidence reveals that Egungun and Gelede stemmed from political and commercial alliances between families from distinct ethnic groups and that these groups developed the capacity to control the material and human resources needed to organize and enact these events that served the interests of their patrons.

## Otta, Its Founders, and Their Critics

Otta's exceptionally fertile soil and location between the forest and the coast attracted generations of settlers who either joined existing kin groups or established their own. Early inhabitants provided some later generations of settlers with land in perpetuity, free of annual rent payments. During the wars of the nineteenth century, other more recent settlers offered alcohol or military service in exchange for land and political, military, or ritual offices. They even founded their own lineages and elected and paid tribute to their own leaders.[1]

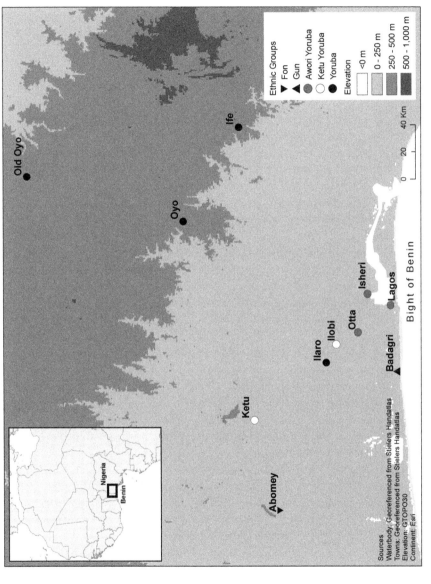

Map 1.1. Map showing the location of Otta in relation to other Awori towns (Isheri and Lagos) and to many of the important towns referenced in this chapter.

The basic unit of social and political organization in Otta has been and continues to be the family. A lineage, or large family comprised of the patrilineal descendants of a single man believed to be the founder of the lineage, typically lived in one or multiple compounds. The *baale* was head of a single compound or a lineage comprised of multiple compounds, and although this figure was generally the oldest male, the *baale* was sometimes the most influential male—or female. Yoruba households were often polygamous, so many men of means had multiple wives, and the senior wife of the *baale* was (in theory) accorded the same degree of respect as her husband. All of the men under the authority of the *baale* demonstrated their respect for him by prostrating (*dobale*) themselves on the ground; women kneeled (*kunle*) to show respect to the *baale*, as well as to their elders or someone of higher standing. The *baale* also received periodic gifts of fish, produce, labor, and support from those living under his authority. The individual families mostly carried out their own economic activities independently, but received ritual, social, economic, political, and even legal support from the *baale*. Organizing and officiating rituals in honor of a lineage's ancestors or other guardian spirits were also among the responsibilities of the *baale*. The heads of the most prominent lineages in a town often held chieftaincy titles, which empowered their holders to wield authority in the day-to-day administration of the town. In this regard, the town operated like a federation of lineages.[2]

Otta contained several wards, each comprised of a group of adjacent compounds. A resident chief, often the most powerful *baale* of the lineages that comprised a ward, represented the ward in the town government. The size and wealth of his lineage, along with the number and size of the compounds acknowledging his authority, determined who was the most powerful *baale*, as well as who among them represented his ward on the council of ward chiefs that governed the town. He maintained order and settled disputes. Power was not only vertical but also horizontal or, one might say, fluid. Compounds, as well as lineages, could transfer their allegiance from one chief to another, fueling competition between the major chiefly lineages to provide the gifts, protections, and favors needed to keep the allegiance of the smaller lineages.

Otta's earliest known ward structure featured two wards, Otun and Osi, which were populated by Awori settlers. The first individuals to represent the interest of their wards in governance at both the town and kingdom levels assumed the titles of *Onikotun* in Otun and *Onikosi* in Osi.[3] Generations of other Yoruba and non-Yoruba settlers later established other wards in Otta.

The Ileshi, the Ikowogbe, and the Ijemo-Isolosi families settled in the Otun and Osi wards, claiming descent from the progenitor of the Awori people. It is based on this claim that Otta's status as a kingdom was established. According to oral tradition, before departing the palace in Ife, a prince named Ogunfunminire—

the first Olofin—led the Awori migration. Two of Ogunfunminire's children, Osolo and Eleidi Atalabi, migrated to the location of present-day Otta. The elder brother, Atalabi, settled in the Otun ward, and his younger brother, Osolo, did the same in the Osi ward. Atalabi was a member of the Ijemo-Isolosi family and held in his possession the beaded crown, which legitimized his claim to the office of the *oba*, or king. The *oba* of Otta is known as the *Olota*. However, due to old age, Atalabi decided not to be installed as king and instead passed on the duties of the office to his son, Akinsewa.[4]

What remains silent in the tradition is whether there was a human presence at Otta when the Awori people arrived. Local traditions date the founding of the town to 1500 and the reign of its first king to 1621. Painted on a building that sits a few blocks from the palace of Otta's king are the words, "Iledi Osugbo Ibile Ile Nla Ota, Seat of Traditional Osugbo Chiefs, Established in 1500" (see figure 1.1). This building serves as the meetinghouse for Otta's Osugbo: the Osugbo, more commonly known as the Ogboni in other Yoruba towns, is a representative body of chiefs who govern the town. Decisions made during Osugbo meetings establish and enact law. As the dating of the Osugbo meetinghouse suggests, the Osugbo represents the earliest form of Otta's government, preceding the establishment of the ward chiefs and the monarchy. Hence, the members of the Osugbo are typically regarded as having been the "real rulers" of towns during the precolonial era.[5]

Oral traditions known as Irete Oworin, Irete Olota, and Osa Eleye in Odu Ifa offer an alternative account of the founding of Otta. According to these traditions, the "Mothers," who also are commonly referred to as "witches," founded and have since dominated Otta.[6] I interpret these traditions as offering mythological support for the notion that a human community preceded the Awori migration to Otta and that the Aworis' arrival signals the origin of the monarchy, but not of the town's first inhabitants. These traditions chronicle the mythological journey of the *orisha* (deity) known as Orunmila to Otta (Ilu Aje, typically translated as the "City of Mothers"), where he encounters the "Mothers," who appear as birds—the most common animal form of witches. Orunmila wanted to learn their secrets; he consulted the Ifa oracle to determine the sacrifices required to ensure the success of his journey. Ifa prescribed that Orunmila offer a white linen sack, a white pigeon, four white kola nuts, four red kola nuts, oil, chalk, red powder from the wood of a camwood tree, and a calabash. Orunmila adhered to Ifa's instructions, and Ifa in turn revealed the secret powers that "witches" possess.

The tradition contains elements of allegory and history, as is typically the case in Ifa divination poetry. The references to Orunmila and the birds represent either the encounter between the founders of Otta's Osugbo and the town's original inhabitants or between the followers of Olofin, who introduced the institution of

Fig. 1.1. Iledi Osugbo Ibile Ile Nla Ota is the place where the members of Otta's Osugbo Chiefs meet to govern the affairs of the town. Photograph by author, August 9, 2004.

the kingship, and the earlier inhabitants, assumed to be Osugbo members. Historian Lorelle Semley offers a persuasive framework for interpreting myths about the founding of towns. Semley claims that founding myths tend to favor elite men, and accounts of Olofin's followers and of Orunmila present men as masters of supernatural resources that they use to assert their claims to power and authority; these men adhere to the instruction of "higher authorities," embodied by their elders or an oracle.[7] Even the plate that features in the Awori migration account described in the introduction functions like an oracle, offering instruction to Awori settlers. Semley casts women leaders and "witches" as "relics of a long-lost matriarchal order." These groups are absent from the Awori migration tradition, but "witches" are present in the tradition from Odu Ifa; they revealed their secrets to Orunmila at Otta. Drawing on Semley's analysis, I interpret the dating of the founding of Otta's Osugbo and of the reign of the first monarch of Otta as marking two stages in the development of the town's political institutions. Furthermore, the sharing of secrets reflects the conferring of power and authority (along with sacred knowledge), whether from "witches" to Orunmila or from Osugbo to the monarchy.

*Ritual Life*

Much of what is known about ritual life in Otta comes from nineteenth-century missionary accounts and more contemporary (i.e., twentieth- and twenty-first-century) ethnographic evidence. Oral traditions and material culture offer vivid portraits of ritual life in Otta. For the Awori people, and for most others who spoke a variant of the Yoruba language and claimed descent from a monarchy that emerged at Ife, the world included both visible (human beings, plants, animals, and inanimate objects) and invisible (spirits) beings.

Ritual life was pragmatic and eclectic. Relations between human beings and spirits, whether ancestral or *orisha*, were interdependent. The realms of humanity and of the spirits mirrored one another and overlapped,[8] and rulers attempted to reign over both humanity and the spirits. Birth, death, and ritual marked movements between these realms. Offerings, which included sacrifices, and divination were among the means of communicating between humans and spirits. In one respect, the relationship was reciprocal. Placating the spirits with offerings and other acts of service was believed to invite fortune, whereas neglect or failure to meet the desires of the spirits yielded misfortune. However, if an individual were to find one spirit more efficacious than another, he or she could neglect one ancestor in favor of the other if the latter was believed to be more powerful or accommodating. Like malnourished human beings, spirits that are neglected grow weak and die—which may seem ironic because it suggests that the dead may die twice. Yet they may also be brought back to life, in a sense, by another person's acts of service.[9]

Ritual life in Yoruba kingdoms framed the struggle to centralize power and garner protection against threats from rivals and other usurpers or challengers to the king's power and authority. *Orisha* comprised a category of spirits that the people of Otta revered in hopes of obtaining their blessings and avoiding, and even redirecting, their wrath. Some *orisha*, such as Shango (the deity of thunder and lightning at the center of an Oyo royal cult), it is said, were once human beings who upon death became revered as ancestors before becoming honored as *orisha*. Many *orisha* were associated with forces of nature (as was also the case with Oya, the human wife of Shango and goddess of tornadoes and the Niger River). Divinations have long been performed to determine the will of ancestors and *orisha*, and offerings have long been made to placate them and win their blessings. Rituals honoring ancestors and *orisha* link kin and non-kin. The most popular *orisha* had devotees far beyond the community in which they were believed to have lived. Whereas rituals honoring ancestors were organized and performed by the living members of a lineage and led by the lineage head or senior priest, rituals honoring *orisha* fell under the domain of the cult organization and its priesthood, whose leading members formed a hierarchy of ranked officials.[10]

## *The Origin of Egungun*

Between the time that Otta established its Osugbo and its monarchy, the practice and priesthood of Egungun originated in the lowland savanna and bordering woodlands that would eventually become the capital of the Oyo kingdom and later spread to Otta during the era of Oyo imperial rule. The Oyo capital was bordered on the northwest by a group called the Bariba, the rulers of the Borgu kingdom—renowned for their network of merchants and for their warriors, who had developed a formidable cavalry as early as the fifteenth century—and on the northeast by the Nupe, who controlled the Niger River crossing at Jebba Island. Interactions between these three ethnolinguistic groups—the Yoruba, the Bariba, and the Nupe—led to the genesis of Egungun. The three groups struggled to gain control over the material resources of this region, forging alliances that resulted in a tradition that transcended their differences: this priesthood was the product of encounters between the Yoruba people of Oyo and their Nupe and Bariba neighbors. Egungun's history is intertwined with that of Shango worship, both of which have been the subject of much debate. The institutions of Egungun and Shango became entrenched in Oyo's political culture in ways that parallel some of the processes that led to their migration to Otta.[11]

Although there are no written records of these rivalries, there exist relevant oral traditions pertaining to early or pre-imperial Oyo that were collected and documented by nineteenth-century missionaries and subsequent generations of scholars. These records of those traditions are the first written accounts of early Oyo history and the importance of Egungun in that context. They have been handed down for so long that the line between history and myth has proven difficult to limn. It is also likely that, at times, these oral traditions were intended to serve as propaganda, to make the past look more glorious than it actually was. Finally, such oral traditions as documented by nineteenth-century missionaries passed through the filters of the scribes' Christian sensibilities and biases, so in the search for the origins of Egungun, we must read these records very carefully for the clues they contain. Other sources have surfaced that deepen our understanding of the religious, political, economic, and gendered aspects involved in the rise of Egungun. Here, however, I present in detail the account of one Christian missionary, Samuel Johnson,[12] and discuss narratives that emerge from other sources.

Central to Johnson's account in *History of the Yorubas* is the story of exile. After the Oyo leadership rejected the sage advice of the *Alaafin*'s mother from Otta and did not adopt the practice of Ifa divination as the sacred oracle for the entire kingdom, a Nupe army invaded the Oyo capital. The Oyo court was then forced to spend a number of years first at Kusu (where the Egungun priesthood was established) and then at Igboho before returning triumphantly to its ancestral capital.

Johnson identifies Egungun as a masquerade practice that the Nupe imposed on the Oyo people during the reigns of *Alaafin* Onigbogi and *Alaafin* Ofinran, who ruled consecutively in the sixteenth century,[13] before the kingdom's rise to the status of an empire in the seventeenth century. According to Johnson's sources, after the Oyo leadership rejected the advice of the *Alaafin*'s mother, she departed from Oyo. Soon after her departure, a minor rebellion against *Alaafin* Onigbogi began in a nearby town. The *Alaafin* sent his war minister, the *Bashorun*, to suppress the rebellion. The king of the neighboring Nupe community learned of the *Bashorun*'s temporary absence from Oyo, and, perceiving the town as defenseless, attacked Oyo Ile (Old Oyo) with a masquerade at the head of the invading army. The *Alaafin* was overthrown; he and his supporters fled to Gbere, the birthplace of his Bariba wife. However, when relations between the *Alaafin* and Borgu's rulers deteriorated, the *Alaafin* and his followers moved to Kusu. There, during the reign of Onigbogi's son, the *Alaafin* Ofinran, Oyo's political elite made two significant innovations: they adopted Ifa as the official oracle of the state, and they established the practice of Egungun as a state institution. The first decision was made in the belief that Oyo's misfortunes had been caused by the rejection of Ifa that was promoted by the *Alaafin*'s mother from Otta. The second decision was made in collaboration with a group of immigrants from Nupe communities who became the first Egungun priests.[14]

While scholars draw on these and other sources to revise elements of Johnson's chronology, the basic framework—that the Oyo capital was located at Old Oyo during two periods separated by a stretch of temporary residence at Kusu and Igboho—has been accepted. By extension, Johnson linked the origin of Egungun to this period and characterized this era as the *Alaafin*'s exile at Igboho.[15]

Oral traditions from this region omit some historical processes or pieces of the puzzle. Sidney Kasfir, a specialist in masquerades of the Igala and Idoma people (located northeast and east of Yoruba-speaking communities, respectively), proposes abandoning what she calls the "donor-recipient model," which she critiques for assuming that the history of masquerades reflects a neat directional movement from the center to the periphery. Instead, she asserts that many groups in the Niger-Benue confluence area share an "ethnoscape" in which ancestral masquerade forms proliferated through a dense network or web of connections that can be teased apart but not definitively separated. In this view, the origin of Egungun reflects the movement of ancestral masquerades along the Benue River and its confluence with the Niger in two directions: (1) east to west—from northern Igbo communities in the east along the Benue to Igala communities near the confluence and farther west to Nupe and Yoruba communities; and (2) west to east—from Yoruba and Nupe to Igala and Igbo communities across the confluence and south of the Benue River. Kasfir writes, "In each of these relocations, ancestral shrines, staffs, and masquerades were carried along, either

downriver on the Benue or overland. In each place the culture of ancestral masks and politics were reconfigured to fit a new situation where the ethnoscape rather than the donor-recipient model applies, since these lands were already occupied by earlier settlers whom the Idoma and Igala . . . referred to as . . . 'original settlers.'"[16] Although movement in both directions is plausible to varying degrees, she argues for the former: that Egungun was originally the product of a chain of transmission from east to west, based on Idoma oral traditions collected north and south of the Benue. Her evidence places the Igala and the Nupe adoption of masks earlier than 1515 and within Johnson's dating of the origin of Egungun in Oyo during the reign of *Alaafin* Ofinran (between 1500 and 1550).[17]

Drawing on a different body of evidence to reach a somewhat similar conclusion as Kasfir, the historian Robin Law also challenges Johnson's basic chronology of pre-imperial Oyo history and, by extension, the origin of Egungun by offering a highly compelling, although speculative, alternative timeline. He reads Johnson's accounts alongside those of two other Yoruba speakers with ties to the royal family in Oyo and compares these accounts in the context of the political challenges facing the *Alaafin* Atiba from the 1830s through the 1850s and archeological evidence collected in the second half of the twentieth century. Law contends that Johnson's accounts conflate the reign of the nineteenth-century ruler Atiba with previous *Alaafin* who ruled Oyo in the sixteenth century. Moreover, he interprets Johnson's account of a sixteenth-century exile as propaganda used to support Atiba's decision to move the capital of Oyo from Oyo Ile (Old Oyo) to Oyo Ago (New Oyo). Law also draws on archeological evidence that demonstrates the presence of continuous human settlement in the vicinity of Old Oyo, thus confirming that the capital was never temporarily uninhabited, as Johnson and his supporters contend. The only period of exile occurred during the nineteenth century.[18]

I extend Law's argument to consider other parallels between Johnson's accounts of Egungun's origin (from royal court historians linked to Atiba's administration) and Yoruba king Oba S. O. Babayemi's analyses of Atiba's ceremonies and policies linked to the appointment of palace officials, princes, and nonroyal chiefs. Building on Law's interpretation and Babeyemi's views of Atiba's policies, I posit that records of the policies and practices of Atiba, as well as those of his two immediate successors, Adelu and Adeyemi, likely shaped Johnson's accounts of Egungun's origin in the sixteenth century. I also contend that the rivalries between the king (the *Alaafin*) and the local nonroyal chiefs (the *Oyo Mesi*), which arguably elevated Atiba's father (*Alaafin* Abiodun) to an unmatched status in the late eighteenth century and then became his undoing, informed Johnson's narratives.

Although there is no precise dating of the Shango tradition or of any dynasty that he represents, the history of manufacturing activities in the region offers

helpful clues to the chronology. Oyo's proximity to natural deposits made it an ideal site for the development of a red stone bead industry. In the eleventh and twelfth centuries, the demand for beads spurred trade with the Nupe, Bariba, and Yoruba villages in the Oyo and Niger River areas and with Ile-Ife, a glass bead and brass casting production center. Archeological evidence reveals that the production of red jasper and carnelian beads was brought under Oyo royal control in the thirteenth century, and the beads were used in the king's crown as a unique badge of political office. Between the thirteenth and fifteenth centuries, Oyo became a prominent exporter of the stone beads it produced and of glass beads imported from Ife, linking commercial networks in the forests to the south with those in the middle Niger River region to the north and east. Bead production brought commercial profits that fueled the process of political centralization and contributed to the migration of people from southern to northern Yorubaland. Through this process northern Yoruba peoples and their neighbors adopted iconographic symbols and ideological elements of Ife kingship.[19]

Technological innovations complemented changes in political ideas and ritual activities linked to Shango. Before the fifteenth century, the idea of Shango as a Yoruba deity of lightning began to converge with that of Sogba, a Nupe deity of lightning. At the same time, the Oranyan dynasty of Old Oyo emerged from Borgu at a time when the Borgu state of Bussa was dominant in an area that extended as far south as Ife. The mythological Shango became bound up with the fifteenth-century historical Nupe king, Tsode. Then, in the sixteenth century, a Borgu dynasty at Old Oyo began to assimilate immigrants and their cultures. The Yoruba migrated in waves into Bariba communities near Old Oyo and adopted the development of a cavalry from their Bariba allies. The Bariba dynasty embraced Nupe elements in the form of Egungun and Shango, and the Shango priesthood became dominant in Old Oyo, incorporating imagery of a horse and rider.[20]

If the kings who reigned at Igboho represent a Bariba dynasty ruling over a majority Yoruba kingdom, might members of an enduring Nupe community in the vicinity have been incorporated into Oyo to reduce the threat they posed? Agiri interprets the office of the *Bashorun*, a war minister and leader of the council of nonroyal chiefs known as the *Oyo Mesi*, as a relic of an extinct dynasty. The *Bashorun*'s position as second in authority to the *Alaafin* in Oyo, his possession of a beaded coronet and a small throne, and his role as the chief priest of Orun (a deity perhaps associated with a sky god) all point to a pre-*Alaafin* time when the *Bashorun* reigned supreme. That the *Bashorun*'s wives were called *ayaba* (wives of the king) also points to his power. Viewed from this perspective, the members of the *Oyo Mesi* represent the incarnation of rulers long ago supplanted or incorporated into the kingdom of the *Alaafin*, first under the Nupe and later under the Bariba. The appointments of the *Oyo Mesi* and the Egungun chiefs, like those of

Atiba three centuries later, drew on the ritual, political, social, and economic networks associated with these office holders; it gave their constituencies a voice under the reigning monarchy.

Johnson's account of Shango as representing a dynasty of Oyo rulers rather than a single individual illustrates efforts to legitimize the dynasty by invoking the spirits of the rulers' ancestors, a practice that is common among "divine" kings. Dynasts have long performed rituals that enact myths as a powerful way of demonstrating a ruler's authority within the spiritual realm, channeling spiritual power in ways that have strong political implications.[21] As Kasfir explains, "If myth is a model which validates the cosmology by grounding it in society, the mask system can be understood as its obverse: a model which validates the social order by grounding it in the cosmic order."[22] Thus, the masquerade performance recasts the ruler as having authority in the realm of the ancestors; to reject him would be to defy the will of one's own ancestors.

Law's hypothesis about the political interests of the nineteenth-century *Alaafin* Atiba (whose royal court historians Johnson likely encountered and from whom he obtained information) is illuminating in the context of the Shango tradition. There are parallels between the reign of Atiba and that of Shango that are worth considering. An analysis of the politics of nineteenth-century Yorubaland suggests that some accounts of the origin of Egungun narrated during this era and believed to refer to events occurring from the thirteenth through the sixteenth centuries reflect what the historical anthropologist Andrew Apter characterizes as the "revision of myth by politics."[23]

Johnson narrates an attempt to move the capital from Igboho to Old Oyo through an episode he calls the "ghost-catcher" story. During the early seventeenth-century reign of *Alaafin* Ogbolu, the *Oyo Mesi* conspired to prevent the move, on the grounds that such a transition would disproportionately strengthen the king. The *Alapinni*, a member of the *Oyo Mesi*, formulated a plan to dispatch a group of individuals to imitate spirits and shout "ko si aye" ("no room") when the king's representatives approached to inspect the site. The king uncovered the deception, captured the imposters, and paraded them in a dramatic court ritual before the opposing chiefs (thus catching the "ghosts"). The capital was moved, and Old Oyo acquired the name Oyoro, or "Oyo of the spirits."

Law interprets this episode as a variant of the tradition that Johnson narrates regarding the adoption of Egungun by the *Alaafin* Ofinran at Kusu. In Law's view, the presence of the imposters in Johnson's account reflects an attempt to make an uninhabited site appear to have been inhabited; the imposters represent the inhabitants of a Nupe settlement that had existed in the vicinity of Old Oyo long before the arrival of Ogbolu's group. Archeological evidence in the form of two types of pottery—one dated to between the eleventh and twelfth centuries and another dated to between the thirteenth and fourteenth centuries—supports the

claim that a continuous human settlement existed in that area: one culture and its associated pottery style gradually emerged out of the other.[24] When the capital was moved to Old Oyo, the *Alaafin* incorporated the settlement's Nupe residents into the kingdom along with their institutions: a possession-based priesthood devoted to Shango (linked to the founder of a dynasty of kings with Nupe roots) and an Egungun masquerade priesthood that incarnated the spirits of the deceased as well as others.[25]

According to Johnson, it was the *Ologbo*, one of the *Alaafin*'s most trusted allies in Egungun, who while surveying Old Oyo recognized the imposters as representatives of the *Oyo Mesi*. The *Ologbo* was the *Alaafin*'s sword bearer and a member of the royal court. He also was one of the chief Egungun priests and a descendant of one of the priesthood's founding Yoruba lineages, the Oloba lineage.[26] The *Alapinni* and the rest of the *Oyo Mesi* resented the *Ologbo*'s decision to support the *Alaafin* against them. They believed he had betrayed them by revealing their plans to the *Alaafin* and by using his position as a member of the Egungun society to side with the *Alaafin* against the masked spirits (ghost-mummers). The *Oyo Mesi* attempted several times to get rid of the *Ologbo*, and they ultimately succeeded in fatally poisoning him.[27]

To test the notion that the "ghost-catcher" story is a variant of the tradition that identifies the origin of Egungun with *Alaafin* Ofinran's reign at Kusu, I turn to other oral traditions and archeological evidence collected in Oba Isin, a village in the Igbomina region of northwestern Yorubaland. The settlement is also linked to the ancient Oba people who left Ife between the eleventh and thirteenth centuries.

### The Owners of Cloth and Iron Make the Masks and Build a Kingdom

The *Ologbo*'s forbears came from Oba, an ancient civilization that migrated from Ife and settled near Oyo to the north. The activities of the more dominant Nupe and Bariba often obscure the contributions of the Oba in the Oyo area. Nevertheless, we find remnants of their influence in art, architecture, and technology that substantiate the oral traditions that link the Oba of Oyo with the Oba of Ife. Oral traditions in the form of *oriki* identify the *Oloba* (the title of the *Olu* or ruler of Oba) as the owner and overseer of an ancient tie-and-dye cloth industry.[28] The *oriki* identify the following as the descendants of the ancient Oba: Egungun chiefs who today claim descent from the *Oloba*'s lineage (including the *Ologbo* who organize and lead Egungun performances), the *Alaran* (who produce the cloth for the masks), and the *Oloje* from the Olojowon family (who carve the masks).[29]

According to tradition, the Oba people were carvers and ironworkers. At some point between the eleventh and thirteenth centuries, they migrated north from Ife to the Igbomina region to tap into an abundance of resources, including

iron ore for smelting and smithing and better hunting grounds for buffalo. They established large-scale ironworks by the thirteenth century.[30] Immigrants, including Oba blacksmiths, iron smelters, wood-carvers, leather workers, diviners, medicine men, and career warriors, among others, continued to arrive in the area. These professionals were skilled in the technologies that enabled an emerging Egungun priesthood to flourish by the sixteenth century.

Textile manufacturing was quite likely the most important technology for masquerades. Aleru conducted excavations at an ancient ironworking site and masquerade grove in present-day Oba Isin and collected ethnographic data there that identify the location as home to an ancient dyeing industry.[31] The connection of the *Oloba* of Oba to the early Egungun priesthood via the *Ologbo* suggests that Egungun chiefs obtained their offices in part through their access to the means of production of high-quality textiles that were used to clothe the incarnated ancestors of Egungun.

## *The Origin of Gelede*

Whereas the origins of Shango and Egungun are deeply implicated in debates over the chronology of Oyo's history, the origins of Gelede are involved in two debates over the chronology of Ketu's history. At issue in the first debate is whether the succession dispute between princes occurred near the turn from the eighteenth century to the nineteenth century or much earlier, perhaps between the fourteenth and fifteenth centuries; the second debate is over whether this dispute marks a change in attitudes toward twins as reflected in shifts from a practice of infanticide to a new fertility rite. Although accounts of Gelede's origins vary, a preponderance of archival, material culture, and ethnographic evidence points to the ancient Yoruba kingdom of Ketu or a smaller kingdom, Ilobi, with a ruling dynasty that was founded by a Ketu prince. Margaret Thompson Drewal and Henry John Drewal's pioneering text, *Gelede: Art and Female Power among the Yoruba* (1983), offers a compelling argument regarding the origin and spread of Gelede that draws heavily on Father Thomas Moulero's unpublished, handwritten 1971 manuscript, "Le Guelede." Based on ethnographic research that Moulero collected over the course of an indefinite period before 1970, "Le Guelede" offers a Ketu-oriented perspective on the history of Gelede. A chapter of the Drewals' *Gelede* and Henry Drewal's *Homage to Thomas Moulero: Private Historian of Gelede* offer the only detailed references to Moulero's evidence.[32]

Moulero attributes the origin of Gelede to a Ketu prince, Adebiya, who sought refuge at Ilobi while engaged in a succession dispute with his younger twin brother. Adebiya used a ruse to frighten his brother and his followers when they came looking for him. As a member of the Mefu royal family, Adebiya later returned to Ketu to seize the throne and reigned from 1816 to 1853 as the *Alaketu* (the title

for the ruler of Ketu). The ruse later became memorialized in the first Gelede costume.[33]

Drewal and Drewal interpret Moulero's evidence alongside oral traditions they collected in the 1970s as well as observable distinctions between male and female Gelede masks and the structure of Gelede performances. Although most of their evidence comes from the Egbado community, it also supports Gelede's origins via a member of a Ketu dynasty that sought residence in Ilobi. The Drewals claim that Gelede arose between 1795 and 1816 during the period of Adebiya's stay in Ilobi, before his ascension to the Ketu throne. They add that Gelede spread during a brief period of peace and prosperity when Ketu people took advantage of the commercial opportunities that resulted from Oyo's consolidation of power along a trade route passing through Egbado communities in western Yorubaland and terminating at Gun and Awori communities, Badagry and Lagos in particular.[34]

Babatunde Lawal's research in Ketu and Ilobi and additional oral evidence offered by other scholars add support to Ilobi's claim to be the birthplace of Gelede. At the same time, references to a succession dispute appear to be absent from the annual Gelede festival, which tends to focus on Iya Nla or the "Mothers"; in addition, references to Gelede's origins cite rites honoring the patron deities of small children. Drewal and Drewal collected data from a former king of Ilobi testifying to the notion that Gelede evolved from such rites. Lawal interprets such evidence as showing that the development of Gelede preceded a succession dispute. Myths point to its female origins or from a man who assumed a feminine aspect.[35]

Gelede myths and performance reflect a link to rituals aimed at preventing the death of children afflicted by *abiku* ("children born to die") or spirit children, spirits that repeatedly cause miscarriage, stillbirth, or premature death of infants from the same mother. Gelede performers wear metal anklets with the intent of scaring away afflicting spirits and holding the small child firmly in the mortal world. Creating masks and dancing with them in honor of these spirit children persuade those children to stay, to live instead of die. Emphasis on pairs, or doubles, and twins has long been a fixture of Gelede myths and rituals. Two Gelede masks have often been observed performing together, and an Efe night vigil typically occurs hours before the daytime Gelede performance. These forms of coupling may refer to the twins involved in the succession dispute in late eighteenth-century Ketu, to a prior history of rituals associated with twins, or perhaps to both. Lawal concludes that Gelede evolved from an ancient fertility rite performed by women who danced with wood carvings balanced on their heads.[36] He suggests that the belief that the "Mothers" influence human fertility and cause premature deaths explains how a fertility dance for spirit children was transformed into an elaborate masquerade performance intended to persuade women to use their power to sustain the community. How such a performance became linked

to a succession dispute is a matter Lawal believes must be left to future research given the lack of conclusive evidence. He insightfully notes the appearance of a figure wearing the first Gelede mask and anklets made of seashells at night that allegedly frightened a rival faction. He raises the question whether the major innovation at Ilobi was the incorporation of metal anklets, given the town's location as the center of an ancient smelting operation.[37]

The historian Kola Folayan refers to an Ilobi tradition of origin referencing the *Igba Ogun* (the sacred calabash of an iron deity) and interprets an Ilobi version of the succession dispute as intimating the introduction of iron-smelting technology. The Ketu prince at Ilobi may have aligned himself with ritual performers who replaced the carved calabash with elaborately carved wooden headdresses, thereby distinguishing Gelede from its predecessor performances.[38] I conclude that Gelede was the product of three parties who joined forces: a royal patron engaged in a succession dispute, a night performer later known as Efe wearing anklets produced by iron smelters, and a group who practiced a fertility rite that involved carrying wood carvings on their heads. They represent the marriage of a political movement, an industrial process (or technology), and a socio-ritual movement.

Lawal believes that Yoruba speakers began shifting from practicing twin infanticide to preserving the lives of those babies before the eighteenth century, although he acknowledges that this shift occurred at different times in different parts of Yorubaland. He claims that the Ilobi version of the succession dispute suggests that Gelede evolved from fertility rites earlier than the eighteenth century. A succession dispute indeed occurred in Ketu after the reign of the sixth king of Ketu, according to evidence acquired by Folayan. The historian Robert Smith offers evidence of the average length of the reigns of Ketu kings, which suggests that the succession dispute that inaugurated Gelede would have occurred during the fourteenth or fifteenth centuries. Furthermore, nineteenth-century records of Gelede performances involving liberated Yoruba slaves in Brazil, Cuba, and Sierra Leone hint at a much earlier date for the origin of Gelede, leading Lawal to conclude that enslaved Yoruba speakers took Gelede across the Atlantic between the sixteenth and eighteenth centuries.[39] I am not fully persuaded by his interpretation of this last body of evidence. Given the intensity of the slave trade in Yoruba speakers in the late eighteenth and early nineteenth centuries, Drewal and Drewal might be correct in their dating of Gelede, and enslaved people could have brought Gelede to the Americas.

Egungun and Gelede emerged as institutionalized practices that harnessed the collaborative and often conflicted interests of royals, producers of material goods, and ritual specialists. In both cases, royals sought legitimacy and power through alliances with lineages linked to iron production, wood carving, and ritual

knowledge (in the form of divination, medicinal practice, fertility rites, or anti-witchcraft rituals). Egungun surfaced in Yoruba history in the capital of pre-imperial Oyo and became institutionalized in Otta as Oyo consolidated its power along an important trade corridor in the vicinity of Otta. At the same time that Egungun became entrenched in Otta, Gelede emerged and spread along the same corridor. In chapter 2 I explore the role of masquerades in the complex political, commercial, and social dynamics of the Oyo Empire that set the stage for the growth of Egungun and Gelede in Otta. While shedding some light on conditions that characterized the entrenchment of these masquerades at Otta, I focus on shifting expressions of gender in Shango worship and Egungun practice in the struggle for supremacy between the Oyo monarchy and the administrative and priestly classes that upheld Oyo's policies in the provinces.

## Notes

1. W. Fowler, "A Report on the Lands of the Colony District," in *Colonial Records Project* (Oxford: Rhodes House Library, 1947), 1–82.

2. Robin Law, *The Oyo Empire, c. 1600–c. 1836: A West African Imperialism in the Era of the Atlantic Slave Trade* (Oxford: Clarendon, 1977), 63–64; Kristin Mann, *Slavery and the Birth of an African City: Lagos, 1760–1900* (Bloomington: Indiana University Press, 2007), 26.

3. R. A. Salako, *Ota: Biography of the Foremost Awori Town* (Otta: Penink Publicity, 2000), 92, 94.

4. Ibid., 13–14.

5. J. R. O. Ojo, "Ogboni Drums," *African Arts* 6, no. 3 (1973): 84.

6. One of the currently highest-ranking members of Otta's Osugbo society, Chief Abolade Agbebi Ojugbele, the *Oluwo* of Otta, identifies the oral tradition in Odu Ifa that reflects a popular view of Otta. Personal communication with Chief Abolade Ojugbele, *Oluwo* of Otta, Osi ward, Otta, 2006. I add quotation marks around the term "witch" because what Yoruba speakers mean by the term and what it means in the English language vary significantly. Pierre Verger, "Grandeur et Decadence du Culte de Iyami Osoronga: Ma Mere La Sorciere Chez Les Yoruba," *Journal de la Societe des Africanistes* 35, no. 1 (1965): 201–219; Dele Layiwola, "Egungun in the Performing Arts of the Yoruba," in *Readings in African Studies*, ed. A. T. Oyewo and S. A. Osunwole (Ibadan: Jator, 1999), 149–152; Yemi Elebuibon, *The Healing Power of Sacrifice* (Brooklyn, NY: Athelia Henrietta Press, 2000), 67.

7. Lorelle D. Semley, *Mother Is Gold, Father Is Glass: Gender and Colonialism in a Yoruba Town* (Bloomington: Indiana University Press, 2011), 13–31.

8. Edna G. Bay, *Wives of the Leopard: Gender, Politics, and Culture in the Kingdom of Dahomey* (Charlottesville: University of Virginia Press, 1998), 18.

9. Karin Barber, "How Man Makes God in West Africa: Yoruba Attitudes towards the Orisa," *Africa* 51, no. 3 (1981): 724–744; Karin Barber, "Oriki, Women, and the Proliferation and Merging of Orisa," *Africa* 60, no. 3 (1990): 313–337.

10. Peter Morton-Williams, "An Outline of the Cosmology and Cult Organization of the Oyo Yoruba," *Africa* 34, no. 3 (1964): 247–256; Bay, *Wives of the Leopard*, 16–24.

11. Robert Smith, "The Alaafin in Exile: A Study of the Igboho Period in Oyo History," *Journal of African History* 6, no. 1 (1965): 61–62.

12. Samuel Johnson, *History of the Yorubas: From the Earliest Times to the Beginning of the British Protectorate* (Lagos: C. M. S. Bookshop, 1921), 158–160.

13. In addition to Johnson's evidence, scholars have turned to other archives of oral traditions: the *Awon Orile Oriki* (the praise poems of the heads of the ruling family) and *itan* (stories or narratives). Ibid., 158–160.

14. Ibid., 159–160; Smith, "The Alafin in Exile," 24, 63.

15. She identifies a third path of influence that she calls the circular path. Johnson, *History of the Yorubas*, 158–160.

16. Sidney Littlefield Kasfir, "The Ancestral Masquerade: A Paradigm of Benue Valley Art History," in *Central Nigeria Unmasked Arts of the Benue River Valley*, ed. Marla C. Berns, Richard Fardon, and Sidney Littlefield Kasfir (Los Angeles: Fowler Museum, 2011), 104.

17. Ibid., 105.

18. Robin Law, "How Many Times Can History Repeat Itself? Some Problems in the Traditional History of Oyo," *International Journal of African Historical Studies* 18, no. 1 (1985): 33–51.

19. Akinwumi Ogundiran, "Chronology, Material Culture, and Pathways to the Cultural History of Yoruba-Edo Region, 500 B.C.–A.D. 1800," in *Sources and Methods in African History: Spoken, Written, Unearthed*, ed. Toyin Falola and Christian Jennings (Rochester, NY: University of Rochester Press, 2003), 47–49; Aribidesi Adisa Usman, "Precolonial Regional Migration and Settlement Abandonment in Yorubaland, Nigeria," in *Movements, Borders, and Identities in Africa*, ed. Toyin Falola and Aribidesi Adisa Usman (Rochester, NY: University of Rochester Press, 2009), 104–105, 110.

20. Marjorie H. Stewart, *Borgu and Its Kingdoms: A Reconstruction of a Western Sudanese Polity* (Lewiston, ME: E. Mellen, 1993), 119, 55, 334.

21. Andrew H. Apter, *Black Critics and Kings: The Hermeneutics of Power in Yoruba Society* (Chicago: University of Chicago Press, 1992), chapter 1; Bay, *Wives of the Leopard*, 21–24.

22. Sidney L. Kasfir, "Masquerading as a Cultural System," in *West African Masks and Cultural Systems*, ed. Sidney L. Kasfir (Tervuren: Musée Royal de l'Afrique Centrale, 1988), 6.

23. Apter, *Black Critics and Kings*, 10–15.

24. Frank Willett, "Investigations at Old Oyo 1965-7: An Interim Report," *Journal of Historical Society of Nigeria* 2, no. 1 (1960): 59–77; Frank Willett, "The Microlithic Industry from Old Oyo, Western Nigeria," *Actes du IVe Congres Panafricain de Prehistoire et l'etude du Quaternaire, Tervuren* 3 (1962); Robert C. Soper, "Carved Posts at Old Oyo," *The Nigerian Field* 43, no. 1 (1978): 12–21; Law, "How Many Times Can History Repeat Itself?," 48–49.

25. Law, "How Many Times Can History Repeat Itself?," 34–36, 41, 48.

26. Johnson, *History of the Yoruba*, 165–166.

27. Ibid.

28. Jonathan Oluyori Aleru, *Old Oyo and the Hinterland: History and Culture in Northern Yorubaland, Nigeria* (Ibadan: Textflow, 2006), 55–102.

29. Johnson, *History of the Yoruba*, 146, 156; Joel Adedeji, "The Alarinjo Theatre: The Study of a Yoruba Theatrical Art from Its Earliest Beginnings to the Present Times" (PhD diss., University of Ibadan, 1969), 153.

30. Usman, "Precolonial Regional Migration," 104–105.

31. Aleru, *Old Oyo and the Hinterland*, 55, 60, 101–102.

32. Moulero was born into a Ketu royal family at the end of the nineteenth century, and in 1928 he became the first African Catholic priest to be ordained in the French colony of Dahomey. He recorded accounts of Ketu's history that he acquired from an unspecified group of Ketu people. In 1970, he produced "Le Guelede." Drewal had the unique fortune of meeting Moulero in 1971 and reading and copying excerpts of "Le Guelede" before the priest's passing

in 1974 and the disappearance of the unpublished text thereafter. Henry John Drewal and Margaret Thompson Drewal, *Gelede: Art and Female Power among the Yoruba* (Bloomington: Indiana University Press, 1983), 227; Henry John Drewal, *Homage to Thomas Moulero: Private Historian of Gelede* (Denver: University of African Art Press, 2008), 1–3.

33. Drewal and Drewal, *Gelede*, 277n7.

34. Ibid., 229, 236.

35. Ibid., 225–228; Benedict M. Ibitokun, *Dance as Ritual Drama and Entertainment in the Gelede of the Ketu-Yoruba Subgroup in West Africa* (Ile-Ife: Obafemi Awolowo University Press, 1993), 31–32; Babatunde Lawal, *The Gelede Spectacle: Art, Gender, and Social Harmony in an African Culture* (Seattle: University of Washington Press, 1996), 48–50.

36. Lawal, *The Gelede Spectacle*, 57.

37. Ibid., 48.

38. Ibid., 68–70.

39. Ibid., 70.

# 2 "Children" and "Wives" in the Politics of the Oyo Empire during the Era of the Atlantic Slave Trade

IN THIS CHAPTER I explore aspects of power and gender that helped shape the role of masquerades in Otta during the era of Oyo imperialism. Otta grew as a transit point for some and a home for other representatives of Oyo's expanding imperial influence as the empire was bolstering its economy and slavery was playing a central role in palace and imperial administration. Some representatives joined a developing cavalry that acquired slaves in the savanna region surrounding Old Oyo, whereas others formed a royal priesthood based on the deified king Shango (mythical or not) or the ancestral masquerade organization, Egungun, that was used to incorporate and rule over imperial subjects and slaves. These factions helped extend Oyo's political and economic power to the east (across the savanna toward the middle Niger River area) and the south (through the forest down to the coast) as Oyo began to control the trade in slaves.[1] South of the savanna lay the forest, through which enslaved peoples traveled in caravans before boarding European and American slave ships at port towns along the Atlantic coast. From 1754 to 1789, the Oyo Empire encompassed conquered and tributary towns and kingdoms in the southwest, where both Shango and Egungun were instrumental in representing and enforcing imperial policy. Shango priests and Egungun masqueraders settled in Otta during a time when practitioners of fertility rites joined forces with a faction seeking to overthrow its rival and establish the Gelede masquerade tradition in another ancient Yoruba kingdom, Ketu, also under Oyo's imperial influence. Gelede honored a range of local and foreign actors who overthrew a Ketu ruler and developed commercial ties with Oyo's representatives in the southwest.

Early scholarship characterized Oyo's imperial politics as a function of two power struggles: one between the nonroyal hereditary chiefs, led by *Bashorun* Gaa—arguably the region's most influential chief—and the monarchy, with *Alaafin* Abiodun reigning as Oyo's most illustrious king; and another between Oyo provincial administrators and local non-Oyo rulers and their subjects.[2] According to this model, struggles in Oyo for control of the wealth derived from the slave trade or for political dominance drove change. In this context, Egungun entered a new phase of its history, serving as a medium through which imperial

authority was displayed, asserted, and challenged.[3] Shango and Egungun priests were sent together into the provinces under imperial control as administrators, enforcing the political and economic supremacy of the imperial elite and inspiring the spread of Egungun in communities frequented by people from Ketu and Otta.[4]

More recent scholarship has often emphasized the gendered dimensions of power in the imperial period, focusing on the "wifely" agency of the administrators and ritual priests who supported the *Alaafin*.[5] These administrators and ritual priests were often referred to as the "wives" or "sons" of the *Alaafin*.[6] The word "sons" in the Yoruba language generally refers to a powerful person's biological children (whether male or female) and followers (including extended family, dependents, slaves, friends, and younger allies). In Yoruba tradition, the *Alaafin* is considered to be Shango incarnate, and the priests of Shango are identified as "wives" who have married into the ritual lineage of the deity. These ritual wives underwent the process of initiation into the priesthood of Shango, which also was the royal cult of the *Alaafin*: a distinctive hairstyle characterized Shango initiates and appeared in both Egungun and Gelede headdresses. The terms "wives" and "sons" are thus used metaphorically. Therefore, a Shango priest who was the "son" of the emperor also played a structural and ritual role as the "wife" of his "father" because the emperor personified the deity (Shango) and all Shango priests were regarded as wives of the deity. Conversely, a Shango priestess who was the "daughter" of the *Alaafin* was also her father's wife. This is complicated because of its interlocking familial, structural, and ritual dimensions, something I advise the reader to keep in mind.[7]

Although scholars have examined how the growing influence of the *Alaafin*'s imperial agents affected the power struggle between the *Alaafin* and the *Oyo Mesi* (the council of nonroyal chiefs) in the capital city, they have not carefully considered how the introduction of Egungun by imperial agents shaped the character of the masquerade in the provinces or how its political importance changed. I discuss these matters in the sections that follow.

## The Itimoko Family Tradition on the Origin of Egungun in Otta

It is important to distinguish between the family-based practitioners of Egungun and the priesthood, the centralized hierarchy of Egungun chief-priests. Practitioners of Egungun are typically members of a family that owns or controls and performs an Egungun masquerade, such as Oya Arogunmola. They may also include individuals from affiliated families who offer their labor and resources and share in the prestige of the performances. The priesthood negotiates the rank of Egungun masquerades and schedules the dates of festival performances. At the request of the king, it also organizes performances that entertain the community and invite spiritual protection over the town. Some practitioners, however, are also

members of the priesthood or aligned with it. When these practitioners are believed to be receiving special privileges because of their affiliations with the priesthood, nonaffiliated practitioners may sound an alarm. Tensions can erupt into public conflicts when the priesthood attempts to regulate the public appearances and status of Egungun affiliated with specific families. The priesthood oversees its members and the scheduling and practice of Egungun masquerade performances that are visible beyond the domain of a family's compound; however, the performers and financers of individual masquerades are not necessarily members of this governing body. Therefore, any in-depth study of the Egungun organizational scheme must consider the relationships between the families that own individual masquerades and the group that schedules Egungun festival performances, performs rituals on behalf of the town, and initiates new members into the priesthood.

In the recorded and remembered history of Egungun in various Yoruba towns, power is constructed through genealogies that are themselves constructed. Waves of family groups claiming an Oyo identity flooded central and southern Yoruba communities during the decline and collapse of the Oyo Empire (1789–1836). Many of these families later recited genealogies to support their descent from people who had created, seized, or transformed a particular Egungun. These genealogies have their own conventions, but they often link families to the former capital at Old Oyo during the pre-imperial era.[8] Such narratives of Egungun's history reflecting the vantage point of provincial communities contrast with Samuel Johnson's focus on the genealogy of the *Alaafin* as the most reliable method for chronicling and interpreting Oyo and broader Yoruba history. (Narratives of Gelede's history focus on Ketu and communities that welcomed travelers from Ketu and Oyo.) While conducting research at Otta, I learned about a family named Itimoko that claims to be descended from a member of the *Alaafin's* family. The Itimoko family is the source of the narratives regarding the origin of an Egungun masquerade named Ege in Otta, which I recount and analyze here.

The leader of the Egungun chiefs at Otta comes from this family and holds the title of *Oloponda*. Chief Fatusi was the *Oloponda* (and the defendant during a 1996 court case in which he was accused of using his power to fix the schedule of Egungun performances to the detriment of the Arogunmola family). He died before my first visit to Otta; his successor, Chief Asanbe, was confirmed as the next *Oloponda* in December 2004, at the beginning of Otta's Egungun festival period. From 2004 to 2006, I conducted a series of formal interviews and open-ended conversations with Chief Asanbe and several other Egungun chiefs, as well as with members of various families performing Egungun masquerades during the 2004–2005 festival; they narrated the history of Otta's Egungun practice, organization, and performers, including the Ege masquerade.

I collected divergent accounts and interpretations of this history during the five months of the festival. By the end of the festival period, I realized that rival-

ries inflamed by the 1996 court case informed the differing accounts. Although he was early in his reign as the *Oloponda*, Chief Asanbe provided the most extensive accounts of Ege, which denotes both the proclaimed son of an Oyo king and the Egungun bearing his name. Asanbe provided the Itimoko family's version of events. Although other narrators in Otta as well as scholars have offered evidence (rejected by the Itimoko family) that contradicts or raises doubts about aspects of Asanbe's accounts, other elements are consistent with and deepen our understanding of Johnson's evidence and the narratives of Oyo imperial history offered by the historians Robin Law and S. O. Babayemi.

In the late eighteenth century, *Alaafin* Abiodun, who defeated his main rival, *Bashorun* Gaa, the war minister and leader of the nonroyal hereditary chiefs, was actively consolidating his power and authority along Oyo's trade corridor in the southwestern region. At that time Otta was a wealthy slave-trading market town in the southwest where people and goods were traded in bulk before being transported to the nearby Atlantic ports of Badagry and Lagos.

Although there are no written accounts of Egungun in Otta before the middle of the nineteenth century, one Itimoko tradition claims that an unnamed *Alaafin* sent his "son" Odikaye from Oyo to Otta to collect tribute. At first, Odikaye is said to have gone back and forth between Oyo and Otta, but the *Alaafin* later elevated Odikaye's position to that of *ajele* (local administrator) for the town of Otta; Odikaye then established a permanent residence known as Ajele Oloyo in the Iga Ajele (Ajele's compound).[9] Odikaye was not only an administrator but was also a Shango priest.

According to one version of the Itimoko story, Odikaye was later joined in Otta by his younger brother, Aina Ege. Instead of living with Odikaye at Ajele Oloyo, Ege settled at a place that later became known as Iga Ege (Ege's compound). Although he was a Shango priest, Odikaye also organized Egungun performances at Otta, and he appointed Ege to serve as the founder and leader of an Egungun priesthood and a masquerade. The distinguishing feature of this masquerade was a beaded crown that identified it with the royal family in Oyo. When Aina Ege died, Odikaye honored him by modifying the masquerade and naming it "Ege" (evidently, after the introduction of this imperial Egungun, others followed or were created). In time, Odikaye became the first *Oloponda*, the most senior Egungun chief in Otta.[10] This detail reveals the local elite's acceptance, if not embrace, of Odikaye's power and authority, although local Egungun practitioners may not have taken part in the Egungun hierarchy of chief-priests that he headed. According to this tradition, the Ege masquerade then became the leading Egungun masquerade in Otta, a mark of its historical significance.

Today, Ege remains preeminent among the Egungun masquerades. Figures 2.1 and 2.2 show a statue of the Ege masquerade, erected in 2000, that stands in the middle of a major square in Otta and marks the location of Iga Ege, the residence

Fig. 2.1. An Egungun masquerader wearing a crown and known as Ege, the "King of Egungun Masquerades at Otta," is depicted in a statue on the town's central square (Okede Square). The Egungun festival's opening ceremonies and weekly evening masquerade performances occur in this square. Shrines dedicated to the deity Shango, the priesthood, and Egungun cult members also are located in this square. An organization known as the Odo Oje Otta, whose motto is "for the 'betterment' and positive changes in Egungun tradition," commissioned this statue in the wake of the 1993 court battle that divided the Egungun community in the town. At the beginning of the January 2000 festival, the king of Otta unveiled this statue. Photograph by Rachel Raimist, December 8, 2010.

of Aina Ege. It is the only statue of an Egungun in the town. Note that, during festival appearances (see figure 2.3), the *Atokun* (the person appointed to direct the Egungun masquerade during its performances) stands next to Ege. The *Atokun* during Otta's 2004 Egungun Festival was Chief J. Akingbola; he also served as the most senior Shango priest in town. Akingbola and Odikaye shared the experience of serving as both the *Atokun* and the chief Shango priest.[11]

According to another Itimoko tradition, the king of Otta sought Odikaye's advice and assistance in halting the spread of a plague epidemic in the town by constructing a shrine to Shango and performing a ritual sacrifice to appease the gods. The tradition has it that, in conducting this ritual, Odikaye invoked both Shango and Agan; the latter is a deity traditionally invoked to cleanse a community of social and environmental ills before an Egungun festival begins.[12] This tradition is illuminating because it shows that ritual traditions brought to Otta by Oyo imperial administrators, presumably to provide oversight and enforce their power, were also welcomed by a politically shrewd or altruistic group of Otta's political and ritual elites. By governing during a time in which such powerful

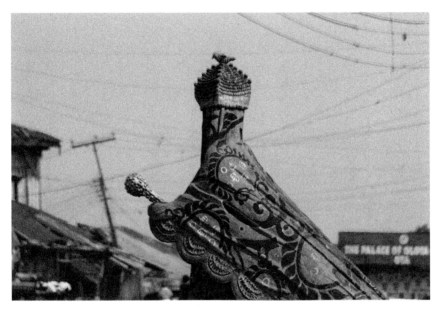

Fig. 2.2. Photograph of the head of the Ege statue that appears in figure 2.1: a bird (representing the *aje*—this-worldly and otherworldly women) sits atop the crown on Ege's head; it is a reminder that even in the realm of the ancestors, royal power is subordinate to that of the *aje*. The convergence of royal, supernatural, and gender power represented in the statue of Ege parallels the identity of Otta as Ilu Aje, a town owned and controlled by the *aje*. Photograph by Rachel Raimist, December 8, 2010.

imperial and ritual forces converged in the town, the elites in question were poised to be credited for elevating the town's status and ensuring its safety.

Another version of the Itimoko tradition regarding the introduction of Egungun in Otta links it to the "children" of the *Alaafin* and to the Shango priesthood. In this case, Odikaye's younger sister, a woman named Olafaya who was a Shango priestess, traveled to Otta to visit her brother. As was customary for traveling priestesses, she brought with her the *shere* Shango and *oshe* Shango, ritual instruments associated with the deity. Olafaya stopped first at a place called Ijogbo, where she placed the *shere* Shango on a wall and took the *oshe* Shango to Odikaye's residence at Ajele Oloyo in Otta. As time passed, Olafaya moved between Odikaye's residence and a place set aside for her at Iga Ege, although she is reported to have spent most of her time at her brother's compound, where Odikaye's followers built a small house for her. When she died, an Egungun masquerade known as Ege was created. In addition to wearing a beaded crown, this masquerader carries the *shere* Shango in its hand while another performer follows behind carrying the *oshe* Shango.[13] Whereas in the version of the Itimoko tradition described

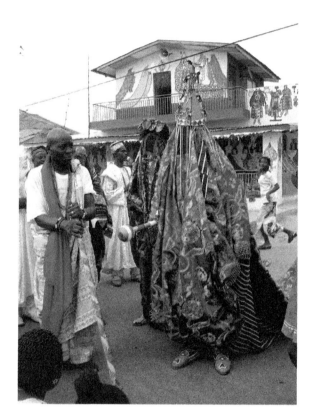

Fig. 2.3. Ege (*right*) and the *Atokun* (*left*), leading a procession of prominent Egungun masquerades and chiefs during the Egungun festival, Ijana ward, Otta. Photograph by author, May 4, 2005.

earlier the Egungun was created to honor Odikaye's brother Ege, in this version it was created to honor his sister, Olafaya, even though the Egungun appears not to have been named after her. Both versions claim that Odikaye's younger siblings died young.

These variations in the accounts of the creation of Ege may well reflect distinct moments in the masquerade's development. It is entirely possible that Aina Ege arrived in Otta and took control of the Egungun, which was renamed in his honor on his death. It is equally possible that, either before or after Aina Ege's death, his sister Olafaya gained authority over the Egungun, which was modified to carry the symbols and power of her offices as a Shango priestess. Taken together, these accounts explain the introduction of various elements of this Egungun's attire. The first account focuses on the crown, a symbol of royal authority and of the masquerader's relationship to the royal family. The second account emphasizes the incorporation of Shango's instruments into Ege's regalia: the *oshe* Shango and the *shere* Shango. Like the crown, Shango's ritual implements mark authority.[14]

Fig. 2.4. The Egungun known as Ege appears on the left, wearing a crown with three birds representing *aje* (the "Mothers"), one on each side of the base and one perched on top. Photograph by author, December 20, 2004.

One striking element of the Ege statue and the Ege mural (see figure 2.4) on the second level of Otta's Egungun shrine deserves special mention—the birds seated on top of Ege's crown. The appearance of birds atop the crown suggests that the *aje* or "the Mothers" lead, own, and/or possess this Egungun. It resonates with oral traditions such as Osa Eleye in *Odu Ifa* that identify Otta as the headquarters of the *aje* and offer support for the belief expressed by the king of Otta and by the town's leading Egungun chief that the *Iya Agba Oje* (the elderly women among the Egungun chiefs) are the leaders, owners, and custodians of the power that maintains the practice and priesthood of Egungun in Otta.[15]

The traditions surrounding Odikaye and his siblings present Egungun and Shango as interlocking ritual traditions, a tandem association that conforms to their symbiotic relationship under the reign of *Alaafin* Abiodun. Interestingly, however, the traditions do not identify Aina Ege and Olafaya as members of or officials within the formal imperial apparatus. It is possible that, like their elder brother, these two individuals initially served as *ilari* (officials who traveled between the capital and the provinces), traveling to Otta to carry back to Oyo the

tribute that Odikaye, now an *ajele* (local administrator), had collected from the king of Otta. Whether or not this man's younger siblings were formally appointed officials, the Itimoko traditions support the notion that the Oyo royal family drew on the members of the Itimoko family to establish and replenish the ritual networks connecting Shango and Egungun.

## Challenging the Itimoko Tradition

Several elements of the Itimoko family's history may encourage the skeptical reader to interpret it as twentieth-century propaganda. When pressed to identify who was the reigning *Alaafin* when Itimoko's ancestors brought Egungun to Otta, one family member, a high-ranking Egungun chief, identified a twentieth-century *Alaafin* who wielded considerable power in colonial Nigeria with the support of a colonial administrator. This circumstance lends credibility to a rival family's claim that the Itimoko were "latecomers" to the practice of Egungun—that is to say, the Itimoko family arrived in Otta to find an already flourishing masquerade practice organized at the level of individual families, and not a centralized organization operating as the priesthood. However, in the nineteenth century, after a series of conversations with local converts, the missionary James White recorded in his journal in the 1850s that Otta once had its own Oyo imperial administrator who collected and transported tributes paid by the king of Otta to the *Alaafin* of Oyo. The narratives articulated by the Itimoko family and their allies fit with other evidence as well.

However, it is also useful to consider other traditions that seem to counter or challenge the Itimoko family accounts of the origins of Egungun in Otta. One such tradition recounts that among the items that the founders of Otta brought with them from Ife to Otta in 1621 was a masquerade cloth, referred to in the introduction as an *"egungun"* to distinguish it from Egungun, the Oyo masquerade tradition and masking society. The narrative states that these founders ritually offered it to spiritual forces to call blessings down on the town.[16] Another account claims that the *baba muko* was the first type of Egungun to exist in Otta, honoring Egungun chiefs or the elderly of a community. During performances, prayers are recited to bless the community or curses uttered to punish it.[17] This account offers few details that might yield clues to dating the first performance; however, if it was one of the first Egungun in Otta or even an early one, it could date back to the early sixteenth century, an era in which a woman from Otta allegedly was the wife of one *Alaafin* and the mother of his son.[18] In its favor, this tradition presents as Otta's earliest Egungun one of a type associated with Oyo in the period before the Nupe invasion. The *baba muko* is typically performed in the context of funeral rites and ancestral veneration, elements closely associated with the earliest Egungun traditions.

To evaluate the validity of the evidence presented in the Itimoko family's tradition, other oral traditions, and material culture, we must review the process of

Oyo imperial expansion in the southwest as described by the missionary Samuel Johnson, as well as by later scholars, who use oral and archival data to reconstruct this history. I base the analysis that follows on the chronology that Johnson offers in his *History of the Yoruba*, which historians have largely accepted for the era of Oyo imperialism.

## Oyo Expansion in the Southwest

Oyo's interest in Otta centered on gaining access to the growing trade between Africans and Europeans along the littoral of the Bight of Benin. Oyo's contact with Europeans began during the reign of *Alaafin* Obalokun, Ogbolu's successor, in the early seventeenth century.[19] In the second half of that century, Obalokun's successor, *Alaafin* Ajagbo, began extending Oyo's rule beyond the central Oyo Yoruba area toward the coast to the southwest. Just before 1670, Oyo began supplying a portion of its slaves to the kingdom of Allada, near the coast, for export to the Americas.[20] Shortly thereafter, Oyo adopted a more aggressive policy toward Allada, invading the kingdom in 1698.[21] By the time it conquered Allada, Oyo had likely gained military control of the northern Egbado and Anago Yoruba areas. It later established formal rule in this region.

Law identifies three stages of Oyo colonization in the southwest. During the first stage, around 1700, immigrants from Oyo founded the Anago towns of Ifonyin and Ihunmbo. During the second stage, from the 1750s into the 1770s, Oyo established the northern Egbado town of Ewon, which became a base for Oyo's subsequent colonization of other towns in the area. During the third stage, from 1774 to 1789, Oyo colonized southern Egbado towns, namely Ilaro and Ijanna, in close proximity to Otta. Law's last stage overlaps with the reign of *Alaafin* Abiodun, whom I discuss in greater detail below.[22]

Since the Itimoko traditions identify Odikaye as an Oyo imperial administrator, this official's responsibilities must be considered when assessing the historical basis of the family's claims. The *Alaafin* exercised authority in Oyo's provinces through *ajele* (resident officials), *ilari* (traveling officials), and other representatives. The *ajele* were also known as *asoju oba*, "those who act as the king's eyes."[23] The *Alaafin* selected *ajele* from among the most loyal palace slaves, Oyo immigrants, and members of the royal family in the capital. The *ajele* collected tolls and tribute, adjudicated local disputes, and oversaw local rulers. The *ilari*, in contrast, were administrators who traveled throughout the provinces; they supervised the *ajele* and accompanied some local rulers to Oyo to honor the *Alaafin* with tributes and gifts during the annual festivals.[24] The Itimoko traditions hold that Odikaye first performed the role of an *ilari* before transitioning into the office of *ajele*.

Other sources offer evidence of the type of tribute that Odikaye and his descendants likely received and brought or sent to Oyo. For example, Otta contributed locally made rush mats to Oyo as a form of tribute.[25] According to Johnson,

a more common form of tribute for towns under Oyo's rule was *bere* grass, which was used to thatch palace roofs.[26] Towns usually paid additional tributes in cowry currency or in kind, depending on their resources. These offerings were a sign of the towns' acknowledgment of their subordination to and support of the *Alaafin*.

The *oba* (kings) and *baale* (lineage heads) of many of Oyo's provincial towns were obligated not only to pay a tribute but also to personally take gifts to the capital during the annual festivals and whenever a new *Alaafin* was crowned.[27] In some instances, the local rulers of provincial towns were either appointed or approved by the *Alaafin*; as a further indication of their subordination and loyalty to the *Alaafin*, these new provincial rulers often traveled to the *Alaafin*'s palace in Oyo for confirmation of their installation.[28] A British colonial official based in Abeokuta produced a report in 1926 in which he claimed that an unnamed king of Otta had traveled to Oyo for confirmation during the imperial era. However, this claim may have had more to do with the status of the kingdoms of Oyo, Otta, and Abeokuta in colonial Nigeria than with Otta's status as a precolonial Oyo imperial subject. The obligations of provincial administrators and rulers to Oyo in the late eighteenth century were determined in part by policies set in the capital. The power struggle in the capital between the *Alaafin* and the *Oyo Mesi* for dominance in Oyo and over the empire's wealth and resources shaped policy and influenced their enforcers in the provinces.

## Bashorun *Gaa and His "Sons" Target the* Alaafin's *Wives*

The reign of Gaa as *Bashorun* Gaa, war chief and leader of the *Oyo Mesi* (the council of nonroyal Oyo chiefs) from 1754 to 1774, marked a defining phase in the politics and economics of Oyo's imperial administration.[29] Power struggles between the *Alaafin* and the *Oyo Mesi* dated back to the time of *Alaafin*'s rule at Igboho. However, the developing imperial apparatus, which gave the *Alaafin* singular power over the political and economic structures of the provinces, exacerbated these tensions between the *Alaafin* and the *Oyo Mesi* in the capital. This imbalance of power favoring the *Alaafin*s may have encouraged a new or intensified arrogance and rigidity in their ruling style.[30] According to Johnson, many of the early to mid-eighteenth-century *Alaafin* were despotic rulers.[31] Their despotism may have stemmed not solely from their individual characters or their growing political and economic power in the provinces but also from their growing religious stature and the increasing visibility of Shango priests and priestesses who operated in the name of the *Alaafin* throughout the empire. As the living embodiment of Shango, the *Alaafin* may have been less willing to negotiate with or bend to the counsel of the *Oyo Mesi*.

Gaa gained fame originally as a powerful war chief, having led the colonization of the northern Egbado kingdom of Ewon before ascending to the post of *Bashorun* in 1754. Gaa's influence in the Egbado region enabled him to wield

power and authority in the provinces after he became the *Bashorun*.[32] He had a favorable reputation there, putting him in a position to maneuver effectively against the *Alaafin*'s power base. Although the *Alaafin* had a large administrative apparatus in the provinces, Gaa's role as the *Bashorun* and his experience as a provincial warrior gave him a military base of support from which to achieve his goal of eclipsing the *Alaafin* as the effective ruler of Oyo.[33]

On becoming the *Bashorun* and thereby assuming the final voice in the selection and removal of *Alaafins*, Gaa attacked the *Alaafin*'s authority in both the capital and the provinces. His reputation grew in the capital as he forced the removal of four consecutive *Alaafin* (Labisi, Awonbioju, Agboluaje, and Majeogbe) from office. Gaa's supporters praised him as their champion against the perceived tyrannical rule of these *Alaafin*. According to Johnson, Gaa "had great influence with the people, and a great many followers who considered themselves safe under his protection from the dread in which they stood of the kings because of their cruel and despotic rule."[34]

Gaa's next move was to organize the overthrow of the *Alaafin*'s administrators in the provinces, replacing them with his own "sons." According to Johnson, Gaa's "sons" thereafter "were scattered all over the length and breadth of the kingdom, [residing] in the principal towns and all the tribute of those towns and their suburbs [was] paid to them. No tribute was now paid to the *Alaafin*; [Gaa's] sons were as ambitious and as cruel as their father."[35] Gaa did more than merely disrupt the *Alaafin*'s economic and political power, however. In the process of removing the *Alaafin*'s administrators, he also challenged the *Alaafin*'s religious and spiritual authority.[36] It would have made sense for Gaa's supporters to attack or remove Shango "wives" (priests and devotees) in the provinces, even if they were not part of the official administrative apparatus, because the Shango priesthood was deeply implicated in the power and authority of the *Alaafin*.[37] Thus, in leading the overthrow of the *Alaafin*'s *ajele*, Gaa was also challenging the spiritual authority of the king.

The anthropologist James Lorand Matory offers an insightful interpretation of the clash between royals and warriors in Oyo history and politics and infers that Gaa's regime was emblematic of the qualities associated with the deity Ogun and his mythical rivalry with the deity Shango in Yoruba oral traditions. As an *orisha* (deity) of war, Ogun appears in oral traditions and nineteenth-century missionary sources as a patron deity of warriors and war chiefs, such as Gaa who, based on his title of *Bashorun*, was leader of the army residing in the capital.[38] Matory references oral traditions contained in the *Odu Ifa* corpus to suggest that Ogun and Shango represent contrasting models of masculinized and feminized power, respectively. The disproportionate representation of men such as Gaa in war fuels associations of Ogun with men and masculinity.[39] The *Alaafin*'s delegation of royal power to initiated Shango priests and priestesses, men and women

who were the ritual wives of the deity and by extension of the *Alaafin*, affirms the association of the emperor and the deity with both masculine and feminine embodiments of royal power.[40] A mythical rivalry between the two deities, Shango and Ogun, parallels the conflicts between the *Alaafin* and the *Bashorun*. Yoruba mythology depicts Shango as more successful in marriage and governance than Ogun. Shango seduced the wives of the Ogun, persuaded these women to leave, cemented alliances between kingdoms through marriage, and developed an effective administration for his kingdom by appointing his wives to positions of leadership. Ogun, conversely, neither enjoyed a successful marriage nor built a kingdom or empire. Matory infers that Gaa's attack on royal power included the targeting of men and women who, as Shango priests and priestesses, were Shango's wives and the *Alaafin*'s messengers and administrators in the capital and the provinces.

When Abiodun became *Alaafin* in 1774, Gaa was the de facto leader of the Oyo Empire. The *Alaafin*'s imperial status had been reduced to that of a figurehead whose power and authority were more symbolic than real. However, hostility toward Gaa soon developed in both the provinces and the capital, as he, too, began to be viewed as a tyrant who looked primarily after his own interests.[41]

In spite of the growing resentment of Gaa, however, he still held sway over politics in the capital. The *Bashorun*, as the head of the Oyo metropolitan army, had a military advantage over the *Alaafin*.[42] Recognizing Gaa's role in deposing previous kings, *Alaafin* Abiodun initially placated the *Bashorun*. He knew that to overthrow Gaa he would need assistance from the provinces, where Gaa had developed a reputation as a despot. Abiodun turned to the *Are-Ona-Kamkamfo*, the commander-in-chief of the provincial army, to lead Oyo provincial forces against Gaa's supporters. The *Are* complied, leading the massacre of *Bashorun* Gaa's troops, first in the provinces and later in the capital.

## Royal Children Replace Warrior Sons

Having removed Gaa, Abiodun implemented a series of policies aimed at returning power and authority to the *Alaafin*. Among other initiatives, he asserted control over the approximately 200-mile trade route from Old Oyo to Badagry, a port town where merchants from Otta engaged in trade. Abiodun regained this control by once again appointing members of the Oyo royal dynasty as *ajele* in small towns and trading posts along the new route. In the Egbado region, one of Abiodun's sons was installed as the *Olu* of Ilaro, ruling a town that was an important administrative center for the Egbado region. The *Olu* was initially responsible for leading local rulers when they carried tribute to Oyo. Moreover, *Alaafin* Abiodun reportedly later appointed the first *Onisare* of Ijanna, a town near Ilaro, and entrusted him with responsibility for collecting tribute and sending it to the *Alaafin* in Oyo. Law claims that Abiodun appointed his sons to these important

positions in the region to counteract Gaa's appointees.[43] This system of adminis-tration was also eventually extended to Egbado proper, as well as to Anago and Awori areas, including Otta.[44]

Abiodun also played a seminal role in the creation of a new class of Egungun that, I claim, is reflected in the Itimoko tradition. When Abiodun became the *Alaafin*, the Egungun society in Oyo already included what the theater historian Adedeji has identified as a theatrical group that performed during palace enter-tainments and the major annual festivals in Oyo, the capital city.[45] Abiodun in-novated by creating a new class of Egungun, distinguished by its function and the location of its performances. This new class accompanied the *ilari*, imperial ad-ministrators who traveled from the palace to the provinces of the empire to en-tertain important members of the *Alaafin*'s royal family and the *ajele*, as well as members of provincial royal families and their important guests.

Some contemporary Egungun masks depict *ilari*, characterized by a distinc-tive hairstyle with part of the head completely shaved. This shaved hairstyle with a braided triangular high crest is known as an *agogo*. During the 2004–2005 Egungun Festival, I observed an Egungun mask at Otta with this feature. The crest on this mask looks like a round blade, a bolt of lightning, or a flame of fire, all of which affirm the volatility ascribed to Shango's personas. These shapes are visi-ble in an assortment of heads carved into the top of the wooden headdress of another Egungun named Ololu Omo Arogunmola (see figure 2.5). I encountered this Egungun and its followers just moments before I walked by a mural, painted on the home of its owner, depicting it. The varying hairstyles associated with *ilari* are more distinctive in the mural than in the carved headdress in part because the latter contains feathers and other elements of ritual offerings. These styles mirror the *ilari* or *soku* (plaited) and *agogo* ("fell out") hairstyles that Lawal iden-tifies in Gelede masks.

Evidence offered by scholars working in other communities further confirms the significance of hairstyles depicted in Yoruba masks for understanding gender and politics in Yoruba history. Citing cases from the northern Yoruba towns of Iganna and Iseyin, Marilyn H. Houlberg documented Egungun depicting the an-cestors of lineages that provided *ilari* to the palace in Old Oyo.[46] Although some art historians claim that the *ilari* are female hairstyles, I interpret them as a femi-nine style adopted by some girls and women, as well as by some Shango priests and priestesses and Oyo royal messengers. The explanation for why Shango devotees, whether male priests or female priestesses, would wear such hairstyles emerges from the convergence of the ritual, political, military, and sexual symbolism and functions associated with these individuals during the era of Oyo imperialism. Shango devotees not only enjoyed status as ritual wives and devotees of the deity and messengers of the *Alaafin* but they also were metaphors for equestrian figures who conquered and incorporated new subjects and territories in the name of

Fig. 2.5. Ololu Omo Arogunmola (Ololu, the descendant of the warrior named Arogunmola) appears in a mural on the home of this Egungun's owner. This painting features two virtually identical masqueraders distinguished by their size, suggesting that the smaller figure on the right is the child of the larger figure. The headdresses of these masqueraders are located to the left on stands, with five heads representing three hairstyles: two heads on the outer rim of the headdress have pointed styles, and two heads feature a more plaited style and are positioned to the right and left of the middle and largest head, which has an *oshe* Shango (the double ax that is the deity's symbol). Photograph by author, February 16, 2005.

their patron.[47] The Yoruba language uses the term *"gun,"* meaning to mount, to refer to the act of a deity possessing a devotee, a rider mounting a horse, or a dominant sexual partner climbing on top of a passive partner to reproduce loyal followers and expand the empire.[48] Egungun masquerades, which scholars often assume aim to honor male ancestors, sported carved headdresses with *ilari*-style hairstyles as a reminder of Egungun's association with an Oyo imperial project that was multifaceted and that promoted the supremacy of the *Alaafin* and his allies in the capital and in provincial communities.

In addition, within the southwestern Yoruba kingdoms (Egba, Egbado, and Awori), Abiodun established or extended the professional performance arm of the Egungun society.[49] Many scholars and non-Oyo Yoruba aptly attribute the spread of Egungun beyond the area of metropolitan Oyo to this period.[50] Abiodun's in-

novations in Egungun contributed to a broader plan for consolidating the *Alaafin*'s political and economic power and restoring his religious authority in the region in the aftermath of *Bashorun* Gaa's assault. Abiodun's policy of having an *alarinjo*, or traveling Egungun, parade throughout the provinces was designed to enhance his status in these communities vis-à-vis the *Oyo Mesi*. More specifically, it affirmed his association with those who supported him in overthrowing Gaa's sons.[51]

Several scholars have associated growth in the arts and expansion of community festivals in this area with periods of economic security and prosperity stemming from both the transatlantic slave trade and local and regional agricultural production.[52] Developments during the reign of Abiodun support this notion. Adedeji cites traditions purporting that Abiodun commissioned guilds of artists from the Oloba clan of the Egungun society based at Oyo to carve new masks, sew new attire, and perform funeral rites, in this instance for his late mother.[53] Some traditions of origin link the beginnings of Gelede to Old Oyo and identify Gelede as the winner of a dance competition. Although present-day Oyo has no Gelede organization and thus no evidence to support the Old Oyo origin thesis, the wealth derived from Abiodun's victory may have provided an opportunity for the spectacles associated with Gelede to thrive in communities frequented by Oyo officials in the vicinity of Ketu, which considerable evidence supports, as I noted in chapter 1, as its place of origin.[54] Such an endeavor illustrates how displaying artistry during elaborate spectacles enhanced the theatricality of Egungun and Gelede, in addition to enhancing Abiodun's legacy.

From the traditions he collected regarding Egungun in various Yoruba towns during this period, Adedeji infers that Abiodun deployed the *alarinjo*, or traveling Egungun.[55] The Itimoko tradition does not necessarily conflict with Adedeji's research concerning the *alarinjo*. Odikaye's Egungun may well have had this character, although it is not identified as *alarinjo* in Otta traditions. The Ege masquerade, with its beaded crown and rich attire, undoubtedly celebrated and upheld the status of the *Alaafin*. The modifications in honor of Odikaye's brother likewise suggest a commemorative, celebratory character, as opposed to the aggressive, punitive character that Egungun at Otta would later acquire when the town was threatened by war.

It is difficult to extrapolate the precise character of Shango in Otta based on this version of the Itimoko traditions. The Shango priesthood is often associated with confrontation and coercion, even oppression, in its ritual conduct. Yet, no matter how stern or confrontational a priest invoking Shango could be, the event that endured in the Itimoko family tradition suggests a powerful, yet benevolent Shango who, through his priest Odikaye, saved the town from plague.

The reign of *Alaafin* Abiodun marked a critical moment in the history of Shango and Egungun in the southwestern region of the Oyo Empire and of Yorubaland

more broadly. Abiodun came to power at a time when Gaa was a dominant force in the capital and throughout the empire, having replaced previous *Alaafins'* agents with his own "sons." Gaa and the other members of the *Oyo Mesi* likely resented the growing number of "wives" who often were actually women. These women had entered the capital as the *Alaafin's* slaves, but through merit and charisma they exerted tremendous power in his name—mediating and limiting access to him. Gaa's "sons" (the agents of Oyo's most renowned warlord) represent the exclusion of women that Matory identifies with Ogun (a deity of war).[56] After taking office, Abiodun amassed enough support to overthrow Gaa, massacre his "sons," and replace them with his own "sons" and "wives" in the form of Egungun and Shango practitioners and priests, who performed rituals in honor of their ancestors and husbands (Shango and the *Alaafin*). As noted earlier, the word "sons" in the Yoruba language generally refers not only to the biological children (whether male or female) of a prominent leader but also to his followers (including extended family, dependents, slaves, friends, and younger allies). Abiodun's regime (which included "sons" and "wives") embodied a gender-fluid model and practice of political authority.

After evaluating the Itimoko family's accounts against those of their challengers and the broader history of Oyo imperial expansion and consolidation in the Egbado province of the southwestern region, I have reached the following conclusions regarding Egungun's importance to the administration of an empire. An imperial administrator settled in Otta, a town where Egungun already existed as a decentralized practice organized at the level of individual families and clusters of families. After the death of Gaa and Gaa's "sons," the administrator brought an Egungun that embodied the prestige and wealth associated with Abiodun's reign. The Itimoko family epitomized a new administration with a more fluid enactment of power that included both masculine and feminine personas manifested in the same body, such as "sons" who were "wives." The Itimoko tradition does not identify Abiodun or any other *Alaafin* during the era of Oyo imperialism. However, other evidence identifies Otta as a tribute-paying kingdom with an *ajele*. Regardless of whether the *ajele* from the Itimoko family was a biological or fictive "child," his association with the imperial royal family and with the practice of Egungun and Shango proved convincing enough to make him acceptable to Otta's elites. The Itimokos entrenched themselves as the leaders of an Egungun priesthood that developed over subsequent generations.

The Itimoko family's accounts and those of their challengers yielded no information about the relationship of Otta's *ajele* and his siblings to their counterparts in other nearby towns. We do know that in the powerful Egbado towns the Oyo administrators contributed to an elaborate political and economic network that linked them to the capital and to other towns under their domain. Otta's location on the periphery of the empire may have rendered it of nominal significance in the eyes of the empire's leaders. Traders traveled between it and other

regional markets in Egbado and the port towns of Badagry and Lagos on the coast. Nonetheless, it was beyond the main Oyo-Badagry trade route and was not actively involved in the affairs or politics of other larger towns.[57] These conditions may have guided Odikaye's own actions and policies within the town and may serve as an alternative explanation for the presence of his family members. Together, the three of them—Odikaye, Aina Ege, and Olafaya—could have drawn on a formidable degree of spiritual, political, and economic power in their capacity as *ajele* and Shango priest, Egungun performer, and Shango priestess, respectively. At the same time, far from the contentious politics of the Oyo metropolis and in the absence of serious local rivalries, Odikaye may have had little need to establish his status and authority in the town in a conspicuously assertive or aggressive manner. Otta's relative isolation and distance from the center of Oyo may have influenced Odikaye's conduct in yet another way: too strong a display of power and aggression might have invited retaliation from the people of Otta, which Odikaye might have felt unable to withstand.

I conclude that Odikaye and his siblings were satisfied with establishing their power and authority without dismantling the local ruling apparatus. In other provincial towns, the relatives and supporters of the *Alaafin* made themselves rulers, replacing or setting themselves over the local kings and chiefs. The *Alaafin*'s children could have followed that precedent, especially because they owned an Egungun with a crown. Nothing in the traditions, however, suggests that the administrators or related family members who came to Otta from imperial Oyo had such aspirations during this period. Instead, the traditions commemorate the introduction of powerful new ritual traditions and celebrate the imperial representatives who brought them in ways that indicate that Otta's inhabitants came to value their presence in the town.[58]

Odikaye, Aina Ege, and Olafaya supported the interests of the *Alaafin* and successfully integrated themselves among the local elite by establishing Egungun and Shango within the town of Otta. Their behavior recalls that of innumerable other Oyo administrators, Shango priests, and Egungun performers and ritual leaders who traveled throughout the empire promoting the Shango and Egungun traditions. However, whereas in Otta these administrators evidently were embraced, in some provincial towns and kingdoms they were deeply resented. Referring to Oyo administrators as well as Shango priests who came to Egba towns either during or immediately after Abiodun's reign (1774–1796), the Egba historian Biobaku astutely observes that they "exploited the religious fears of the people to feather their own nests and in order to exact enormous tribute for the *Alaafin*."[59] An Egba warrior named Lishabi led a rebellion that turned into a massacre. He organized a military movement under the banner of an Egba mutual aid and farmer's society. In the end, these Egba reportedly killed approximately 600 *ilari* (who embodied the gender fluidity of Shango priests and traveling officials) in a single day.[60] The contrasting reception of Oyo administrators in Otta and in the

Egba region supports my hypothesis that, even if the spread of Egungun and Shango occurred with a certain degree of uniformity and regularity throughout the Oyo Empire vis-à-vis the imperial administrative apparatus, the reception and development of these ritual traditions varied according to local conditions and the goals, ambitions, and power of the individual officials who brought them.

Taken together, these traditions allow historians to reconstruct the early history of masquerading in Otta. The development of Egungun in the town during the imperial period, in light of its relationship to Egungun at Oyo in the same period, illustrates the power of performance, the ways in which subtle and overt political dramas were enacted as administrators arrived, performed duties, found acceptance, and built community. Egungun spread largely with the aid of Shango priests and priestesses. Ege, which I identify as an imperial Egungun masquerader distinguished by the crown it wears and its relationship to the Oyo royal family, embodies the more ceremonial and benevolent qualities of the *orisha* Shango. The conditions in which the administrator and his siblings found themselves in Otta made it advantageous to embrace these qualities of Shango. Yet as the Egba case here and the remaining chapters of this book suggest, a range of conditions provided opportunities for distinct elements of Oyo imperial culture to take root.

The peace and prosperity of Abiodun's reign soon gave way to insecurity as more powerful subject kingdoms rebelled against Oyo by attacking its allies in the region. These attacks sparked waves of migration from nearby Egun and Egbado communities into Otta. Oyo, Egun, and Egbado peoples settled in and around the Itimoko compound, forging new identities and practices that reflected their experience of displacement in a diaspora. Egungun practitioners and their allies assumed greater positions of prominence as police and warriors, and they acquired more land on which to settle followers and allies. The complex gender identities and relationships enacted through the Itimoko family's Egungun were eclipsed by the masculine warrior ethic associated with Abiodun's and the empire's ultimate demise that began with the *Alaafin*'s death in 1789 and culminated in Oyo's collapse in 1836. During this period, the empire's decline facilitated the outbreak of war and the persistence of a warrior masculinity that then came to define the identity of the community of Oyo, and Egun peoples congregated around the Itimoko family. A new chapter in the history of masquerades at Otta had begun.

## Notes

1. This area, otherwise referred to as the Oyo kingdom or "Yoruba Proper," includes the capital of Oyo-Ile and the surrounding area, which was populated by the Oyo Yoruba and under the control of the *Alaafin*. Conversely, the Oyo Empire included the area occupied by Oyo's tributaries, outlying dependencies, or semi-subject kingdoms. See Robin Law, *The Oyo*

*Empire, c. 1600–c. 1836: A West African Imperialism in the Era of the Atlantic Slave Trade* (Oxford: Clarendon, 1977), 73–82.

2. I. A. Akinjogbin, "The Oyo Empire in the Eighteenth Century: A Re-Assessment," *Journal of the Historical Society of Nigeria* 3, no. 2 (1966): 449–460; Law, *The Oyo Empire*, 234; J. F. Ade Ajayi, "The Aftermath of the Fall of Old Oyo," in *History of West Africa*, ed. J. F. Ade Ajayi (London: Longman, 1987), 174–214.

3. See theater scholar Joel Adedeji and historian S. O. Babayemi for discussions of Egungun's place in the rise of the Oyo Empire. Joel Adedeji, "The Alarinjo Theatre: The Study of a Yoruba Theatrical Art from Its Earliest Beginnings to the Present Times" (PhD diss., University of Ibadan, 1969), chapters 3–4; S. O. Babayemi, *The Fall and Rise of Oyo C., 1706–1905: A Study in the Traditional Culture of an African Polity* (Lagos: Lichfield Nigeria, 1980), chapters 1–2; Babayemi, *Egungun among the Oyo Yoruba* (Ibadan: Board Publication, 1980).

4. Adedeji, "The Alarinjo Theatre"; Babayemi, *The Fall and Rise of Oyo C.*

5. James Matory, *Sex and the Empire That Is No More: Gender and the Politics of Metaphor in Oyo Yoruba Religion* (Minneapolis: University of Minnesota Press, 1994).

6. Samuel Johnson, *History of the Yoruba: From the Earliest Times to the Beginning of the British Protectorate* (Lagos: C. M. S. Bookshop, 1921), 177–178.

7. Matory, *Sex and the Empire*.

8. Nineteenth-century missionary records as well as contemporary ethnographic evidence reference people claiming an Oyo identity based on descent from the capital of the Oyo Empire.

9. Chief S. A. Asanbe, the *Oloponda* (the most senior Egungun chief at Otta), narrated this history during my interview with him. He is from the Itimoko family. Interview with Chief S. A. Asanbe, *Oloponda* of Otta, Itimoko compound, Ijana ward, Otta, 2006. The Oba M. A. Oyede III, the king of Otta, also cited this tradition when I asked him about the origins of Egungun at Otta. Interview with Oba M. A. Oyede III, *Olota* of Otta, Otun ward, Otta, 2005.

10. Interview with Chief S. A. Asanbe, *Oloponda* of Otta, Itimoko compound, Ijana ward, Otta, 2006; Deji Kosebinu, Dele Adeniji, and Rasheed Ayinde, *Millennium Egungun Festival in Ota Awori: Special Program Brochure* (Otta: Bisrak Communications, 2000), 24–25.

11. Interview with Chief S. A. Asanbe, *Oloponda* of Otta, Itimoko compound, Ijana ward, Otta, 2006; Interview with Chief J. O. Akingbola, *Atokun* of Otta, Ijana ward, Otta, 2005. The two images of the mural note the appearance of the Egungun shrine before and during the 2004 festival period. Before each Egungun festival, artists repaint the masks of the performers that have registered.

12. Interview with Chief S. A. Asanbe, *Oloponda* of Otta, Itimoko compound, Ijana ward, Otta, 2006. Agan first appears in the written record in Johnson's account of an Egungun performance at Oyo, 1858. Morton-Williams was the first to document Agan's existence at Otta in the 1950s. Both Kosebinu and Salako provide contemporary accounts of Agan rituals.

13. Interview with Chief S. A. Asanbe, *Oloponda* of Otta, Itimoko compound, Ijana ward, Otta, 2006.

14. Eva. L. R. Meyerowitz, "Notes on the King-God Shango and His Temple at Ibadan, Southern Nigeria," *Man* 46, no. 27 (1946): 25–31.

15. Interview with Chief S. A. Asanbe, *Oloponda* of Otta, Itimoko compound, Ijana ward, Otta, 2006; Interview with Oba M. A. Oyede III, *Olota* of Otta, Otun ward, Otta, 2010.

16. James White, December 3, 1855, from journal ending December 25, 1855.

17. Kosebinu et al., *Millennium Egungun Festival*; Interview with Prince Kunle Andrew, Otun ward, Otta, 2005.

18. Johnson, *History of the Yoruba*.

19. Johnson says that this contact was established during the reign of *Alaafin* Obalokun. Law finds Johnson's evidence consistent with the written accounts of Europeans. Ibid., 168; Law, *The Oyo Empire*, 217–218.

20. Peter Morton-Williams, "The Oyo Yoruba and the Atlantic Trade," *Journal of the Historical Society of Nigeria* 3, no. 1 (1964): 25; Robin Law, *The Kingdom of Allada* (Leiden: CNWS, 1997); Jamie Bruce-Lockhart and Paul E. Lovejoy, "Introduction," in *Hugh Clapperton into the Interior of Africa: Records of the Second Expedition, 1825–1827*, ed. Jamie Bruce-Lockhart and Paul E. Lovejoy (Leiden: Brill, 2005), 1–78.

21. This process cannot be traced in detail because the evidence is so scanty. According to Law, the only detailed chronology pertains to Oyo's expansion in the extreme southwest. Law, *The Oyo Empire*.

22. Ibid., 113–118.

23. Ibid., 110–113.

24. Morton-Williams, "The Oyo Yoruba and the Atlantic Trade," 40–41; J. A. Atanda, *The New Oyo Empire: Indirect Rule and Change in Western Nigeria 1894–1934* (London: Longman, 1973), 26; Akinjogbin, "The Oyo Empire in the Eighteenth Century," 451–52; Law, *The Oyo Empire*, 110–13.

25. James White, December 3, 1855, from journal ending December 25, 1855.

26. Johnson, *History of the Yoruba*, 49, 98; Law, *The Oyo Empire*, 99.

27. Law, *The Oyo Empire*, 100.

28. Nigerian National Archives, Ibadan, CSO 26, C. T. Lawrence, "Assessment Report on Otta District: Abeokuta Province," 1926.

29. Babayemi, *The Fall and Rise of Oyo*, 50.

30. Law, *The Oyo Empire*, 81–82.

31. Johnson, *History of the Yoruba*, 168–78.

32. Kola Folayan, "Egbado to 1832: The Birth of a Dilemma," *Journal of the Historical Society of Nigeria* 4, no. 1 (1967): 17; Law, *The Oyo Empire*, 93.

33. Johnson, *History of the Yoruba*, 178; Law, *The Oyo Empire*, 93.

34. Johnson, *History of the Yoruba*, 178.

35. Ibid., 180.

36. Law, *The Oyo Empire*, 104; Babayemi, *The Fall and Rise of Oyo*, 35.

37. Law, *The Oyo Empire*, 180.

38. Johnson, *History of the Yoruba*.

39. Also, historically, the majority of Ogun devotees or priests have been men while women have comprised the majority of Shango devotees. Moreover, ritual possession has long been rare or nonexistent among Ogun devotees while it has been common among Shango devotees. Matory, *Sex and the Empire*, 6–9.

40. Shango iconography has been dominated by a logic of complementary gender opposition, according to Matory, and this is reflected in the male possession priests who, by adopting feminine hairstyles and titles (iyawo or wife of Shango), established a style of productive and reproductive servitude that was usually attributed to the wives of mighty husbands. Ibid.

41. Johnson, *History of the Yoruba*, 182–187; Law, *The Oyo Empire*, 80.

42. Law, *The Oyo Empire*, 74.

43. Johnson, *History of the Yoruba*, 168; Peter Morton-Williams, "The Yoruba Kingdom of Oyo," in *West African Kingdoms in the Nineteenth Century*, ed. Cyril Daryll Forde and Phyllis Mary Kaberry (London: Oxford University Press for the International African Institute, 1967), 41; Law, *The Oyo Empire*, 94–95.

44. Nigerian National Archives, Ibadan, CSO 26/2, 20629, F. C. Royce, "Assessment Report of Otta District, Egba Division, Abeokuta Province," 1927, 52, 368.

45. Adedeji, "The Alarinjo Theatre," 146.

46. Babatunde Lawal also identifies a more rounded point for an *ilari* style in a Gelede mask (Lawal, *The Gelede Spectacle*, 195–197). See also Marilyn Houlberg, "Notes on Egungun Masquerades among the Oyo Yoruba," *African Arts* 11, no. 3 (1978): 56, 58.

47. Clara Odugbesan, "Feminism in Yoruba Religious Art," in *Man in Africa*, ed. Mary Douglas, Phyllis Mary Kaberry, and Cyril Daryll Forde (London: Tavistock Publications, 1969), 206–209.

48. Matory, *Sex and the Empire*, 206.

49. Peter Morton-Williams, "The Egungun Society in South-Western Yoruba Kingdoms," in *Proceedings of the Third Annual Conference of the West African Institute of Social and Economic Research* (Ibadan: University College, 1956), 90–103.

50. Adedeji, "The Alarinjo Theatre," 144–145, 58; Babayemi, *The Fall and Rise of Oyo*; Adedji, *Egungun among the Oyo Yoruba*, 26–27; Wale Ogunyemi, "Egungun Cult in Some Parts of Western Yorubaland: Origin and Functions," *African Notes* 21, nos. 1–2 (1997): 100–101; Kosebinu et al., *Millennium Egungun Festival*, 39–60.

51. Johnson, *History of the Yoruba*, 168; Law, *The Oyo Empire*, 94–95; Folayan, "Egbado to 1832," 24–25.

52. Law, *The Oyo Empire*, 81–82, 90–101; Henry John Drewal and Margaret Thompson Drewal, *Gelede: Art and Female Power among the Yoruba* (Bloomington: Indiana University Press, 1983); Sidney Littlefield Kasfir, "Masks from the Towns of the Dead," in *Igbo Arts: Community and Cosmos*, ed. Herbert M. Cole and Chike Cyril Aniakor (Los Angeles: Museum of Cultural History, University of California, Los Angeles, 1984), 163.

53. Adedeji, "The Alarinjo Theatre," 146–148.

54. Lawal, *The Gelede Spectacle*, 48–49.

55. Ibid.

56. Matory, *Sex and the Empire*, 6–9.

57. Nigerian National Archives, Ibadan, CSO 26, C. T. Lawrence, "Assessment Report."

58. Interview with Chief S. A. Asanbe, *Oloponda* of Otta, Itimoko compound, Ijana ward, Otta, 2005; Gbamidele Ajayi, Interview with Jimoh Adejare Idowu, Oyo, Oyo State, 2005.

59. S. O. Biobaku, *The Egba and Their Neighbours, 1842–1872* (Oxford: Clarendon, 1957), 8.

60. Ibid., 9.

# 3 The Emergence of New Warriors, Wards, and Masquerades

*The Otta Kingdom during the Era of Oyo Imperial Collapse*

Bᴇᴛᴡᴇᴇɴ ᴛʜᴇ ᴅᴇᴀᴛʜ of the Oyo Empire's most renowned ruler, *Alaafin* Abiodun, in 1789 and the destruction of the capital in 1834, the empire was in a state of rapid decline. From the northern savanna to the central and southern forests of Yorubaland, there were rebellions in the provinces and violent attempts by warriors to seize slaves, trade routes, and territories.[1] In 1784 and 1789, the Fon-speaking kingdom of Dahomey to the west of Oyo attacked the Gun community of Badagry, a port town.[2]

Hoping to avoid Badagry's fate, the Awori kingdom of Otta welcomed the refugees who fled Badagry, offering these newcomers land on the condition that they provide military support to Otta. The newly created Gun-Oyo community established a new ward on the north side of Otta known as Ijana (meaning "those who fight along the road"). One of an unknown number of new chiefs of Ijana was made the senior *Balogun* (war captain) of Otta, and another was named the *Ajana*, or head of the Ijana quarter. The new Ijana chiefs would defend Otta against Dahomeyan invasions between 1794 and 1821.[3]

I focus in this chapter on local responses to regional political and military dynamics, chronicling the establishment of the two immigrant wards in Otta and the masquerades that, I contend, shaped their character and embodied their identity.

## The Rise of Warriors and a New Era of Slavery in Otta's Ijana Ward

### Refugees Gain Power in Otta

Before the arrival of the Gun refugees, the king of Otta, known as the *Olota*, was the highest-ranking official in the town. A body of chiefs selected the king from one of the candidates offered by each of the three royal families from the town's oldest wards—Otun and Osi (see maps 3.1–3.4).[4] The inhabitants of Otun and Osi were descendants of Awori people who had originally migrated from Ile-Ife. The *Olota* claimed descent from Oduduwa, the progenitor of the Yoruba kingship at Ile-Ife via Oduduwa's son, the *Olofin* of Isheri—the ruler of an older Yoruba town.

Each of the two Aworí wards of Otta had a local chief: the *Oníkotun* for the Otun ward and the *Oníkosi* for the Osi ward. The *Oníkotun* and the *Oníkosi* served on the council of town chiefs that advised the *Olota*. They maintained law and order within their wards and also led their ward residents in battle against external enemies.[5]

Around the time that the new Ijana ward (see maps 3.3 and 3.4) was created, the chiefs of the Otun and Osi quarters appear to have been failing to dispense justice fairly to their inhabitants.[6] James White, the CMS missionary who lived at Otta in the middle of the nineteenth century, left an account of a crisis in Otta that provided an opportunity for the ambitious Ijana chiefs to gain new power and authority:

> In former days, the legislative and executive power of the [Otta] nation lodged in the hands of the true Otas, [the Aworí people from] Otun and Osi, but two circumstances served to transfer the executive power to the Ijana whilst the legislative power and the power of making a king were the prerogative of the Otun and Osi. On one occasion, a man of Osi was guilty of a capital offence, for which according to law he was to suffer death. But natural affection prevailed against justice and regards for the laws, and there was not found an Osi man who had so much resolution as to execute the sentence of the laws. Some time afterwards, a similar circumstance occurred at Otun, but not one man [there] could be found to lift up his hand against his fellow [man]. This failure of punishment on the part of the chiefs afforded a wide scope of men immortality and led to the commission of vices of every description. Whereupon the chiefs declared that whereas delicate feelings have prevented the putting in force the laws of the country, the executive power of the nation is henceforth transferred to strangers.[7]

White's evidence suggests that the *Balogun* and the *Ajana* of the Ijana ward benefited most from the transfer of executive and political authority. These chiefs had initially been responsible for leading and defending Otta during wartime and for keeping and punishing war captives, some of whom became slaves. Once given added authority to police the town, these chiefs also held and punished criminals in the chiefs' official residences. This new authority provided an opportunity for the *Balogun* and the *Ajana* to target, scrutinize, and punish Otun and Osi men who had previously enjoyed great political autonomy. Ijana war chiefs reportedly abused their authority by unjustly capturing and either detaining or enslaving residents of Otta as well as strangers.[8] Furthermore, as the threat of war became more pervasive and its conduct demanded experienced warlords to defend against attack, the military leadership that the Ijana chiefs provided became a more important feature of Otta's political culture.[9]

Around the same time that the *Ajana* of the Ijana ward gained new executive and judicial responsibilities, he also acquired new economic privileges. The

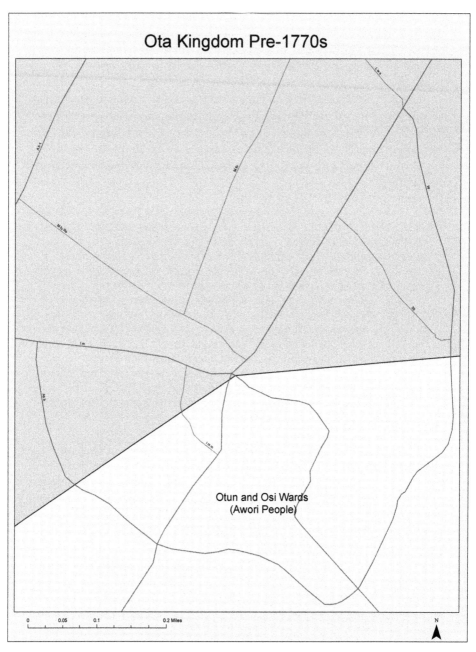

Map 3.1. Map showing the settlement of Otta (Ota) before 1770. There were only two wards (Otun and Osi) inhabited by Yoruba speakers of Awori descent. The rest of the land at the time was uninhabited.

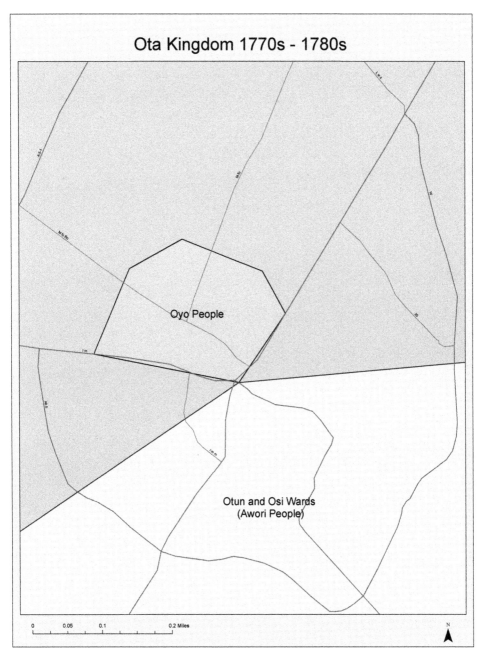

# Ota Kingdom 1770s - 1780s

Oyo People

Otun and Osi Wards
(Awori People)

0    0.05    0.1        0.2 Miles

N

Map 3.2. Map of Otta after the arrival of the *Ajele* Odikaye and his relatives and companions from Oyo during the reign of *Alaafin* Abiodun.

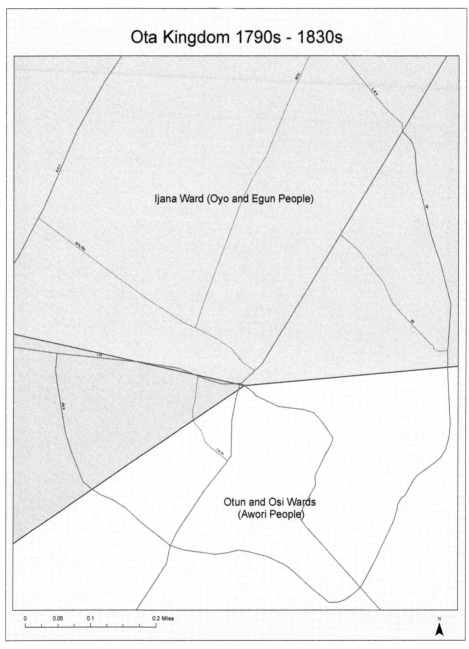

Map 3.3. Map of Otta after the founding of the Ijana ward around 1789, when Oyo and Egun people fled north and east to Otta from Badagry. The Ijana ward quickly surpassed the Otun and Osi wards in size and population.

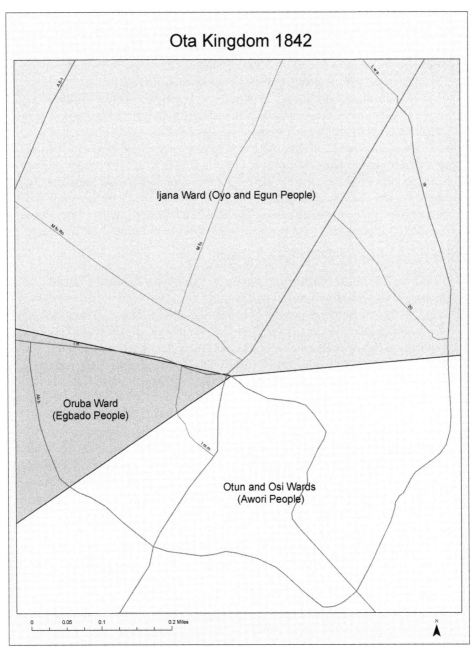

Map 3.4. Map of the four major wards and their ethnic makeup after the Dahomey attack on the Egbado communities in the 1830s.

historian Babatunde Agiri claims that the *Ajana* benefited from policies that were introduced to resolve local disputes over trade. The Ijana and Osi chiefs disagreed about their roles in the slave trade, in which Otta people acted as middlemen between long-distance sellers from the north and buyers on the coast to the south. The chiefs reportedly resolved the issue by determining that the Ijana chiefs would monitor caravans moving along routes north and northeast of Otta, while the Osi chiefs would monitor those moving south and southeast. Agiri adds that both sets of chiefs derived wealth from trade in Hausa slaves and agricultural produce. They also used slaves to produce maize and yams for sale to passing slave caravans, as well as to the growing slave port of Lagos to the southeast. Agiri suggests that through their involvement in the slave trade and commodities, the Ijana and Osi chiefs became the wealthiest individuals in Otta at that time.[10] By the end of the first quarter of the nineteenth century, the wealth, power, and prestige of the *Ajana* exceeded that of the Otun and Osi chiefs and had begun to rival that of Otta's king.

## Egungun in the Age of the Ijana Warriors

Before the *Ajana*'s ascendancy, the practice of Egungun at Otta had centered primarily on ancestor worship, fertility rites, and royal court and public entertainment. In the late eighteenth century, the Egungun association was controlled by the Oyo population in the Ijana quarter and possibly also by their new Gun coresidents. If Egungun that was practiced outside of Ijana control existed in Otta at that time, it was probably confined to family ancestor worship. Many people in Otta and nearby towns, such as Ilogbo, claim that Egungun lay at the heart of the ritual life of their ancestors.[11]

The Ijana ward's chiefs benefited from having Otta's leading Egungun chiefs as residents in their ward. However, the relationship between Egungun and the Ijana chiefs was bidirectional. As the Ijana ward came to dominate Otta, Egungun became a significant institution in the conduct of the town's executive and judicial processes. Just as the Ijana warrior-chiefs mobilized Egungun masquerades to assert their power, so the Egungun priesthood, acting in its own interests and on its own authority, sought to entrench itself within Otta's political culture and hierarchy.[12]

The *Balogun* and *Ajana* introduced a new warrior Egungun to Otta known as Gbodogbodo.[13] This Egungun was a "Soldier Man" Egungun that is still performed in Otta today. Unlike the Soldier Man (Soja Man) Egungun performer in modern-day Otta, however, Gbodogbodo carried a cutlass as a symbol of one of its main functions—to kill criminals, including witches, often at the request of high-ranking political leaders. These killings reportedly occurred in the *igbale*, or Egungun grove.[14]

In ancient and modern times alike, the existence of an Egungun grove in a town has required the presence of an Egungun priesthood or a council of Egun-

gun chiefs. Egungun performances have long been understood as collective affairs that require the support of one or more families working together, whether publicly or in private.[15] Before the Gun migration, the *ajele* and other Oyo immigrants to Otta had apparently established an Egungun priesthood that oversaw the performance of Egungun masquerades in honor of their ancestors and the *Alaafin,* as well as of Otta's political elite and their guests.[16]

There are several parallels between the narratives that relate the emergence of Egungun among Oyo's leadership at Igboho before the seventeenth century and those that relate the use of Egungun by the Ijana chiefs in Otta between the late eighteenth and early nineteenth centuries. In their respective eras, each community faced the threat of invasion by a more powerful neighbor, Oyo by the Nupe and Otta by Dahomey. In response to these threats, the rulers of Oyo and their Otta counterparts formed alliances with their neighbors and consolidated their power to defend themselves against attack. These rulers also introduced significant changes in their military organizations and constitutional arrangements that gave significant power to newcomers—Nupe in Oyo and Gun in Otta. In the process, they set in motion conflicts that subsequently played a major role in the political life of their communities. Ultimately, these conflicts precipitated the fall of both kingdoms. The conflict between the *Alaafin* and the *Oyo Mesi* weakened Oyo, which lost its struggle with Dahomey for control of the Egbado region.[17]

## "We Carry Gelede Idahomi": A Western Yoruba Response to Dahomeyan Invasions

In 1830, Dahomey conquered Ijanna, an Egbado town and Oyo stronghold, prompting yet another wave of immigrants to seek refuge in Otta.[18] The Egbado, Awori, and Ekiti refugees received land on the west side of town and established a new ward known as Oruba (which comes from the phrase *Eru Oba,* meaning "the baggage of the king" or "bending one's head in submission"). An Ekiti warrior named Edun Ogunlola migrated from Ikole Ekiti to Otta. He earned the title of *Akogun,* the most senior chief in the Oruba ward, in exchange for his contribution to the town's war efforts. In this case, unlike the arrangement with the Gun settlers, the refugees' leaders' powers were confined to the domain of the Oruba ward (see map 3.4).

The Oruba ward adopted a Gelede masquerade known as Idahomi.[19] As we have seen, accounts of the origins of the Gelede masquerade tradition vary, but they generally date it within or slightly after the era of *Alaafin* Abiodun's reign as the ruler of Oyo. During the height of the Oyo Empire, the kingdom of Ketu lay just beyond the empire's borders, and its capital was an important city along Oyo's trade route to the coast. One account of the beginnings of this masquerade that I have not yet mentioned traces it to an entertainment competition in the capital of Oyo. Whereas an Egungun tradition identifies Abiodun as having organized a

competition in which one of the masquerade chiefs, the *Alagbaa* in this instance, emerged as the victor, a Gelede tradition contends that a Gelede masquerade staged the most elaborate spectacle.[20] Another account makes no mention of Oyo or a competition, but, as we have seen, explains that a Ketu prince created the first Gelede masquerade and used it to defeat his rival for the throne.[21] The assumption that Gelede originated at a single place and moment in time and then spread to other locations overlooks the web of connections that make a single source unlikely. Although the relationship of Oyo masquerade culture to the origin of Gelede is speculative, Oyo's flourishing empire provided the conditions in which Gelede thrived.[22]

Gelede flourished from the third decade of the nineteenth century as a symbol of Egbado and Awori resistance to Dahomey and, perhaps more covertly, to Abeokuta, an Egba state north of Otta that was founded in 1825. Attacks on Egbado communities were inspired in part by the events surrounding the Owiwi war of 1832, which was fought between the Egba of Abeokuta and a combined Ibadan-Ijebu army.[23] The Egbado town of Ijanna became allied with Ijebu, whereas the Egbado towns of Ibara, Ishaga, and Ilewo supported the Egba. The war was fought to a standstill on the banks of the Owiwi River, when both parties ran out of munitions. The Egba, however, were able to obtain fresh supplies from Adele, a former *Oba* of Lagos, then in exile at Badagry. The town of Ishaga, moreover, helped the Egba intercept an Ijebu supply convoy, and the *Ajana* of Otta offered to protect one of the Egba's flanks.[24] With the advantage of a fresh supply of munitions and support from Adele and the *Ajana*, the Egba routed the Ijebu. An Egba *oriki* commemorates this event:

> Excepting *Ajan*[a], of Otta,
> Excepting Adele, of Lagos,
> Abeokuta people befriend no one.[25]

As a result of this war, the Egba gained control of trade routes that opened an outlet for their slaves at Lagos.[26] Seeking to punish those Egbado settlements that had sided with Ibadan and Ijebu against the Egba in the conflict, Egba warriors then plundered several Egbado towns, including Ijanna.

Events following the Owiwi war had major repercussions for the population of Otta and the development of the town's masquerades. In 1833, the Egba began to attack many Egbado towns, turning their attention to Ilaro as well as Ijanna. Local dissidents in Ilaro were unhappy with their ruler, the *Olu*, allegedly because he imposed exorbitant fines and illegally extended his term in office.[27] To address such misbehavior they invited the Egba to intervene in Ilaro's affairs, with the aim of removing the *Olu* from office. However, when the Egba warriors arrived, they indiscriminately killed the inhabitants of Ilaro and plundered the town. Most of the survivors fled to Ijanna, which the Egba then accused of collaborating with

the Ijebu. At the time, the Egbado were still nominally vassals of the *Alaafin* of Oyo. For that reason, the Egba may have believed that Oyo's ally Ibadan had sent a contingent to help the Ijebu and that Ijanna may have supported the contingent.[28] Whatever the truth of the matter, the Egba attacked and destroyed Ijanna, after which many Ijanna and Ilaro refugees sought refuge in Refurefu, another Egbado town.[29] Adele of Lagos, who had helped the Egba obtain munitions during the Owiwi war, later joined company with the Egba forces and attacked the Egbado town of Ilobi in 1836. The Ilobi people, whom some traditions claim originally created Gelede, had previously held off Egba raids. However, they could not fight off the combined attack, and Ilobi was sacked in 1839.[30] Many of the town's survivors fled to Okeodan.[31] Evidence suggests, however, that a significant number of the Egbado people who fled as refugees from Ilaro, Ijanna, and Ilobi also formed a new wave of immigrants to Otta, where, as I have suggested, they established the Oruba quarter and soon introduced an important new masquerade, Gelede Idahomi.

It was a contemporary informant who told me that the name "Oruba" comes from the phrase *Eru Oba*, which as I have mentioned can mean "baggage of the king."[32] In this instance, "baggage" meant the sacrifices offered for the well-being of the community, a practice that was commonplace in both Egungun and Gelede masquerade rituals and in Esu and Ogun *orisha* rituals during this period. These sacrifices may have been placed in calabashes, an important trope in Awori traditions of origin and migration.[33] However, James White provides a slightly different, yet seemingly plausible, name for this quarter. He refers to Oruba as *ile oriba*, which he translates as "the bending of the heads in token of submission." White claims that slaves belonging to the king of Otta inhabited this area.[34] My contemporary informant, however, contends that slaves were no more prominent in Oruba than in any other quarter of Otta.[35] In fact, both stories may contain elements of truth. If the "baggage" consisted of sacrifices, those killed may have been slaves who were often sacrificed during communal crises, such as war, in the hope of ensuring a favorable outcome. Furthermore, refugees from the Dahomeyan and Egba wars had settled in the town to escape slavery. Whatever their origins, the people of this ward played an important role in Otta's subsequent resistance to Dahomeyan and Egba aggression, as well as in the history of the town's masquerade practices.[36]

During the late 1830s and early 1840s, tensions continued to mount between Otta and Abeokuta. In addition, Dahomey resumed its military activity in the area. These conflicts culminated in the Otta-Abeokuta war of 1842, in which Dahomey also played a part. Again, although the history of the Gelede masquerade society and of many Gelede masks is unclear, one Gelede mask is linked to a specific moment in the history of Otta and of western Yoruba communities: Gelede Idahomi at Otta dates back to the Otta-Abeokuta war.

Although historians disagree about the immediate causes of the war, much of the evidence points to two factors. The first possible cause was conflict over control of the trade routes passing through Otta, which linked the Egba and beyond to the port of Lagos. The second possible cause related to kidnapping and enslavement, which probably became more frequent in the area with the breakdown of regional security. According to one source, the Ijana chiefs had become wealthy from their position as middlemen in the growing commerce in slaves and other goods between the interior and the coast. Efforts on their part to tighten their control over trade provoked charges of kidnapping, enslavement, and price fixing from Egba traders trying to make their way to Lagos. Egba authorities claimed that the abuses of the Ijana chiefs made the journey to the coast unsafe.[37] From this perspective, the Owu war and the Otta-Abeokuta war had similar catalysts—kidnapping and enslavement—except that the victims were Oyo traders in the former case and Egba traders in the latter.[38]

The Otta historian Dada Agunwa believes that another spark ignited the war. He claims that when Adele, as *Oba* of Lagos from 1835 to 1837, sent messengers on an errand to Abeokuta, Otta people kidnapped them and held them hostage, unbeknownst to the town's *Oba*, Elewi. According to Agunwa, Adele informed Elewi that Lagos would attack his town unless the hostages were released, and Elewi replied that he would settle the matter. The king then sent for an Ifa priest and consulted the oracle. However, after performing the divination and receiving instructions to make sacrifices, the Otta people who were there cursed the Ifa priest and refused to make the offerings, common tropes that signal impending disaster when recounted in historical narratives. Adele then conspired with the Egba to attack Otta. Agunwa argues that the kidnapping of Adele's messengers and subsequent rejection of the sacrifices ordered by Ifa were the catalysts that started the war between the Egba and Otta.[39]

Agunwa also posits that, before the outbreak of war, some of the Otta people had been kidnapping not only foreigners but also local inhabitants, which fueled dissension and made the town more vulnerable to attack. He reports that one of the inhabitants of the town kidnapped the child of a *Balogun* of Otta and sent the child to Aguda.[40] The story also refers to kidnappings, greed, and Ifa, tropes of impending disaster that figure in other accounts.[41] According to a tradition recounted by Agunwa, however, the kidnapper then betrayed Otta to the Egba. He drank some palm wine and, after becoming intoxicated, revealed to the Egba how best to attack the town.[42] The drinking of palm wine is a common theme in Yoruba oral traditions. Its appearance in this account suggests a fusion of moral reflections on the past and the events that actually occurred.

Agiri claims, to the contrary, that the greed of the *Ajana*, the head of the Ijana chiefs, provoked the war. He argues that in 1841 the *Ajana* overcharged Egba traders for safeguarding the trade routes through Otta. According to this version of

the story, the Egba then sent an army led by Lumloye, the Otun chief of the Egba, to attack Otta, igniting the Otta-Abeokuta war.[43]

Whether it was greed or the kidnapping of Egba traders, Lagos messengers, or Awori children that sparked the war, most traditions agree that once the battle erupted Prince Kosoko of Lagos, whose mother was from Otta, called on Ibadan to assist in defending the town against the Egba. With the help of its allies, Otta was able to hold off the Egba onslaught. According to the Yoruba missionary and historian Samuel Johnson, "the Ottas were known to be an obstinate people, and in the defense of their homes every man amongst them was a hero!" The Egba fled the town, and Otta won the battle.[44] In Otta, this interpretation has emerged as the official history of the war; indeed, many popular oral traditions in the town regarding its valiant defense against the Egba and Dahomey refer to this battle.

A contemporary Otta historian, Salako, contends that Dahomey fought on the side of the Egba during the Egba-Otta war. According to his account, the Egba approached through the Ijana ward, while Dahomey approached through the Oruba ward. According to Salako, the Otta people had devised a strategy for defending their town against these enemies: the adult men hid from the invading armies as they approached. When the Egba and Dahomeyan warriors arrived in Otta, they found the women of the town roaming around as if the men had abandoned the place. The invaders lustily approached the women. The women quickly removed U-shaped picks (*ponpodo*) and ear-cleaning pins (*ikoti*) from their clothing and used them to gouge out the eyes of their invaders. Almost simultaneously, the men of Otta, led by a warrior named Iganmode, appeared and used their cutlasses (*ele* in Awori dialect) to fight the surprised invading armies. In describing this event, Salako cites arguably the most popular verse of Otta's *oriki*, which served as the town's anthem and in which appear several common tropes—a warrior, Otta's enemies, and tools of warfare:

> *Iganmode*
> *Af' eleja,*
> *Afi' koti yoju Egba,*
> *Afi ponpodo yoju Ketu.*

> A bundle of soldiers
> Who fight with a cutlass
> Who use an ear-cleaning needle to remove the eyes of the Egba
> Who use a U-shaped pin to remove the eyes of the Ketu.[45]

If the actions of the women are interpreted literally as a military strategy, then a single warrior or a group of warriors from Otta targeted the eyes of their enemies. If taken more metaphorically, the reference to "removing the eyes" could refer to the Otta people's attempt to counter the violence they experienced by

inflicting violence of some kind on their enemies. Although Salako identifies Dahomey as the invading force, he cites a tradition that names Ketu as the invaders. Another source, discussed later, identifies both Ketu and Dahomey as enemies of Otta.

Despite the popularity of Salako's twenty-first-century rendition, not all stories regarding this battle repeat this theme. The early twentieth-century writer Agunwa claims that the Otta people used the pins and other instruments not in a deliberate plan but as a result of happenstance. Moreover, Agunwa makes no reference to the gender of those who defended the town. According to him, the Egba army took Otta by surprise, and the only weapons the inhabitants of the town had available to defend themselves were needle- and U-shaped pins and ear-cleaning needles. Under the circumstances, the people of Otta fought valiantly. From that moment on, the Egba began to refer to the Otta people as the children of Iganmode, "a bundle of soldiers" who fought with needle and pin.[46]

Traditions recounted by several contemporary Otta chiefs, perhaps not surprisingly, support Salako's claim that the Otta people devised a deliberate strategy to protect their town. However, they emphasize the importance of an additional object introduced in another part of the town's *oriki* in enabling the success of the battle. The following lines, which appear in the final stanza, mention a mask, another tool of warfare, often acquired as a war trophy in the nineteenth century:

> Otta, a platoon of soldiers, who use the cutlass to fight
> Who use the iron bud [ear-cleaning needle] to remove the eyes of the Egba
> Who use a two-edged sword to remove the eyes of the Ketu
> Who use the carved mask to remove the eyes of the Idahomi.[47]

According to a twenty-first-century resident of Otta, when Dahomey approached the Oruba quarter, the town elders called a council meeting to develop a defensive strategy.[48] The elders consulted Ifa, as was customary during moments of crisis, and the oracle demanded that they make three sacrifices. The first sacrifice involved an offering at a shrine known as *Oju Otuku*, near Iju, which was then part of or later became incorporated into the Oruba quarter. The second sacrifice was the "*Eru Oba*," or the slave of the king, mentioned earlier.[49] In this case, the king's slave carried sacrifices on behalf of the king to a junction in the town, possibly the site of the *Oju Otuku* shrine. The slave was then buried alive or killed and buried with the sacrificial objects, providing sacred blood believed to be necessary for success in battle.[50] The terms *Eru Oba* ("the king's baggage" or, in this context, "the king's slave/load") and *Ile Oriba* ("bending the head in submission"), from which, as we have seen, the name of the Oruba quarter may derive, most likely refer to this second sacrifice.[51] According to contemporary informants, Ifa also prescribed that a mask be carved to resemble the Dahomeyans, as part of a

third sacrifice. This mask became known as Gelede Idahomi. Traditions recount that the masquerader wearing the Idahomi mask alerted the Otta people to the Dahomeyan army's approach, attempted to remove the enemies' eyes, and terrified enemy soldiers with his violent behavior and grotesque appearance.[52]

Contemporary Otta chiefs offer evidence drawn from Yoruba rituals to support the notion that Gelede Idahomi masqueraders targeted the eyes of Otta's enemies. There was in the past a charm, or *juju*, called *Ogun ifoju* ("medicine that removes the eyes"). A wooden image of an adversary was carved, as the Gelede Idahomi mask exemplifies. Incantations that included *oriki* were recited over the charm, and the eyes of the image were pierced. It was believed that at that moment or shortly thereafter the eyes of the actual enemy would go blind. The *Ogun ifoju* was generally used at war camps.[53] However, during the Egba-Otta war, this charm may have been used in Otta as the Dahomeyan army approached, according to the memories of some of Otta's current residents.

Might the scars and boils carved on the mask have afflicted the adversary via the same process as that which occurred during the enactment of the *Ogun ifoju*? The tradition assumes that the approaching Dahomeyan army was familiar with such medicines, felt alarmed, and perceived the need to bring its own *juju*.[54] The mask reflected the workings of a people, the inhabitants of Otta, who were renowned for their medicine and witchcraft.

Salako's account of the war relates that the Dahomeyans were attacked and defeated in the Oruba quarter, while the Egba suffered the same fate in the Ijana quarter. The people of Otta even sang a song to commemorate their victory over the Egba:

The Egba are running away
Wait for me, let me put on my trousers
The Egba are running away.[55]

However, as all but the contemporary accounts make clear, Otta's success was short-lived. The Egba soon returned with reinforcements, and Ado, Ibadan, and Prince Kosoko of Lagos offered to help the town. According to Johnson, however, the Egba inflicted severe retribution on the Otta people, attacking caravans that supplied the Ibadan troops and quickly surrounding the town before its allies could arrive. The people of Otta kept the Egba army at bay temporarily, but the Egba warriors persisted, nearly starving their Otta counterparts, who had no access to provisions, before staging a final attack during which they razed the town's walls and nearly destroyed it.[56]

Three factors converged at Otta to produce the emergence of Gelede Idahomi there. For the Egbado refugees who had settled in the Oruba ward, Dahomey's attack marked an opportunity to unite with the other wards in an effort to end a decade of extreme violence. For the Gelede devotees among them, the creation of

the new Idahomi mask represented a final attempt to defeat their enemies, solid-
ify their place within the town, and establish Gelede as a budding masquerade
tradition within their community. Moreover, for the men and women who de-
fended the town, the role played by Gelede Idahomi among other elements of
town resistance reflected the gendered politics of both warfare and the town's
identity and was one of the many ways in which men and women worked together
to defend their communities. It surely reinforced, and may have helped give birth
to, Otta's reputation as a community inhabited by powerful women. Whereas
women were not expected to fight in battle, the establishment of Gelede Idahomi
showed that the women of Otta departed from that tradition and asserted them-
selves in war, generally the domain of men. Finally, in the sectional political
conflicts that pitted the Ijana ward against the Otun and Osi wards, the mask's
emergence fostered solidarity against common enemies.

The emergence of traditions linking the Gelede Idahomi masquerade to a
Dahomeyan invasion of Otta may have been in response to the two experiences
of Dahomeyan invasion: that of the initial invasion of the Egbado and the later
combined invasion of the Egbado and the Awori. After the Egba established them-
selves as the predominant power in the Egbado-Awori region, it is likely that
they, too, would have supported the creation of a Gelede mask made to attack and
ridicule Dahomey. Such a hypothesis would explain the prominence of this mask
in Egbado and Awori areas from the middle of the nineteenth century until today
and the absence of popular traditions regarding an equivalent Gelede Egba mask.
Taking this hypothesis even further, I believe that the emergence of this mask
unified the Egbado and Awori people not only against the Dahomeyan threat but
also against the Egba, who were thought to have aided Dahomey in its attack on
Otta. Yet, after their friendship with Dahomey ended in the mid-1840s, the Egba
also were poised to adopt the Gelede mask.

Although contemporary inhabitants of Otta identify the Gelede Idahomi fig-
ure with the history and memory of Otta's defense against a Dahomeyan inva-
sion, it is also possible, or perhaps likely, that the Idahomi association with the
Dahomeyan invasions first surfaced or simultaneously surfaced within the Egun-
gun masquerade tradition during that period.[57] An Egungun named Idahomi
appears today in Otta's Egungun festivals, as I observed in 2005 (see figure 3.1).

The behavior and appearance of Egungun Idahomi today reportedly parallel
the behavior and appearance of the modern Gelede Idahomi. These parallels sug-
gest that the Idahomi figures share similar origins in the respective Egbado and
Awori responses to and memories of Dahomeyan invasions of many western
Yoruba towns and kingdoms. Based on her observations of Egungun Idahomi
performers in Egbado communities during the 1980s, the performance theorist
Margaret Thompson Drewal describes the Egungun Idahomi as ugly but not very
threatening and limited in its interaction with an audience of observers.[58] The

Fig. 3.1. A contemporary image of Egungun Idahomi appears on the wall of an Egungun shrine in Ijana ward. The black spots over the arms and legs and the black circles on the attire of the figure depict boils or sores all over the body of a Dahomeyan warrior. The message is clear: attack Otta and be cursed with boils. Photograph by author, May 4, 2005.

situation was a bit different at Otta two decades later. One Egungun Idahomi performer I observed moved about a large crowd of observers, violently swinging an approximately one-meter stick in a threatening manner at children in the crowd. According to a senior Gelede chief, the performer of the Gelede Idahomi masquerade had been banned in Otta for some time because of what the chief suggests was its even more violent behavior (see figure 3.2).[59] Evidence derived from ethnographic sources suggests that the violence manifested in the performance of the Egungun and Gelede Idahomis mimicked nineteenth-century Dahomeyan warriors, reflecting an attribute of some Egungun masquerades, rather than an attribute of Gelede.

The historical record and contemporary memories of the physical appearance of the Gelede Idahomi contain elements suggesting its role in battle. The Gelede Idahomi mask was carved to look like a Dahomeyan warrior, with scars and boils carved and painted on the face of the mask and over the body of the masker. Contemporary Gelede Idahomi and Egungun Idahomi masks from Otta, Abeokuta, Ilaro, and Iganna often feature amulets on top of the headpiece (see figure 3.2). The presence of scars, boils, and amulets on the Idahomi masks at Otta reminded audiences visually of the dangers that warriors experienced in battle

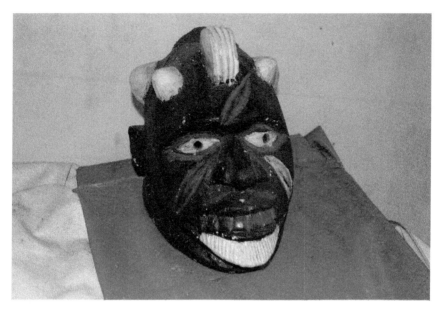

Fig. 3.2. A contemporary Gelede Idahomi mask, in the possession of Chief S. A. Olaniyan, the Olori Gelede, Oruba ward. Photograph by author, June 13, 2006.

and of the ritual items (including amulets, charms, and medicines) they placed on and in their attire to offer spiritual protection. Thompson Drewal insightfully identifies the boils with "a condition associated with the malnutrition suffered by warriors stationed in war camps in alien territories during the nineteenth-century Yoruba/Fon wars."[60] However, because of the enduring threat of violence from its neighbors throughout the nineteenth century, the people of Otta remembered the scars, boils, and amulets on the Idahomi mask as a warning of the afflictions that awaited Otta's enemies.

Similarly, the boils may also represent both smallpox and a curse aimed at spiritually weakening Otta's enemies. Egungun masks with facial bumps that allude to smallpox also personify nineteenth-century Dahomeyan warriors.[61] The art historian Robert Farris Thompson draws on the testimony of a senior member of an Egbado Gelede group that emphasizes the significance of smallpox symbolism in Gelede rituals: "Obaluaiye (Lord of smallpox) is the spirit controlling the Gelede cult while Yamisorogun (witches) act as his missives." It is for this reason that the protective influences of both spirits are invoked during the performance of the Gelede rituals.[62]

Thus, rituals involving the performance of the Gelede Idahomi offer practitioners the ability to harness the same "protective influences" of the smallpox

deity and of so-called witches to wage a form of psychological warfare on their enemies. The spiritual element of these "influences" could free the person who wore the Gelede Idahomi mask from having to participate in physical combat.

Henry John Drewal and Margaret Thompson Drewal offer thoughtful commentary on the ways in which performers wearing such masks parody the violence associated with Dahomeyan warriors: "Certain non-Yoruba characters are the subject of a satire in idan performance, especially the Dahomean (idan Dahomi), a nineteenth-century enemy of the Yoruba. Here a devastating, anti-aesthetic treatment makes a mockery of a diseased and wounded warrior with enormous blue boils all over his face and a gash over his left eye . . . the Dahomean performs . . . producing a rather casual threat . . . chasing children as if he were going to axe them."[63]

Juxtaposing evidence from Otta and other communities that practice masquerading, I conclude that the tradition of the Egungun and Gelede Idahomi masquerades reflects memories of Dahomeyan aggression expressed in a satirical manner for didactic and cathartic purposes. I interpret the tradition of Otta warriors using a Gelede Idahomi when fighting the Dahomeyans immediately preceding or during the 1842 war as a later invention. The absence of nineteenth- and early twentieth-century accounts of warriors wearing Gelede Idahomi masks in the large body of evidence pertaining to the war lends support to my hypothesis that the tradition is a more recent invention.

## Egungun and Gelede Masquerades and the Transition from a Mono- to a Multiethnic Community

Egungun masks have taken many forms. During the period of imperial decline, when the Oyo region was in a state of constant warfare, many warriors wore warrior Egungun adorned with charms into battle to give them what they believed would be extraordinary powers, such as invisibility, imperviousness to bullets, and the ability to inflict disease on the enemy. Medicine men often wore Egungun adorned with powerful medicines (which often came from the same source as the charms of warrior Egungun) to help them manipulate weather patterns, eradicate disease, or perform witchcraft for the well-being of the town.[64]

Scholars and practitioners alike refer to Gelede almost exclusively as an entertainment masquerade that uses humor and sometimes ridicule in its treatment of foreigners, particularly Hausa and Europeans. The literature offers considerably less direct and indirect evidence of the involvement of Gelede in violent conflicts such as warfare,[65] although Lawal describes a Gelede ritual known as *itutu ilu* (the ritual pacifier) used to garner spiritual support to obtain victory in warfare.[66] At Otta, Gelede Idahomi performers are not only known as entertainers but they also engage in acts of violence. As stated earlier, its performance was

recently discontinued for an indefinite period of time because of its continued association with violent activities. In addition, Gelede Idahomi's violence links it to Egungun. The use of Egungun to ritualistically and physically purge afflictions from a community was widespread during the nineteenth century. Such wide-ranging tactics, including the use of masks for many purposes, were born out of the era of disorder and warfare that followed the collapse of the Oyo Empire. Politically and militarily vulnerable Egbado and Awori communities drew on the ingenuity and agency of their artisans, ritual specialists, and warriors as they deployed masked fighters to defend their communities.

There is evidence that Egungun were involved in warfare during the nineteenth century. Egungun appeared on the battlefront of the Ibadan army to both entertain the troops and ritualistically prepare them for warfare by using charms and medicines aimed at making them invincible. The Egungun recited the *oriki* of great warriors past and present and invited the hearers to imagine themselves as being invincible to their enemies' attack.[67] It is said that the experience of hearing one's *oriki*, after having just undergone rituals and acquired charms to make one immune to enemy attacks, makes the warrior believe he is invincible and he therefore fights as if he is.[68] Egungun performers were often captured during battle and the masks confiscated by the victor, who returned home with the Egungun of his enemies as a war trophy. The victor would even introduce his newly acquired Egungun as an illustration and extension of his military and spiritual supremacy, which, of course, are intertwined.[69]

Academic discussions of the relationship between Gelede and Egungun often focus on their functional differences. On the one hand, Gelede represents a nonviolent approach to social conflicts. On the other, Egungun represents individual rivalry and a violent approach to social conflicts. But rituals evolved and changed as the people who practiced them needed new modes of expression. As Otta developed from a small town of a single ethnicity to a large multiethnic community with a strong need for defense, both Egungun and Gelede changed to meet the needs of the times.

## Notes

1. J. F. Ade Ajayi, "The Aftermath of the Fall of Old Oyo," in *History of West Africa*, ed. J. F. Ade Ajayi (London: Longman, 1987), 174–214; J. D. Y. Peel, *Religious Encounter and the Making of the Yoruba* (Bloomington: Indiana University Press, 2000), 35–38.

2. Robin Law, "The Gun Communities in the Eighteenth Century" (paper presented at the 34th Annual Meeting of the African Studies Association of the U.S.A., St. Louis, November 23–26, 1991); Law, "A Lagoonside Port on the Eighteenth-Century Slave Coast: The Early History of Badagri," *Canadian Journal of African Studies* 28, no. 1 (1994): 47–52; Kristin Mann, *Slavery and the Birth of an African City: Lagos, 1760–1900* (Bloomington: Indiana University Press, 2007).

3. Salako claims that during the reign of *Oba* Adelu, the *Olota* of Otta from 1794–1821, Dahomey waged war against Otta in retaliation for its barring the passage of slaves from the interior through Otta. However, other sources contend that Otta was involved in the slave trade. Thus, the Dahomeyan invasions of Badagry in 1784 and 1789 and the slave raids it embarked on annually in the region, as well as the emergence of the Ijana ward, all lend support to the claim that Dahomey attacked Otta. R. A. Salako, *Ota: Biography of the Foremost Awori Town* (Otta: Penink Publicity, 2000), 62.

4. James White, December 3, 1855, from journal ending December 25, 1855.

5. Interview with Chief S. A. Matoro, *Onikosi* of Otta, Osi ward, Otta, 2006.

6. The failure of the Otun and Osi chiefs to carry out state executions of people from their own wards reflects a bond cemented by a blood oath that one could not betray.

7. White, December 3, 1855, from journal ending December 25, 1855; emphasis added. Also, it is worth noting that what White refers to as executive power Westerners call judicial power. Much of the literature on African kingdoms makes no distinction between executive and judicial power.

8. Dada Agunwa, *The First Book on Otta: In Memory of King Aina and King Oyelusi Arolagbade* (Otta, 1928).

9. Salako, *Ota*, 90.

10. B. A. Agiri, "Kola in Western Nigeria, 1850–1950: A History of the Cultivation of Cola Nitida in Egba-Owode, Ijebu-Remo, Iwo and Ota Areas" (PhD diss., University of Wisconsin, 1972), 19.

11. Interview with Chief S. A. Asanbe, *Oloponda* of Otta, Itimoko compound, Ijana ward, Otta, 2005; Interview with Oba of Ilogbo, Palace, Ilogbo, Ogun State, 2006.

12. Law, "The Gun Communities in the Eighteenth Century," 17. Oyo was complicit in the attacks on Badagry, in spite of the intense rivalry between factions in Badagry at the time of the Dahomeyan attacks of 1784 and 1789. Also, Law notes that religious life in Badagry was organized on the ward level. In light of the claim that Oyo people brought Egungun to Otta and settled in the Ijana ward, Egungun could have become or continued to have developed as a ward-wide religious practice, involving ancestor worship in particular, during the incorporation of the Gun warriors into the Ijana ward. A counterclaim holds that the Oyo people arrived to find the Awori people in Otta already practicing Egungun and only subsequently allowing an Oyo to become the *Oloponda*, the head of the Egungun priesthood of Otta. Moreover, given intense debates regarding claims to chieftaincy titles, traditions of origin and migration, and the like, it is important to note that the arguments, hypotheses, and claims noted in this book reflect primarily information that I gleaned from local communities and that I could most easily corroborate with archival and other historical evidence. It can be strongly suggestive, but is rarely conclusive.

13. Interview with Chief Abayomi Ojugbele, Otun ward, Otta, 2006; Interview with Chief Wasiu Dada, *Ekiyo* of Otta, Ijesu compound, Ijana ward, Otta, 2006.

14. Interview with Chief Abayomi Ojugbele, Otun ward, Otta, 2006; Interview with Chief Wasiu Dada, *Ekiyo* of Otta, Ijesu compound, Ijana ward, Otta, 2006. This was around the same time that Adele Ajowan, then *Oba* of Lagos, encouraged the introduction of Egungun between 1816 and 1821 at Lagos. Robin Law, "The Career of Adele at Lagos and Badagry, c. 1807–1837," *Journal of the Historical Society of Nigeria* 9, no. 2 (1978): 35–59. The leading chiefs at Lagos, led by Adele's brother Osunlokun, deposed Adele from the Lagos throne. Adele settled at Badagry, where he soon met a contingent of Lagos forces and Dahomey and Porto Novo forces in 1822.

15. Interview with Chief Abayomi Ojugbele, Otun ward, Otta, 2006.

16. Interview with Chief S. A. Asanbe, *Oloponda* of Otta, Itimoko compound, Ijana ward, Otta, 2005.

17. In pre-imperial Oyo, however, Egungun masquerades were embraced to redress the misfortune associated with having previously rejected them. Conversely, in Otta during the era of Oyo imperial decline there are no traditions of Egungun having been embraced by the *Balogun*, the *Ajana*, or the Awori indigenes (from Otun and Osi) to avoid the misfortune associated with having previously abandoned Egungun. Yet this has long been a motivation for introducing or reintroducing an Egungun.

18. Samuel Johnson, *History of the Yoruba: From the Earliest Times to the Beginning of the British Protectorate* (Lagos: C. M. S. Bookshop, 1921), 226–230.

19. For further discussion of Dahomey's and Abeokuta's attacks on Egbado territories, see Kola Folayan, "Egbado to 1832: The Birth of a Dilemma," *Journal of the Historical Society of Nigeria* 4, no. 1 (1967): 15–34; Robin Law, *The Oyo Empire, c. 1600–c. 1836: A West African Imperialism in the Era of the Atlantic Slave Trade* (Oxford: Clarendon, 1977), 276–277. For discussion of the Gelede Idahomi masquerade, see Margaret Thompson Drewal and Henry John Drewal, "More Powerful than Each Other: An Egbado Classification of Egungun," *African Arts* 11, no. 3 (1978): 32–33; Babatunde Lawal, *The Gelede Spectacle: Art, Gender, and Social Harmony in an African Culture* (Seattle: University of Washington Press, 1996), 100.

20. Henry John Drewal and Margaret Thompson Drewal, *Gelede: Art and Female Power among the Yoruba* (Bloomington: Indiana University Press, 1983), 225, 31, 34.

21. Emmanuel D. Babatunde, "The Gelede Masked Dance and Ketu Society: The Role of the Transvestite Masquerade in Placating Powerful Women while Maintaining the Patrilineal Ideology," in *West African Masks and Cultural Systems*, ed. Sidney L. Kasfir (Tervuren: Musee royal de l'Afrique centrale, 1988), 53–54; Lawal, *The Gelede Spectacle*, 68–70.

22. Sidney Littlefield Kasfir, "The Ancestral Masquerade: A Paradigm of Benue Valley Art History," in *Central Nigeria Unmasked Arts of the Benue River Valley*, ed. Marla C. Berns, Richard Fardon, and Sidney Littlefield Kasfir (Los Angeles: Fowler Museum, 2011), 111.

23. S. O. Biobaku, *The Egba and Their Neighbours, 1842–1872* (Oxford: Clarendon, 1957), 18–21.

24. I have to make sense of the *Ajana* action to explain why Otta was first attacked by and then decided to support the Egba.

25. Biobaku, *The Egba and Their Neighbours*, 20.

26. Ibid.

27. Ibid.; Kola Folayan, "Egbado and Yoruba-Aja Power Politics" (MA thesis, University of Ibadan, 1965), 30–49.

28. This comes on the heels of Oyo having lost control of the Egbado region to Dahomey just a few years earlier.

29. Biobaku, *The Egba and Their Neighbours*, 19–21.

30. Nigerian National Archives, Abeokuta, ED 1146/6, J. Hinian Scott, "Otta District Council Chieftaincy Committee Meetings: Minutes of the Meeting Held at Olota's Palace Otta on Wednesday the 10th of April" (1935).

31. Agunwa, *The First Book on Otta*, 70.

32. Interview with Chief Wadudu Deinde, Oruba ward, Otta, 2006. Although *eru* in the more widely spoken Oyo dialect of the Yoruba language translates as "slave," in the Awori dialect spoken in Otta *Eru Oba* refers to the baggage of the king. An alternative interpretation of *eru* as "slave" appears later in this chapter. Personal communication with Gbamidele Ajayi, 2006.

33. Deji Kosebinu, *Alani Oyede: The People's Monarch* (Otta: Bisrak Communications, 2000), 1–5; Salako, *Ota*, 13; Kehinde Faluyi, "The Awori Factor in the History of Lagos," in

*History of the Peoples of Lagos State,* ed. Babatunde Agiri, Ade Adefuye, and Jide Osuntokun (Lagos: Lantern Books, 1987), 222–225.

34. White, December 3, 1855, from journal ending December 25, 1855.

35. Interview with Chief Wadudu Deinde, Oruba ward, Otta, 2006.

36. In my attempts to acquire more information regarding whether slaves comprised a significant percentage of the population of the Oruba quarters, I learned that slaves often married into or were otherwise incorporated into families. Interview with Ojugbele, Jauary 5, 2006. In addition, White mentions a case in which a man sought to have a child with his slave because, in his estimation, his wife was "unable to provide him with a child." White, May 23, 1870, from journal ending September 25, 1870.

37. Nigerian National Archives, Abeokuta, "Otta Affairs: Brief History of Otta" (Abeokuta, 1933).

38. Agunwa, *First Book on Otta,* 70.

39. Ibid.

40. Aguda was either a Brazilian town or a Brazilian-owned plantation.

41. Biobaku claims that the *Ajana*'s greed, reflected in his demanding a high price for friendship and safe passage for Egba traders, caused the war. Biobaku, *Egba and Their Neighbours,* 27. Colonial records, which Biobaku likely consulted, support this idea. Nigerian National Archives, Ibadan, CSO 26/2, 20629, F. C. Royce, "Assessment Report of Otta District, Egba Division, Abeokuta Province" (1927); Nigerian National Archives, Abeokuta, "Otta Affairs"; Nigerian National Archives, Ibadan, Abe. Prof. 4, D33, "Abeokuta Province: A Report on the Otta District, Egba Division" (1936).

42. Agunwa, *First Book on Otta,* 71.

43. Agiri, "Kola in Western Nigeria," 17.

44. Johnson, *History of the Yoruba,* 255–256.

45. Salako, *Ota,* 64.

46. Agunwa, *First Book on Otta,* 72.

47. This *oriki* is written on a plaque hanging in the palace of the present *Olota,* Oyede III.

48. Interview with Chief Wadudu Deinde, Oruba ward, Otta, 2006.

49. Adeboye Babalola and Olugboyega Alaba, *A Dictionary of Yoruba Personal Names* (Lagos: West African Book Publishers, 2003), 320.

50. As Peel (*Religious Encounter*) reminds us, the sacrifice of human beings has and continues to be regarded as the most powerful form of sacrifice to the *orisha.* J. A. Adefila and S. M. Opeola, "Supernatural and Herbal Weapons in 19th Century Yoruba Warfare," in *War and Peace in Yorubaland, 1793–1893,* ed. I. A. Akinjogbin (Ibadan: Heinemann Educational Books [Nigeria], 1998), 221.

51. Babalola defines the term as "the father's head." "Father" in this instance refers to the king, the Father, or Baba of the community. Babalola and Alaba, *A Dictionary of Yoruba Personal Names,* 613.

52. Interview with Chief Wadudu Deinde, Oruba ward, Otta, 2006.

53. O. Olutoye and J. A. Olapade, "Implements and Tactics of War among the Yoruba," in *War and Peace in Yorubaland, 1793–1893,* ed. Adeagbo Akinjogbin (Ibadan: Heinemann Educational Books [Nigeria], 1998), 209.

54. Edna G. Bay, *Asen, Ancestors, and Vodun: Tracing Change in African Art* (Urbana: University of Illinois Press, 2008).

55. Interview with Chief S. A. Asanbe, *Oloponda* of Otta, Itimoko compound, Ijana ward, Otta, 2005.

56. Johnson, *History of the Yoruba,* 255–256; Biobaku, *The Egba and Their Neighbours,* 27.

57. Margaret Thompson Drewal, *Yoruba Ritual: Performers, Play, Agency* (Bloomington: Indiana University Press, 1992), 100.

58. Ibid.

59. I am curious as to why it was the Gelede Idahomi masquerader, not the Egungun Idahomi masquerader, whom authorities banned at Otta. Asiwaju and Lawal claim that the Efe performances, which belong to the Gelede tradition, provided a space in which the Yoruba could protest against and ridicule the colonial government. Even more pervasive are references to Egungun masquerades that authorities in different towns banned because of the violent behavior associated with these performers. A. I. Asiwaju, "Gelede Songs as Sources of Western Yoruba History," in *Yoruba Oral Tradition: Poetry in Music, Dance, and Drama*, ed. Wande Abimbola (Ile-Ife: Department of African Languages and Literature, University of Ife, 1975), 200–204; Lawal, *The Gelede Spectacle*, 273; Interview with Salawu Abioru Olaniyan, *Olori* of Gelede in Otta, Oruba ward, Otta, 2006.

60. Drewal, *Yoruba Ritual*, 100.

61. Suzanne P Blier, *African Vodun: Art, Psychology, and Power* (Chicago: University of Chicago Press, 1995), 6.

62. Robert Farris Thompson, *Black Gods and Kings: Yoruba Art at UCLA* (Bloomington: Indiana University Press, 1976), chapter 14/2.

63. Drewal and Drewal, "More Powerful than Each Other," 35.

64. Interview with Prince Kunle Andrew, Otun ward, Otta, 2005.

65. Asiwaju, "Gelede Songs as Sources of Western Yoruba History," 200–204.

66. Lawal, *The Gelede Spectacle*, 93–94.

67. Joel Adedeji, "The Alarinjo Theatre: The Study of a Yoruba Theatrical Art from Its Earliest Beginnings to the Present Times" (PhD diss., University of Ibadan, 1969), chapter 4; Bolanle Awe, "Praise Poems as Historical Data: The Example of the Yoruba Oriki," *Africa* 44, no. 4 (1974): 347.

68. Adeagbo Akinjogbin, ed., *War and Peace in Yorubaland, 1793–1893* (Ibadan: Heinemann Educational Books [Nigeria], 1998).

69. Karin Barber, *I Could Speak until Tomorrow: Oriki, Women and the Past in a Yoruba Town* (Washington, DC: Smithsonian Institution Press, 1991), 204.

# 4 "A Thing to Govern the Town"

*Gendered Masquerades and the Politics of the Chiefs and the Monarchy in the Rebuilding of a Town, 1848–1859*

In 1842, ABEOKUTA attacked Otta, destroying its walls and its military forces and killing or enslaving many of its inhabitants while forcing the rest to seek refuge in, among other places, a neighboring port town known as the Awori kingdom of Lagos. The Egba chiefs of Abeokuta claimed dominion over Otta by right of conquest and then placed it under the administration of a group of Egba chiefs residing in the Igbein ward of Abeokuta. After the leaders of Abeokuta restored the monarchy in Otta in 1848, the town was gradually resettled over the course of the next decade. But Otta was polarized by competing factions—those who supported the monarchy (royals) and those who wanted to overthrow it (warriors). The former enacted Gelede masquerades depicting local elites and introduced a deadly new Egungun masquerade. The latter group mobilized Egungun warrior and Oloru night masquerades. Confrontations between the factions repeatedly drove residents, fearing an outbreak of civil war, from the town. The monarchy and its supporters ultimately won this contest in 1858 with the help of the British consul in nearby Lagos to the south, Abeokuta's leaders from the north, and Christian missionaries. Thereafter—from 1859 until the formal establishment of colonial rule throughout the region in the 1890s—Otta was a battleground for a new confrontation between the British at Lagos and the Egba at Abeokuta.

James White, the missionary of Yoruba descent discussed in earlier chapters, came to the St. James Anglican mission (see figure 4.1) in Otta on December 13, 1854. He understood early on that the local leaders were not enthusiastic about his efforts to nurture a Christian community in Otta; map 4.1 shows the distance of the mission from the center of town where its leaders made decisions, reflecting the ambivalence of Otta's leaders toward his work in the town. He wrote of his experience in journal entries, reports, and letters for other missionaries in West Africa and their patrons in London, the headquarters of the Church Mission Society (CMS) that employed him. Exposing his bias, White suggests that the male organizers and performers of masquerades made it difficult for him to recruit

Fig. 4.1. St. James Anglican Church was the second two-story building in Nigeria built by European missionaries in 1842 on the southeastern end of Otta's Osi ward; the first was built the same year in Badagry. The European missionary William Marsh worked here from 1852 to 1854. James White replaced Marsh and lived and worked here for twenty-five years. Photograph by author, July 30, 2003.

women and children to Christianity. As his frustration grew, he increasingly presents himself and the people of Otta as exploited by the town's leaders.

White offers vivid accounts of the Otta community's struggle to assert its autonomy while facing threats of violence from Abeokuta and the Fon kingdom of Dahomey. His writings also include some of the earliest and most detailed descriptions of masquerade associations, which enacted a range of spectacles, some entertaining and some violent. He offers an eyewitness account of Gelede public festival enactments of pageantry; they featured masked competitors portraying women with elaborately styled hair, as well as Muslim and elderly men and those representing Otta's administrative areas or wards. White also narrates episodes in which a secret political order of men bound by ritual oaths to a deity known as Oloru led a coup against the monarchy. In this chapter, I use White's accounts of masquerade performances (and accounts left by unnamed colonial writers) to identify events that reflect critical stages in the process of Otta's development as

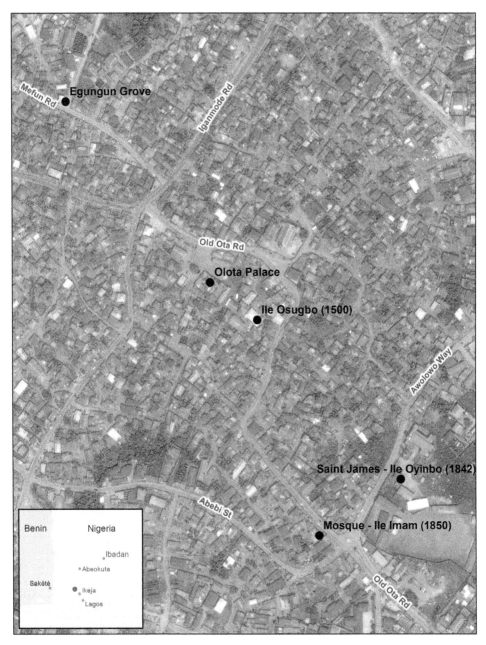

Map 4.1. This map of Otta using a contemporary aerial image identifies important historical points of interest in the town. The CMS mission was located on the far southeast edge of the town in the middle of the nineteenth century. The mission's distance from the three palaces in the center of town reflects the wishes of Otta's rulers to position the mission on the margins of Otta's political and religious life and decision-making processes.

an Awori town. White was the only person we know of who offered eyewitness accounts of Otta's resettlement, but given his position as a missionary, a reader cannot expect his reports to be objective.

This chapter offers a novel approach to the study of nineteenth-century missionary narratives by juxtaposing White's narrative with oral narratives shared by twentieth- and twenty-first-century masquerade chiefs and performers about the creation, achievements, and transformation of specific Egungun masquerade figures. In this context, work by the performance theorist and Yoruba ritual specialist Margaret Thompson Drewal, on whose analysis I have drawn in earlier chapters, is useful for defining performance as related to Egungun enactments. Thompson Drewal characterizes performance, in its broadest sense, as the praxis of everyday social life. It involves applying embodied skill and knowledge to a social or political action and in that way informs the process of producing knowledge about culture. Performance, she writes, "might include anything from individual agents' negotiations of everyday life, to the stories people tell each other, popular entertainments, political oratory, guerilla warfare, to bounded events such as theater, ritual, festivals, parades, and more."[1] In the context of the Egungun, Gelede, and Oloru masquerades, performance represents the ways in which masqueraders and observers dress, speak, and move to invoke, placate, mimic, or embody otherworldly forces that have the power to bless or to curse, nurture, or destroy a community. Through performance, performers identify precedents in myths and enact, improvise, and comment on them, in the process shaping social, political, and material relations.

In drawing on White's accounts of his daily work as an evangelist and his reports of events as narrated by individuals he encountered, I treat these accounts as performances themselves: their narrative conventions and modes of address reflect a prescribed set of actions and thoughts deemed appropriate for CMS missionaries, White's intended audience. I further contend that missionary narratives constitute performances akin to the utterances and actions of the masqueraders, singers, dancers, and other ritual performers, as well as of the chiefs, observers, and practitioners I observed during my ethnographic research in Otta and other Yoruba towns. I use performance as an overarching framework to bring these sources into conversation with one another. This approach to the analysis of written and oral sources yields a more complete picture of the history and practice of masquerades at Otta than is available elsewhere or than each alone can offer.

## A Warlord's Ambitions: Egungun and the Politics of Repression, 1848–1853

### Egba and the Ajana in Otta after the Otta-Abeokuta War

After the Otta-Abeokuta war of 1842, Olukori, the king or *Olota* of Otta, died either during the siege or in captivity at Abeokuta, leaving behind his son,

Prince Oyede, as heir to the kingship.[2] While in captivity, which must have been an emasculating experience for the prince, Oyede somehow sent word to *Oba* Kosoko of Lagos, whose mother was from Otta, that he had been captured. Oyede pleaded with Kosoko to negotiate a peace between Otta and Abeokuta that would allow the Otta people to return to and rebuild their town. Kosoko agreed, petitioning the rulers of Abeokuta on his kinfolk's behalf. Abeokuta's officials responded by demanding that Kosoko pay a substantial sum before sanctioning the resettlement of the town in 1847.[3] Even after the peace agreement was negotiated, Otta's history was characterized by its efforts to resist Abeokuta's hegemony, and the town has challenged Abeokuta's right of conquest up to the present day. Thus, having to live under Abeokuta's thumb has had enduringly emasculating effects on the residents of the town, its Awori leaders in particular.

Between 1842 and 1848, with Otta's prince in captivity, the *Ajana* assumed unprecedented power for an Otta chief. The Egba chiefs of Abeokuta, recognizing his power, sent one of their members to Otta to live in the *Ajana*'s ward. While this Egba chief in residence did not rule directly, records from the period make it clear that he oversaw the administration of the town's affairs. On the one hand, the *Ajana* could have perceived the installation of a foreign official in his ward as a serious check on his own authority and as a threat to his status as the town's regent, effective leader, and patriarch or "big man." On the other hand, the Egba chief's presence may actually have furthered his ward's status as the seat of power in the town in this period. It also offered the *Ajana* the opportunity to build on the reputation that he had established as a loyal friend of Abeokuta's leaders by aiding them in the Owiwi war of 1832.[4]

The conditions of resettlement, however, significantly challenged the *Ajana*'s ability to fulfill his primary roles of protecting and policing the town. One of Abeokuta's conditions banned Otta's military from protecting the town, allowing it to operate only at the Egbas' request. This condition robbed the Ijana ward of its most critical resource and component of its identity: its warriors and their function as the defenders of the town. It left the town perpetually vulnerable to attack in an environment of recurring warfare. Abeokuta and Dahomey, the warrior states most responsible for destabilizing the Egbado and Awori communities, frequently threatened Otta. From the 1840s to the 1860s, these states conducted raids in the Otta vicinity, causing Otta's inhabitants repeatedly to flee their undefended homeland.[5]

To create some semblance of order in these conditions, the *Ajana* struggled to garner sufficient resources to attract and maintain followers and to protect them from rivals. To these ends, he mobilized a powerful warrior Egungun to entertain the town's newest guests and allies, the British colonists and British-trained missionaries.

Attempting to understand Otta's local politics in troubled times, White relied heavily on his early converts for information. One informant was Abraham Ajaka, a relative of the monarch, who frequently explained to White the origins of the conflicts among Otta's leaders. Ajaka referred to Otta's leaders only as the "chiefs selected from the four divisions [or wards] of the town."[6] This commentary supports the idea that all the chiefs were equally complicit in the instability of the time, which may explain why White almost never mentions the *Ajana* in his narrative.

Yet documents from the Egba Archives characterize the *Ajana* as having ruled with an iron fist during this era.[7] Moreover, they associate him with extreme violence. British colonial officials writing between the 1920s and the 1940s offer yet another perspective on the *Ajana*'s reign. These officials recount narratives told to them by informants from Abeokuta and Otta who were born in the mid- to late nineteenth century.[8] It is unclear how the distance of time from the events that followed the *Ajana*'s reign might have influenced their perspective. Developments between the 1850s and the 1940s may have elevated the status of the *Ajana* and his role in Otta's history. The function of the *Ajana* in mustering the aid Otta provided during Egba military campaigns, such as the Owiwi war, and in representing Otta interests to foreign powers such as the British, may have elevated his importance from the Egbas' perspective.

Otta historians, writing during the colonial and postcolonial periods and narrating oral histories, offer a less critical perspective on the *Ajana* than do British colonial sources.[9] Writing from the 1920s to the 1940s, Dada Agunwa identifies the *Ajana* as having aided the Egba only during the Owiwi war and then no longer mentions him, even as he then addresses several important issues in Otta's history. Agunwa ultimately praises the British for intervening in Otta's affairs.[10] Twenty-first-century historians such as Deji Kosebinu, R. A. Salako, and Wasiu Dada, in both written and oral texts, seem far more reluctant to discuss the details of the *Ajana*'s reign along with other turbulent episodes that occurred in the nineteenth century. They do, however, identify the *Ajana* as having been so "troublesome" that his conduct had to be regulated, yet they stop short of making him a scapegoat.[11]

Twentieth- and twenty-first-century sources, taken as a whole, provide evidence supporting the history of nineteenth-century Otta that I present here. They offer a series of vignettes from which to reconstruct the the period between 1848 and 1859 in general and the relationship between the *Ajana* and Egungun in particular. Any evaluation of the *Ajana* must consider the extent to which the terms of resettlement may have made it difficult for him to maintain stability in the town. The evidence suggests that at least initially he had the support of the Egba chiefs.[12] In fact, an Egba faction may even have felt some loyalty to the *Ajana* because the holder of that office in the early 1830s provided the abovementioned

aid that helped the Egba win the Owiwi war of 1832.[13] As discussed in chapter 3, an Egba song commemorating the *Ajana*'s contribution to the victory, has survived long beyond that moment, despite recurring conflicts between the people of Otta and the Egba of Abeokuta.[14]

Either the same or another contingent among the Egba felt that the *Ajana*, having become Otta's premier warrior and chief second only to its king, was best equipped to impose order and promote Egba interests. I contend that an Egungun masquerade was a particularly useful resource in the *Ajana*'s quest to secure the town, establish order, and pursue his personal ambitions. What follows is an analysis of the *Ajana*'s use of two masquerades against the backdrop of the political conflicts that erupted in this period. This approach shows the conditions under which these Egungun masquerades reflected alternative models of masculine dominance. It also illustrates the events that nurtured the development of the town's and its wards' and leaders' identities.

## The *Ajana's Use of Egungun*

As noted in the previous chapter, Gbodogbodo, a warrior Egungun masquerade involved in warfare and law enforcement, came to prominence during a time when Otta was struggling to adapt to both external and internal threats. These included Dahomey's military raids from the west and struggles within the town itself over law enforcement. The members and allies of the Egungun priesthood or organization were poised to assert even greater power and authority than they had in the previous eras of Oyo imperialism and decline. The *Ajana* likely found that having control over a prestigious Gbodogbodo Egungun masquerade was particularly advantageous because he was ruling Otta under the conditions of the peace agreement negotiated with Abeokuta.

The anthropologist J. D. Y. Peel offers a description of Egungun, informed by his extensive knowledge of missionary sources, that conveys the qualities that likely made the masquerade desirable for the *Ajana*. According to Peel, the Egungun priesthood was "a more personalized form of ancestral cult whose form encouraged individual self-promotion and often rowdy rivalry between groups of supporters. It was presumably this potential which made it necessary for Egungun to be headed by a senior chief or high-profile elder. . . . Egungun sometimes adopted a style of provocative confrontation." Peel adds that Egungun's role was to "expose the living to the power of the dead and so to underwrite the community." Missionaries often referred to Egungun masquerades as "a thing which the Yorubas take to govern their town."[15] Peel's commentary suggests that a masquerade could easily be co-opted by an individual seeking to expand his authority. Mobilizing an Egungun masquerade required the engagement of only a small part of the bureaucracy. The writings of missionaries, however, reflect little awareness

of the personas of masquerades controlled by a community's leading big men; attention to such detail was beyond the scope of the missionaries' work and was of little interest to their audience. Fortunately, oral traditions collected during ethnographic research offer extensive commentary on an important aspect that missionaries omitted—the relationship between the reign of particular big men and the identity and behavior of the masquerades that they patronized. An analysis of oral traditions reveals that the *Ajana* benefited as the owner of a masquerade named Gbodogbodo, which was empowered to punish criminals.[16]

The tradition narrated by one of the leading Egungun chiefs in present-day Otta holds that in 1848 the Gbodogbodo (a name associated with the *Baba* or "Father/Superior" of Egungun) became so dominant and abusive that it was banned and exiled to the nearby town of Iyesi, the hometown of the *Ajana*'s mother.[17] The circumstances surrounding its banning are unclear. The *Ajana* may have called his masquerade out too frequently on behalf of himself or others, or the other ward chiefs or a rival masquerade may have campaigned to remove Gbodogbodo (as the "Father") from the town in an effort to promote their own Egungun masquerade. It is also possible that those lacking a masquerade to rival Gbodogbodo may have felt that it was too much of a threat and therefore needed to be banned. Despite ambiguity about the details, oral and written evidence suggests that the Egba (endeavoring to entrench themselves as the *Baba* or "Superiors" among Otta's leaders) were most likely behind the removal of Gbodogbodo.[18]

Following the departure of Gbodogbodo from Otta, the *Ajana* introduced a new Egungun. The *Ajana*'s second son had been struggling to conceive a child with his wife. The young man consulted a diviner of the Ifa oracle about this problem and was directed to create an Egungun masquerade. Following this directive, the *Ajana*'s son inaugurated a new Egungun around 1848.[19] In contrast to the form of hegemonic masculinity embodied by Gbodogbodo (the "Father" of Egungun masquerades), this new Egungun had a more conciliatory masculine persona; it was known as Ajofoyinbo, meaning (as noted earlier), "we dance for the white man or Westerner," perhaps because missionaries began to frequent the town during the *Ajana*'s reign as the regent.[20] In essence, the *Ajana* switched from promoting the Gbodogbodo Egungun that expressed aggression toward outsiders and local people to supporting a new one (Ajofoyinbo) that demonstrated hospitality toward both and was performed by the *Ajana*'s son. The *Ajana* may have interpreted the banning of the older Egungun as a warning and seized the opportunity by promoting another masquerade to appease the newly arrived British foreign power and check the hegemonic Egba of Abeokuta.[21]

The British pressured Abeokuta not only to make peace agreement with Otta but also with the nearby Awori town of Ado, which prevented Abeokuta from destroying Ado.[22] Furthermore, the new Ajofoyinbo Egungun masquerade at

Otta mimicked and honored Europeans in a manner that parallels a practice that the explorer Hugh Clapperton documented in the late 1820s near Oyo.[23] Clapperton offers one of the first portraits of an Ajofoyinbo masquerade that could have mocked as much as it appeased, albeit in a distant town, that predates the *Ajana's* masquerade bearing the same name at Otta. Either way the inference from the Otta case is that the masculine persona of the *Ajana's* version of the Ajofoyinbo masquerade was nonviolent, even if it used satire as another way of reinforcing his dominance by making a spectacle of the town's new European allies.

The *Ajana* must have been aware of the role of the British in negotiating treaties between Ado and Abeokuta (1843) and between Otta and Abeokuta (1847). We can speculate that, by promoting his Ajofoyinbo masquerade, he was responding to a changing political context: the *Ajana*, if only reluctantly, was portraying himself as having appealed to the British to intervene in the Otta-Abeokuta relationship and to prevent the Egba from imposing their authority at Otta.

## Gelede in Otta in the 1850s

### *The Return of the Prince: Gelede and the Politics of Appeasement, 1854*

While the *Ajana* struggled to effectively remake the nature of his authority, Prince Oyede, the heir to the throne and a survivor of the war, remained in captivity at Abeokuta, with his ego and status diminished, until 1854, seven years after the resettlement of Otta.[24] Several factors appear to have delayed his return. According to James White, who began his tenure at Otta shortly after Oyede's return, the prince did not have the money to procure his release from Abeokuta or perform the ceremonies required for his coronation. After the death of his father, the property of the king and his successor, Oyede, had been stolen in their absence.[25]

Political factors also impeded the prince's ability to ascend quickly to the throne. A document dated to 1933 in the National Archives in Ibadan, Nigeria, and titled "Otta Affairs" records that, while in exile, Oyede seriously discredited himself, possibly to the point of shame in the eyes of his subjects, by prostrating himself and rolling on the ground in front of a shrine devoted to Abeokuta's deity Ogun, its *orisha* of war.[26] Furthermore, to avoid execution, the prince was reputed to have uttered the phrase, *"Ori mi di ti Ogun Onigbeyin"* ("I give my head/ swear my allegiance to Ogun Onigbeyin").[27] Oyede's contemporaries would have regarded these acts as heretical, a betrayal of the oaths of his office, and a show of weakness. The local historian Agunwa corroborates much of the account in the "Otta Affairs" sources. Agunwa, however, does not identify Oyede alone with these ignoble events; he recollects that the people of Otta collectively swore an oath to Ogun as part of the terms of the peace agreement with Abeokuta.[28] Agunwa therefore leaves open the possibility that Oyede was not responsible for

the shameful oath of submission to Abeokuta's war deity. In addition, even if Oyede performed acts of submission before an audience of Abeokuta's leading chiefs and ritual authorities, the oath he swore constituted a performance of ritual consent to Ogun—the archetypal warrior and personification of war. If such an oath were broken, the vengeful deity would cause death, war, or some other impediment to a successful reign, according to Yoruba belief.

White reported hearing from one of Oyede's relatives that the chiefs had initially agreed to crown Oyede king. However, the missionary suggests that the prince could not immediately assume the throne because, as noted earlier, he lacked the necessary resources and had spent such a long time in exile, leaving the chiefs to rule in his place. Both circumstances caused him to lose favor with the chiefs and the people of Otta, leading the chiefs to reject him and to organize a coup.[29] In this context, the chiefs could have retrospectively condemned Oyede for swearing the oath or looked for another reason to remove him from power.

As it happened, Abeokuta helped Oyede return to Otta in 1854 with the intention not only of restoring the monarchy but also of limiting the power of the *Ajana*.[30] The events that followed Oyede's release from captivity in Abeokuta demonstrate how new constraints placed on Otta's leaders, based on their abuse of power or inability to perform their prescribed roles, further eroded local autonomy and fueled foreign intervention. When Oyede finally returned, with Egba approval, the prince found the *Ajana* well entrenched as regent and plotting a coup against him.[31] Moreover, three of the chiefs, according to White, committed acts during Oyede's absence that made them state criminals.[32] Two of the chiefs took possession of some of the late king's wives, and a third obtained the late king's crown and sold it. These acts were punishable by death under local law, which mandated that the property and wives of a deceased king pass to his successor. Having committed acts of high treason, the three chiefs feared that Oyede would seek vengeance upon his ascension to the throne.[33] Oyede returned but was not installed as king for five years. The intervening events, which involved two other masquerade groups and which I describe next, illustrate how the town and particularly its leadership asserted themselves in a rapidly changing environment. By backing Oyede, the Egba at Abeokuta and the British at Lagos were attempting to exert greater control over Otta.

The factions that dominated the politics of the town were entrenched when the prince returned, which added a new contingent to the two-party struggle: now either the royals or the warriors needed to win the support of the citizens. A set of Gelede masquerade performances provided the opportunities for the two factions to win the loyalty of their subjects by cultivating a sense of community bound by a shared history. Gelede was a practice shared by the Awori and Egbado peoples, who in turn shared an experience of geographical and political displacement at the hands of the warrior states of Dahomey and Abeokuta.

James White had lived in Otta for only a little longer than two weeks when he witnessed an elaborate Gelede performance on December 31, 1854.[34] It marked a moment of crisis, when the town faced several simultaneous threats. The chiefs and their wards were divided internally, largely over the extent of their support for the *Ajana*. The chiefs were also at odds with Oyede, and they feared that he would retaliate for the crimes they had committed against the monarchy during his exile.[35] Finally, the chiefs and Oyede both confronted a third challenge: they were faced with governing a town that was far more diverse than it had been before the war.[36]

According to White's journal entries, this Gelede performance was a one-day event, although other Gelede performances sometimes lasted nearly a month.[37] White provides a lengthy and illuminating description of the festival, one that suggests that this Gelede was both timely and spectacular:

> The whole force of [Otta's] attention is directed to their public amusement to which the inhabitants of the adjacent towns and villages are invited. In these games, the most superstitious fineries are exhibited. To render the scene attracting and pleasing—they dressed the actors who appear with wooden masks in silk and, which they either borrow of their neighbors after paying a reasonable sum of money or purchased by a subscription of the whole town and which are solely devoted to the public use. Then the sculptors and painters display their skill in endeavoring to present to the public such, in their opinion, elaborate masterpieces of masks intended to delineate as nearly as possible the human features . . . [the following masked figures:] "The woman with plaited hair," "the old man with white hair," and the "Mohammedan with his long beard and head-dress" . . . appear alternately in public and dance as mightily as possible in the center of a large circle formed by a crowd of spectators who join in the music and dances. . . . From the neck to the feet, the actors are covered with a great quantity of clothes. [The Gelede performers] tie iron and brass rings about their legs, which tinkled as they danced along. [The] actor is concealed in his masks and clothes and [although they are punished] severely for not being dexterous enough to prevent disgrace by a fall, yet the people do not as in the case of the Egun[gun] impose on the credulous by identifying the actors with some deceased friends. Nevertheless speaking of the actors, the people say—"this stick is handsomely dressed"—"this stick knows how to dance well." While the game is performing, it is a subject of dispute among the spectators, which actors are more richly adorned and which mask is most excellently done and painted. Their industry at trade, and agriculture is not prompted so much for the sake of satisfying their wants as to be enabled to join in these games. The chiefs take a considerable part in them and not even are they ashamed to appear in public as actors. Any one who is not able to subscribe towards them does not take a part, but is held under disgrace and is even excluded from the society of his respectable companions.[38] [See figures 4.2 and 4.3 for images of contemporary masks that likely resemble masks that White describes.]

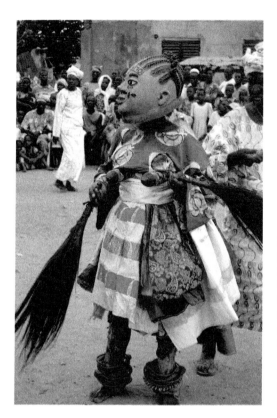

Fig. 4.2. Gelede masquerader
performing in honor of the
recently deceased mother of King
Oyede III, a descendant of Prince
Oyede of the 1850s. This Gelede
figure wears a wooden headdress,
carved in the form of a woman
with plaited hair like the figure in
White's 1854 account. This event
occurred in the market in front of
King Oyede III's palace. Photo-
graph by author, April 7, 2006.

One of the first features to note about this description is White's use of the
habitual present tense, suggesting timelessness rather than a specific moment in
the past. This choice is not surprising: White was new to Otta, and one of his du-
ties as a missionary was to report to his superiors his observations of the customs
of the town and the manners of its people, with a view to eventually supplanting
these traditions with Christian practices.[39] It is likely that this was not White's
first experience of a Gelede performance. He may have witnessed Gelede mas-
querades in Sierra Leone, even some involving people who were originally from
Otta. In this same entry of December 31, he recalls that the Otta people who lived
in Charlotte Village, Sierra Leone, where he was born, had developed a reputa-
tion for being particularly obstinate and strong in their commitment to honor-
ing the *orisha*.[40] Thus, White presents the historically specific Gelede of 1854 in
the tense that allows him to generalize this particular masquerade as represen-
tative of a type; his goal was less to distinguish this Gelede from others than to
note the extent to which elements easily identifiable with "paganism" captured the

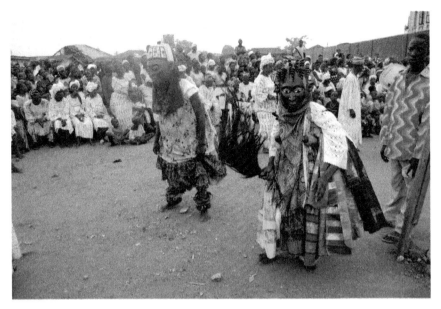

Fig. 4.3. Two Gelede performers wear headdresses depicting a man and a woman. The performer on the left resembles a light-skinned man, possibly of Hausa or Fulani descent, wearing a Muslim man's cap. The performer on the right resembles a woman with a style of plaited hair that is different from that shown in the image in figure 4.2. The headdresses of these performers are similar to the "Mohammedan with his . . . head-dress" and the "woman with plaited hair" in White's 1854 account. This performance honored King Oyede III's deceased mother in front of the king's palace. Photograph by author, April 7, 2006.

interest of the "heathen" populace. Given my claim that this Gelede was histori-cally particular and significant, White's choice of tense and overall representation of the performance as timeless make the task of historicizing it all the more challenging.

Despite these problems, White's description of the event provides a number of clues to its significance. When we consider this account in light of the condi-tions in the town, its importance becomes more apparent. First, this Gelede gal-vanized the "whole town" with the "whole force" of its attention. It also demanded that anyone who could contribute had to do so or face ridicule and ostracism. Moreover, it affirmed Otta's relationship with its immediate neighbors, the adja-cent towns and villages in attendance. White suggests that Otta's economic and social life seemed to revolve around such spectacles. Although this last obser-vation may be an exaggeration, the point stands that in 1854 Gelede created a common purpose and thus built community, appearing to practically demand inclusiveness.

Having endured dislocation and significant personal losses, many refugees and other immigrants from Egbado communities and elsewhere had recently settled in the town, especially in its newest ward, Oruba. These immigrants indeed needed to regain a sense of community, and the Otta chiefs needed to promote unity as they incorporated the newcomers into the town's political, social, and cultural life.[41] Gelede played an important part in both processes.

In addition, the people of the town and the region needed to foster solidarity if they were to defend themselves against external threats, namely Dahomey's and Abeokuta's continuing kidnapping and warfare.[42] Dahomey and Abeokuta had been allies when they attacked Otta during the war of 1842; however, they became bitter rivals in 1843 when Abeokuta attacked Ado, then under Dahomeyan authority.[43] The conflict between Dahomey and Abeokuta dragged on, and in 1851 and 1864 Dahomey attacked Abeokuta. On both occasions, the Egba leaders of Abeokuta summoned men from Otta to join their armies in defending the Egba homeland, which they had a right to do because Otta was a subject kingdom of Abeokuta.[44] On each occasion, the Egba defeated its enemy.[45] However, Otta's support of the Egba against Dahomey did not prevent men from Abeokuta from repeatedly raiding Otta's farms and disrupting the town's trade. Meanwhile, the king of Dahomey periodically threatened to attack Otta itself for fighting alongside Abeokuta. Attacks or rumors of attacks by Dahomey or Abeokuta sent the women and children of Otta fleeing repeatedly to nearby towns. Although some of Otta's inhabitants returned when tensions subsided, others settled permanently in neighboring communities, including Lagos, where the British had recently established a presence and were developing a reputation for interfering in Yoruba politics.[46]

In 1851, a dispute over the throne in Lagos between two claimants, Kosoko and Akitoye, and their supporters provided an opportunity for the British to intervene in the politics of the coastal kingdom. During this dispute, Kosoko had found an ally in the king of Dahomey because both had rejected anti-slave trade treaties with the British. Meanwhile Akitoye, who was of Egba descent on his mother's side, had a longstanding alliance with Abeokuta. To gain an edge over his rival, Akitoye sought an alliance with the British. He appealed to British naval and consular representatives on the coast to remove Kosoko and reinstate himself as the *Oba*, or king, in exchange for his support of their movement to abolish the slave trade and promote the spread of Christianity. The British agreed, bombarding Kosoko's forces in Lagos, driving him and his followers into exile, and allowing Akitoye to claim the throne.[47]

During the 1850s, Otta struggled to survive, maintaining its tenuous autonomy in part by appealing to the British for help as Akitoye had done. However, for a variety of reasons having mainly to do with their ties to the Egba, the British did not intercede on Otta's behalf.[48] Thus raids, wars, and internal instability contin-

ued to plague Otta. What came to define Otta's identity as a town was its experience of having been emasculated by the Egba. In essence, the Egba took on the role of "Father," albeit an abusive father.

Economic development trends that played out from 1808 to 1867 compounded the challenges facing Otta's leaders. As part of its project to abolish the transatlantic slave trade, which it initiated in 1808, Britain promoted the development of foreign trade in palm produce. The growth of the new palm trade exacerbated tensions between men and women within individual households and throughout communities in the region and in Otta in particular, because of the expanded opportunities to earn income and accumulate wealth it offered women. Palm production had traditionally been regarded as women's work, and so women benefited from the growth of the new trade more than men, who were slower to capitalize on the new market.[49] Thus, at a time when Otta's large-scale slave traders, predominantly men, lost revenue from the decline of the external slave trade, many of the town's women were earning greater incomes than ever through the palm trade. The status and influence that women garnered through the expanding palm trade inspired jealousy and conflict.[50] Meanwhile, Dahomey and Abeokuta periodically imposed tolls, fines, and blockades and waged violent attacks to disrupt trade along routes leading to and from Otta, aggravating the social and economic rivalries between men and women. Thus, the people of Otta needed reassurance that their political, social, and economic needs would be met.

In these uncertain times, the community of Otta looked to Gelede performances to resolve or lessen the impact of multiple crises. Assuming that nineteenth-century Gelede practice was similar to its twentieth-century incarnations, the masquerade provided an opportunity for participants to flaunt, satirize, or ridicule the behavior of anyone residing within the general vicinity of Otta. Even the inhabitants of Abeokuta and Dahomey were possible targets of Gelede.[51] Oyede, the heir apparent to the throne, and the chiefs who had violated norms of behavior, provided ready subjects for Gelede commentary. The tone of Gelede performances in the 1850s, however, appears to have been harmonious and celebratory. Gelede afforded Otta's rulers an opportunity to generate communal goodwill and attract positive attention. An 1854 Gelede enabled them to galvanize support for themselves and promote unity among contentious groups within the town, not only between immigrants and indigenous peoples but also between men and women.

### *"This Is the Way We've Always Done It": Juxtaposing Nineteenth-Century Eyewitness Observations with Twentieth-Century Gelede Scholarship*

Having discussed the 1854 Gelede masquerade in detail, let us examine the practice of Gelede more generally during this era. In addition to White's description

of that Gelede, which he witnessed shortly after his arrival, his journal provides key information about an 1871 Gelede.[52] He describes "a grand play in this town which may be called the Gelede exhibition—the principal amusement of the nation."[53] Given White's designation of the 1871 event as an "amusement," his description of the masquerade's masks, costumes, and other adornments, and his discussion of the town's involvement in the celebration, it is clear that the 1854 event was also a Gelede masquerade performance.[54]

A longer historical view of the history of Gelede at Otta suggests that in the 1850s a critical development in its practice occurred. Gelede originated at Otta as one of many strategies for mobilizing a violent response to attacks by Otta's neighbors. However, by the time White recorded the Gelede performance of 1854, Abeokuta had violently enforced its dominion over the leaders and inhabitants of Otta, who then mobilized Gelede in this context as a nonviolent but satirical performance. Taken together, these accounts indicate that the twentieth-century practice of Gelede has much in common with that of the previous century. It is important to keep in mind that most of the twentieth-century research on the Gelede masquerade tradition has been ethnographic. Yet the equation of Gelede masquerades with nonviolence is not continuous; it is historically contingent and linked to an era in which Dahomey and Abeokuta had crippled if not subjugated the Awori and Egbado, as well as Ketu communities, where Gelede has thrived.

Twentieth-century research on Gelede describes it as an annual masquerade that marked seasonal changes, typically including observances or rituals involving fertility, both agricultural and human.[55] The Yoruba term *gelede* translates as "soothing a woman's private parts."[56] In its attention to fertility, Gelede largely paid homage to women's reproductive capacities. As the translation of the name of the masquerade suggests, such capacities should be viewed warily. Thus, among other things, Gelede both celebrated women's capabilities and sought to placate or appease them.[57]

As I have noted, Gelede performers donned vividly carved and painted wooden masks or headdresses, generally produced by local artisans. Attached to the mask headdress or waist of the wearer were silk and other fabrics. Iron or brass anklets were worn on the feet, making a rattling sound when the performer moved. Together, the headdress, the cloths, and the anklets—which do not fully conceal the wearer—identify a masquerade as Gelede.[58] Modern Gelede performances are also marked by the appearance of masked figures that signify the main actors in the community, both human and spiritual, whose collaboration is necessary for its survival. The human actors typically include, for example, the elites who provide authority and leadership, the women who run the marketplace and sell their wares and produce, and the foreigners or outsiders who bring trade into the town. Gelede also includes masked figures representing less

powerful people in the town, such as mothers, tradeswomen, electricians, porters, drunkards, and prostitutes.[59]

Contemporary Gelede performances cultivate social cohesion among men and women by providing space for community members (men in particular as the masqueraders) to playfully chastise one another (and women) without retribution, instead of allowing tensions to erupt into violence and women then using covert means ("witchcraft") to take a life. The Gelede aesthetic of play rejects open confrontation.[60] Like many public spectacles involving ritual performances, Gelede ultimately serves to foster unity and solidarity, specifically by resolving conflicts through peaceful, playful means.[61] In a shared public space, maskers embodying all ranks of society engage with each other through dance and song, commenting on the behavior of individuals or groups and addressing public issues. Gelede provides an open, fluid forum in which men perform masculinity and femininity and the lowly (as masqueraders) can comment on the more prominent (kings or chiefs) and even chastise or challenge them, albeit in a playful, nonviolent way, as I show next.

Gelede is a two-way dialogue. Women are openly involved in the masquerade, whether as the organizers or patrons of a Gelede masker, as Gelede chiefs, or as observers who offer or withhold applause or critique. In other words, although other masquerades (i.e., Egungun and Oloru) restore order and harmony through punitive methods involving violence, vengeance, and a generally authoritarian manner, Gelede achieves order through methods that lend themselves to peaceful conciliation or appeasement, such as humor, satire, mimicry, and other indirect, gentle, or "soft" styles of conduct.[62]

Twentieth-century Western-trained observers of Gelede have linked this masquerade to conflict resolution. Gelede encourages community members, social deviants in particular, to regard each other as children of the same mother. The spirit at the center of Gelede's propitiation function is known by various names: *Iya Nla* (the great mother), *Iyami* (my mother), and *Iya Osoronga* (the witch mother). The inhabitants of the community collectively appeal to the spirit or principle of motherhood to rid them of the evils that plague them.[63] Compared with Egungun, Gelede allows more room for collective action.

Since, as I assert throughout this book, masquerades have both molded and been molded by their historical contexts, I cannot make definitive statements about the meaning or function of nineteenth-century Gelede in the town of Otta. Nonetheless, twentieth-century Gelede masquerades have been studied extensively, and to the extent that modern Gelede resemble those described in accounts written by White, we can draw plausible inferences about Gelede's influence during an earlier period in Otta's history. The case can be made that the Otta Gelede of 1854 provided a way to address and defuse the social, economic, and political tensions plaguing the town. As a public performance involving worship and

entertainment, it offered the people of the town respite and an opportunity to comment on the world around them. As a masquerade geared toward appeasement, conciliation, and recognition of the diversity of the groups constituting Otta, some of whom had limited power in ordinary circumstances (women, children, youth, immigrants), Gelede offered a medium for celebrating diversity and channeling it toward solidarity. Also, because the chiefs of the various wards participated in Gelede's festivities, they had the opportunity to work together; a spectacular Gelede performance had the potential to redirect the powers and authorities that were competing within the town and channel them into a more harmonious balance of power.

An analysis of a range of historical and contemporary sources suggests that the 1854 Gelede performance that White recorded played a particularly important role in integrating the Egbado immigrants into the town of Otta. Taken together, White's journals, colonial documents, locally published modern histories, and contemporary oral evidence reveal that Egbado people from communities to the west and northwest of Otta arrived in the town in significant numbers between the 1830s and 1850s, settling in the Oruba ward.[64] Several sources claim that the Oruba ward was the center of Gelede activity in the town since the 1840s, although other wards embraced the masquerade as well.[65] One local tradition in Otta claims that the Egbado immigrants introduced Gelede and created the Gelede Idahomi mask to aid in the town's defense against Dahomey in 1842.[66] This tradition is consistent with twentieth-century ethnographic research finding that Gelede (as suggested previously by a highly plausible account based on early records) originated as a Ketu tradition that then spread among the Egbado, who in turn introduced it to the people of Otta in the first half of the nineteenth century.[67] In addition, according to one chief whom White repeatedly engaged in dialogue, Otta had by 1855 become comprised primarily of "strangers," and these outsiders or people of non-Awori descent had customs and laws that differed from those of the indigenous inhabitants. In a journal entry dated June 7, 1855, White records that the chief told him that these strangers were difficult to control without a king on the throne, which we may interpret as implying that they did not conform to Awori norms.[68] Gelede, a Ketu masquerade tradition repackaged as an Egbado practice, could easily have been interpreted as foreign. White's references to the 1854 Gelede event as consuming the public attention and economic resources of the inhabitants—particularly the chiefs—of Otta and adjacent towns, alongside oral evidence marking the introduction of Gelede only a decade prior, suggest that this masquerade tradition was seminal in incorporating strangers—Oyo, Gun, and Egbado in particular—into the life of the town.[69]

The *oriki* of Otta refers to the people of the town collectively as those who "used a Gelede mask to remove the eyes of the Dahomeyan warriors," commemorating an important episode in Otta's history that I discussed earlier in this

book. This *oriki* indicates that at some point Gelede became part of the collective consciousness of the town.[70] Although White neither mentions the town's *oriki* nor refers to the role of Gelede Idahomi in defending Otta against Dahomey, and while the 1854 Gelede was not referenced in the colonial sources, the theme that connects White's accounts to the *oriki* and their associated *itan* (historical narratives) is that Gelede fostered unity within the town, particularly vis-à-vis a common antagonist. We can deduce that the Gelede performance of 1854 was particularly important to the Egbado population based in the Oruba ward. This Gelede masquerade reminded the Egbado and the Awori that they were bound by their resistance to common oppressors—Dahomey and, at times, even Abeokuta.

White's commentary on the reputation of the Egbado people provides yet another lens through which to see the importance of the 1854 Gelede to these relative newcomers to Otta. According to White, the Egbado people generally excelled in the "arts of the Yoruba . . . of which music is a part." He suggests that they manifested their overall artistic brilliance in sculpture, painting, music, and dancing and that many townspeople preferred them over other Yoruba performers.[71] White's reflections on the Egbado suggest that this group's aesthetic sensibilities complemented those of the people of Otta, which included Awori, Oyo, and Gun as well as Egbado. In spite of the Egbados' brilliance, it was the people of Otta who, according to White, were regarded as "superior" among the Yoruba in the area of sacred music.[72] If he was indeed correct, then, based on my own ethnographic research in 2006, I am inclined to conclude that the people of Otta have maintained a reputation as being particularly skilled in the performance of praise songs for Egungun masquerades. Otta's Egungun performances are renowned for including uniquely elaborate Egungun poetry.[73] Thus, public spectacles such as Gelede and Egungun provided opportunities for newcomers and natives to harmonize their talents while forging a new cultural and political identity.

Other elements of the masquerade may have been commonplace for Gelede festivals in this era. Even so, I believe they took on particular significance because of the challenges facing the community at that historical moment. White's account further demonstrates that Gelede promoted the circulation of wealth throughout the community at a time when it was struggling to revive its economy. Supporters of the event provided loans or purchased masks for their neighbors or the community at large. With communal support, sculptors and painters showcased their skills by making masks that vividly portrayed human features. Cloth sellers and tailors either sold or marketed their respective goods and services to performers. In contemporary times, women donate fabric in keeping with Gelede's emphasis on cooperation.[74] White's description of what the masked individuals borrowed for their attire suggests that such a pooling of resources may also have occurred in 1854.

Gelede performances have long mobilized entire communities, as citizens contribute money, services, and other material resources to their staging. In addition, Gelede and other communal festivals were prominent in the town's trade and agricultural cycles. The appearance of the various masked figures further identified the main actors of the community, whose collaboration was critical to its survival: "the woman with plaited hair" (the market woman), "the old man with white hair" (the local male elite), and the "Mohammedan with his long beard and head-dress" (the wealthy Muslim trader).[75] The scale of the 1854 Gelede spectacle at Otta and its occurrence in the face of civil disputes and external menaces that sparked seasonal flights from the town invited locals and visitors to view the town as a safe place in which to settle and do business, instead of as a community fraught with volatile tensions. In addition, the Gelede offered a respite and distraction from the internal strife and threat of external attack that preoccupied the minds of the entire community; it created healing and solidarity and fostered a positive image inside and out of the town.

An evolving set of power struggles between regional players (e.g., Dahomey, Abeokuta, and Lagos), leading men through Egungun, and men and women in changing market conditions was key for Gelede. The 1854 festivities gave voice to the particular predicaments women faced in Otta in the nineteenth century, making it easier to appreciate how these practices set the stage for twenty-first-century ethnographies of Gelede. Historically, women have had greater prominence in Gelede than in Egungun. Whereas conflict regularly drove women and children away from the town for fear of being physically harmed or enslaved, Gelede encouraged women and children to focus on the pleasure they derived from participating as singers and dancers. Similarly, the masquerade would have encouraged male youth to concentrate on the opportunity to perform and draw the community's praise and affection as opposed to focusing on a warrior life and ethos.

A comparison of anthropological and modern studies of Gelede with White's account illustrates how the 1854 Gelede performance helped the town meet the challenges it faced. It offered respite, release, and entertainment. It celebrated diversity, yet channeled difference toward solidarity. It integrated the Egbado people of the Oruba ward into the town's administration. It allied the town with its neighbors and promoted the circulation of wealth among its inhabitants. Finally, it enabled women and children to view Otta as a safe and pleasant place at a time when internal and external threats fueled perceptions of the town as dangerous to its own citizens and when the town's leading men seemed incapable of fulfilling one of their primary roles as men—protecting women, children, and the elderly.

The release of Prince Oyede from captivity, immediately followed by an important Gelede festivity, only delayed the face-off between the chiefs and the monarchy that I discussed in the previous chapter. Although Gelede invited

political actors to enact their political criticism through ritual drama, Gelede's brotherhood and sisterhood of communal solidarity subsequently gave way to another kind of alliance from which the monarch was excluded. In an effort to maintain his stranglehold on power and keep a king from ascending to the throne, the *Ajana* formed an alliance with the other ward chiefs (the *Olukotun*, the *Olukosi*, and the *Akogun*). With the aid of a night masquerade, Oloru, to which all the chiefs swore their loyalty, the *Ajana* then organized a coup against the monarchy that evolved into a civil war in 1857–1858. Nearly three years after the prince returned to Otta, he still had not procured the resources required to be crowned king.

## Oloru and Egungun in Late-1850s Otta

### The Monarchy and the God of the Night, 1857–1858

As the *Ajana* struggled to maintain his dominance within local politics, he and the remaining chiefs united against a common enemy, Oyede. The Egba at Abeokuta and the British at Lagos, in conjunction with the local missionary, supported Oyede in his quest to be crowned king of Otta. The *Ajana*, it appears, could not look to Egungun for assistance in these high-level political machinations. He needed an institution that was more deeply integrated within the town's political apparatus, something that appealed to the collective loyalties of other chiefs and political elites, and he found it in Oloru.

Oloru seems to have occupied a prominent place in Otta's politics in the middle of the nineteenth century.[76] This deity was similar to Oro, the spirit representing the collective male dead among the Egba.[77] As the socially, ritually, and politically sanctioned takers of life and representatives of the male dead, Oloru and Oro were both invoked by Otta's chiefs to punish state criminals, enforce public curfews, and perform communal rituals during moments of crisis. At such times, the deities' devotees drummed unique rhythms or sang songs to alert community members that women, children, and uninitiated men needed immediately to leave public areas and hide from the deity's view; the uninitiated men were like boys among men. A violent expression of hegemonic masculinity was granted to initiated Oloru men. If the deities' devotees captured transgressors, they killed them without exception. White, who as a missionary denied the existence of the Yoruba deities, wrote, "The Oloru is with the Ota, the god of the night in whose hand is lodged the legislative and executive power of the nation and that of life and death. In this light, women and the uninitiated are taught to regard it, but the secret is nothing more than a body of the principal chiefs who occupy the night to transact business." White characterized Otta's Oro as a "borrowed superstition of the Egba" and subordinate to the town's own Oloru.[78]

When the Otun and Osi chiefs transferred executive power to the *Ajana* in the first two decades of the nineteenth century, the Gbodogbodo masquerade

assumed the role of police, judge, and executioner and, for a time, I believe, usurped many of Oloru's responsibilities. After the Gbodogbodo Egungun masquerade was banned, however, the Oloru managed to reclaim much of its former authority.

On the night of January 10, 1857, the Oloru society descended on Oyede's compound to remove some of his supporters, allegedly for poisoning cattle. The use of poisons was strictly forbidden among the people of Otta. Secretly, one of the society's members informed Oyede that Oloru was going to act against him and his supporters. When the Oloru arrived at Oyede's residence, they found a group ready to oppose them. Oyede's supporters began identifying the Oloru members present by name—a taboo and a crime. Women in Otta recognized the volatility of the situation and began fleeing the town with their children for fear that a civil war would erupt.[79]

Shortly thereafter, Oyede arrived at James White's residence with Chief Ogunla, the Egba representative who had accompanied him from Abeokuta in 1854. Oyede entered White's private study and asked what he needed to do to become a Christian.[80] White perceived Oyede's request as a plea for political support; nevertheless, he saw the occasion as an opportunity to make converts and spread the Gospel.[81] As it happened, not only White but also other powerful and influential external actors—the British consul and King Dosumu at Lagos and the Egba officials—all wanted to avoid bloodshed, keep Oyede alive, and maintain the institution of the monarchy in power.[82] These actors all needed a stable government headed by the king to support their diverse interests: Christian conversion, foreign commercial development, and Egba control of the trade routes linking the interior and Lagos.[83] They pressed the Otta chiefs to find a resolution with Oyede that did not involve bloodshed.[84]

Meanwhile, some of Otta's chiefs repeatedly sent messages filled with accusations against the prince to Egba authorities in Abeokuta. The chiefs protested Oyede's role in revealing Oloru secrets and asked that the deity be appeased by the blood of Oyede or his supporters. After much delay, the Egba chiefs sent representatives to Otta on January 27, 1857. After examining the case, the Egba officials fined Oyede two slaves and ten bags of cowries, and his relative and advisor Anoda a lesser amount. They found two Oloru men guilty of murder. One they took to Abeokuta; the other they sentenced to decapitation, and after the executioner performed the execution he fastened the victim's head to a tree for public viewing. To the dismay of the chiefs, the officials supported the immediate installation of Prince Oyede as the king of Otta.

On February 15, the same day on which the Egba authorities proclaimed Oyede as king, the prince's enemies—the *Ajana*, the *Olukotun* (leader of the Otun ward), the *Olukosi* (leader of the Osi ward), and their followers—demonstrated their disapproval and desire for revenge by dispatching Oloru at about 7:00 p.m.

that night. Oloru masqueraders attacked and executed one of Oyede's uncles as well as another prominent man in town. The followers of Oloru then also mounted the decapitated heads of these men on a tree for public viewing. British Consul Campbell and King Dosumu of Lagos admonished the Otta chiefs and the Egba officials to do everything in their power to maintain peace and avert a civil war, imposing fines on the Otta chiefs. On February 23, the Egba deputies, who had traveled to Otta to collect the fines, left Otta for Abeokuta reportedly with one hundred bags of cowries, three male slaves, and approximately eighty sheep.[85] This event suggests that the Egba officials believed that Otta's chiefs violated political norms by attacking Oyede's supporters after it had been decided that his installation was imminent. It even seems that the Egba may have interpreted the behavior of the chiefs as a direct challenge to Abeokuta's authority.

The attempted coup of 1857 ended in a costly victory for Oyede. Several of his loyal supporters died in the conflict, and he himself lost money and slaves. However, he won the right to the kingship and preserved the institution of the monarchy. Ultimately, the chiefs' appeal to Oloru did not bring about the demise of Oyede, in part because Oyede was able to draw on the support of external allies—the Egba, the British consul, and the king of Lagos—that the local chiefs could not. The event foreshadowed a trend in Otta during the second half of the nineteenth century: the curbing of local police (or terrorist) masquerades and their supporters by outsiders, the Egba at Abeokuta and the British at Lagos.

Sometime during the first few months of 1858, Oyede was installed as Otta's *Oba*, reestablishing the monarchy. White does not discuss any details of Oyede's installation, despite his vivid commentary on the circumstances immediately preceding and following the event. Within a year, all of the ward chieftaincies and other leading offices were vacated.[86] It is unclear what happened to the chiefs during the year between Oyede's installation and the time when the vacancies were documented. As the losers in the conflict, they may have left the town, been removed from office, been killed, or died of natural causes.

Shortly after Oyede's coronation, an entirely new regime, embodying another masculine order, assumed office. The positions of *Odota, Onisata, Owoye, Ajana, Olukotun, Olukosi,* and *Akogun,* the latter four of which comprise the head chiefs of Otta's four wards, were all newly filled. White claims that some of the candidates who filled these offices were selected from neighboring towns, where Otta people had taken refuge since the war with Abeokuta. The office of the *Ajana* was now filled by someone selected by Oyede's supporters. Although White did not document what happened to the *Ajana* or the other chiefs, it appears that a new political regime, supported by foreign powers in Lagos and Abeokuta, supplanted the older, more militarized, and autonomous regime.[87] In Otta, for years to come, those seeking to dominate political leadership would need to gain the support of the predominant regional powers—either the Egba, the British, or both.

White does describe the ceremony in which Oyede conferred the title of *Ajana* on its new holder. He wrote that King Oyede poured dust on the head of the candidate, and he then used the leaves of a plant called *osan* to pat the head of the man three times. Next, Oyede placed a kind of "billhook" on the man's head. On completion of these acts, the recipient became the *Ajana* of Otta, the office retaining much of the legal and judicial authority it had exercised before the interregnum. As White emphasizes, "He proclaims the laws and enforces their observance and he executes criminals."[88] However, the *Ajana* could no longer rely on the Egungun Gbodogbodo or Oloru, which had once been so central to the power and authority of this office.

### Egungun Apaje—"Killer of Witches" and Appeaser of "Unseen Powers," 1858–1859

Around the same time that the monarchy was restored, a new Egungun masquerade entered Otta and assumed the role of executioner that had previously been held by the earlier *Ajana*'s Gbodogbodo masquerade. According to tradition, the families of Osorun Eyo and Ekide Bangbopa brought an Egungun named Apaje, meaning "killer of witches," from Oyo.[89] The tradition excludes many of the details surrounding this masquerade's origins at Oyo and emergence at Otta. However, an analysis of the few details known about Apaje, along with an examination of the *oriki* associated with this masquerade's performance and with the families that organized it, reveals that Apaje was shaped by and responded to the changes occurring within Otta's political culture and Egungun practice during the mid-nineteenth century.

Today a portrait of Apaje, identified as Apaje Isorun, on the Egungun shrine pictured in figure 4.4, illustrates the rank of this masquerade within the Egungun society. Apaje stands behind Ege, the head of Egungun masquerades at Otta (see chapter 2), and is said to be second in seniority to Ege. The masquerader holds a club, at the end of which appears a blade, signifying Apaje's charge to swiftly dispense justice among Egungun performers, ordinary viewers, and Egungun priests alike.

Whereas the Egba chiefs had played an important role in creating the conditions that enabled the king and the chiefs to assume their offices, it is unclear what role they played in Apaje's emergence at Otta. According to tradition, an Owu woman from Abeokuta brought an Egungun bearing the name "Apaje" to Badagry during the middle of the nineteenth century.[90] If that was the case, the Egba chiefs at Abeokuta may have found it advantageous to support the introduction of a similar Egungun at Otta to supplant the warrior Egungun Gbodogbodo.[91]

The owners of Apaje settled in Ijana.[92] Once again, a new Egungun gained prominence as the executioner. As one of the leading Egungun in Otta, Apaje

Fig. 4.4. Egungun shrine, painted in 1999, shows murals of Egungun masquerades whose sponsors registered them for the festival. The most senior Egungun masquerades appear on the top level. Apaje Ishorun (or Apaje) is on the far right. The mural was painted on the Egungun shrine in December 1999. Itimoko compound, Ijana ward. Photograph by author, May 4, 2005.

performed rituals to ensure the well-being of the town as the "the killer of witches . . . the calabash bearer of charms in the midst of charms." This juxtaposition is illuminating. We can interpret the calabash containing the charms as the implement that Apaje used to kill the witches and, hence, to secure the safety of the town. In this functional respect, Apaje paralleled the Gelede Idahomi, a masquerade that carried ritual offerings to protect the town from its enemies. However, while for the Idahomi masquerade the enemy was Dahomey, for the Apaje masquerade it appears to have been witches.

Contemplating the significance of Apaje, I initially assumed that it had a negative relationship with witches. However, as I investigated the tradition of the Gelede Idahomi masquerade, I began to consider another possibility. According to the person who narrated the tradition of the Gelede Idahomi to me, "witches" and "elders" were synonymous: among them were the individuals who consulted the Ifa oracle to determine how to defend the town against the Dahomeyan

invaders. Some Yoruba ritual protocols consider the term "witch" or "*aje*" to be offensive and derogatory.[93] Pondering this point caused me to rethink my assumption about the meaning of the name "Apaje" and the relationship it assumes between the *aje* and the Egungun. As scholars of Gelede have vividly demonstrated, the *aje* or witches have been regarded as the "Mothers," who are also known as *aye* (the world), *onile* (owners of the land), and *Iya Agba* (elderly women or grandmothers).[94] What I began to consider, following the lead of some of my informants, is that many Egungun have performed rituals to placate instead of to attack the "mothers." From this perspective, Apaje's relationship to women as mothers parallels Gelede's relationship to women. In chapter 5, I further explore the relationship between women and Egungun.[95] However, based on the evidence presented here, it is reasonable to ask whether the discourse on witchcraft has been misleading and whether the name Apaje can be understood within a particular Yoruba-speaking context as a play on the meaning or idea of a "witch."

Shifting the analysis to the historical context at Otta in 1858, an examination of missionary documents reveals that, at that time, suspicions and accusations of witchcraft were common in the Yoruba culture, including in Otta.[96] These suspicions fueled tension between husbands and wives, between co-wives, and between patriarchs and the many individuals thought to be seeking their downfall.[97] One idea that emerges powerfully from the discourse on witchcraft is that men felt threatened by women's growing wealth from the palm produce trade and women's capacity to translate that economic power into social and political power.[98]

The rhetoric of witchcraft and the manner in which it contributed to the desire for an Egungun bearing the name "Apaje," or performing the role associated with the meaning of this name—"killing witches"—reflect one of the challenges posed by the new warlord-centered political order and critiques of that order. I posit that the new order that was emerging in Otta exacerbated gender and ethnic tensions and encouraged foreign intrusions into internal political struggles. This volatility inspired a rhetoric of witchcraft that emphasized the struggle to harness or eradicate unseen power.[99]

Another tension-inducing factor was that warriors now had very little power, despite the warlords using the time from the peace agreement of 1848 up to the coup of 1858 to build and extend their influence. The Ijana warlords' propensity for engaging in a socially destructive exercise of power and the pursuit of wealth at the expense of chiefs and a few remaining warriors from other wards in Otta, along with elites from Abeokuta, provided a fertile environment for the heightening of witchcraft fears. In essence, their actions led to the loss of property and innocent life, behavior commonly associated with witches.

Warlords such as the leaders of the Ijana warriors were extraordinary men. Their feats, aided by spiritual resources, enabled them to achieve what ordinary men found impossible. Peel notes that these warlords gained power and authority as "big men" through their ability to distinguish themselves from others and to embody the qualities of the spirits (*orisha*): "To go beyond what was the norm for ordinary men—in this culture which so strongly prescribed courtesy and restraint in all social interaction—was to behave more like an *orisha* than a man . . . it is likely that big men and *orisha* were so attractive to the Yoruba precisely because they actually did what lesser men, in their positions of relative weakness and dependency, could only yearn to do."[100] By behaving like *orisha* and lacking restraint, warlords also behaved like witches. The problem was that these men were so powerful that they were difficult to keep in check. Conditions were ripe for an Egungun that could "kill witches."

The paradox of their existence was that these same men who regarded themselves and were regarded by others as more than human also thought of themselves as being vulnerable to witches in the form of the malice of their enemies. These fears may have fueled the ambition of the *Ajana* and the other Ijana chiefs to target the monarchy for extinction, while at the same time subjecting them to attack. The Otta people, in general, constantly feared attack from a host of elusive foreign agents, particularly Dahomey and Abeokuta but also the British at Lagos. Rumors that Dahomey was targeting Otta for siding with Abeokuta, and vice versa, and of Abeokuta threatening Otta for aiding Kosoko, fueled insecurity in the town and inspired women repeatedly to flee their fathers and husbands, taking refuge in the local church mission house or in Lagos or in other communities. Also, as Otta struggled to repopulate itself and its "big men" struggled to attract or maintain followers, men looked to reassert their authority in their households and in the town. Thus, political and regional rivalries aroused household tensions, all of which contributed to fears that witches were causing the town's demise. The anthropologist Karin Barber describes how such an environment of intense social and political competition, with enemies near and far, fueled concern about witches:

> This view of the world as pervaded by "enemies," declared and undeclared, whose intentions are unknown but who can be assumed to be full of malice and envy, is deeply rooted in Yoruba culture. . . . In their most crystallized form, "enemies" are represented as witches, malevolent, destructive and—according to most people—always female. Witches are rarely exposed and expelled from the community; they are dimly suspected, half-known, and half-tolerated for long periods. No one can be sure which women in their own household are witches. But the strongly drawn picture of "the witch" merges into a shadowy region of ill-intentioned people, simply known as *aye*, "the world." The world can be assumed to be hostile. Men as well as women inhabit

this region, but no one can be sure who they are. They use their own powers, the powers of witches, the powers of hired-medicine men, and the powers of the orisa, who are regarded as deeply embroiled in human struggles. . . . These conceptions are pervasive, and I have argued, appropriate to a society driven by the dynamic of competitiveness of big men, each of whom is indeed a potential threat to his rivals.[101]

Fear of the malice of their rivals and enemies often led these near-immortal men (and women) to take care not to provoke their rivals' anger. Therefore, they expended great energy in seeking to appease the most powerful while at the same time trying to secure any and all means of protection from destructive forces, seen and unseen. Masquerades were an important tool whereby men could obtain such protection. They afforded men a way to distinguish themselves from their peers and suppress their rivals by targeting and executing the latter as criminals and witches. In essence, masquerades offered both protection from "witches" and permission to harm them.

Masquerades assumed a unique role in the political history of Otta during the mid-nineteenth century. The loss of its king, standing army, and defensive outer wall in the 1842 Otta-Abeokuta war emasculated Otta's surviving leaders, hindering their capacity to protect the town's inhabitants against invading armies. From 1848 to 1858, these leaders struggled to reassert their authority and control over the town's residents. A warlord envisioned himself as the *Baba* or Father/ Superior of an oligarchy, while a prince promoted the monarchy with himself as the king and father of the town. These factions—the supporters of the oligarchy and of the monarchy—were forged through masquerades, "thing[s]" they used to govern the town. The warlord mobilized three masquerades to unleash havoc, entertain Westernized guests, impose curfews, and identify the supporters of the monarchy as state criminals to be punished. A prince and his supporters sought to and succeeded in restoring the monarchy, superseding the authority of the warlord and other chiefs by entertaining and mocking them before targeting them as witches and punishing them with death. The prince won this local power struggle with the aid of external parties, the British and the Egba, who were seeking greater influence throughout the region.

The victory was short-lived, however; the prince who became the king soon found himself holding a title without the autonomy his ancestors enjoyed. The king and the inhabitants of the town soon became pawns in a larger game of politics between the British and the Egba for dominance. Masquerades continued to evolve as conditions and political actors changed. In the next chapter I consider how these changes affected life in Otta early in the twentieth century, with consequences that echo in contemporary Otta.

# Notes

1. Margaret Thompson Drewal, "The State of Research on Performance in Africa," *African Studies Review* 34, no. 3 (December 1991): 1.
2. James White, January 10, 1857, from journal ending March 25, 1857; Nigerian National Archives, Abeokuta, "Otta Affairs: Brief History of Otta" (Abeokuta, 1933). Agunwa claims it was Elewi, not Olukori, who died during the war. Dada Agunwa, *The First Book on Otta: In Memory of King Aina and King Oyelusi Arolagbade* (Otta, 1928), 72. Kosebinu and Salako contend that Olukori died in 1853. Deji Kosebinu, *Alani Oyede: The People's Monarch* (Otta: Bisrak Communications, 2000); R. A. Salako, *Ota: Biography of the Foremost Awori Town* (Otta: Penink Publicity, 2000), 64–65.
3. White, January 10, 1857, from journal ending March 25, 1857; Agunwa, *The First Book on Otta*; "Historical Events, Otta District Court" (St. James Church, Otta, Ogun State, 1962).
4. Agunwa, *The First Book on Otta*, 27; Nigerian National Archives, Abeokuta, ED 309, "Otta District Council Meetings: Minutes of Proceedings of Meetings of the Otta District Council" (Abeokuta, 1952).
5. White daily documented the impact of the Dahomey threat on the populace of Otta. James White, March 3, 1857, from journal ending March 25, 1857; White, March 23, 1863, from journal ending March 25, 1863; White, Letter, May 4, 1863. White also offers insightful observations of the recurring threat and reality of Egba attacks on Otta in the following sources: June 7, 1855, from journal ending June 25, 1855; November 8, 1855, from journal ending December 25, 1855; December 3, 1855, from journal ending December 25, 1855; Annual letter to Major Hector Straith, January 1, 1857; January 27–30, 1858, from journal ending March 25, 1858; August 10, 1859, from journal ending September 25, 1859; December 16, 1861, from journal ending March 25, 1862; September 28, 1862, from journal ending March 25, 1863; October 23, 1862, from journal ending March 25, 1863; October 28, 1862, from journal ending March 25, 1863; March 25, 1863, from journal ending March 25, 1863; Letter, May 4, 1863; from journal ending September 25, 1865; January 9, 1866, from report ending March 25, 1866; from journal ending September 25, 1867; March 27, 1872, from journal ending September 25, 1872.
6. White, January 10, 1857, from journal ending March 25, 1857; White, January 27–30, 1858, from journal ending March 25, 1858.
7. Nigerian National Archives, Abeokuta, "Otta Affairs."
8. Ibid.
9. Agunwa, *The First Book on Otta*; Salako, *Ota*.
10. Agunwa, *The First Book on Otta*, 70.
11. Kosebinu, *Alani Oyede*; Salako, *Ota*, 14, 63–65, 90; Interview with Chief Wasiu Dada, *Ekiyo* of Otta, Ijesu compound, Ijana ward, Otta, 2006.
12. The relationship between the *Ajana* and the Egba officials was complex. The Egba likely supported his position as the regent of Otta in the interim period. If not, they probably would have held him captive at Abeokuta as they had done with Oyede, the heir to the throne. White says that the Ijana ward, which was also the residence of the Egba overseers of Otta, was allied with Abeokuta.
13. Dada Agunwa recalls that the Egba asked for and received Otta's support in the Owiwi war of 1832 and in the Aibo war of 1856, which I discuss later. Agunwa, *The First Book on Otta*, 70. S. O. Biobaku recorded the song. S. O. Biobaku, *The Egba and Their Neighbours, 1842–1872* (Oxford: Clarendon, 1957).
14. Agunwa, *The First Book on Otta*, 70; Biobaku, *The Egba and Their Neighbours*, 20. See chapter 3 for further details of the conflict.

15. J. D. Y. Peel, *Religious Encounter and the Making of the Yoruba* (Bloomington: Indiana University Press, 2000), 53, 57–58.

16. Interview with Chief Abayomi Ojugbele, Otun ward, Otta, 2006; Interview with Chief Wasiu Dada, *Ekiyo* of Otta, Ijesu compound, Ijana ward, Otta, 2006.

17. Interview with Chief Wasiu Dada, *Ekiyo* of Otta, Ijesu compound, Ijana ward, Otta, 2006.

18. Nigerian National Archives, Abeokuta, "Otta Affairs."

19. Interview with Chief Wasiu Dada, *Ekiyo* of Otta, Ijesu compound, Ijana ward, Otta, 2006.

20. Ibid.; Adeboye Babalola and Olugboyega Alaba, *A Dictionary of Yoruba Personal Names* (Lagos: West African Book Publishers, 2003), 112.

21. British missionaries and Saros (African converts from Sierra Leone) began to exert influence in Badagry and Otta in the 1840s, building two-story structures in both places.

22. A missionary named Henry Townsend approached the Egba and helped negotiate a peace treaty between Abeokuta and Ado. Nigerian National Archives, Abeokuta, ED 1146/6 J. Hinian Scott, "Otta District Council Chieftaincy Committee Meetings: Minutes of the Meeting Held at Olota's Palace Otta Wednesday the 10th of April" (1935).

23. Hugh Clapperton, *Journal of a Second Expedition into the Interior of Africa: From the Bight of Benin to Soccatoo* (London: John Murray, 1829), 53–56.

24. Ibid. According to Otta's history, as recounted by local historians and other residents of the town, Oyede became king in 1853 or 1854. They do not indicate whether Oyede was held captive or remained in exile from the end of the war until his ascension to the throne. "Historical Events, Otta District Court." Kosebinu, *Alani Oyede*, 50; Salako, *Ota*, 200.

25. Oyede lived in exile in Abeokuta for a total of twelve years, five between the war and the peace treaty and the next seven between the Egba of Abeokuta permitting the resettlement of residents of Otta and Oyede's return to Otta as the heir to the throne. White, January 27–30, 1858, from journal ending March 25, 1858.

26. "Ogun" refers generally to the Yoruba god of war, but many townships or kingdoms in Yorubaland had their own Oguns. The Ogun in question, Ogun Onigbeyin, was under the control of Abeokuta.

27. Nigerian National Archives, Abeokuta, "Otta Affairs."

28. Agunwa, *The First Book on Otta*, 73.

29. White, January 10, 1857, from journal ending March 25, 1857; White, January 27–30, 1858, from journal ending March 25, 1858.

30. In Otta's political hierarchy, the king was supreme, and the *Ajana* was second to the king. Thus, by assuming office, Oyede gained a status higher than that of the *Ajana*.

31. Nigerian National Archives, Abeokuta, "Otta Affairs."

32. White does not name them and local traditions do not record them, but it is more than likely that these chiefs were the *Ajana* (the head of the Ijana ward), the *Olukosi* (the head of the Osi ward), and the *Olukotun* (the head of the Otun ward). These three chiefs were entrenched within Otta's political and economic life and therefore were in the best position to seize the property of the monarchy. Conversely, the *Akogun* (the head of the newly forming Oruba ward) was a recent appointee, and therefore he was in a weaker position vis-à-vis the other ward chiefs.

33. White, January 10, 1857, from journal ending March 25, 1857.

34. White, December 31, 1854, from journal ending March 25, 1855.

35. White, January 27–30, 1858, from journal ending March 25, 1858.

36. Ogunla, a chief from the Ijana ward, told White that Otta's population was comprised overwhelmingly of strangers, who came with unfamiliar customs and laws and were seemingly

difficult for the indigenous inhabitants—who, he adds, numbered only forty—to control. White, June 7, 1855, from journal ending June 25, 1855. A few months later in that same year, based on a conversation he had with a convert, White writes that the "population consists of fragments of the various shattered towns from the various tributaries to the chief town, Otta." White, December 3, 1855, from journal ending December 25, 1855.

37. The 1871 Gelede festival involved performances that spanned nearly a month. White, January 13, 1871, from journal ending March 25, 1871; White, January 15, 1871, from journal ending March 25, 1871; White, February 12, 1871, from journal ending March 25, 1871.

38. White, December 31, 1854, from journal ending March 25, 1855.

39. Peel, *Religious Encounter*, 11, 18.

40. White, December 31, 1854, from journal ending March 25, 1855; White, October 16, 1855, from journal ending December 25, 1855. Gelede, as nineteenth- and twentieth-century evidence presented by the following writers suggests, has long been a western Yoruba tradition, and refugees from western Yorubaland, along with White's own family, had settled in Sierra Leone. Samuel Johnson, *History of the Yoruba: From the Earliest Times to the Beginning of the British Protectorate* (Lagos: C. M. S. Bookshop, 1921), 31; Ulli Beier, "Gelede Masks," *Odu: Journal of Yoruba and Related Studies* 6 (1958): 5; Henry John Drewal and Margaret Thompson Drewal, *Gelede: Art and Female Power among the Yoruba* (Bloomington: Indiana University Press, 1983), 7; John W. Nunley, *Moving with the Face of the Devil: Art and Politics in Urban West Africa* (Urbana: University of Illinois Press, 1987), 33; Emmanuel D. Babatunde, "The Gelede Masked Dance and Ketu Society: The Role of the Transvestite Masquerade in Placating Powerful Women while Maintaining the Patrilineal Ideology," in *West African Masks and Cultural Systems*, ed. Sidney L. Kasfir (Tervuren: Musee Royal de l'Afrique Centrale, 1988), 45; Benedict M. Ibitokun, *Dance as Ritual Drama and Entertainment in the Gelede of the Ketu-Yoruba Subgroup in West Africa* (Ile-Ife, Nigeria: Obafemi Awolowo University Press, 1993), 29; Babatunde Lawal, *The Gelede Spectacle: Art, Gender, and Social Harmony in an African Culture* (Seattle: University of Washington Press, 1996), 71.

41. Chief Wadudu Deinde, whose father was the secretary of the king who ruled Otta in the 1920s and therefore documented the history of the Oruba community, offers a vivid account of the circumstances surrounding the establishment of the Oruba ward. Interview with Chief Wadudu Deinde, Oruba ward, Otta, 2006. Salako provides brief references to the early history of the Oruba ward. Salako, *Ota*, 14, 64.

42. Ogunla told White that, as of 1855, the Egba had on seven occasions attacked and forced the people of Otta to flee their homes, taking many as war captives and allowing some to return only in the previous year, seemingly with Oyede. White, June 7, 1855, from journal ending June 25, 1855.

43. Nigerian National Archives, Ibadan, CSO 13, S2141/51, J. Hinian Scott, "Minutes of a Meeting Held at the Olota's Palace" (1935), 2.

44. The Egba also summoned able-bodied men from Otta to assist them in the Aibo war of 1856. Agunwa, *The First Book on Otta*, 70.

45. Ibid., 69–75; Nigerian National Archives, Abeokuta, "Otta Affairs"; Gbamidele Ajayi, Interview with Chief Abayomi Ojugbele, Otun ward, Otta, 2008; Edna G. Bay, *Wives of the Leopard: Gender, Politics, and Culture in the Kingdom of Dahomey* (Charlottesville: University of Virginia Press, 1998), 186; Salako, *Ota*, 14, 64; Interview with Chief Wadudu Deinde, Oruba ward, Otta, 2006.

46. White, June 7, 1855, from journal ending June 25, 1855; White, November 8, 1855, from journal ending December 25, 1855.

47. Robert Smith, *The Lagos Consulate, 1851–1861* (Berkeley: University of California Press, 1979); Kristin Mann, *Marrying Well: Marriage, Status, and Social Change among the*

*Educated Elite in Colonial Lagos* (Cambridge: Cambridge University Press, 1985); Mann, *Slavery and the Birth of an African City: Lagos, 1760–1900* (Bloomington: Indiana University Press, 2007).

48. One man informs White of his frustration with White's predecessor for not offering food to the children sent to the mission school. The man's frustration reflects the community's expectation that they would derive immediate tangible benefits from the presence of the mission, an extension of British power based at Lagos. White, January 10, 1857, from journal ending March 25, 1857.

49. Francine Shields, "Palm Oil and Power: Women in an Era of Economic and Social Transition in 19th Century Yorubaland (South-Western Nigeria)" (PhD diss., University of Stirling, 1997), 34–40; Mann, *Slavery and the Birth of an African City.*

50. Robin Law, "'Legitimate' Trade and Gender Relations in Yorubaland and Dahomey," in *From Slave Trade to "Legitimate" Commerce: The Commercial Transition in Nineteenth-Century West Africa*, ed. Robin Law (Cambridge: Cambridge University Press, 1995), 109–10; Shields, "Palm Oil and Power," 198.

51. As noted in the previous chapter, western Yoruba peoples created masquerades depicting Dahomeyan warriors in both the Gelede and Egungun contexts. For further discussion of Dahomeyan warriors, who are known as Idahomi in some Yoruba contexts, see Drewal and Drewal, *Gelede*, 63; Lawal, *The Gelede Spectacle*, 100.

52. These events occurred in 1854 and 1871.

53. White, January 13, 1871, from journal ending March 25, 1871.

54. White, December 31, 1854, from journal ending March 25, 1855.

55. Henry John Drewal, "Efe: Voiced Power and Pagentry," *African Arts* 7, no. 2 (1974): 26; Babatunde Lawal, "New Light on Gelede," *African Arts* 11 (1978): 67; Babatunde, "The Gelede Masked Dance and Ketu Society," 45; Emmanuel Bamidele Bolaji, "The Dynamics and the Manifestations of Efe: The Satirical Poetry of the Yoruba Gelede Groups of Nigeria" (PhD diss., University of Birmingham, 1984), chapter 2.

56. Drewal and Drewal, *Gelede*, xv; Lawal, *The Gelede Spectacle*, 74–75.

57. Beier, "Gelede Masks," 6–10; Drewal and Drewal, *Gelede*, 8–9; Babatunde, "The Gelede Masked Dance and Ketu Society," 45–46; Ibitokun, *Dance as Ritual Drama*; Lawal, *The Gelede Spectacle*, 74–75, 78–79, 81.

58. Lawal, *The Gelede Spectacle*, 183–188.

59. Drewal and Drewal, *Gelede*, 152, 97–201; Lawal, *The Gelede Spectacle*, 163, 74, 84–90.

60. Scholars have highlighted how Gelede festivals used protest and satire to challenge colonial policies. Asiwaju, "Gelede Songs as Sources of Western Yoruba History," in *Yoruba Oral Tradition: Poetry in Music, Dance, and Drama*, edited by Wande Abimbola (Ile-Ife: Department of African Languages and Literature, University of Ife, 1975), 203–204; Drewal and Drewal, *Gelede*, 197–199; Lawal, *The Gelede Spectacle*, 75–78.

61. Lawal, *The Gelede Spectacle*, chapter 4.

62. Peter Morton-Williams, "Yoruba Responses to the Fear of Death," *Africa* 30, no. 1 (1960): 34–40.

63. Beier, "Gelede Masks," 5–8; Drewal and Drewal, *Gelede*, 7–16; Babatunde, "The Gelede Masked Dance and Ketu Society," 45–46; Ibitokun, *Dance as Ritual Drama*, 28–42; Lawal, *The Gelede Spectacle*, 71–74.

64. White, June 7, 1855, from journal ending June 25, 1855; White, December 3, 1855, from journal ending December 25, 1855; Agunwa, *The First Book on Otta*, 73; Salako, *Ota*, 14; Interview with Chief Abayomi Ojugbele, Otun ward, Otta, 2005; Interview with Chief Wadudu

Deinde, Oruba ward, Otta, 2006; Interview with Prince Wasiu Ashola Ojugbele, Osi ward, Otta, 2006.

65. Ojugbele, Deinde, and Olaniyan characterize the Oruba area as the center of Gelede in the town. Interview with Prince Wasiu Ashola Ojugbele, Osi ward, Otta, 2006; Interview with Chief Wadudu Deinde, Oruba ward, Otta, 2006; Interview with Salawu Abioru Olaniyan, *Olori* of Gelede in Otta, Oruba ward, Otta, 2006.

66. Interview with Chief Wadudu Deinde, Oruba ward, Otta, 2006.

67. Drewal and Drewal, *Gelede*, 229, 31, 36; Babatunde, "The Gelede Masked Dance and Ketu Society," 53–54; Lawal, *The Gelede Spectacle*, 49.

68. White, June 7, 1855, from journal ending June 25, 1855.

69. Keinde Faluyi claims that the flexibility of the Awori social system has enabled it to continuously assimilate immigrants into its kinship system, increasing the population and building social solidarity even while generating new challenges. I believe that this applies, for instance, to the Awori's ability to embrace Gelede. The Awori's success in this endeavor resurfaces in Faluyi's labeling of Gelede as common among the Awori of the contemporary states of Lagos and Ogun, Nigeria. Kehinde Faluyi, "The Awori Factor in the History of Lagos," in *History of the Peoples of Lagos State*, ed. Babatunde Agiri, Ade Adefuye, and Jide Osuntokun (Lagos: Lantern Books, 1987), 229.

70. Kosebinu published Otta's *oriki* in the brochure of the Egungun festival. Deji Kosebinu, Dele Adeniji, and Rasheed Ayinde, *Millennium Egungun Festival in Ota Awori: Special Program Brochure* (Otta: Bisrak Communications, 2000), 42–43. Kosebinu's version of Otta's *oriki* was translated by Bamidele Ajayi. What is most important for my purposes is the following verse of this *oriki*: "Otta, the bundle of soldiers who uses a carved mask to removes the eyes of the Idahomi." It is this verse that Deinde claims refers to the Gelede Idahomi. This figure, Gelede Idahomi, has been popular in Gelede because it reflects the environment in which this tradition emerged and flourished, as a tradition embraced by many western Yoruba groups who shared a common experience of torment by Dahomey. Drewal and Drewal, *Gelede*, 49, 62–63.

71. White, Annual letter to Major Hector Straith, January 1, 1857.

72. Ibid.

73. Interview with the *Oloponda* of Ilaro and M. A. B. Ajayi, Ilaro, 2006; Interview with Chief Ifagbade Oduniyi and Chief Adedoyin Talabi Faniyi, Ibokun Road, Oshogbo, 2006.

74. Interview with Salawu Abioru Olaniyan, *Olori* of Gelede in Otta, Oruba ward, Otta, 2006.

75. Market women, elders, and foreigners have been critical to the lives of Yoruba communities such as Otta, as well as to Gelede, in terms of both their appearance in the carved masks and their contribution to the event as a whole.

76. These events are chronicled in the following passages from White's papers: January 10 and 13, and February 8, 9, 10, 14, and 17, 1857, from journal ending March 25, 1857; letter, May 28, 1857; January 27–30, 1858, from journal ending March 25, 1858; and Annual letter to Rev. H. Venn, January 1, 1859. Captain F. C. Royce, the assistant district officer for Otta, provides a vivid account of an Oloru ceremony. He does not, however, indicate when the ceremony he chronicles occurred. It most likely occurred in the mid-1920s, around the time that he collected the data for his report. Nigerian National Archives, Ibadan, CSO 26/2 20629, F. C. Royce, "Assessment Report of Otta District, Egba Division, Abeokuta Province" (1927), 35–37.

77. Stephen Farrow, *Faith, Fancies and Fetich, or Yoruba Paganism: Being Some Account of the Religious Beliefs of the West African Negroes, Particularly of the Yoruba Tribes of Southern Nigeria* (New York: Macmillan, 1926), 4, 69–70; Jonathan O. Lucas, *The Religion of the Yorubas* (Lagos: C. M. S. Bookshop, 1948), 121, 124–127; Biobaku, *The Egba and Their Neighbours*, 7; N. A. Fadipe, *Sociology of the Yoruba* (Ibadan: University Press, 1970), 249; J. R. O. Ojo, "Ogboni

Drums," *African Arts* 6, no. 3 (1973): 50–52, 84; Law, "'Legitimate' Trade and Gender Relations," 209.

78. White, January 10, 1857, from journal ending March 25, 1857.

79. Ibid.

80. Oyede's appeal for Christian conversion corroborates Peel's argument that some indigenous elites in southwestern Yoruba towns looked to the missionaries and the British at Lagos as objects of prestige and protective charms that would defend them against their rivals. Peel, *Religious Encounter.*

81. White, February 8, 1857, from journal ending March 25, 1857.

82. White, February 17, 1857, from journal ending March 25, 1857.

83. Moreover, the presence of a newly converted Christian king, Oyede, could advance British evangelical interests and also had the potential to advance Britain's policy of commercial change. In addition, having backed Oyede's return to Otta in 1854, the Egba were interested in securing the stability of the monarchy so that they could indirectly rule Otta through a single individual, the king, instead of having to contend with several individuals, the ruling chiefs headed by the *Ajana.*

84. White, January 27–30, 1858, from journal ending March 25, 1858.

85. Ibid.

86. White, November 24, 1858, from journal ending March 25, 1859.

87. Ibid.; White, Annual letter to Rev. H. Venn, January 1, 1859.

88. White, November 24, 1858, from journal ending March 25, 1859.

89. Mr. Ajiboga recites the *oriki* of Apaje and cites the references to Osorun Eyo from the *oriki* in his account of how Apaje emerged at Otta. Interview with Chief Abayomi Ojugbele and Nurudeen Ajiboga, Osi ward, Otta, 2006; Gbamidele Ajayi, Interview with Chief Abayomi Ojugbele, Otun ward, Otta, 2008; Interview with Chief Keinde Odunlami, Akran Palace, Badagry, Lagos State, 2006.

90. Interview with Chief Keinde Odunlami, Akran Palace, Badagry, Lagos State, 2006.

91. The historical record does not suggest that Oloru was likewise banned. Compared to his lengthy discussion of Oloru's involvement in the plot against Oyede in the 1850s, White barely mentions Oloru in the 1860s and 1870s, limiting his discussion to moments when, by all indications, the followers of Oloru perform their roles in a manner consistent with established norms. Therefore, White does not reveal Oloru to have been at the center of controversy after the 1850s. White, May 25, 1870, from journal ending September 25, 1870. C. T. Lawrence, a colonial writer, reported that it continued to have the reputation of occasionally killing innocents, and an Osi chief even informed the colonial police that he had a misunderstanding with the authorities associated with Oloru in the 1920s. Nigerian National Archives, Ibadan, CSO 26, C. T. Lawrence, "Assessment Report on Otta District: Abeokuta Province" (1926), 51.

92. Interview with Chief Abayomi Ojugbele and Nurudeen Ajiboga, Osi ward, Otta, 2006.

93. Professor Remi Ajala, a Yoruba speaker from Oshun State, Nigeria, and the *Oloponda* of Egungun at Ilaro echo Chief Deinde's point about the problems associated with the term "witch." Interview with Chief Wadudu Deinde, Oruba ward, Otta, 2006; Interview with Remi Ajala, Department of Archeology and Anthropology, University of Ibadan, 2006.

94. Beier, "Gelede Masks," 10; Drewal and Drewal, *Gelede,* 9–11; Babatunde, "The Gelede Masked Dance and Ketu Society," 45, 52–53; Ibitokun, *Dance as Ritual Drama,* 29–42; Lawal, *The Gelede Spectacle,* 31–34.

95. Interview with Eshorun of Oshogbo and Chief Adedoyin Faniyi, Ibokun Road, Oshogbo, 2006; Interview with Remi Ajala, Department of Archeology and Anthropology, University of Ibadan, Ibadan, 2006.

96. White, February 18, 1862, from journal ending March 25, 1862; J. D. Y. Peel, "Gender in Yoruba Religious Change," *Journal of Religion in Africa* 32, no. 2 (2002): 145.

97. Karin Barber, *I Could Speak until Tomorrow: Oriki, Women and the Past in a Yoruba Town* (Washington, DC: Smithsonian Institution Press, 1991), 208–212, 34–36.

98. Law, "'Legitimate' Trade and Gender Relations," 209–210; Shields, "Palm Oil and Power," 280–285.

99. Peel, "Gender in Yoruba Religious Change," 142–146.

100. Peel, *Religious Encounter*, 82.

101. Barber, *I Could Speak until Tomorrow*, 210.

# 5   Wives, Warriors, and Masks

*Kinship, Gender, and Ethnicity*
*in Otta, 1871–1928*

THE LAST DECADES of the nineteenth century were characterized by the inter-locking transition of many African societies from wartime to peacetime and from precolonial to colonial rule.[1] Yoruba society in particular was deeply unsettled. The arrangements between ethnic groups (whether among Yoruba speakers or between them and the other Africans and Europeans) were changing in ways that altered cultural practices and institutions.[2]

Lagos became the seat of colonial power in the region after the British bombarded it, drove its king, Kosoko, into exile, and replaced him with Akitoye in 1851. The British felt that Akitoye would better promote their commercial interests and support their efforts to abolish the slave trade and emancipate enslaved peoples.[3] However, the British at Lagos clashed with the Egba at Abeokuta over control of trade between the coast and the hinterland. Because of Otta's proximity to the border of Lagos Colony and its location along a major trade route connecting Abeokuta to the coast, the town often found itself playing the role of pawn in the power struggles between the British and the Egba throughout the second half of the nineteenth century. The Awori-populated Osi ward of Otta tended to side with the British after they played a key role in negotiating a treaty between Otta and Abeokuta in 1847 and in instituting regime change in Lagos. The Oyo- and Gun-populated Ijana ward was compelled to side with Abeokuta when an Egba official established a permanent residence in that ward, enabling him to monitor the activities of Otta's leaders. Abeokuta's loss of kola groves in the early decades of the Yoruba wars (from the 1830s to the 1850s) and increasing involvement in trade from Lagos via Otta along with Otta's shift from trading palm oil to trading palm wine and kernels led the Egba to raid Otta's land in 1859.[4]

Thus British and Egba factions became entrenched in Otta, fueling instability in an already fragile town after the British established Lagos as a Crown Colony in 1861, extending the protectorate to include Osi, the southernmost ward of Otta.[5] The British established a blockade on the road between Abeokuta and Lagos in response to conflicts between the Egba and the British government and, by extension, between the Otta people and the governor of Lagos, who accused Otta of siding with Abeokuta in 1865; as noted earlier, Otta's population was divided

between allegiance to the British and the Egba. The British stationed a police force, comprised largely of Hausa men, in Otta in 1867 to promote the colony's policies.[6] The British also extended its authority over the Yoruba communities of Oyo and Ibadan between 1888 and 1898 and through an alliance with Abeokuta in 1893 that recognized Egba claims to Otta; in 1914, all of these communities were formally incorporated into the British colony of Nigeria.[7]

In 1897 the British began to establish native councils of chiefs to oversee their respective districts, and in 1898 installed the king of Oyo as the paramount chief and highest native authority over the Oyo province, which included the Oyo, Ibadan, and Ife districts.[8] The *Alake*, the crowned ruler of Abeokuta, abolished the position of the Egba resident representative over Otta and began to rule directly over the town in 1900.[9] British colonial rule backed Abeokuta's claims to authority over Otta and Oyo's claims to territories formerly under its imperial rule in the late eighteenth century. Otta therefore had to contend with two levels of colonial administrative authority.[10]

Beginning in the 1890s, Otta's proximity to Lagos Colony and fertile land led to the construction of new railway lines and roads, as well as to new waves of immigrants, intensifying competition between Yoruba and non-Yoruba peoples. In 1897, on the north edge of town along an old road leading to Abeokuta, a railway station was built at the Sango-Otta market; the railway line connected Lagos to Jebba, a town on the northern frontier of Yorubaland. Sango-Otta became an outlet for products from the Otta district and a predominantly non-Awori settlement for Hausa men (who were mostly Muslim) traveling between Lagos and the hinterland to the north. Villages surrounding Otta attracted non-Awori immigrants when a railway station was torn down between 1912 and 1915 and replaced by a new road that enabled farmers at Otta to ship their products directly to Agege, a major distribution point for settlements throughout Lagos Colony.[11]

These political and commercial changes and rivalries inspired elites at Otta to consciously emphasize the town's Awori identity. Relationships between various social actors were evolving as well. Warriors and husbands returned from war camps to their home communities, seeking to transfer their success in battle to dominance in civilian, economic, political, and family life; these men competed with royals and civil chiefs from Otta's Awori (Osi and Otun) wards for followers and women in the hopes of achieving this dominance. Other Yoruba and Hausa men also arrived at Otta seeking work, whether as competitors or allies of Awori residents. Both Yoruba and European men—as agents of British commerce, evangelism, and colonialism—were asserting their dominance in all aspects of Yoruba life as a new order formed.[12] Women encountered a range of challenges and opportunities as merchants, ritual custodians, and wives during the transition from the era of warfare to the early era of colonial rule.[13]

Economic historians contend that new economic realities in the latter half of the nineteenth century—the abolition of the slave trade and the ongoing expansion of commerce in palm produce, textiles, and other goods with Europeans on the coast—exacerbated gender, generational, familial, factional, and intra-Yoruba tensions.[14] At the same time, kings and powerful chiefs as well as traders quickly took advantage of the expanding export market in palm produce and cotton, reinforcing socioeconomic divisions and inequality.[15] In the competition for followers, title-holding and commercial elites adorned and redistributed both locally produced and imported cloths as part of what historian Kristin Mann identifies as the "political regalia of the state."[16] These wealthy patrons often attracted and retained followers by sponsoring public ceremonies featuring Gelede and Egungun masqueraders dressed in elaborately decorated cloths; these events showcased the resources that elites could redistribute to their followers. At these ceremonies, these elites paid for food and drinks for participants and attendees. They also demonstrated their shared allegiance to the town, its institutions, and evolving traditions.

For decades, both victorious and vanquished men had been engaged outside their communities in the fight to acquire slaves and resist their own enslavement; as mentioned, these men were returning home in the 1880s and 1890s.[17] When the men arrived in their hometowns, they sought to fulfill their social role as the husbands (and heads of households) of wives who had become wealthy and influential merchants and ritual specialists with broad commercial and social networks. Women whose reputations for achievement exceeded those of their husbands (or who found, in conversion to Islam or Christianity, opportunities to challenge convention) often faced suspicion of witchcraft and the threat of persecution.[18] Warriors also found new religious communities comprised of Muslims and Christians along with the newly established and growing colonial government.[19]

Christian missionaries witnessed the anger of men who felt disempowered on their return to civilian life in communities still experiencing the enduring threat of war. Samuel Johnson (based in Oyo) and other missionaries wrote far less about Gelede than Egungun, characterizing the former as an imitation of an Egungun or as a means whereby the Egbado people represented departed ancestors. Johnson regarded Egungun as a national religious institution that evolved from the worship of the spirits of the ancestors in Oyo and spread throughout Yorubaland during Oyo imperial rule and after its collapse. He interpreted Egungun festivals as opportunities for men to tax women by requiring them to provide food for these events.[20] In contrast, as we have seen, James White, based in the Awori stronghold of Otta, observed and documented two Gelede performances in the nineteenth century in a community that had welcomed Egbado refugees. Unlike twentieth-century ethnographers, White identified Gelede neither with honoring women nor with their capacity to use witchcraft for benevo-

lent purposes. Yet, subsequent writers linked the figures he described in the account given in chapter 4 to witchcraft; and on other occasions (in 1863, 1865, 1871, and 1878) White also depicted the residents as holding strong beliefs in witchcraft. Both Johnson and White characterized the masquerades as affiliated with the Egbado people.

A comparative analysis of White's discussion of the Gelede festival that occurred in 1871, of two Awori Gelede masks collected in 1887, and of oral traditions chronicling the origins and development of a group of Egungun masquerades that I date from the 1880s to the 1920s reveals that the organizers of Egungun performances adopted a mode of performance that had been earlier featured in Gelede. This period marks an era of transition when Egungun began to surpass Gelede as the premier spectacle in Otta.

## Gelede and Egungun in the Transition to Colonial Rule

### Gelede Symbolism

In his account of a performance in 1871, White characterizes Gelede as the "principal amusement" of the Otta nation:

> Today, there was a grand play in this town which may be called the Gelede exhibition—the principal amusement of the nation. It consists of wooden masks worn by various individuals who were richly dressed in silk and velvet. The principal object of this amusement is to display the skill of the artists in producing the best workmanship in carving and painting, and the wealth of that particular section of the town which provides for the amusement in exhibiting the most costly cloths. Hence it becomes a matter of emulation, as the other divisions of the town in their turn study not only to rival but to excel the last players. On the present occasion, the people from all of the neighboring towns and villages flocked here to witness the occasion, and it was said that since the existence of Ota, no grander public entertainment was ever witnessed and in fact, I have never witnessed any such since my residence in this town. The best masks worn on this occasion are those on top of which are standing carved figures of banana trees bearing fruit, some painted red to represent ripeness, and finished off with parrots attached to their appendices. In the morning, it was said, that one of the players was represented with the figures of two children attached to their sides all showing motion, as if they were living creatures but this, I did not see.[21]

This performance, it seems, united a town that was facing ongoing threats of attack from Abeokuta and Dahomey, and it offered the "nation" a moment of respite and relief from worry. Performers and the sections of the town that sponsored and were represented in Gelede sought to emulate existing styles and modes of performance and to surpass one another in skill and showmanship. What is not clear from White's account is whether the evaluation of some performers as

adorning the "best masks" reflects his own judgment as an untrained observer, the views of the artists who carved and performed the masks, or the attendees who cheered during performances.

Whereas White's account of a 1854 Gelede performance at Otta focuses on masks depicting men and women, his account from 1871 focuses on animals and agricultural products, both of which could pass for indirect references to *aje* ("witchcraft" or the "Mothers"—the parrot as a common animal form of an *aje* and a red-painted banana tree as a symbol of fertility and meeting place for *aje*). Lawal reports that his informants identify the parrot as the favorite pet of Iya Nla, the Great Mother and object of Gelede devotion. Lawal adds that banana trees are one of the most popular plant motifs that appear in Gelede and that their inclusion in a mask placates *aje*, thereby preventing infant mortality.[22] The inclusion of this mask among the "best masks" at the most "grand play" witnessed at Otta at the time may reflect the intensity of Otta's appeal to the "Mothers" for protection and peace. It might even be a reminder of Otta's identity as *Ilu Aje*, the headquarters of *aje*. At the same time, artists seeking fame likely found the mask praiseworthy and essential to a successful performance.

The presence of a mask with two children likely refers to twins, arguably the most common human motif in Gelede. Performers enact Gelede associated with twins to invite the benevolent side of *aje*.[23] In fact, one of the aims of Gelede is to entice the spirits of twins to remain in this world rather than to depart through untimely death. At the end of his account, White claims not to have seen the mask with two children, apparently drawing a distinction between it and the other masks, which he leads the reader to believe he observed. However, White does not note any distinctions between Gelede masks worn by Ketu, Egbado, or Awori people, nor does he provide much information that can be compared to more general patterns in the practice of Gelede across communities. Nearly two decades before this event, he identifies the Egbado as having excelled in the arts of music, dance, sculpture, and painting.[24] Yet, what White attributes to the Egbado people may well reflect inspiration drawn from the Ketu people. We have seen strong evidence that the Ketu people invented Gelede and shared it with the Egbado people.[25]

The changing ideas and objects reflected in evolving masquerade styles are demonstrated in a drawing of two Gelede masks collected in 1887 that are now in the British Museum. With the support of the Lagos government, A. R. Elliot collected these items in Lagos for the Colonial and Indian Exhibition held in London in May 1886.[26] A label created for the British Museum provides the following description of "one Gelede mask used in plays": "Mask carved in wood and coloured. It represents a native head with . . . cheeks; on the top a figure holding up a circular table with a central head and knobs around; around the base four men

standing with guns." The motifs included in the masks also appear in other media, including the Otta town anthem (which commemorates Otta's war with Abeokuta) and a new Egungun at Otta. Drewal and Drewal offer a more detailed description of the masks donated by Elliott:

> [The Gelede masks] pay tribute to courageous warriors, devotees of Ogun, and priestesses and their ritual obligations. The male headdress portrays an Awori Yoruba, his head encircled by four warriors, holding guns. Standing in the center is another warrior, probably an officer of some rank and a priest of Ogun by his bracelets, carrying a circular tray with several covered containers and a human head in the center. War and ritual sacrifice dominate this mask. In the nineteenth century, much of Yorubaland, including Awori country, was engulfed in internecine warfare in which thousands of Yoruba were captured, sold, or sacrificed. The last is the case here, for the artist carefully marked the decapitated head of a non-Awori with distinctive Oyo Yoruba scarifications and coiffure.
>
> The female Gelede . . . portrays a kneeling priestess, her distinctive necklaces and bracelets signaling her status. On her head she carries a tray with four receptacles and a human head. Her kneeling position, echoed by the four smaller surrounding females, is a gesture of supplication, humility, and respect appropriate for the presentation of ritual gifts. The act of holding the breasts, depicted in the smaller kneeling female figures, indicates reverence and generosity in soliciting the god's support.[27]

Similarly, Otta's anthem (Otta Iganmode) pays homage to a group of warriors heralded as having defended the town. The four warriors sounding the figure may well represent the four wards of Otta united in their defense of the town against common enemies.

## Egungun and Gender in Colonial Otta

Although missionary accounts offer rich daily reports and periodic reflections on events reflecting profound changes occurring in Yoruba society, they provide only condescending and cursory descriptions of Egungun masquerades, some of which were performed at the same time and drew participants and their allegiance away from Christian worship services.[28] Unlike Gelede, the practice of Egungun extended beyond Ketu-Yoruba, Egbado-Yoruba, and Awori-Yoruba communities to settlements once under Oyo imperial influence and to places that later welcomed Oyo refugees, providing more opportunities for missionaries to observe this evolving practice. Several missionaries describe the involvement of Egungun masqueraders in violent attacks against women. During the 1890s, masqueraders reportedly drove women from their trading stalls in the market and stole their goods in Abeokuta.[29] Some writers uncritically accept the observations

of the missionaries and assume that men were "insiders" and women were "outsiders" in Egungun, based on evidence that identifies men as performers who persecute women as witches.[30] In addition, economic historians assert that men enacted Egungun to reestablish their power and authority—at women's expense—in the economic and domestic spheres.

I question this static, ahistorical reading of Egungun as an exclusively masculine space by focusing on the ways in which gender is reflected in and constituted through Egungun practice itself. I also consider the labor and material resources that were marshaled to enact a masquerade event, as well as the women who served as ritual mothers who often presided over or sponsored the ceremonies or were recipients of verbal praise and other greetings, garnering respect from prostrating men and kneeling women.[31] Instead of concentrating on women's agency as mothers, I focus the analysis on women's agency as the *wives* and daughters of men practicing Egungun. I emphasize this neglected aspect of women's agency to further support an idea that undergirds this book—that there is a wider range of ways in which women did and still do participate in Egungun than writers have previously acknowledged. My approach to women as wives and daughters in families that perform Egungun acknowledges competing centers of power; whereas most studies of Egungun focus on the priesthood as the basis for determining who organizes and enacts ritual performances, and how, I focus on an individual family that performs its own masquerade. What surfaces here is the tension between the centralization and decentralization of power.

Oral traditions shared by families that include Egungun masquerade performers and chiefs comprise the bulk of the evidence offered here. Versions of these traditions and oral histories have appeared in locally published histories and court testimony. I draw on oral traditions and histories along with my own observations of contemporary performances to challenge the perspectives of gender dominance expressed in missionary sources. The methodology deployed here asks and answers finely nuanced questions about gender relations within the family-centered practice and the centralized priesthood of Egungun. This approach demonstrates the historical influence of Egungun's performative practices on social and population groups within the town of Otta. Juxtaposing these sources and methods allows me to triangulate the transformation of masquerading at Otta in the early period of British colonial rule. The evidence presented here focuses on the history of an Egungun masquerade named Oya (which I discussed in the introduction) from the perspective of a single family, the Arogunmolas, which derives its name from an ancestor. The evolution of this Egungun masquerade, introduced to Otta by the co-wives of a returning warrior, demonstrates that, at the turn of the twentieth century, Egungun was not solely a men's affair.

## Yoruba Models of Wifely Cooperation

In precolonial Yoruba culture, as described by both British and African missionaries, a wife was expected to cooperate with her husband and promote his health and well-being and that of her co-wives and their children, as well as of other members of the lineage. Her responsibilities included clothing, feeding, and caring for herself, her children, and her husband, as well as other members of her husband's lineage and her paternal, maternal, and ritual kin. Her duties also included minimizing competition, rivalry, and conflict between diverse groups of individuals. A wife whose personal ambitions were merged with those of her husband's lineage and its members was highly respected.[32]

This model of wifeliness developed, perhaps, with the rise of the Oyo Empire, when palace women were expected to serve as royals and as priestesses for deities who promoted the interests of the *Alaafin*, the emperor of Oyo.[33] As the empire disintegrated, kings turned to warriors (mostly young men) instead of to "wifely" priests (men and women who were devotees of Shango, the patron deity of Oyo kings) to legitimate their regimes. Warriors began to rival the power of kings and their "wives." Thus a new model of wifeliness began to displace that of the imperial model; it positioned wives not as complementary companions who carried out state policies but rather as companions of warriors, with divided loyalties. Wives therefore needed to be excluded from matters of state. Matory argues that the intentions behind rituals may vary from one historical situation to another, and distinct classes of actors can harness the same ritual to "project very different meanings upon the social world and, thereby, advance very different projects." He also links the rise and fall of specific gender paradigms to changes in historical circumstances, revealing that what may seem like fixed categories are in historical flux.[34]

New warrior states such as Abeokuta, which emerged in 1830 and ruled through coalitions of competing warriors, rivaled the hegemony of older states such as Otta, even as their own royals and their loyalists struggled to keep the warriors at bay.[35] Identification with historical agents of Oyo imperial rule (e.g., an Egungun mask bearing the name of a wife of Shango) should be understood as a claim to wifely agency in what Matory characterizes as "the Oyo Renaissance" under the British colonial model of indirect rule.[36] Thus, while laboring under two levels of colonial administrative authority, Otta's elites contested the loss of their autonomy under British and Egba rule as marginal and excluded structural "wives." They found in Egungun opportunities to promote a vision of themselves as loyal subjects and structural and symbolic "wives" of Oyo, an authority at least as prominent as the warriors of Abeokuta, where Egungun was also embraced.[37] I use Matory's insights into the gender paradigm embodied in the mythology of Shango and performances of Shango priests (who are the

deities' "wives") as well as of other Oyo post-imperial agents ("wives" of the *Alaafin*) to analyze the complex relationships between a husband and two wives during the introduction of a new Egungun in Otta.

In addition to Matory, other scholars have recently questioned the salience of the perspectives and legacies of missionaries. The feminist sociologist Oyeronke Oyewumi argues that status in a lineage is determined by whether a person is an insider or outsider, as well as by the date of one's entry into that lineage, either by birth or marriage.[38] Contemporary ethnographic evidence offered by Oyewumi suggests that families have not only organized and performed their own rituals but also have been responsible for providing candidates for chieftaincy titles in Egungun and many other Yoruba ritual institutions. The lineage is primary in that it shapes participation in the practice and the priesthood, as does gender, but not in the way suggested by the static, dichotomous framework of insider men–outsider women.

Another form of evidence derived from ethnographic research offers penetrating insights into Yoruba models of wifely cooperation. The agency of wives is powerfully illustrated in the cultural anthropologist Karin Barber's groundbreaking study of women's performance of the *oriki* associated with their birth and marital lineages. Drawing on the performance theory view of oral texts as action not object, and as process not pattern, she argues that women performers channel power and authority to the objects of their praise, which are mostly husbands for wives and fathers for daughters.[39] The anthropologist S. A. Babalola and the historians Bolanle Awe and S. O. Babayemi among others identify *oriki* (like other genres of oral tradition) as valid sources of historical evidence.[40] Barber, however, argues that *oriki* must be understood first in the context in which they are performed and that the performance tends to be more about showcasing the skills and achievements of the performers, who are typically women, than about the objects of the performance, mostly men.

In what Barber insightfully identifies as a catalyst in the "competitive struggle for self-aggrandizement," *oriki* play a critical role. They serve as the primary instrument through which one's reputation is publicly acknowledged and enhanced. Moreover, they position the object of the performance at the center of a social and political universe and other individuals as orbiting around the object. *Oriki* are not records of family trees, nor do they preserve the details of kinship links. Instead, they "raid the genealogy" to accumulate attributes such as trophies. Barber finds that *oriki* serve as vehicles that women can use to display their own achievements, in addition to those of their husbands and their lineages.[41]

To illustrate how Egungun functioned as a site of power for men and women as wives and of cultural and political resistance for the people of Otta, I reconstruct the history of the Oya Arogunmola masquerade. This history is based on my collection and analysis of historical data derived from court documents and oral

and ethnographic evidence that support two divergent accounts of the introduction of the Oya masquerade to Otta. These accounts reflect social and political divisions in the town: one describes the claims of the Arogunmola family as the originators of the Oya masquerade, and the other supports the Ijemo family as the custodians of the same masquerade.

My analysis draws heavily on accounts of *oriki* and other oral traditions that I collected from Chief Abayomi Ojugbele, a retired civil servant and patriarch in the Arogunmola family. He was the first person to tell me about a controversial 1996 court case in which he was the plaintiff and the Egungun chiefs (who backed the Ijemo genealogy) were the defendants.[42] The tension between the Ijemo and Itimoko families from the Oyo-populated Ijana ward and the Arogunmola family from the Awori-populated Otun ward was at the heart of this court case and reflected historical conflicts between the warriors and the royals who dominated political life in Otta in the second half of the nineteenth century. What follows is a review and assessment of accounts of Oya's history and *oriki* offered by the Ijemo and Arogunmola families, as well as of photographs I took during observations of both families' Oya performance in the 2004–2005 Egungun festival. I juxtapose these sources with other oral traditions and histories, nineteenth-century missionary sources, and unpublished early twentieth-century sources to demonstrate the agency of wives and the gendered and ethnic relations that masquerade performances have offered opportunities to restructure.

## The Origin of the Oya Arogunmola Masquerade

### *Conflicting Accounts and Independent Sources*

According to the Ijemo family, it created the first Oya masquerade in the town during the reign of Isiyemi, king of Otta (1882–1901). Dada Aka was the first person to perform as Oya or, as Egungun practitioners put it, to "carry" the mask. Members of the Ijemo family carried the Oya mask up to the time of the conflict between the Ijemo and Arogunmola families in the 1980s. The Oya Ijemo masquerade was the only Oya based at Otta, and the Arogunmola family played a minor role in assisting with the Oya Ijemo performances during the Egungun festival. Then, in 1988, members of the Arogunmola family created their own Oya, known as Oya Arogunmola, and began to argue that it was the first Oya masquerade that was performed in Otta. The practice of creating a new Egungun from an older one was well established in Otta by 1988.[43] According to the Ijemo family, the Arogunmolas had nothing to do with the creation of Oya Ijemo or Oya Otta. This account of Oya Ijemo's history appears in written statements and the judgment presented in court.[44] The *oriki* of Oya Ijemo performed by one of its supporters from another family, who is an Egungun performer in the Itimoko family, offers, however, no evidence that corroborates elements of the Ijemo account.

During the Egungun festival that I attended in Otta, no one performed the Oya Ijemo masquerade on the date scheduled for its solo performance; a masquerader adorned Oya Ijemo's lavish *agbada* ("gown") on one of the dates set aside for all of the Egungun masquerades belonging to the *alagbada* ("owners of long flowing gowns") group (see figure 5.1). Oya Arogunmola, however, not only performed alone on its scheduled day but its sponsors also hosted the last day of the festival, which supports its claim to being the oldest, most prominent, and therefore the last to perform. The event was the only performance of the *alagbada* attended by the king of Otta. The alliance between the Ijemo family and the *Oloponda*, who comes from the Itimoko family, is visually expressed in a striking banner draped during the Egungun festival on the front gate of a home near the current palace of the king of Otta (see figure 5.2). To the casual observer, the banner parallels other advertisements that appear throughout the town and in the festival brochures, which express appreciation for the hard work that the *Oloponda* and others have put in toward making the festival a success. However, anyone with knowledge of the fractures that still exist surrounding the two Oya masquerades in the community may also read the banner as a show of allegiance between the Ijemo and Itimoko families against the Arogunmola family.

The Arogunmola family offers a more detailed and well-supported account that identifies three of their ancestors—Arogunmola, Moniyepe, and Oshungbayi—as having introduced the Oya masquerade to the Otta community. What distinguishes this account from others is the reference to two women as among the originators of the masquerade. According to oral tradition, an Oyo woman named Moniyepe arrived at her new home, the town of Otta, during the days of Oyo imperial rule, as the second wife of her new husband, a warrior named Arogunmola. Before emigrating to her husband's town, Moniyepe had inherited an Egungun mask from her father. She brought to the marriage the essentials of an Egungun that her descendants practice to this day. When the newlyweds arrived at their home in Otta, one of their first acts was to introduce the Oya masquerade to the community. It was the warrior Arogunmola's senior wife, Oshungbayi, who organized, financed, and led the first performance in which her husband carried the mask as Oya. Using her assets as a prominent cloth trader, she also introduced a new style of clothing and mode of performance for the Egungun ritual, which was witnessed by the entire town and its immediate neighbors. Oshungbayi (the senior wife) went on to become the first occupant in the town to hold a chieftaincy office known as the Iyalode, charged with representing the interests of women and merchants on the king's advisory council.

After Arogunmola's death, his descendants brought the Oya mask in 1951 from their home in the Ikotun compound to the Ijemo compound, where Fadina, then the king of Otta, resided.[45] The two families shared maternal relations and began to collaborate in performing the Oya masquerade. This collaboration was

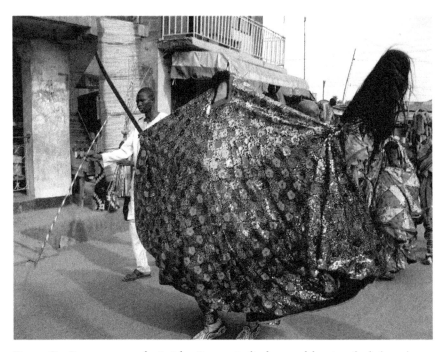

Fig. 5.1. Oya Ijemo masquerade stretches its arms to displace an elaborate *agbada* (gown), while holding its characteristic sword in the right hand and a horsetail, a symbol of status, in the left. Oya wears decorative shoes with bed embroidery. Hardly visible in this image are several other Egungun performers who form part of Oya Ijemo's procession during the festival. Photograph by author, December 27, 2004.

precipitated by an attempt by another Egungun chief, known as the *Alapinni*, to take the Oya mask from the Arogunmola family. The Ijemo hosted performances of the Oya masquerade from 1951 to 1988, during the reigns of Fadina and T. T. Dada as the kings of Otta. Abinleko, a member of the Ijemo family and maternal relation of the Arogunmola family, performed as Oya until his death in 1988. After his death, another Ijemo family member, who was not a maternal relation of the Arogunmola family, wanted to perform as Oya, but the Arogunmolas opposed this. The Itimoko family then aided the Ijemo family in creating their own Oya, according to statements introduced by the Arogunmola family as evidence in the court case.

Verses from the *oriki* and *ewi* (a particular genre of poetry chanted for Egungun) associated with the Oya Arogunmola masquerade contain references to many elements of this family's account.[46] What follows are three versions of the Oya Arogunmola praise poetry; the first and second versions come from Chief

Fig. 5.2. The Ijemo family is one of the three lineages that provide candidates for the office of the king of Otta. A person with knowledge of the conflict between the Ijemo and Arogunmola families must wonder whether the reference to the "entire indigene of Otta Awori land" reflects the Ijemo's desire to attain legitimacy through emphasizing their local roots. Although legitimacy in Egungun has often been based on claims to Oyo ancestry, this banner suggests an assertion of an Awori identity, which is shared by a people who trace their descent from the founder of Otta, a hunter from Ife. Photograph by Rachel Raimist, December 8, 2010.

Ojugbele, whereas the third version comes from an Egungun performer from the Itimoko family. All three reference a trader (at 5-a and 8-b in the Arogunmola versions and 2-c in the Itimoko version). All three seemingly praise Arogunmola in particular for handling socially deviant people—stubborn children (6-a and 9-b) in the Ojugbele's Arogunmola versions and vagabonds (3-c) in the Itimoko version. The dangers that await the enemies of the Arogunmola family are vividly conveyed in all three versions. As Barber suggests, *oriki* have a complex relationship with the past; it should not be assumed that these traditions have gone unchanged since the time of Arogunmola, Moniyepe, and Oshungbayi. The elements of these *oriki* that offer insights into people, behaviors, and aspects of life from the 1880s to the 1920s are the focus of the rest of this chapter.

***Oriki* Oya Arogunmola (Arogunmola Family)**

1-a. Oya of Oje of the ant mound
2-a. He who sways the sword in the grove in the morning
3-a. The father of Moniyepe
4-a. The father of Idowu, who came after the twins
5-a. Poverty is the only thing that conquers a trader
6-a. Arogunmola is capable of handling any stubborn child
7-a. The husband of Iyalode Osungbayi
8-a. A wealthy woman with flamboyant dresses
9-a. Who dances gorgeously
10-a. The offspring of twins
11-a. She looks like the king's wife
12-a. Whereas she is not the king's wife
13-a. Who dances gorgeously
14-a. The offspring of a twin
15-a. She makes for herself and also makes for the lazy ones
16-a. A coward has no place at the war
17-a. Through misunderstanding she became the friend of Shango
18-a. The father of Ope Ifa
19-a. Arogunmola, a warrior who dangles his gun to threaten the people
20-a. Poverty is the only weapon that conquers a trader
21-a. Arogunmola is capable of handling a stubborn child
22-a. Oya the scary one
23-a. Who rode on a horse with pride
24-a. The pretty princess with bundles of beads on her bottom
25-a. Oya please do not cut down the tree at my backyard
26-a. Because I know how dreadful Oya can be
27-a. Oya as scary as the outbreak of fire
28-a. Oya rode on a camel down to the top of the Ogun river
29-a. Oya rode on a fancy horse to the house of Ipo
30-a. That is why they praised the king of Ipoland
31-a. Like the way Oya is being praised
32-a. Oya as scary as the outbreak of fire
33-a. Death mixed with wealth
34-a. Whom is nursed with a velvet
35-a. Oya became adorable
36-a. Oya that we worship
37-a. Oya a darkness behind a farmer
38-a. Oya please do not cut down the tree at my backyard
39-a. Because I understand how dreadful Oya can be
40-a. Permit me to marry Oya in Orinsipo town
41-a. Permit me to marry the big breasted princess

42-a. Oya visualize me clearly
43-a. Oya who burn deeply like wood
44-a. Oya so scary
45-a. If you do not allow me to marry Oya in Orinsipo town
46-a. I will move stylishly and cling to Oya
47-a. Mother, mother, I like to marry Oya
48-a. Father, father, I like to marry Oya
49-a. If you do not allow me to marry Oya
50-a. I will move stylishly and cling to Oya
51-a. By the hem of her garment
52-a. I will use the biggest finger to break the kolanut in the grove

### *Ewi* Oya Arogunmola (Arogunmola Family)

1-b. Oya o, Oya o, Oya o
2-b. The great one of Oje
3-b. Oya who sits so fitted on the horse
4-b. The handsome and proud prince
5-b. I shall spend today to give honor
6-b. Honor to my father Arogunmola (he who from war became wealthy)
7-b. The fearful or lazy ones will never be seized at war
8-b. Unsaleable situation is capable of handling the market
9-b. Arogunmola is capable of handling any other stubborn child
10-b. I shall spend today to give honor
11-b. Honor to my witch-mother (Oshonronga)
12-b. Who is expected in sitting down
13-b. A clean dove that dines with the eagles
14-b. A clean bird that eats in the open farm
15-b. Honor to my mother of power
16-b. Who takes the leg to the stream
17-b. Honor that three open spaces cannot contain the elephant
18-b. Bearer of the brooks goddess (Yemonja)
19-b. That is how he took his mother to "Popo"
20-b. Do not offer me the pap (Ogi)
21-b. My mother is an Oya bearer
22-b. I went stylishly I became the king
23-b. I went as lengthy as I can I became an Oje chief
24-b. There in Oje
25-b. Oya o, Oya o, Oya o
26-b. The great one of Oje
27-b. Oya became a worshipper of Oya
28-b. Oya is not childlike again
29-b. Oya became a worshipper of Oya and refused to be barren

30-b. The great one of Oje
31-b. Come and have it is just a deceit (let the food go with the owner of food)
32-b. Let the food owner go with his food
33-b. Oya rode on the donkey to the house of "Ira"
34-b. Oya rode on the camel down to hills of Ogun
35-b. Oya rode on the fancy horse to the house of "Ipo"
36-b. That is why they praise Oya as "Onipopopo"
37-b. The great one of Oje called the pounded yam-vendor and pounded her head in the pounding pot
38-b. The great one of Oje called the Amala vendor and hit her head on the pot of Amala
39-b. Who will initiate the Muslim into an Oro cult
40-b. The same people are fighting themselves in the house of Oya-Foruke
41-b. Every cloth wishes they are being chosen
42-b. The shirt wishes being more to fill
43-b. When I am praising Oya-dolu (Oya became the stronghold)
44-b. Any Shango worshipper that is around should not hesitate to take his leave (live?)
45-b. At the point Shango killed the people of Otta
46-b. That is where we regard "Asofa"
47-b. At the point where he killed the eran finfin (sweet ram)
48-b. That is where we regard Afin (palace)
49-b. Where nine people died
50-b. That is where we regard ninth point
51-b. Where the locust tree was planted and could not bring forth fruit

### *Oriki* Oya Arogunmola (Itimoko Family)

1-c. Now the turn of Oyadolu, Arogunmola
2-c. Dull market overpowers the trader
3-c. Arogunmola overcomes vagabonds
4-c. I will not praise Oyadelu without praising Shango
5-c. Olunnagun, Baba Adewure (where one prays for oneself)
6-c. Fire knows how to burn (or dance) the father of Jaiyeosinmi (let the world rest)
7-c. Stone that turns suddenly, stone that is very strong
8-c. Stone that eats the spotted, that eats the crawling
9-c. Where he killed the crawling animal
10-c. The place is called Ajifa eat of the crawling
11-c. Where he killed the spotted animals
12-c. Is called Ajofin (eater of the spotted)
13-c. My lord, he who causes dew to drop continuously
14-c. To beat people in hundreds

15-c. Without rain falling, without the thunder striking
16-c. There is no one Shango cannot kill
17-c. My lord, he who makes dew to fall continuously
18-c. To beat people in hundreds
19-c. I will not worship Shango
20-c. Without worshipping Oya
21-c. When Shango wants to fight (or strike)
22-c. He will hide in the house
23-c. When lizard wants to fight
24-c. It will hide in the wall
25-c. It is Shango I will worship
26-c. I will not worship Oya
27-c. Oyadelu, owner of the heaven "ekuru" deadly ekuru
28-c. He who sounds dry skulls loudly

One of the most difficult challenges in assessing the history of the Oya masquerade is dating its creation. The Ijemo family claims that it was created during the reign of Isiyemi, which local oral and written histories agree lasted from 1882 to 1901.[47] The Arogunmola family asserts that Oya was created or introduced to Otta during the era of Oyo imperialism, which the historian Robin Law dates from 1600 to 1836.[48] However, the Arogunmola family also maintains that Oshungbayi, the senior wife of the warrior Arogunmola, was alive when they introduced the Oya masquerade.[49] The British colonial administrator, working with the king of Otta, conferred on her the office of the Iyalode, according to Arogunmola family tradition. R. A. Salako, a local historian and the author of *Ota: Biography of the Foremost Awori Town* (2000), offers a list of the occupants of the Iyalode chieftaincy that supports the Arogunmola family's claim that Oshungbayi was the first one and that she was known as Iyalode Oyinbo, meaning the white man's or Westerner's Iyalode, after a British administrator conferred this title on her. The Oya Arogunmola's *oriki* also refer to Arogunmola as the husband of Iyalode *Oyinbo* (7-a). Salako's list identifies the third Iyalode as having been crowned in 1949.[50] Thus, with colonial rule having begun in the 1890s and a colonial administrator having conferred the title of Iyalode on Oshungbayi, the dating of the origin to 1882–1901, which the Ijemo family suggests for the introduction of the Oya masquerade, appears to be accurate.

## Where and How Warriors Gained Wealth and Honor

Arogunmola left behind his first wife, Oshungbayi, a cloth trader, to maintain the household in Otta while he joined in the war effort near Oyo. The narrative of the experiences of Arogunmola, Moniyepe, and Oshungbayi at a war camp is consistent with oral and written accounts of warriors using Egungun masquerades on

the war front: Egungun masqueraders not only participated in the fighting but also executed war captives brought to camp after the battles.[51] Victorious warriors would seize the Egungun masks of their enemies and later parade them as war trophies.[52] Furthermore, possession of or affiliation with a prominent Egungun mask, or even a renowned masquerader, helped warriors in their competitive struggles with other soldiers on the same side. Egungun brought warriors prestige and illustrated their dominance of the space occupied by their Egungun and, by extension, of other places where it might be performed. Competitions between Egungun masquerades at war camps (such as those in urban contexts during elaborate festival performances) offered their sponsors and supporters an impressive venue where they could assert their dominance and garner support, much as their descendants now do in contemporary masquerade performances.[53] Warriors vied with one another to acquire masquerades and wives, because through these valuable resources they could achieve immortality: wives produced children to continue their bloodlines, and Egungun performances honored them in perpetuity as ancestors.[54]

In light of these considerations, let us further consider the story of Arogunmola and his wives. While at the war camp, Arogunmola, whose name means "he became wealthy through war" (as noted in the *Ewi* Oya Arogunmola *oriki* cited earlier), met Moniyepe, the custodian of an Egungun mask that represented an ideal loyal wife for a warrior. As noted earlier, Moniyepe, an Oyo woman, inherited this Oya mask from her father. Arogunmola asked Moniyepe for her hand in marriage. She accepted the offer on the condition that he would help her honor her late father and other ancestors by performing the Egungun mask she possessed. Because Arogunmola's own father was a masquerade performer and his first wife's father was an Egungun chief, the warrior felt well situated to meet Moniyepe's demand.[55] Her knowledge of the performance, prayers, and *oriki* associated with the Egungun was essential to harnessing the mask's potency when it was animated during performance. By bringing the Egungun mask and knowledge of its ritual usage to her marriage, Moniyepe entered the Arogunmola family with a degree of authority and influence that was likely of value to her co-wife.

Oral traditions that other scholars and I have collected show that the most prominent nearby towns (Lagos and Badagry) had each possessed an Oya Egungun at least several decades before its arrival in Otta.[56] In Egungun mythology, Oya is widely regarded as one of the oldest and most prominent Egungun masquerades; its origins are linked to the beginnings of the Oyo Empire.[57] Oya's distinguishing feature is the large sword that it wields.[58] Otta, however, did not yet have such an Egungun.[59] In linking her fortunes to the ambitious Arogunmola, a warrior who did not yet have his own Egungun, and whose town did not yet have an Egungun Oya, Moniyepe may have been shrewdly positioning herself

and her family's Egungun to their best advantage. Today, Oya is the most prestigious of all the masquerades in the town of Otta, and Moniyepe's name is honored in connection with it.

## Transforming a Warrior into a Wife

While Moniyepe provided the Egungun mask, Oshungbayi (her senior wife) supplied the essential material resources and social and economic networks needed to effectively package, promote, and perform this masquerade. Oya was not the grotesque mask of a violent warrior decorated with skulls or the remains of dead animals; it was a stunning "wife" adorned with beautiful cloth in the style of a wealthy sword-wielding merchant, representing Oya's persona as death mixed with wealth. When the Oya mask was in the possession of Moniyepe's father, it featured Egungun attire known as *egbudu*, in the style of the sack previously favored by Egungun performers in Oyo, which may have looked something like the costume shown in figure 5.3. Oshungbayi, however, created new clothes for the mask.

As a cloth merchant, she was well positioned to know the capacity of cloth to enhance the physical and symbolic presence of the wearer, especially in a masquerade performance.[60] At the core of her networks were market women and the Egungun practitioners, who were needed to gather a large audience from the town. Her father was a wealthy hunter and farmer in addition to being the first *Alaran* of Otta, a high-ranking Egungun from the Ijana ward, and her mother was a wealthy cloth trader from the Isalu Oke compound in the Osi ward.[61] Thus, she came from an influential family possessing the material resources and the economic and ritual affiliations needed to position her more advantageously than the other members of her domestic group to host the inauguration of a new Egungun performance. The material wealth she had accumulated was probably critical to the family's ability to provide a feast for the town and give Arogunmola and Moniyepe opulent cloth to wear for the occasion.

Oshungbayi used her inventory of rich fabrics to supply the Oya Egungun with new clothing: an *agbada*, a long, flowing garment worn historically by predominantly Muslim Hausa men and adopted by the Yoruba elite during the nineteenth century.[62] This *agbada* probably consisted of several kinds of cloth—velvet, damask, cotton, and a valuable, locally produced fabric called *aso oke*. Arogunmola wore the mask made of fine fabrics that Oshungbayi provided. Thus, it can be inferred that a warrior performed as Oya, Shango's (a warrior-king's) loyal wife, parading in the attire of wealthy fashionable men.

Figures 5.4–5.7 show a man, a descendant of Arogunmola, parading a series of vibrant *agbada*. Following the tradition of *alagbada* performers established during Oshungbayi's time, the Oya performer emerged from the Ikotun compound wearing an *agbada* and paraded it throughout the square before return-

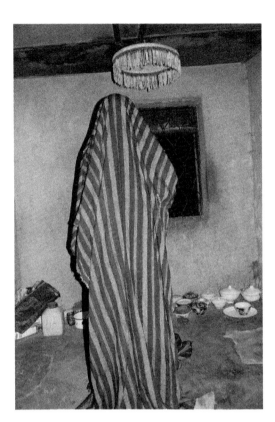

Fig. 5.3. This *Ago*, one of the oldest types of Egungun masquerade attire, is in the possession of Chief Eshorun, the second-highest-ranking Egungun chief in Oshogbo, Oshun State, Nigeria. Photograph by author, August 28, 2006.

ing to the compound to switch to another *agbada*. As the Oya performer returned, companions accompanied him with the previously worn *agbada*, placing it in the middle of the performance space as a demonstration of the extent of the family's wealth. Note the woman carrying a wooden sword in figures 5.5 and 5.6 while engaging the Oya masquerader; the woman stands slightly in front of a group of Arogunmola family members and Egungun praise singers (wearing blue attire) as she lifts her sword to cheer Oya's performance. Contemporary Oya performances show men and women united in their attendance, verbal praise, financial patronage, and visible enthusiasm; they also offer a reflection on the past, to a moment when wives worked together to revise existing family traditions to meet the needs of a new generation and to promote themselves as pioneering leaders. Harmonizing their resources with those of their husbands, these women seized the opportunity to shape how generations of men paraded as "wives"– bringing life, wealth, and protection to their kin, and death, poverty, and vulnerability to their adversaries. The collaboration between the co-wives of the masqueraders

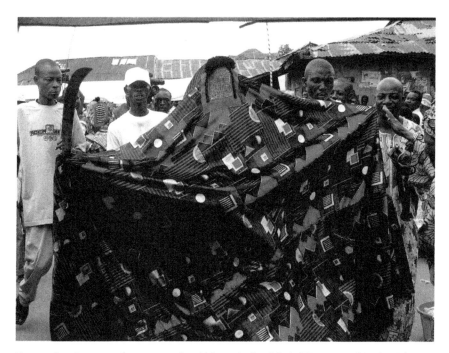

Fig. 5.4. Oya Arogunmola wears a red and blue *agbada* while holding a sword in the right hand. A cameraman documents Oya's performance as "she" closes an Egungun festival. Ikotun compound, Otun ward. Photograph by author, April 17, 2004.

demonstrated in this case exemplifies an aspect of Egungun performances that scholars often neglect in favor of a view of these enactments as sites of unresolved conflicts between such groups of women.

## *The Social, Religious, and Cultural Appeal of Islam*

Oshungbayi surely drew from her social and commercial networks, inviting the inhabitants of Otta to the Arogunmola compound to witness the introduction of the new masquerade. Arogunmola appeared as Oya parading the *agbada*, and Oshungbayi followed closely behind, singing the *oriki* of the Egungun and the Arogunmola family. This reportedly marked the first time that the entire population of Otta descended on one compound to witness the performance of an Egungun wearing an *agbada*.[63]

Oshungbayi's decision to sew the cloth in the form of an *agbada* (as noted, the attire worn by Hausa Muslim men) is a powerful visual representation of historical bonds forged between the spheres of Egungun and Islam over at least the preceding century; these bonds grew from the appeal of aspects of Islam to

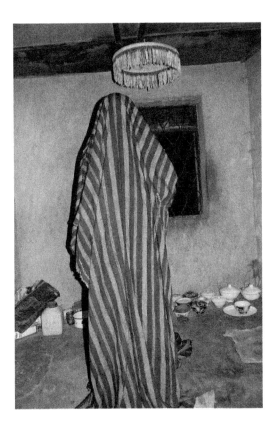

Fig. 5.3. This *Ago*, one of the oldest types of Egungun masquerade attire, is in the possession of Chief Eshorun, the second-highest-ranking Egungun chief in Oshogbo, Oshun State, Nigeria. Photograph by author, August 28, 2006.

ing to the compound to switch to another *agbada*. As the Oya performer returned, companions accompanied him with the previously worn *agbada*, placing it in the middle of the performance space as a demonstration of the extent of the family's wealth. Note the woman carrying a wooden sword in figures 5.5 and 5.6 while engaging the Oya masquerader; the woman stands slightly in front of a group of Arogunmola family members and Egungun praise singers (wearing blue attire) as she lifts her sword to cheer Oya's performance. Contemporary Oya performances show men and women united in their attendance, verbal praise, financial patronage, and visible enthusiasm; they also offer a reflection on the past, to a moment when wives worked together to revise existing family traditions to meet the needs of a new generation and to promote themselves as pioneering leaders. Harmonizing their resources with those of their husbands, these women seized the opportunity to shape how generations of men paraded as "wives"—bringing life, wealth, and protection to their kin, and death, poverty, and vulnerability to their adversaries. The collaboration between the co-wives of the masqueraders

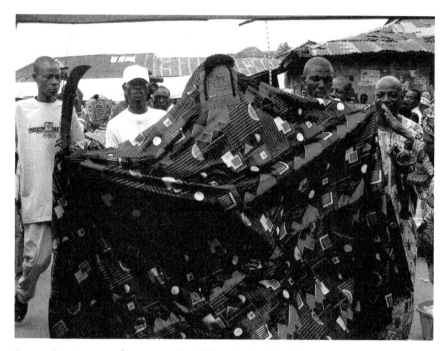

Fig. 5.4. Oya Arogunmola wears a red and blue *agbada* while holding a sword in the right hand. A cameraman documents Oya's performance as "she" closes an Egungun festival. Ikotun compound, Otun ward. Photograph by author, April 17, 2004.

demonstrated in this case exemplifies an aspect of Egungun performances that scholars often neglect in favor of a view of these enactments as sites of unresolved conflicts between such groups of women.

## The Social, Religious, and Cultural Appeal of Islam

Oshungbayi surely drew from her social and commercial networks, inviting the inhabitants of Otta to the Arogunmola compound to witness the introduction of the new masquerade. Arogunmola appeared as Oya parading the *agbada*, and Oshungbayi followed closely behind, singing the *oriki* of the Egungun and the Arogunmola family. This reportedly marked the first time that the entire population of Otta descended on one compound to witness the performance of an Egungun wearing an *agbada*.[63]

Oshungbayi's decision to sew the cloth in the form of an *agbada* (as noted, the attire worn by Hausa Muslim men) is a powerful visual representation of historical bonds forged between the spheres of Egungun and Islam over at least the preceding century; these bonds grew from the appeal of aspects of Islam to

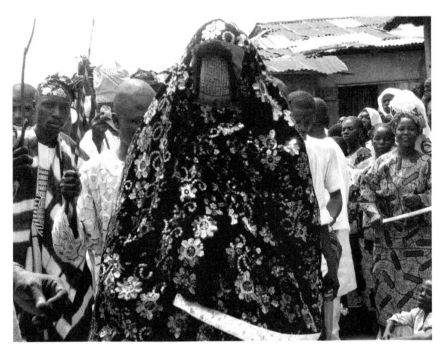

Fig. 5.5. The same Oya Arogunmola performer who appears in figure 5.4 returns wearing another *agbada*. It leads a procession of more than ten followers who collect monetary offerings and directs the audience and the Oya performer. In this instance, Oya greets the *Iya Agba Oje*, a group of women Egungun chiefs who oversee the affairs of Egungun at Otta. The photographer of this picture is standing in front of these women, thus leaving them out of view. Although the women chiefs are out of sight, their influence is often felt, as described in verses 10-b to 21-b of the *Ewi* Oya Arogunmola. Photograph by author, April 17, 2004.

the Yoruba. Over that time, West African Muslims contributed a number of elements to Yoruba culture. In imperial Oyo, Muslim clerics produced amulets and charms and served as trusted advisors.[64] Muslim merchants facilitated long-distance trade between Oyo and its northern Islamicized neighbors. Muslim warriors, although often remembered as being among the dissidents who revolted against Oyo in the 1830s, were prominent warlords and soldiers in Oyo-populated warrior states, such as Ibadan and Ijaye.[65] In the 1850s, some of the leading Otta and Lagos chiefs and their followers in nearby Lagos embraced Islam, and the king and the most senior Egungun chief at Otta decided to rear selected children in their households as Muslims following the direction of diviners.[66] (The Yoruba practice of Ifa divination is itself a derivation of Islamic ritual practice.[67]) Muslims also comprised a powerful bloc of able-bodied men, as Otta's resident missionary often mentioned.[68] Furthermore,

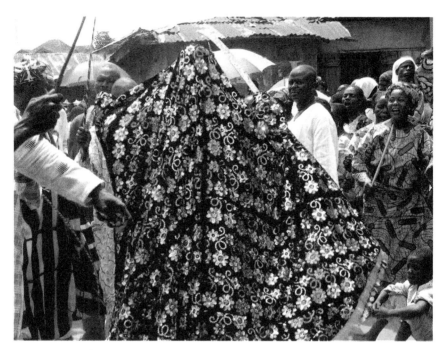

Fig. 5.6. A view of Oya Arogunmola from behind wearing the same *agbada* as shown in figure 5.5. The woman to the right and front of Oya holds a painted wooden sword in solidarity with Oya. Ikotun compound, Otun ward. Photograph by author, April 17, 2004.

representations of Muslims appear in Yoruba masquerade performances. In 1854, a Gelede mask identified as a "Mohammedan with his long beard and head-dress" appeared in a Gelede performance reportedly attended by the majority of Otta's inhabitants.[69]

Yet the relationship between Egungun and Islam took many forms. Some Yoruba Muslims increasingly rejected or distanced themselves from Egungun, according to many writers, because they interpreted it as the religion of their infidel ancestors and therefore as antithetical to Islam.[70] The Fulani jihad of Uthman Dan Fidio—in theory—targeted backsliding Muslims, among others, when its Yoruba supporters at Ilorin sacked the capital of Oyo in the 1830s.[71] Samuel Johnson records an account according to which the head slave of the emir (king) of Ilorin confiscated and discarded the Egungun masks during the sacking of Oyo. Egungun masqueraders were barred from performing in Ilorin after it came under the rule of a Muslim emir.[72] Nevertheless, an *agbada*-parading Oya masquerade may have served the purpose of bridging divisions between practitioners of Egungun and Islam.

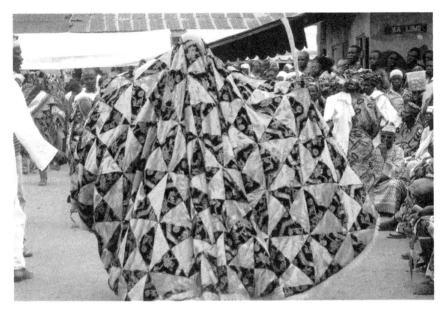

Fig. 5.7. Oya Arogumola has returned to the performance space once again, this time wearing yet another *agbada*. In this figure, Oya displays a flamboyant gold, green, and black *agbada* before a large crowd of observers. Other Egungun masqueraders representing other categories of performers appear in the distant background to the left. Ikotun compound, Otun ward. Photograph by author, April 17, 2004.

Peel cites an entry from a Christian Mission Society missionary named Townsend living in the nearby town of Abeokuta in 1847 in which he writes that Muslim attire was becoming "very fashionable with the young and gay." Peel notes that, although Townsend does not mention a religious motive for the adoption of Muslim attire, the incident marks an early stage in a community that was internalizing its identification with Islam. There are hints that in some Yoruba communities Islam was associated with Oyo migrants, who were among the principal vectors for the religion's spread. Islam was part of an "Oyo style of things" according to Peel, who cites missionary accounts to support his assertion.[73] Otta's first Muslim ruler (Eleshi) was crowned king in 1902, immediately after the death of the king (Isiyemi) who witnessed the introduction of the path-breaking Oya masquerade.[74] Then in 1905, the daughter of the *Oloponda* of Otta gave birth to a son, who began instruction in Islam under the town's chief imam in 1918 and continued to demonstrate promise by reading the Quran sixty times in 1922.[75] The social, religious, and cultural appeal of the new masquerade likely fueled Oshungbayi's decision to mix Yoruba ritual practices and paraphernalia associated with masquerades with those of warrior, Muslim, and merchant elites.

*Recentering Masquerade Practice and Gender,*
*Generational, and Ethnic Relations*

As a resident of Otun (one of Otta's Awori wards), the financer of a popular Egun-gun in Oyo culture, and a respected wealthy merchant, Oshungbayi indirectly was able to intervene in the contentious politics of the wards. Her intervention is inferred from the adoption of *alagbada* masquerades by families throughout the four wards of Otta based on the recognition of the capacity of a mesmerizing Egungun performance to project its sponsor's social and commercial status throughout a community whose members needed patrons. Oshungbayi asserted her power and prestige in the Egungun domain and, by extension, advanced the interests of Awori who were engaged in protracted power struggles against the Ijana's primarily Oyo residents. Oya joined the select group of masquerades based at Ijana that performed important rituals on behalf of the town. It became such a key Egungun that other families across the town either created new Egungun or refashioned existing masquerades to join a new group of *alagbada* Egungun, among which Oya was the pioneer.

The Oya masquerade emerged at a moment when Otun's inhabitants (who were of Awori descent) were attempting to challenge the hegemony of both the Ijana ward's warriors of Oyo descent, who occupied the town's highest political and military offices (excluding the kingship), and the chiefs of the Egungun society. Based in the Otun ward, the Oya masquerade helped elevate the ward's status, which was one of the two indigenous areas from which the king of Otta was selected.

At the same time, the Egungun chiefs and their supporters in the Ijana ward should have been prepared to accept, if not embrace, the Egungun Oya for reasons having to do with a prominent tradition within Yoruba culture. One of the main factors that made Oya attractive to Arogunmola and his supporters at Otun, and also to the Egungun hierarchy at Ijana, was its place among the myths of the Oyo people. Given Oya's status as an ideal wife in their mythology, Oya appealed to the Oyo families at Ijana because it brought greater status to the institution of Egungun in Otta. It is only fitting that the work of Arogunmola's two wives in establishing an Oya masquerade in Otta not only resonated with but also reinforced the association of Oya in Oyo mythology with the ideal of a loyal wife and powerful woman with whom to reckon.

Moniyepe, the custodian of her father's Egungun, must have found a measure of comfort for herself and praise in the eyes of others by preserving her ancestors' legacy through carrying on the Oya Egungun.[76] Moniyepe and Oshungbayi both shaped that legacy through their roles as performers of the *oriki*, calling out the Oya masquerade and the power it possessed as the embodiment of a loyal, self-possessed wife.[77] What they did for the Oya masquerade at Otta shaped the

social and cultural geographies and the balance of political power in the town, the implications of which are still evident today.

Praise songs often vacillate between showmanship and substance, entertainment and reverence, self-aggrandizement and praising others.[78] Oya performances offered both of the wives opportunities to boast of their personal achievements and praise their own ancestral lineages. By performing praise songs, Oshungbayi drew attention to her new masquerade and to her husband, increasing their visibility and status. She likely attracted attention as the most prominent local actor associated with this masquerade because, unlike Arogunmola, she had the most consistent presence in the town, particularly within the merchant community.[79]

## Trading Cloth for a Crown

In 1921 it was Oshungbayi, not her husband or her co-wife, who acquired the chieftaincy title of Iyalode. Interpretations of the Iyalode's functions vary from "mother of the town" to "queen of the ladies" to "king of women" to "head of the market." The power vested in holders of this office appears to have been weaker in the older, highly centralized kingdoms (i.e., Oyo and Ife) than in the new warrior states (Ibadan and Abeokuta), where economic power could more easily open up access to political power. The Iyalode sat on the king's council, where, particularly in Ibadan and Abeokuta, she and other members shaped economic and military strategies.

Scholars debate whether the emergence of the title of Iyalode reflects women's longstanding importance in Yoruba political culture or exclusion from political and economic life during the nineteenth-century wars.[80] The protracted period of warfare fueled an enduring threat and reality of violence that privileged men. The Iyalode's capacity to mobilize provisions to support the war efforts of their community, Awe, Denzer, Matory, and McIntosh argue, ultimately garnered them political influence. Oshungbayi's acquisition of this title more than two decades after the end of the period of warfare and well into the colonial period suggests that colonialism contributed to the development of a new "traditional" chieftaincy office for women. One event that occurred around the time of her conferment, which Iyalode Oshungbayi may have mediated, was a protest in Otta in the second decade of the twentieth century against the taxation of women.[81]

In the masquerade's praise songs, the warrior and his two wives are collectively regarded as "owners of the big cloth," a reference to the *agbada*. Verses that appear to refer to Oshungbayi characterize her as "a wealthy woman with flamboyant dresses" (line 8-a.), "looking like a king's wife, whereas she is not a king's wife" (lines 11-a and 12-a) and "the one who makes for herself and also for the lazy ones" (line 15-a).

To understand the controversy surrounding the Oya masquerades, it is essential to appreciate the ways in which Otta's history is remembered and expressed. The references to Shango in the *oriki* of Oya Arogunmola offered by the Arogunmola and Itimoko families reveal the loyalties of the performers. In verse 17-a ("Through misunderstanding she became the friend of Shango") of the Arogunmola version, a disagreement serves as the context for developing a friendship with Shango. Because it was the Itimoko family that introduced Shango to the Otta community, "Shango" refers to the Itimoko family. This verse could be interpreted as satire. Conversely, several verses of the Itimoko version reveal loyalty to Shango as the patron deity of the Itimoko family as superseding praise of Oya. These verses include verse 4-c ("I will not praise Oyadelu without praising Shango"), verses 19-c through 20-c ("I will not worship Shango, Without worshipping Oya"), and verses 25-c through 26-c ("It is Shango I will worship, I will not worship Oya").

The *ewi* (a genre of Egungun poetry) of Oya Arogunmola appeals to the spirits of the "Mothers." Otta has long been known as *Ilu Aje*, the city of the "Mothers"; *aje* is a term loosely, and arguably inappropriately, but also commonly, translated as "witches." Oral traditions preserved in the *Odu Ifa* corpus identify the town as founded and owned by the "Mothers."[82] Oyede III, the current king of Otta, along with several high-ranking Egungun chiefs, identifies the *Iya Agba Oje* (who are affiliated with the Itimoko family) as the power behind the Egungun practice at Otta.[83] Verses 11-b through 15-b—"Honor to my witch-mother (Oshonronga), Who is expected in sitting down, A clean dove that dines with the eagles, A clean bird that eats in the open farm, Honor to my mother of power"—are filled with references to beautiful and powerful birds and mothers, reflecting the shape-shifting qualities and spiritual embodiments of the "Mothers." The direct and indirect references to the "Mothers" in the *ewi* of the Arogunmola masquerade appeal to a power that the missionaries and scholars often overlook in their discussions of Egungun belief and practice: they support the notion that no human endeavor, including Egungun performance, has been successful without the consent of an ever-present invisible force that takes many forms and has been known as the "Mothers." From the perspective of an Arogunmola family member, praising the "Mothers" through an Oya Arogunmola poem transcends familial loyalties by indirectly placating the *Iya Agba Oje*, an Itimoko-affiliated group believed to be the living embodiment of the "Mothers."

Oral traditions derived from the descendants of Arogunmola, Moniyepe, and Oshungbayi arguably have made as important a contribution to the legacies of this family as the roles that such sources claim these historical figures performed. Arogunmola's children, however, appeared to have gradually lost interest in maintaining the tradition from the 1920s to the 1950s. Beginning in the 1950s, a maternal relative in the Ijemo family took on the responsibility of organ-

izing and performing Oya. This masquerade remained under Ijemo control with limited support from Arogunmola's descendants until the 1980s, when their interest in it was renewed, for reasons that remain unclear.

Since Oya's inaugural performance during the reign of Isiyemi (1882–1901), *alagbada*, the genre of Egungun performances inspired by the Arogunmola family, has grown in popularity. This genre has never been and is still not an exclusively male performance. Barber discusses the ways in which women *oriki* performers direct the action of the Egungun masquerader with appellations awakening its powers.[84] Even beyond the domain of Egungun, women's public performances of praise poetry, as Barber notes, offer them opportunities for showmanship and self-display, in which they sometimes boast of their own feats.[85] A similar pattern is evident in the form of references to the two wives of Arogunmola in the praise songs of the Oya masquerade and as performers of these songs during their lifetimes.

Barber's discussion of a bride who performs the *oriki* of her parents' and her husband's lineages to invite their blessings of protection from death and disease and of fertility and wealth sheds light on the experiences of Moniyepe in Otta.[86] Might the Oya performance have provided the opportunity for a new bride to appease spiritual forces, introduce herself to her maternal kin, build her husband's reputation, cultivate trust, and assert her power? Barber makes another point that needs to be mentioned here—women who attempted to trade or leverage their economic success for political capital were often viewed as threatening to powerful men and were sometimes targeted by violence.[87] Although trade with Europeans and the lack of prior gender associations did open up space for some women, they did so in a limited way. To avoid being labeled as witches, women needed to use subtle tactics, such as public singing, to get their points across.[88]

Perhaps because of their bias against the practice of Egungun and their limited understanding of it, the missionaries were unable to see how Egungun performances were changing as they responded to the crises of this age. They failed to notice that, as the protracted period of warfare came to a close, the ideal of the warrior was changing from one of violence on the battlefield to one of strength in upholding the structure of the community by attracting followers with demonstrations of generosity. In the aftermath of the war, Egungun became a site of competition that was more social and political than physical; its use declined as a tool of terror, designed to give advantages against the enemy, as it had done in the long wars. The masquerade practice was becoming a multifaceted expression of spiritual power that could be wielded for a variety of purposes by many constituencies and thus could be respected or fought against, depending on how it was displayed. The story of the first Oya masquerade at Otta indicates that this Egungun was enacted not to *persecute* women but to *honor* them, and to supplant the violent warrior Egungun ethic with an ambitious ethic of civic responsibility.

The Oya masquerade arguably offered Oshungbayi such a powerful means of narrating and projecting her achievements and reputation that she became a desirable ally of a British colonial administrator who was based in the provincial headquarters in Abeokuta. Her rise demonstrates some of the attributes that made many other African women eligible for entry into the early colonial apparatus. For instance, the historian Lorelle Semley illustrates the ascendancy of two women from the Yoruba town of Ketu who were appointed as French colonial intermediaries in 1911 (before being dismissed six years after taking office). A policy of elevating non-elites to the post of district chief under French colonial rule made it possible for Alada Abuke, a royal wife and outspoken supporter of the French, to obtain an official post as tax collector, labor recruiter, and supervisor of subordinate village heads. Ya Segen gained such notoriety as an *orisha* priestess with religious and political influence that French administrators temporarily regarded her as almost an assistant district head before losing faith in her ability to implement colonial policy.[89] Stature among their peers made Oshungbayi and the two Ketu women of Semley's study legible to the colonial regime. Yet, Oshungbayi's position as the Iyalode also made her accountable to the king's advisors and the king of the Otta district. Thus it seems she did not interact directly with colonial officials and so was less dependent than the two Ketu women on their ongoing evaluation of her work.

The historian Nwando Achebe offers a detailed account of the rise and fall of an exceptional Igbo woman who became a colonial collaborator and organizer of a masquerade that later became her downfall. In Enugu-Ezike in the Nsukka Division, Ahebi Ugbabe, a daughter of farmers, endured exile and being forced into prostitution before becoming a multilingual merchant and British ally. She went on to aid the British in invading and colonizing the same community that had exiled her in the days of her youth. She acquired several newly created colonial positions that were available only to men, and thus became symbolically a "man" while moving up the ranks—from headman, warrant chief (the only woman in colonial Nigeria to occupy the post), and then to king by the mid-1920s. In 1939, she reached the limits of her stature as a "man" when she created and called out a masked spirit, deemed the domain of biological men; for committing such an egregious act, in addition to working with the British to exclude the male elders from the "day-to-day running and decision-making of the state," the male elders confiscated her masquerade. The British backed the local elders against Ugbabe in court.[90] Achebe's analysis of the gender transformations that Ugbabe underwent at almost the same time but in a different region of colonial administration suggests the opportunities, as well as their limitations, available to women who behaved more like husbands than wives.

*Interfamily Conflicts and the Spread of* Alagbada *Masquerades*

Between 1902 and 1927, other families in Otta began to emulate the new style of
Egungun performer introduced by the Arogunmola family. According to a tra-
dition narrated by members of the family that perform the Lebe Oko masquer-
ade, Amodu Oke Akanbiyi introduced an *alagbada* masquerade named Lebe that
paraded *agbadas* similar to Oya's attire. Akanbiyi's maternal kin, the Itimoko
family, collaborated with Akanbiyi during the first Lebe Oke performances. After
Akanbiyi inaugurated a new Egungun, he died. For reasons that are silent in the
tradition, no adult male among his children was available to carry on his Egun-
gun; his children buried Akanbiyi's body in a tomb under the floor of his home
and kept the cloth of the Lebe masquerade close to him—hence it acquired the
name Lebe Oke. Akanbiyi's death, combined with the absence of sons ready to
carry on their father's masquerade, created an opportunity for the family to fur-
ther its collaboration with its Itimoko relatives by taking the Lebe Oke mask to
the Itimoko family, Akanbiyi's maternal relatives, to perform the Lebe Oke mas-
querade. As Oyo immigrants who occupied many of the Egungun chieftaincy of-
fices, the Itimoko family was ready and eager to perform Lebe Oko.

While the Itimoko family held custody of Lebe Oko, Akanbiyi's daughter,
Adelowo, gave birth to several *abiku*, infants who died shortly after birth. She
decided to consult the Ifa oracle with the hope of identifying the source of her
affliction with *abiku*. Telling her that there was a practice of honoring the ances-
tors of her family that had been abandoned, Ifa directed Adelowo to revive the
practice of an Egungun in her father's family. She informed Oba Ileshi, who was
then the king, of the situation, and he responded by demanding that the Itimoko
family return the cloth of the Lebe Oke masquerade to Akanbiyi's family. At this
point, the Akanbiyi and Itimoko families discontinued their work together in
performing the Lebe masquerade. Nine days later, the Itimoko family brought the
cloth to the palace, where the king had been mediating the conflict. The Itimoko
family soon commissioned the sewing of another cloth to use to perform their
own Lebe masquerade under the name Lebe Itimoko.

Meanwhile, the king advised Adelowo to cover her body with the cloth of
Lebe Oke so she could gain the blessings of her ancestors in preventing infant
mortality. Adelowo complied. Still she struggled to decide what to do with the
cloth because there was no one in her family prepared to carry it in performance.
She consulted Ifa a second time and received instructions to create a new *alag-
bada* masquerade named Olanboowa, meaning "wealth crowded us"; the name
was shortened to Laboo. She followed Ifa's direction. This is remembered as the first
time that a new Egungun, Laboo, was created from an existing one, Lebe Oke,
following a dispute between members of families who had collaborated to perform
an Egungun masquerade.[91] The creation of Laboo, which later became known as

Laboo Idire, likely is remembered in this way because many more Egungun masquerades that belong to the *alagbada* group emerged after the dispute was resolved.

Following the death of Oba Eleshi and the ascension of a new king, Oba Aro-lagbade I, to the office of the *Olota* of Otta in 1927, new interfamilial conflicts arose and fueled the expansion of the *alagbada* group. Adelowo's family per-formed the Laboo masquerade with another family, known as Falola, in the lat-ter's compound as part of its collaboration with that family. When a crisis caused irreconcilable differences between the Akanbiyi and Itimoko families, Laboo's carrier and others members of Adelowo's family stopped going to Falola and created their own *alagbada* masquerade. Adelowo's family named the new mas-querade Laboo Idire. These events occurred before the split between the Aro-gunmola and Ijemo families leading to the Oya Arogunmola and Oya Ijemo masquerades.

The organizers of Otta's Egungun festival remember Laboo Falola as the se-nior of the two Laboo, and thus in accord with Yoruba notions of seniority they schedule it before the Laboo Falola, with each having its own day to perform. The fixing of the order of the two Laboo occurred during the reign of Oba Oyede II (1927–1947). Chief Ojugbele identifies 1938 as the year when the order of the La-boo masquerades was determined for Otta's Egungun festival. Ojugbele identi-fies Oyeshiku as the president of Otta's Customary Court and presider over a case involving a dispute over the order of the Lebes' performances. The record of an Otta district court meeting that had nothing to do with the Lebe case offers sup-port for Ojugbele's reference to Oyeshiku's position. Ojugbele adds that it was fol-lowing Oyeshiku's ruling that the Itimoko family inaugurated Lebe Itimoko.[92]

The history of Lebe is contested, with members of the Itimoko family narrat-ing an alternative version. The Itimoko family claims that its ancestors brought the first Lebe masquerade (known as Lebe Itimoko) to Otta from Oyo. When the Itimoko family performed the newly arrived Lebe masquerade, members of the Akanbiyi family joined in. Then, in 1938, a conflict arose between the Itimoko and Akanbiyi families, with each vying for ownership of Lebe. The families took the issue before the newly established Customary Court of Otta, which ruled for the Akanbiyi family. The Itimoko family responded by commissioning the sewing of a new cloth and having it paraded as Lebe Itimoko while the Akanbiyi family continued to organize its own Lebe performance known as Lebe Oke.[93]

The history of Lebe Oke illustrates more clearly than the history of Oya Aro-gunmola a woman's capacity to assert control of an Egungun in her patrilin-eage. Adelowo, the daughter of the creator of Lebe Oke, received direction from Ifa to revive the dormant Lebe masquerade as a solution to infant mortality. Her kinship status enabled her to acquire the Lebe mask and cover herself with it. Typically, it was regarded as taboo for a woman to touch an Egungun cloth.

However, the combination of being plagued with children who died shortly after birth and Ifa's mandate that she offer a sacrifice to her ancestors through covering herself with the cloth enabled her to obtain a temporary reprieve from Egungun's normal taboo. What is more, when she consulted Ifa a second time she acquired the authority to create a new Egungun known as Laboo that—as the meaning of its name indicates—would celebrate Egungun as a source and expression of wealth. Her sex prevented her, however, from carrying either the Lebe Oko or the Laboo mask. The rival Itimoko family contested Adelowo's claim to the Lebe masquerade by asserting both its descent from Oyo and Lebe's origin in an Oyo town.[94] At the same time, the proliferation of Egungun masquerades enabled not only individuals and families to assert their identities but also the use of performance to engage in a discourse about power.

Margaret Thompson Drewal's *Yoruba Ritual* (1992) offers an insightful view into the ways in which masquerade rituals not only demonstrate what is but also create and bring into being new possibilities: "Egungun performances reshape perceptions of the world and give concrete form to ontological concepts. Ritual specialists bring that which is normally inaccessible, unseen, or imagined, into the phenomenal world where it can be observed and contemplated. Through practical mastery of performance techniques, the maskers manipulate the perceptual world, the world as it is experienced daily; they play upon, embellish, and transform reality. The as if becomes is as illusion becomes its own reality, or, more appropriately, illusion reveals an otherwise undisclosed reality. The performers possess *ase*, the power to bring things into existence."[95]

This expanded definition of Egungun performers is useful when exploring the origin of an entirely new group of masquerades, the *alagbadas* led by Oya, Lebe, and Laboo. Seen in this light, patrons and matrons, masqueraders and praise singers, husbands and wives, and fathers and daughters all function as performers. Their work provides them with opportunities to renegotiate their relationships with one another and with the world around them.

The traditional understanding of the role of gender and of the part women play in masquerade practices that is informed primarily by the accounts of colonial missionaries and other officials leaves much to be desired. I discovered fresh insights into these social and political dynamics by focusing on the origins of the Oya Arogunmola masquerade, in which two of Arogunmola's wives played prominent roles in realigning axes of power in Otta. Moniyepe brought her father's Egungun to her marriage, and Oshungbayi used her wealth and resources as a successful cloth merchant to confer prestige on the masquerade. I also discovered that Adelowo, Akanbiyi's daughter, played a powerful role in bringing the Lebe Oke and Laboo Idire masquerades to Otta by reviving her father's Egungun and creating a new Egungun to prevent infant mortality and celebrate her family's wealth.

As wives and daughters, these women played the most important roles in establishing and developing a new mode of performance that paralleled the structure of Gelede performances at Otta. Thus a blanket assessment of Egungun as antithetical to women and hostile to the female gender is incorrect. Indeed, as masquerade practices have evolved over the course of the twentieth and into the twenty-first centuries, women have if anything assumed even greater prominence through masquerade performances, irrespective of the gender of those who carry the masks.

## Notes

1. Robin Law, "Historiography of the Commercial Transition in Nineteenth Century West Africa," in *African Historiography: Essays in Honour of Jacob Ade Ajayi*, ed. Toyin Falola (Harlow: Longman, 1991).

2. Samuel Johnson, *History of the Yoruba: From the Earliest Times to the Beginning of the British Protectorate* (Lagos: C. M. S. Bookshop, 1921); Toyin Falola, *Yoruba Historiography* (Madison: African Studies Program, University of Wisconsin–Madison, 1991).

3. Kristin Mann, *Slavery and the Birth of an African City: Lagos, 1760–1900* (Bloomington: Indiana University Press, 2007), 84.

4. B. A. Agiri, "Kola in Western Nigeria, 1850–1950: A History of the Cultivation of Cola Nitida in Egba-Owode, Ijebu-Remo, Iwo and Ota Areas" (Ph.D. diss., University of Wisconsin, 1972), 35, 56–58; Mann, *Slavery and the Birth of an African City.*

5. James White, August 8, 1861, from journal ending September 25, 1861; Letter, May 4, 1863. See also J. F. Ade Ajayi, *Christian Missions in Nigeria, 1841–1891: The Making of a New Elite* (London: Longman, 1965); Robert Smith, *The Lagos Consulate, 1851–1861* (Berkeley: University of California Press, 1979); Mann, *Slavery and the Birth of an African City.*

6. Nigerian National Archives, Abeokuta, "Otta Affairs: Brief History of Otta" (Abeokuta, 1933); James White, from journal ending September 25, 1865.

7. Johnson, *History of the Yoruba*, 643–659, 70; Agiri, "Kola in Western Nigeria," 19–20; J. A. Atanda, *The New Oyo Empire: Indirect Rule and Change in Western Nigeria 1894–1934* (New York: Longman, 1973), chapter 2; Judith A. Byfield, *The Bluest Hands: A Social and Economic History of Women Dyers in Abeokuta (Nigeria), 1890–1940* (Portsmouth, NH: Heinemann, 2002), 44–48.

8. Atanda, *The New Oyo Empire*, 90; A. I. Asiwaju, *Western Yorubaland under European Rule, 1889–1945: A Comparative Analysis of French and British Colonialism* (London: Longman, 1976).

9. Nigerian National Archives, Abeokuta, ED 1146/6, J. Hinian Scott, "Otta District Council Chieftaincy Committee Meetings: Minutes of the Meeting Held at Olota's Palace Otta on Wednesday the 10th of April" (1935).

10. Nigerian National Archives, Abeokuta, "Otta Affairs"; Nigeria National Archives, Ibadan, Abe. Prof. 4, D33, "Abeokuta Province: A Report on the Otta District, Egba Division" (1936), 3–4, 8–9; Nigeria National Archives, Ibadan, Otta District Court, "Population Census, Historical Events" (1962).

11. Agiri, "Kola in Western Nigeria," 83–85.

12. Kristin Mann, *Marrying Well: Marriage, Status, and Social Change among the Educated Elite in Colonial Lagos* (Cambridge: Cambridge University Press, 1985); Law, "Historiography

of the Commercial Transition"; Kristin Mann and Richard Roberts, *Law in Colonial Africa* (Portsmouth, NH: Heinemann, 1991); Martin Lynn, *Commerce and Economic Change in West Africa: The Palm Oil Trade in the Nineteenth Century* (Cambridge: Cambridge University Press, 1997); Mann, *Slavery and the Birth of an African City*.

13. Marjorie Keniston McIntosh, *Yoruba Women, Work, and Social Change* (Bloomington: Indiana University Press, 2009).

14. A. G. Hopkins, "Economic Imperialism in West Africa: Lagos, 1880–1892," *Economic History Review*, 21, no. 3 (1968): 580–606; Law, "Historiography of the Commercial Transition"; Francine Shields, "Palm Oil and Power: Women in an Era of Economic and Social Transition in 19th Century Yorubaland (South-Western Nigeria)" (PhD diss., University of Stirling, 1997).

15. Byfield, *The Bluest Hands*, 20.

16. Mann, *Slavery and the Birth of an African City*, 47–48.

17. Johnson, *History of the Yoruba*.

18. Karin Barber, *I Could Speak until Tomorrow: Oriki, Women and the Past in a Yoruba Town* (Washington, DC: Smithsonian Institution Press, 1991); Robin Law, "'Legitimate' Trade and Gender Relations in Yorubaland and Dahomey," in *From Slave Trade to "Legitimate" Commerce: The Commercial Transition in Nineteenth-Century West Africa*, ed. Robin Law (Cambridge: Cambridge University Press, 1995), 195–214; Shields, "Palm Oil and Power."

19. The Saint Michael African Church was established at Otta in 1904. The local Muslim community built the Otta Central Mosque in 1918. Secretary Adesope Sanusi, "Population Census 1982 Historical Events" (Otta District Council, n.d.).

20. Johnson, *History of the Yoruba*, 30.

21. White, January 13, 1871, from journal ending March 25, 1871.

22. Babatunde Lawal, *The Gelede Spectacle: Art, Gender, and Social Harmony in an African Culture* (Seattle: University of Washington Press, 1996), 251–252.

23. Ibid., 260.

24. White, Annual letter to Major Hector Strait, December 31, 1857.

25. Henry John Drewal and Margaret Thompson Drewal, *Gelede: Art and Female Power among the Yoruba* (Bloomington: Indiana University Press, 1983), 149.

26. "Colonial and Indian Exhibition Circular," *Lagos Observer* (Lagos, Nigeria), November 5, 1885.

27. Drewal and Drewal, *Gelede*, 188–189.

28. See chapters 1 and 4 in this book.

29. Law, "'Legitimate' Trade and Gender Relations," 207.

30. Johnson, *History of the Yoruba*; Law, "'Legitimate' Trade and Gender Relations," 209; Shields, "Palm Oil and Power."

31. Pierre Verger, "Grandeur et Decadence du Culte de Iyami Osoronga: Ma Mere La Sorciere Chez Les Yoruba," *Journal de la Societe des Africanistes* 35, no. 1 (1965): 201–219; Joel Adedeji, "The Alarinjo Theatre: The Study of a Yoruba Theatrical Art from Its Earliest Beginnings to the Present Times" (PhD diss., University of Ibadan, 1969); Oludare Olajubu and J. R. Ojo, "Some Aspects of Oyo Yoruba Masquerades," *Africa* 47, no. 3 (1977): 253–275; Margaret Thompson Drewal and Henry John Drewal, "More Powerful than Each Other: An Egbado Classification of Egungun," *African Arts* 11, no. 3 (1978): 28–39, 99.

32. Sandra T. Barnes, "Ritual, Power, and Outside Knowledge," *Journal of Religion in Africa* 20, no. 3 (1990): 248–268; Barber, *I Could Speak until Tomorrow*; James Matory, *Sex and the Empire That Is No More: Gender and the Politics of Metaphor in Oyo Yoruba Religion* (Minneapolis: University of Minnesota Press, 1994).

33. See chapter 2 for more discussion of the relationship of a Yoruba model of wifeliness to the Oyo imperial administration.

34. James Matory, *Sex and the Empire That Is No More: Gender and the Politics of Metaphor in Oyo Yoruba Religion*, 2nd ed. (Minneapolis: University of Minnesota Press, 2005), xvii.

35. Ibid., 1–25.

36. Ibid.

37. Nigerian National Archives, Abeokuta, "Otta Affairs"; Nigerian National Archives, Ibadan, Abe. Prof. 4, D33, "Abeokuta Province," 3–4, 8–9; Nigerian National Archives, Ibadan, Otta District Court, "Population Census, Historical Events."

38. Oyewumi uses linguistic evidence to argue that the terms *oko* and *iyawo*, generally interpreted to mean "husband" and "wife," respectively, actually connote insider and outsider status in a lineage. Thus, a man who is married occupies the status of *oko* (husband) in the lineage of his birth and of *iyawo* (wife) in the lineage of his wife and vice versa. Oyeronke Oyewumi, *The Invention of Women: Making an African Sense of Western Gender Discourses* (Minneapolis: University of Minnesota Press, 1997).

39. Barber, *I Could Speak until Tomorrow*.

40. Bolanle Awe, "Notes on Oriki and Warfare in Yorubaland," in *Yoruba Oral Tradition: Poetry in Music, Dance, and Drama*, ed. Wande Abimbola (Ile-Ife: Department of African Languages and Literature, University of Ife, 1975), 267–292; Awe, "Praise Poems as Historical Data: The Example of the Yoruba Oriki," *Africa* 44, no. 4 (1974): 331–349; S. A. Babalola, *Awon Oriki Orile* (Glasgow: Collins, 1967).

41. Bearing in mind Barber's awareness of the complex relationship that *oriki* have to the past, this chapter draws on *oriki* and another set of oral traditions known as *itan* (stories or narratives), which she claims are preserved and recited primarily by men. Her interpretations are the product of a vast stock of knowledge amassed over more than a decade of experiences living, teaching, conducting research, and participating in theatrical performances in Nigeria. Her mastery of the Yoruba language rivals that of many "native" speakers.

42. Oya's contested histories are chronicled in oral traditions and in court records such as judgments, transcripts of testimonies, and schedules of Egungun festivals from the 1970s to 1990s.

43. A group of Egungun chiefs known as the *Oje Parapo* consented to the creation of new Egungun from older versions in the following cases: Laabo Ilugba from Laabo Idire, Ayoka Ese from Ayoka Imosu, Obalolaiye from Owolani, and Owolani from Oya Ijemo. None of these new Egungun ever claimed supremacy over its predecessors.

44. R. Ajibade vs. A. Fatusi, HCT 45/93, "Reply to Statement of Defense" (High Court of Ogun State, Otta Judicial Division, 1994); R. Ajibade vs. A. Fatusi, "Suite No. Hct /45/93 (Judgement)" (High Court of Ogun State, Otta Judicial Division: Honorable Justice C. O. Shoremi, 1996).

45. Other members of the Arogunmola family decided not to carry the Oya mask because they felt it was not consistent with their Christian or Islamic practices or beliefs. Other distant relatives cited their participation in Gelede and Oro as reasons for not wearing or financing Oya.

46. *Oriki* refer to praise poetry that may be distinguished by multiple genres, *ewi* or *esa* refer to a particular genre chanted during Egungun performances. Oludare Olajubu and J. R. Ojo, "Some Aspects of Oyo Yoruba Masquerades," *Africa* 47, no. 3 (1977): 257; Olatunde Olatunji, *Features of Yoruba Oral Poetry* (Ibadan: University Press, 1984); Isidoro Okpewho, *African Oral Literature: Backgrounds, Character, and Continuity* (Bloomington: Indiana University Press, 1992), 128–129.

47. Ajibade vs. Fatusi, "Suite No. Hct/45/93"; Interview with Chief Abayomi Ojugbele, Otun ward, Otta, 2005; Interview with Chief S. A. Asanbe, *Oloponda* of Otta, Itimoko compound, Ijana ward, Otta, 2005.

48. Interview with Chief Abayomi Ojugbele, Otun ward, Otta, 2005; Robin Law, *The Oyo Empire, c. 1600–c. 1836: A West African Imperialism in the Era of the Atlantic Slave Trade* (Oxford: Clarendon, 1977).

49. Furthermore, Chief Ojugbele—the voice of the Arogunmola family—claims that the first son of Arogunmola was alive as late as 1951. Interview with Chief Abayomi Ojugbele, Otun ward, Otta, 2005.

50. R. A. Salako, *Ota: Biography of the Foremost Awori Town* (Otta: Penink Publicity, 2000), 114.

51. A number of scholars discuss the spiritual powers associated with Egungun masks and their use in warfare. S. O. Babayemi, *The Fall and Rise of Oyo C., 1706–1905: A Study in the Traditional Culture of an African Polity* (Lagos: Lichfield Nigeria, 1980), 43; J. A. Adefila and S. M. Opeola, "Supernatural and Herbal Weapons in 19th Century Yoruba Warfare," in *War and Peace in Yorubaland, 1793–1893*, ed. Adeagbo Akinjogbin (Ibadan: Heinemann Educational Books, 1998), 220–225; O. Olutoye and J. A. Olapade, "Implements and Tactics of War among the Yoruba," in *War and Peace in Yorubaland, 1793–1893*, ed. Adeagbo Akinjogbin (Ibadan: Heinemann Educational Books [Nigeria], 1998), 208–213. Missionaries tended to focus on the involvement of Egungun in violence. David Hinderer, October 1, 1850, from journal ending September 25, 1851, Ca 2/049/104.

52. Barber notes the acquisition of an Egungun headpiece through war. Babayemi, *The Fall and Rise of Oyo*, 204; Veronica Uzoigwe, "The Masquerade," in *Ibadan Mesiogo: A Celebration of a City, Its History, and People*, ed. Dapo Adelugba, Remi Raji, Omowunmi Segun, and Bankole Olayebi (Ibadan: Bookcraft, 2001), 148; Interview with Afolabi Oguntade, Oloolu compound, Ibadan, 2006.

53. Adedeji, "The Alarinjo Theatre"; S. O. Babayemi, *Egungun among the Oyo Yoruba* (Ibadan: Board Publication, 1980).

54. Babatunde Lawal, "The Living Dead: Art and Immortality among the Yoruba of Nigeria," *Africa* 47, no. 1 (1977): 50–61; Barber, *I Could Speak until Tomorrow*.

55. Arogunmola's father's masquerade was called Opekugbodu (or Opekugbogu), which belongs to a category of Egungun at Otta known as *elebiti*. Interview with Chief Abayomi Ojugbele, Otun ward, Otta, 2005. It is possible that the Oyo military camp mentioned in the tradition refers to one of the many Ibadan war camps that existed in the 1870s and 1880s. Many of Ibadan's founders were warriors who had fled south with their followers from Oyo. Arogunmola may have journeyed to an Ibadan war camp to show appreciation for the town's support of Otta during its war with Abeokuta. He may also have gone because, at a moment when Otta itself was demilitarized, Ibadan's battlefields were places of economic and political opportunity. Johnson, *History of the Yoruba*, 244–246, 255; S. O. Biobaku, *The Egba and Their Neighbours, 1842–1872* (Oxford: Clarendon, 1957), 27; Toyin Falola, *The Political Economy of a Pre-Colonial African State: Ibadan, 1830–1900* (Ibadan: University of Ife Press, 1984), 15–18; Falola, "From Hospitality to Hostility: Ibadan and Stranger, 1830–1904," *Journal of African History* 26 (1985): 51–68.

56. Judith Gleason, *Oya: In Praise of the Goddess* (Boston: Shambhala, 1987); Interview with Alagbaa Oyadolu, Akran Palace, Badagry, Lagos State, 2006.

57. Other popular Egungun include Amuludun, Ologbojo, and Alapasile.

58. Note the images of Oya that appear later in the chapter.

59. Interview with Chief Abayomi Ojugbele, Otun ward, Otta, 2005.

60. In *The Bluest Hands*, historian Judith Byfield insightfully articulates the relationship of cloth to status. "Since dress was an important component of Yoruba aesthetics, the type of cloth used to construct one's outfit was equally important. The quality of the cloth indicated an

individual's socioeconomic status and wealth because only those with sufficient wealth could acquire the finest cloths." Byfield, *The Bluest Hands*, 8.

61. Gbamidele Ajayi, Interview with Chief Abayomi Ojugbele, Otun ward, Otta, 2008.

62. Johnson, *History of the Yoruba*.

63. Interview with Chief Abayomi Ojugbele, Otun ward, Otta, 2005.

64. J. D. Y. Peel, *Religious Encounter and the Making of the Yoruba* (Bloomington: Indiana University Press, 2000), 189–194.

65. Law, *The Oyo Empire*, 75–76, 204, 45–48, 55–59.

66. Dada Agunwa, *Iwe Itan Bi Esin Imale Ti Se De Ilu Otta Ati Ilosiwaju Ninu Esin Imale*, trans. Gbamidele Ajayi (Otta, 1947); James White, January 10, 1852, journal of visit to Lagos; White, Letter, January 16, 1853.

67. Louis Brenner, "Muslim Divination and the History of Religion of Sub-Saharan Africa," in *Insight and Artistry in African Divination*, ed. John Pemberton (Washington, DC: Smithsonian Institution Press, 2000), 209; Peel, *Religious Encounter*, 194.

68. White, March 7, 1855, from journal ending March 25, 1855; White, August 10, 1858, from journal ending March 25, 1859.

69. White, December 31, 1854, from journal ending March 25, 1855.

70. T. G. O. Gbadamosi, *The Growth of Islam among the Yoruba, 1841–1908* (Atlantic Highlands, NJ: Humanities Press, 1978).

71. Law, *The Oyo Empire*, 255–258.

72. Johnson, *History of the Yoruba*, 217–218; Adedeji, "The Alarinjo Theatre," 166–173.

73. Peel, *Religious Encounter*.

74. Salako, *Ota*.

75. Agunwa, *Iwe Itan Esin Imale*.

76. Deji Kosebinu, Dele Adeniji, and Rasheed Ayinde, *Millennium Egungun Festival in Ota Awori: Special Program Brochure* (Otta: Bisrak Communications, 2000).

77. Barber discusses how the identities of devotees and the spirits or objects of their devotion coalesce. Karin Barber, "How Man Makes God in West Africa: Yoruba Attitudes towards the Orisa," *Africa* 51, no. 3 (1981): 724–726.

78. Barber, *I Could Speak until Tomorrow*.

79. I collected several versions of praise songs associated with the Oya masquerade belonging to the Arogunmola family. These songs are so extensive that inclusion here would introduce a wide range of questions that ultimately would distract from the argument I advance in this chapter. LaRay Denzer, "Yoruba Women: A Historiographical Study," *International Journal of African Historical Studies* 27, no. 1 (1994): 12–14. Oshungbayi became the first Iyalode at Otta. R. A. Salako mentions her in a brief history of the office of the Iyalode at Otta. I believe that the title was borrowed from Abeokuta, which claimed authority over Otta following the war of 1842 and where Madame Tinubu (referenced later) became the first woman to hold such an office in that town. Salako, *Ota*, 114. The proverbial qualities of Yoruba discourse suggest that seizing the "crown of the lazy" may also be a reference to taking the glory of those who undeservedly receive it. During moments of tension between husbands and wives, the latter might make such a statement to critique their husbands for seeking public praise for the fruits of women's labor. Olayinka Dada, a native of Otta and a speaker of the Awori dialect spoken in this town, translated these songs.

80. Awe and Matory contend that the office of the Iyalode arose in the nineteenth century; Denzer, McIntosh, and Semley argue that the office dates back at least as far as the era of Oyo imperial rule. Bolanle Awe, "The Iyalode in the Traditional Yoruba Political System," in *Sexual Stratification: A Cross-Cultural View*, ed. Alice Schlegel (New York: Columbia University Press,

1977), 144–147; Denzer, "Yoruba Women," 8–14; Matory, *Sex and the Empire*, 1st ed., 18–20; McIntosh, *Yoruba Women, Work, and Social Change*, 221–225; Lorelle D. Semley, *Mother Is Gold, Father Is Glass: Gender and Colonialism in a Yoruba Town* (Bloomington: Indiana University Press, 2011), 157–159.

81. As the history of women holding this title in other Yoruba towns indicates, their ability to resolve disputes especially as they relate to the market or relations with foreign powers inspired their communities to reward them with this office. Dada Agunwa, *The First Book on Otta: In Memory of King Aina and King Oyelusi Arolagbade* (Otta, 1928), 60–70; McIntosh, *Yoruba Women, Work, and Social Change*, 221–225.

82. Verger, "Grandeur et Decadence."

83. Interview with Oba M. A. Oyede III, *Olota* of Otta, Otun ward, Otta, 2005.

84. Barber, *I Could Speak until Tomorrow*.

85. Ibid.

86. Ibid.

87. The careers of women who acquired the title of Iyalode (in Abeokuta, Ibadan, and Ijaye) best illustrate this process. Awe, "The Iyalode in the Traditional Yoruba Political System," 144–195; Denzer, "Yoruba Women," 9–13; Akínwùmí Ísòolá, *Madam Tinubu: The Terror in Lagos* (Ibadan: Heinemann Educational Books [Nigeria], 1998).

88. Barber, *I Could Speak until Tomorrow*; Andrew Apter, "Discourse and Its Disclosures: Yoruba Women and the Sanctity of Abuse," *Africa* 68, no. 1 (1998): 68–97; William R. Rea, "Rationalising Culture: Youth, Elites, and Masquerade Politics," *Africa* 68, no. 1 (1998): 98–117; Rea, "A Prevalence of Witches: Witchcraft and Popular Culture in the Making of a Yoruba Town," Journal of Religion and Popular Culture 18 (Spring 2008): 5, http://ezproxy.carleton.edu /login?url=http://search.proquest.com/docview/232424839?accountid=9892.

89. Semley, *Mother Is Gold*, 71–76.

90. Nwando Achebe, *The Female King of Colonial Nigeria: Ahebi Ugbabe* (Bloomington: Indiana University Press, 2011).

91. Interview with Chief Abayomi Ojugbele, Otun ward, Otta, 2005.

92. Ibid.

93. Ibid.

94. Interview with Chief S. A. Asanbe, *Oloponda* of Otta, Itimoko compound, Ijana ward, 2005 and 2006.

95. Margaret Thompson Drewal, *Yoruba Ritual: Performers, Play, Agency* (Bloomington: Indiana University Press, 1992), 90.

# Conclusion

## *Egungun and Gelede in Otta Today*

FROM PRECOLONIAL TIMES to the present, masquerades have played critical roles in the ritual, social, political, and economic systems of many communities in southwestern Nigeria, where most Yoruba people reside today. The power of this tradition lies in the performers' ability to shape the region's cultural and historical legacy, not only in times of peace and prosperity but also in times of trouble and change. *Masquerading Politics* has demonstrated this power through multiple sources—historical records, missionary accounts, oral histories I gathered through ethnographic research on site, and secondary ethnographies that I both use to corroborate some findings and critique when my research diverges from theirs.

The book has shown how one Nigerian town, Otta, given its strategic location, became a focal point for evolving masquerade practices that were deployed not only for ceremonial or ritual purposes within families and communities but also, as the Oyo Empire disintegrated, to support military campaigns and serve punitive and other purposes in civil and administrative affairs. As British colonialism came to dominate the political and social life of the region by the early twentieth century, the masquerades remained active—with their punitive functions diminishing while operating in parallel with government agencies in maintaining civil order and social harmony and symbolizing community identity.

I conclude *Masquerading Politics* by examining the vital role of masquerades—Egungun and Gelede in particular—in the late twentieth and early twenty-first centuries in Otta, where I conducted my field research from 2004 to 2006 and again in 2010. This assessment demonstrates not only that Egungun has become even more central to Otta's identity in the postcolonial context but also that my approach to understanding the role of gender in masquerades—and in political, cultural, and social life in the region over the course of the period my analysis covers—resonates with the unique and powerful roles that women play in Egungun today.

Historically, sex has determined who wears the masks in Egungun and Gelede, but not the sex or gender represented in the mask. The woman's role in human reproduction is often cited as the reason why female bodies have not traditionally worn masks. Drawing on missionary accounts and later ethnographic

sources, many scholars of masquerades in Africa interpret the sex and gender identities of the masquerader as a determinant of a person's and group's power and authority over others instead of viewing the masquerader's identities as fluid and historically contingent. My own ethnographic research has led me to take an alternative approach.

The history of the Oya Arogunmola masquerade in the 1920s and 1950s and in the postcolonial (1990s) period reveals that kinship, in the case of the prominent female leader Oshungbayi, and age—in the summary of the 1996 court judgment referencing the importance of a woman's court testimony that we consider in greater detail later—offered females the opportunity to translate economic influence and experience into state-recognized authority. Oshungbayi converted her economic resources into influence over an Egungun masquerade, over local politics at the level of the ward, and over the application of colonial policy as a chief. The unnamed woman in the judgment of the court cases involving the Oya masquerades was able to convert her status within her family, which gave her a title among the masquerade chiefs, into a legal precedent.

A set of dynamic gender ideas have been transmitted through the mythology and practices of the deities Shango and Oya and the Egungun masquerade. Whether male or female, Shango devotees have expressed multiple gender positions. They represent both the incarnation and wife of the deity and, particularly during the era of Oyo imperial rule, both the *Alaafin* of Oyo and his wife. The model of the outspoken wife has been embodied in the deity Oya, who can be read as a powerful embodiment of female masculinity. It was fitting that the voice of a woman, whom the judge identified as the "oldest masquerade chief" and "a witness of truth," determined the outcome of the landmark case involving the Oya masquerade.[1]

Affirming their status as political critics, members of the Gelede masquerade group critiqued the crisis through performances that contained references to various Egungun masqueraders and chiefs, including the two families at the center of the court case. Gelede members performed the Efe night masquerade at the request of Otta's king following his coronation. As one Gelede chief noted, Efe could speak without the fear of retribution:

> What do we do
> That things will be okay
> Please, show us the right way
> They say Laboo's case is different
> The ones as intelligent as Ayoka are not many
> Always happy Ajolodo
> Is the one that opens the Oje
> It does not quarrel with anybody
> Now it is the war of Oya

The war of okara highly respected in Oje
There is war, we need to be careful
Caution the Oje chiefs to settle the dispute
Caution the Oloponda to intervene
Run quickly and inform Iya Agan
Who lives close to the Igbale,
Be prepared to make things work well in Oje
Those of you who remain as elders[2]

Efe, as the Gelede chief claims, warns Egungun chiefs to lean on the *Olo-ponda*, the most senior of the male chiefs, and the *Iya Agan*, one of the most senior female chiefs and a member of the *Iya Agba Oje*, to bring about a peaceful resolution of the crisis. Efe also admonishes the members of the two Oya families and the Egungun chiefs to behave like elders, suggesting they have not acted accordingly.

The Gelede chief recites another song that offers a more blistering critique, directed at the Egungun chiefs for offering a title to a woman:

These members of Oje amaze me
No more elders in the Oje council, quite ridiculous
You have turned the Oje council to another thing
Woman now turned to in an Atokun [the person who directs the Egungun
    masquerader during a performance]
Beating people at the performance of Egungun
This is quite amazing
We could not find any of the Oje members
In the affairs of the town
We did not find any member of the Oje council
In the helms of affairs of the town
We messaged Ado [a nearby Yoruba town that shares the same local govern-
    ment area as Otta]
They were informed at Oyo
All of them were informed
Gelede performed on the fateful day
We could not find the Oje members
We could not find the Oje members
In the helms of affairs of the town[3]

Efe embodies the voices in the town that appear to oppose the power and authority of Egungun's female chiefs. The song gives credence to a patriarchal discourse that links misfortune to women behaving like men and emasculating men. The Gelede chief who performed this song during my conversation with him effectively credits Efe with disciplining women.

A month after my conversation with the Gelede chief, I observed four Efe performances that featured performers who represented their respective wards. The aim of the event was to honor the life of the then-king's late mother. One Efe performer sang a song calling out Egungun chiefs among others believed to have sold a mask, title, or other ritual artifact for money. Efe offered a warning that extended to the reigning king, the members of the *Iya Agba Oje*, the *Iya Oni Yemonja* (the leader of Yemonja devotes), and Oro:

> We shall still ask them
> I did not know what interests them in the soup
> That made them display the locust bean [used to cook iwedu and efo]
> So that everyone can see
> I did not know what interests them about the soup
> That made them abolish our tradition
> If not that they are so greedy
> They would not have abolished our tradition
> Caution, be cautious Arolagbade be cautious
> Because if you are not cautious
> They shall sell the Ojudinabi shrine right in your presence
> Because the house owner was not cautious his house got burnt
> If the farmer is not cautious, he shall be robbed
> Did you remember
> Remember how Igboro was sold off
> Caution, Arolagbade be cautious
> Aro, Oloponda be careful
> I am afraid about Igbale
> Because if you are not careful
> Iya Agba Ojes, be cautious
> Because if you are not careful
> They shall soon sell off the Igbale out of your care
> Iya Oniyemonja, be cautious
> All of you the orisha worshippers
> If you are not careful
> They shall soon sell off all the gods of Otta land
> This is why I am warning in songs
> So that they do not sell off all our heritage in Otta right in our presence
> They have turned the Oro groove into a place where they worship Jesus
> I am so afraid of that
> Where we did make the rituals for the town
> It has been turned to where they worship Jesus
> Worship Jesus by force
> If you are not cautious
> This is why we sing that we shall still ask from them

We shall still ask from them
They because of greed sold off all the heritage of the town

This song speaks to a statement I once heard a year earlier—that some residents in the town avoided speaking to foreign researchers because previous visitors had purchased either an Egungun or Gelede mask.[4]

The history of the Lebe Oke and Laboo Idire masquerades, spanning the first four decades of the twentieth century, further demonstrates that kinship—in the case of the daughter of Lebe Oke's creator—offered potential mothers an opportunity to translate their reproductive, spiritual, and social needs into a new Egungun that indirectly showcases their achievements. Adelowo, the daughter of the originator of the Lebe Oke, repeatedly drew on the authority and power accorded to the Ifa oracle in a manner that garnered her support from the king in laying claim to Egungun masquerades. She also established a new ritual precedent, creating a new masquerade from an existing one. Today, a group of female chiefs rival—if not supersede—the male chiefs in the affairs of Egungun in Otta. In a conversation with me, the Oba Oyede III, the king of Otta, referred to these female chiefs as "women who are sometimes regarded as men." They are collectively known as the *Iya Agba Oje* (elderly mothers of Egungun) and the "power behind Egungun." Their approval and prayers are essential to the successful completion of an individual Egungun masquerade's performance and of the festival season more generally. Individual Egungun members pay their respects to these women by visiting their headquarters or by parading and bowing before the *Iya Agba Oje* during a public performance (see figures C.1 and C.2), greeting these women as if they are their forefathers. These women collectively function like the *Iyamode*, whom Johnson described in *History of the Yorubas* as having been honored as the father of deceased kings.

## Community Identity and Masquerades Today

Anthropologist Insa Nolte describes Yoruba communities as "pacted," meaning that the body of traditions and rituals that weave them together are continuously expressed, modified, and renewed.[5] Masquerade performances, as demonstrated throughout this book, are rituals with both fixed and improvised elements in which social and political actors enact competing visions of their communities. In times of change, the masquerade often becomes a theater in which the community can see its inner conflicts dramatized through the enactment of multiple visions.

Otta today has several communal identities. One is its identity as an ancient, independent Awori kingdom, whose founders migrated from Ile-Ife. Another is its identity as a stronghold of "witches," perceived by outsiders as socially deviant or even diabolical people. Yet, if we adjust the lens through which we view this

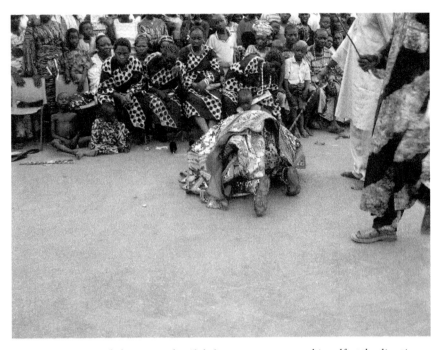

Fig. C.1. An Egungun belonging to the *Alabala* category prostrates himself, at the direction of a male Egungun chief who holds a wand in his hand, before four of the female chiefs (wearing the same maroon and white attire) who comprise the *Iya Agba Oje*. This performance occurred on a day dedicated to the performance of the *Alabala* masquerades by leading families in Otta. Ijana ward. Photograph by author, December 23, 2004.

identity, we correct this distorted view, revealing instead that Otta is the home of historically powerful *aje*, spiritually potent men and women.[6] Yet another identity is that Otta is the holy land or Mecca of Egungun.[7] These multiple identities are reflected and renegotiated in Otta's masquerade traditions, especially Egungun and Gelede. The town's praise song reflects an identity forged by the use of a Gelede mask to resist foreign invasion. Masquerade performances offer a space in which individuals and groups within Otta engage in social interactions and address the conflicts that often arise on several levels. These masquerades also function as a performance arena, a sociopolitical institution, and a ritual system whereby people can contest and reconfigure power in virtually all areas of their lives. At times when people are struggling to meet their basic needs, the masquerade affords them a mechanism through which they can release tensions and seek resolution.

Masquerade festivals currently often overlap with widely celebrated religious seasons, accommodating the needs of Christians and Muslims in particular.

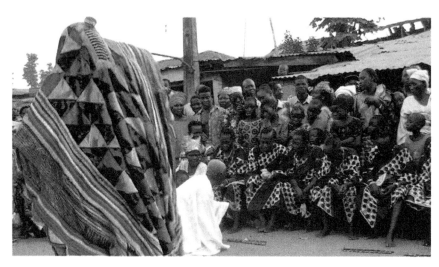

Fig. C.2. An Egungun *Alabala* masquerade shows off its dancing skills while an elderly man wearing white kneels in front of the *Iya Agba Oje*, asking them for money as observers standing behind the female chiefs witness the exchange. Photograph by author, December 23, 2004.

During the festival season, families and citizens of Otta living in North America and Europe return to the communities of their childhood to renew family ties or establish new ones through marriage. On these occasions communities typically experience an economic boom, as tourists also flock to witness the masquerade spectacles, patronizing local markets and merchants.

Masquerade practices and organizations in modern Otta continue to be deeply implicated in and overlap with the existing ruling groups and structures of their place and time. Today, Nigeria is a republic, dominated by the ruling political party, the All Progressives Congress. The executive, judicial, and legislative systems of the nation and its towns are inherited from British colonial government. Yet traditional ruling structures also endure, operating alongside, apart from, or in interaction with these statutory structures. For example, someone who hopes to run for office may seek a chieftaincy title if he or she does not yet have one or may sponsor a masquerade. Many legal disputes are brought before chiefs rather than litigated in the Nigerian court system. In the case described later involving ownership of the Oya masquerade, for instance, many people were upset and offended that the issue of masquerade ownership was brought into the court system for judgment.

Masquerades continue to influence and to be influenced by their relationships to these political and judicial structures. Aware of the power of masquerades,

Fig. C.3. Babangida is both the name of a masquerade painted on the Egungun grove in Otta's Ijana ward and the name of a former military dictator who still lives in another Nigerian town and who supports political campaigns in Otta. Photograph by author, December 20, 2004.

politicians and other elites often support them. Many attend masquerade festival performances, making grand entrances and exits and occupying places of prominence in the audience during performances. Some make speeches, praising the organizers and seizing the moment to call attention to themselves. A few, as noted earlier, even sponsor masquerades in their own names, including Ibrahim Babangida, a former military head of state of Nigeria, whose Egungun (see figure C.3) was performed at the Egungun shrine in Otta during the 2005 Egungun festival.[8]

Although the ideologies of Christianity and Islam have often been hostile to Yoruba masquerade traditions, decrying them as false or heathen or backward, masquerade performances and traditions have nonetheless been able to absorb, accommodate, and even mediate these hostilities. Arogunmola's Egungun took on what was once regarded as an Islamic symbol in the form of Hausa men's attire known as *agbada*. In this case, as in many other instances, new beliefs that might have undermined masquerades have instead been absorbed by and indeed honored within them. Today, nearly half of Otta's inhabitants are Muslim. In 2000 and 2004, Otta held the quadrennial Egungun festival, in which all the traditional masquerades, religious groups, and cults participated and expressed

themselves. This spectacle was more than mere nostalgia for the old ways; it also represented an ongoing manifestation of how conflict has been channeled and community harmony sustained for generations in Yorubaland.

## Masquerades and Dispute Resolution in Contemporary Otta

### Egungun as an Instrument of Social Order

A contemporary episode may serve to illustrate how, in Yoruba culture and society within the context of the Nigerian nation, the tradition of Egungun is used to resolve divisions within the Otta community. In 2005, police were regularly harassing a number of Otta youth. During the Egungun festival, there was an attack on some police officers, apparently stemming from the ongoing tensions between young people and the police. The chief of police complained to the king, who referred the complaint to the masquerade society. No one was formally disciplined, but the masquerade in effect allowed both sides of this dispute to air their grievances without burdening the formal structure of the courts. The tension between youth and the police eased and life returned to normal. If such social pressures had not been contained, addressed, and guided through Egungun, or if they had been taken to court, would the outcome have been as beneficial to all?

Another contemporary case traces its origins to the middle of the nineteenth century, when Egungun masqueraders were involved in violent clashes between the Egba people from Abeokuta and people from Otta. Based on the claim that the Owu conquered Otta in 1842 and have maintained authority over the town ever since, the *Oluwo* (the ruler of the Owu, an ethnic group from a town of that name in the area of Abeokuta), with the active support of former Nigerian president Olusegun Obasanjo, installed several individuals as traditional rulers and chiefs in the Otta vicinity. Local residents, however, argued that their community should be under Awori, not Owu, jurisdiction. A group of protestors, including Egungun masqueraders, hunters, market women, and several local ritual authorities, fought with a group of Egba people along the road to Obasanjo's farm, a few miles from Otta.[9] Obasanjo later appeared at the palace of the *Olota* of Otta to resolve the dispute. This incident highlights the involvement of Egungun in ongoing tensions between the Egba and the Awori, dating back to the middle of the nineteenth century. The Awori who were defending what they saw as the traditional basis of public authority in their town turned naturally to Egungun to express their ethnic identity and historical claim to status in Otta.

These two episodes attest to Egungun's enduring presence in Otta. I turn now to a more extended description of Egungun's role in another dispute over legacies and authority within the masquerade tradition, one that indicates how seriously the formal court system regards masquerades.

*Contesting Local History in a Modern Masquerade Festival
and a Nigerian Courtroom*

On Friday, April 26, 1996, the Honorable Justice G. O. Shoremi ruled on a case involving a dispute between the plaintiff, Abayomi Ojugbele, the owner of the Egungun masquerade named Oya Arogunmola, and the defendant, the most senior Egungun masquerade chief, known as the *Oloponda* of Otta. The latter stood accused of having improperly fixed the schedule of performances in Otta in 1993. At the heart of the case was the question whether or not the Egungun Oya Arogunmola was, in essence, the Oya Otta—the oldest and most prominent Egungun masquerade in the town with links to the eras of the Oyo Empire and British colonial rule. If it was, the plaintiff argued, then his Egungun should have been the sole masquerade to appear on the last day of the Egungun festival in Otta in 1993. The schedule of performances at this festival has great significance because, according to tradition, *"Egunla lo keyin igbale"* ("the biggest and oldest Egungun departs last from the Egungun shrine"). At issue in this case were the status or prestige of these families and their identification with the legacies of royals, warriors, indigenes, and newcomers to Egungun within the community. Also at stake was the community's desire to identify with an Oyo practice and institution that were preeminent in Yoruba culture and served Otta's interest in distinguishing itself from rival towns.

A number of changes marked the 1993 Egungun festivities. From at least the 1950s until the 1988 Egungun festival, the Arogunmola and Ijemo families had together paraded an Egungun bearing the name Oya with the designation Oya Otta.[10] In 1993, however, for reasons disputed by each party, these families discontinued their collaborative venture, and each decided to parade its own Oya masquerade in the festival. Each family argued, in and out of court, that the other family had split from it and created a new Oya. Beginning that year, there were two Oya masquerades at Otta: Oya Arogunmola and Oya Ijemo. Charged with deciding the order of masquerade performances during the festival period, the council of Egungun chiefs scheduled the plaintiff's masquerade (Oya Arogunmola) in the fifth slot, which took place in January, the first month of a five-month-long festival season, and the other Oya masquerade (Oya Ijemo) in the second-to-last slot, which occurred in April. Both of these Oya masquerades were also scheduled to appear on the closing day, alongside other Egungun. However, the most prominent position in the closing day's festivities—the final performance—was reserved for another Egungun masquerade named Ege. The owners of Ege believed that their Egungun was the oldest and therefore should be the last to perform. Ege had ties to the chief who was charged with creating the schedule, and, for the first time, this masquerade appeared on the last day of the festival.

When the Oya Arogunmola masquerade society protested the schedule by refusing to appear on its appointed day in January, the council of Egungun chiefs and the other organizers of the Egungun festival banned it from all further participation in that year's festival, which would continue until May. Soon thereafter, the owner of the Oya Arogunmola masquerade initiated a court case pressing two claims against the defendant, Chief Fatusi. First, it was argued that Fatusi, as Otta's senior masquerade chief, had the ultimate authority to determine the performance schedule and was responsible for adhering to established precedent. Second, according to the plaintiff, tradition had established that Oya Arogunmola was the oldest of the *alagbada* category of Egungun masquerades in Otta and the most prominent of all the Egungun irrespective of category in the town. Wanting to reclaim his Egungun's status, Ojugbele, the owner, sought redress from outside the Egungun society.[11]

A number of witnesses offered testimony that included detailed accounts of the history of the two Oya masquerades. Each of the families claimed ownership of an original Oya and that the other family had introduced the alternate version of Oya in 1988. The Arogunmola family claimed it brought Oya to Otta during the era of Oyo imperial rule (although after reviewing all the evidence I date its arrival to the 1880s or 1890s) and that one of its ancestors became a chief after creating the first *agbada* (the Muslim-style gown worn by elite men) for Oya during British colonial rule. The Ijemo family argued that it introduced Oya no later than the 1890s.

These families' appearance in the Otta Judicial Division in the High Court of Justice of Ogun State marked the first time that a matter pertaining to Egungun masquerades and to the council of chiefs who oversee their performances had come before any court of law, colonial or postcolonial. This case brought the legitimacy of the Egungun chiefs over the affairs of local masquerades to the forefront of public debate. It raised questions about the chiefs' authority and the relative status of the town's leading families. In the process, the case polarized the community. Some citizens criticized Ojugbele, the plaintiff, for breaking tradition by filing a complaint in a civil court.[12] During a separate masquerade festival, the performers and chiefs of the Gelede tradition expressed their concerns about the Egungun court case in songs calling for a peaceful resolution.[13]

In the past, it was typically the king of Otta who adjudicated disputes involving masquerades, and the king's ruling had always been final. However, in this instance, a vacancy on the throne provided an opportunity for the plaintiff to seek an alternative authority.[14] In his judgment on the case, Justice Shoremi made the following statement before declaring a ruling: "There is no doubt that each party would want me to believe the traditional evidence [oral traditions and histories] adduced by them. There is no doubt that one side or the other must be mistaken, yet both may be honest in their belief. In such a case, demeanor is little guide to

the truth. The best way to test the traditional history is reference to the facts in recent years as established by evidence and seeing which of the two competing histor[ies] is more probable."[15]

The judge ultimately determined that the defendant was not at fault because it was not his responsibility to set the schedule in the first place. He also ruled that the Oya Arogunmola masquerade had the right to perform last based on the testimony of an elderly woman he described as the "oldest masquerade chief" and "a witness of truth."[16] What made this woman's testimony convincing was her capacity to produce a detailed account of Oya's migration from Oyo to Otta during the era of Oyo imperialism.[17] The judge's reliance on the testimony of a woman is of critical importance to the themes covered throughout this book. It upends assumptions about women as outsiders in the affairs of Egungun masquerades and resonates with the longstanding view of women as enjoying elevated standing in Otta. It also demonstrates that gender is not an isolated category; it is contingent and linked to other variables, such as age.

Pamphlets and brochures circulated during recent festivals indicate the centrality of Egungun to the cultural identity of the town and underpin its claims to a unique status in Yorubaland. A local publisher committed to historical documentation produced Egungun festival brochures in 2000 and 2004; these sixty-page booklets include short articles devoted to such subjects as the "Importance of Egungun in the Socio-Cultural Development of Otta-Aworiland," "Egungun in Otta: Its Spread, Forms, and Celebrations," and "The Origin of Egungun (Masquerade) in Yorubaland." The booklets also include the town's anthem, the names of its Egungun chiefs and the most prominent Egungun masquerades, and lists of various organizations involved in the festival, along with the names of other leading officials. The booklets declare Otta to be the "Pilgrim's City," "Holy Land," and "Mecca of Egungun" and boast that its Egungun festival has achieved the level of a "Carnival" in the twenty-first century. These descriptions resonate with both Christians and Muslims, who are well represented among Otta's Egungun chiefs, masqueraders, and observers. They represent Egungun both as secular (as a carnival) and sacred (by association with Muslim sacred sites). They further declare this masquerade to be the "symbol of unity of the Awori," the people who founded the town.[18]

The circumstances surrounding the court case and the festivals that followed raise several issues about the politics and history of masquerading among the Yoruba and in West Africa more generally. As an institution historically known to have exercised a range of legislative and executive powers within a town, Egungun are recognized on many levels as a political institution. Egungun have been charged, in early and modern times, with upholding the moral authority of unseen forces. The practitioners of this institution historically were afforded the privilege of performing rituals, adjudicating disputes, and punishing criminals,

although the last of these functions has been relegated to the domain of the modern-day state. However, little is known about the complexity of Egungun's politicking or the relationship of that politicking to other institutions and figures with power and authority. The 1996 court case highlights many of the important themes this book has investigated. One is the dialectical character of Egungun within Yoruba society: in Yoruba communities and in other West African cultures, masquerades are institutions that both shape and are shaped by other dynamics of power and forces of history. Another is the centrality of Egungun to the well-being and the culture of Otta during the pre- and early colonial periods.

The case also shows how a prominent individual can engage in politicking on his or her own. To own an Egungun, even one whose prominence is disputed, is to hold a certain amount of power and authority. The Arogunmola family was able to challenge someone as prominent and important as a senior chief within the Egungun hierarchy and call him to task for allegedly failing to fulfill his duty, which they insisted had to be guided by tradition. Yet, the family came under considerable criticism for breaking tradition, as some saw it, by seeking redress for a grievance over the status of its Egungun within another institution of power, the modern court system. This episode, then, reveals what has often been overlooked in West African political histories in general and in histories of Yorubaland more specifically: masquerades have long been, as they are now, key political actors in their own right. They have been integral to the politics of Yoruba towns for centuries.[19]

The 1996 court case also illuminates the relationship of women to masquerades. The scholarship on Egungun has, as I have noted more than once, long emphasized the masquerades' role in disciplining and subduing women.[20] Indeed, missionaries in precolonial times and European authorities in the early colonial era regarded Egungun as "women terrifiers."[21] Yet, in this court case, the judge regarded an elderly woman as the voice of traditional authority regarding Egungun—and heeded her counsel when handing down his decision.[22] In another sense, the judge's decision to turn to this woman as the final arbiter in the conflict between the owner of the Egungun Oya Arogunmola and the *Oloponda* was fitting, because Otta has long had a reputation among the Yoruba for the respect it accords to women.[23]

As we have seen, the Oya Arogunmola masquerade flourished historically under a triumvirate consisting of a man, Arogunmola, and his two influential and powerful wives, Moniyepe and Oshungbayi. Both the judge's action in the 1996 case and the role of women in the development of the Oya Arogunmola and other Egungun masquerades throw into question the conventional view of Egungun as an institution that men use to control women.

While this book has opened new horizons on the masquerade tradition in West Africa by showing its role in political, military, and economic affairs, as well as in

ancestral homage and spirituality, its challenge to traditional views of gender is perhaps its most original historical contribution. Again, Egungun has historically been represented as inherently antagonistic to women. Yet the modern Egungun in Otta seem to continue to challenge orthodox notions of women and Egungun, and as my analysis suggests, the history of the region is rich in examples of women owning Egungun or asserting authority over them in their families or as high-ranking members of the Egungun masquerade society. In Otta today, women continue to exercise considerable influence and authority within the Egungun society. Perhaps most strikingly, a group of women are Egungun chiefs. This enhanced status of women within Egungun may be the result of new opportunities fueled by Christians' and Muslims' declining interest in the practice or of other social changes that have yet to be studied.

Future research on the conditions that fueled the proliferation of masquerades may add fresh insights to mine, revealing additional nuance to our understanding of evolving notions of kinship, gender, and ethnicity in colonial Africa. The wealth of colonial documentation left by officials and local historians, along with the availability of oral traditions and histories, makes this particularly fertile ground for research on the development of Yoruba ethnic identity from the periphery. We have seen here how important Egungun and, to a lesser extent, Gelede have been to the weaving of the kaleidoscopic ethnic fabric that contributes to Otta's identity as a site epitomizing the potential of the masquerades to galvanize social change.

In addition, more research is needed to sort out the violent and nonviolent aspects of Gelede. Scholars have assumed that Gelede represents a nonviolent approach to conflict, in contrast to the more violent approach of Egungun. My analysis of nineteenth-century Gelede, which reveals the violent aspects of Gelede Idahomi, suggests that Gelede might have exhibited other characteristics at various historical moments. It would be valuable to develop a more deeply historical appreciation of this masquerade form, so that we do not continue assuming that the modern manifestation of Gelede represents an unchanging tradition.

Although it is impossible, of course, to predict the future of the masquerade tradition in Nigeria or in Otta, several factors indicate that this vibrant tradition will continue. Consider, for example, how it has been interwoven into the economic fabric of the town, which now relies heavily on the masquerade festivals as a tourist attraction. Additionally, it has emerged as a central component of the political, religious, and cultural fabric of Otta. These factors, along with the continuing versatility and dynamism of the tradition, suggest that it has adapted and will continue to adapt to twenty-first-century conditions. The evidence from Otta suggests that the overlapping political and performance applications of the masquerade tradition may make it too important to fail.

## Notes

1. R. Ajibade vs. A. Fatusi, "Suite No. Hct /45/93 (Judgement)" (High Court of Ogun State, Otta Judicial Division: Honorable Justice C. O. Shoremi, 1996).
2. Personal communication with Mr. Salawu Abioru Olaniyan, Olori Gelede Otta, Oruba Quarters, March 12, 2006.
3. Ibid.
4. Efe performance, Olota's Palace, April 7, 2006.
5. Insa Nolte, *Obafemi Awolowo and the Making of Remo: The Local Politics of a Nigerian Nationalist* (Edinburgh: Edinburgh University Press, 2010).
6. Babatunde Lawal, *The Gelede Spectacle: Art, Gender, and Social Harmony in an African Culture* (Seattle: University of Washington Press, 1996), 267n16; Interview with Oyinade Ogunba, Olabisi Onabanjo University, Ago-Iwoye, 2006; Interview with Eshorun of Oshogbo and Chief Adedoyin Faniyi, Ibokun Road, Oshogbo, 2006; Interview with Remi Ajala, Department of Archeology and Anthropology, University of Ibadan, 2006.
7. Deji Kosebinu, Dele Adeniji, and Rasheed Ayinde, *Millennium Egungun Festival in Ota Awori: Special Program Brochure* (Otta: Bisrak Communications, 2000).
8. Babangida also sponsored an election campaign meeting with food, as organizers investigated his prospects for success as a presidential candidate.
9. Ademola Oni, "Six Feared Dead as Egba, Awori Clash in Ota," *Nigerian Muse*, April 8, 2008, http://www.nigerianmuse.com/20080409063849zg/nigeria-watch/six-feared-dead-as-egba-awori-clash-in-ota/.
10. Nigeria achieved independence from British colonial rule in 1960 and endured civil war from 1967 to 1970 and periods of alternating civilian administrations and military dictatorships from 1970 through 1988. The last period of military rule ended in 1999.
11. R. Ajibade vs. A. Fatusi, "Suite No. Hct /45/93 (Judgement)."
12. Ibid.
13. Mr. Salawu Abioru Olaniyan holds the position of Olori Gelede, meaning he is the most senior Gelede chief in Otta. Interview with Salawu Abioru Olaniyan, *Olori* of Gelede in Otta, Oruba ward, Otta, 2006.
14. R. Ajibade vs. A. Fatusi, HCT 45/93, "Reply to Statement of Defense" (High Court of Ogun State, Otta Judicial Division, 1994); Ruhollah Ajibola Salako, *Oba Moshood Oyede, the Olota of Ota: So Far So Good* (Otta: Pennik Publicity, 2004), 4, 59.
15. R. Ajibade vs. A. Fatusi, "Suite No. Hct /45/93 (Judgement)."
16. Ibid.
17. Neither the plaintiff nor the defendant clearly won or lost.
18. Visitors from other towns who attend the festival may not embrace these slogans as unreservedly as the inhabitants of Otta, but there is no doubt that the community wholeheartedly embraces the Egungun festival. During the festival cycle, the ordinary conduct of affairs in the town seems to be suspended. Irrespective of one's age or role—from schoolchild to merchant to elderly relative—everyone's activity seems to be directed to the service of the festival. I witnessed a gathering of thousands at the opening ceremony of the Egungun festival on December 12, 2004, which included an appearance of the governor of Ogun State. More than 100 Egungun masqueraders appeared on ninety-seven scheduled days over a four-month period. The 2004 festival did not conclude until April 17, 2005, the day set aside for the Oya Arogunmola masquerade mentioned earlier, when the king of Otta declared the event officially closed. Deji Kosebinu, Dele Adeniji, and Rasheed Ayinde, *2004 Egungun Carnival in Otta Aworiland* (Otta: Bisrak Communications, 2004), 49–50.

19. A. F. C. Ryder, *Benin and the Europeans, 1485–1897* (Harlow: Longmans, 1969); S. O. Biobaku, *The Egba and Their Neighbours, 1842–1872* (Oxford: Clarendon, 1957); J. F. Ade Ajayi and Robert Smith, *Yoruba Warfare in the Nineteenth Century* (Cambridge: Cambridge University Press, 1964); Robin Law, *The Oyo Empire, c. 1600–c. 1836: A West African Imperialism in the Era of the Atlantic Slave Trade* (Oxford: Clarendon, 1977); Toyin Falola, *Yoruba Historiography* (Madison: African Studies Program, University of Wisconsin–Madison, 1991); Falola, *The Political Economy of a Pre-Colonial African State: Ibadan, 1830–1900* (Ibadan: University of Ife Press, 1984); Andrew H. Apter, *Black Critics and Kings: The Hermeneutics of Power in Yoruba Society* (Chicago: University of Chicago Press, 1992); Edna G. Bay, *Wives of the Leopard: Gender, Politics, and Culture in the Kingdom of Dahomey* (Charlottesville: University of Virginia Press, 1998); S. A. Akintoye, *Revolution and Power Politics in Yorubaland, 1840–1893: Ibadan Expansion and the Rise of Ekitiparapo* (London: Longman, 1971); J. A. Atanda, *The New Oyo Empire* (London: Longman, 1973); Emmanuel Ayankanmi Ayandele, *The Ijebu of Yorubaland, 1850–1950: Politics, Economy, and Society* (Ibadan: Heinemann Educational Books [Nigeria], 1992).

20. George W. Harley, *Masks as Agents of Social Control in Northeast Liberia* (Millwood, NY: Kraus Reprint, 1975); Peter Morton-Williams, "The Egungun Society in South-Western Yoruba Kingdoms," in *Proceedings of the Third Annual Conference of the West African Institute of Social and Economic Research* (Ibadan: University College, 1956), 90–103; Ulli Beier, "The Egungun Cult," *Nigeria Magazine* 51 (1956): 380–392; Peter Weil, "The Masked Figure and Social Control: The Mandika Case," *Africa* 41, no. 4 (1971): 279–293; Margaret Thompson Drewal and Henry John Drewal, "More Powerful than Each Other: An Egbado Classification of Egungun," *African Arts* 11, no. 3 (1978): 28–39, 99; Marc Schiltz, "Egungun Masquerades in Iganna," *African Arts* 11, no. 3 (1978): 48–55, 100; S. O. Babayemi, *Egungun among the Oyo Yoruba* (Ibadan: Board Publication, 1980); Sidney L. Kasfir, ed., *West African Masks and Cultural Systems* (Tervuren: Musée Royal de l'Afrique Centrale, 1988).

21. Robin Law citing American Baptist missionary William H. Clarke in "'Legitimate' Trade and Gender Relations in Yorubaland and Dahomey," in *From Slave Trade to "Legitimate" Commerce: The Commercial Transition in Nineteenth-Century West Africa*, ed. Robin Law (Cambridge: Cambridge University Press, 1995), 209–210.

22. R. Ajibade vs. A. Fatusi, "Suite No. Hct /45/93 (Judgement)."

23. Interview with Oyinade Ogunba, Olabisi Onabanjo University, Ago-Iwoye, 2006; Interview with Chief Ifagbade Oduniyi and Chief Adedoyin Talabi Faniyi, Ibokun Road, Oshogbo, 2006; R. A. Salako, *Ota: Biography of the Foremost Awori Town* (Ota: Penink Publicity, 2000), iv.

# Bibliography

Abimbola, Wande. "Ifa Divination Poems as Sources for Historical Evidence." *Lagos Notes and Records* 1 (1967): 17–26.

Achebe, Nwando. *The Female King of Colonial Nigeria: Ahebi Ugbabe*. Bloomington: Indiana University Press, 2011.

Adedeji, Joel. "The Alarinjo Theatre: The Study of a Yoruba Theatrical Art from Its Earliest Beginnings to the Present Times." PhD diss., University of Ibadan, 1969.

Adefila, J. A., and S. M. Opeola. "Supernatural and Herbal Weapons in 19th Century Yoruba Warfare." In *War and Peace in Yorubaland, 1793–1893*, edited by Adeagbo Akinjogbin, 219–233. Ibadan: Heinemann Educational Books (Nigeria), 1998.

Agiri, B. A. "Early Oyo History Reconsidered." *History in Africa* 2 (1975): 1–16.

———. "Kola in Western Nigeria, 1850–1950: A History of the Cultivation of Cola Nitida in Egba-Owode, Ijebu-Remo, Iwo and Ota Areas." PhD diss., University of Wisconsin, 1972.

Agunwa, Dada. *The First Book on Otta: In Memory of King Aina and King Oyelusi Arolagbade*. Otta, 1928.

———. *Iwe Itan Bi Esin Imale Ti Se De Ilu Otta Ati Ilosiwaju Ninu Esin Imale*. Translated by Gbamidele Ajayi. Otta, 1947.

Ajayi, Gbamidele. Interview with Chief Abayomi Ojugbele. Otun ward, Otta, 2008.

———. Interview with Jimoh Adejare Idowu, Oyo, Oyo State, 2005.

Ajayi, J. F. Ade. "The Aftermath of the Fall of Old Oyo." In *History of West Africa*, edited by J. F. Ade Ajayi, 174–214. London: Longman, 1987.

———. *Christian Missions in Nigeria, 1841–1891: The Making of a New Elite*. London: Longman, 1965.

Ajayi, J. F. Ade, and Robert Smith. *Yoruba Warfare in the Nineteenth Century*. Cambridge: Cambridge University Press, 1964.

Ajibade, R., vs. Fatusi, A. HCT 45/93. "Reply to Statement of Defense." High Court of Ogun State, Otta Judicial Division, 1994.

Ajibade, R., vs. Fatusi, A. "Suite No. Hct /45/93 (Judgement)." High Court of Ogun State, Otta Judicial Division: Honorable Justice C. O. Shoremi, 1996.

Akinjogbin, Adeagbo, ed. *War and Peace in Yorubaland, 1793–1893*. Ibadan: Heinemann Educational Books (Nigeria), 1998.

Akinjogbin, I. A. "The Oyo Empire in the Eighteenth Century: A Re-Assessment." *Journal of the Historical Society of Nigeria* 3, no. 2 (1966): 449–460.

Akintoye, S. A. *Revolution and Power Politics in Yorubaland, 1840–1893: Ibadan Expansion and the Rise of Ekitiparapo*. London: Longman, 1971.

Aleru, Jonathan Oluyori. *Old Oyo and the Hinterland: History and Culture in Northern Yorubaland, Nigeria*. Ibadan: Textflow, 2006.

Apter, Andrew H. *Black Critics and Kings: The Hermeneutics of Power in Yoruba Society*. Chicago: University of Chicago Press, 1992.

———. "Discourse and Its Disclosures: Yoruba Women and the Sanctity of Abuse."
   *Africa* 68, no. 1 (1998): 68–97.
Asiwaju, A. I. "Gelede Songs as Sources of Western Yoruba History." In *Yoruba Oral
   Tradition: Poetry in Music, Dance, and Drama*, edited by Wande Abimbola,
   199–204. Ile-Ife: Department of African Languages and Literature, University of
   Ife, 1975.
———. *Western Yorubaland under European Rule, 1889–1945: A Comparative Analysis of
   French and British Colonialism*. London: Longman, 1976.
Atanda, J. A. *The New Oyo Empire: Indirect Rule and Change in Western Nigeria
   1894–1934*. London: Longman, 1973.
Awe, Bolanle. "The Iyalode in the Traditional Yoruba Political System." In *Sexual
   Stratification: A Cross-Cultural View*, edited by Alice Schlegel. New York:
   Columbia University Press, 1977.
———. "Notes on Oriki and Warfare in Yorubaland." In *Yoruba Oral Tradition: Poetry
   in Music, Dance, and Drama*, edited by Wande Abimbola, 267–292. Ile-Ife:
   Department of African Languages and Literature, University of Ife, 1975.
———. "Praise Poems as Historical Data: The Example of the Yoruba Oriki." *Africa* 44,
   no. 4 (1974): 331–349.
Ayandele, Emmanuel Ayankanmi. *The Ijebu of Yorubaland, 1850–1950: Politics, Economy,
   and Society*. Ibadan: Heinemann Educational Books (Nigeria), 1992.
Babalola, Adeboye, and Olugboyega Alaba. *A Dictionary of Yoruba Personal Names*.
   Lagos: West African Book Publishers, 2003.
Babalola, S. A. *Awon Oriki Orile*. Glasgow: Collins, 1967.
Babatunde, Emmanuel D. "The Gelede Masked Dance and Ketu Society: The Role of the
   Transvestite Masquerade in Placating Powerful Women while Maintaining the
   Patrilineal Ideology." In *West African Masks and Cultural Systems*, edited by
   Sidney L. Kasfir. Tervuren: Musee Royal de l'Afrique Centrale, 1988.
Babayemi, S. O. *Egungun among the Oyo Yoruba*. Ibadan: Board Publication, 1980.
———. *The Fall and Rise of Oyo C., 1706–1905: A Study in the Traditional Culture of an
   African Polity*. Lagos: Lichfield Nigeria, 1980.
Bailey, Marlon M. *Butch Queens up in Pumps: Gender, Performance, and Ballroom
   Culture in Detroit*. Ann Arbor: University of Michigan Press, 2013.
Barber, Karin. "How Man Makes God in West Africa: Yoruba Attitudes towards the
   Orisa." *Africa* 51, no. 3 (1981): 724–744.
———. *I Could Speak until Tomorrow: Oriki, Women and the Past in a Yoruba Town*.
   Washington, DC: Smithsonian Institution Press, 1991.
———. "Oriki, Women, and the Proliferation and Merging of Orisa." *Africa* 60, no. 3
   (1990): 313–337.
Barnes, Sandra T. "Ritual, Power, and Outside Knowledge." *Journal of Religion in Africa*
   20, no. 3 (1990): 248–268.
Bay, Edna G. *Asen, Ancestors, and Vodun: Tracing Change in African Art*. Urbana:
   University of Illinois Press, 2008.
———. *Wives of the Leopard: Gender, Politics, and Culture in the Kingdom of Dahomey*.
   Charlottesville: University of Virginia Press, 1998.
Beier, Ulli. "The Egungun Cult." *Nigeria Magazine* 51 (1956): 380–392.
———. "Gelede Masks." *Odu: Journal of Yoruba and Related Studies* 6 (1958): 5–23.

Biobaku, S. O. *The Egba and Their Neighbours, 1842–1872*. Oxford: Clarendon, 1957.

Blier, Suzanne P. *African Vodun: Art, Psychology, and Power*. Chicago: University of Chicago Press, 1995.

Blier, Suzanne Preston. *The Anatomy of Architecture: Ontology and Metaphor in Batammaliba Architectural Expression*. Cambridge: Cambridge University Press, 1987.

Bolaji, Emmanuel Bamidele. "The Dynamics and the Manifestations of Efe: The Satirical Poetry of the Yoruba Gelede Groups of Nigeria." PhD diss., University of Birmingham, 1984.

Brenner, Louis. "Muslim Divination and the History of Religion of Sub-Saharan Africa." In *Insight and Artistry in African Divination*, edited by John Pemberton. Washington, DC: Smithsonian Institution Press, 2000.

Bruce-Lockhart, Jamie, and Paul E. Lovejoy. "Introduction." In *Hugh Clapperton into the Interior of Africa: Records of the Second Expedition, 1825–1827*, edited by Jamie Bruce-Lockhart and Paul E. Lovejoy, 1–78. Leiden: Brill, 2005.

Byfield, Judith A. *The Bluest Hands: A Social and Economic History of Women Dyers in Abeokuta (Nigeria), 1890–1940*. Portsmouth, NH: Heinemann, 2002.

Clapperton, Hugh. *Journal of a Second Expedition into the Interior of Africa: From the Bight of Benin to Soccatoo*. London: John Murray, 1829.

"Colonial and Indian Exhibition Circular." *Lagos Observer* (Lagos, Nigeria), November 5, 1885.

Denzer, LaRay. "Yoruba Women: A Historiographical Study." *International Journal of African Historical Studies* 27, no. 1 (1994): 1–39.

Drewal, Henry John. "Efe: Voiced Power and Pageantry." *African Arts* 7, no. 2 (1974): 26–29, 58–66, 82.

———. *Homage to Thomas Moulero: Private Historian of Gelede*. Denver: University of African Art Press, 2008.

Drewal, Henry John, and Margaret Thompson Drewal. "The Arts of Egungun among Yoruba People." *African Arts* 11, no. 3 (April 1978): 18–20.

———. *Gelede: Art and Female Power among the Yoruba*. Bloomington: Indiana University Press, 1983.

Drewal, Margaret Thompson. "The State of Research on Performance in Africa." *African Studies Review* 34, no. 3 (1991): 1–64.

———. *Yoruba Ritual: Performers, Play, Agency*. Bloomington: Indiana University Press, 1992.

Drewal, Margaret Thompson, and Henry John Drewal. "More Powerful than Each Other: An Egbado Classification of Egungun." *African Arts* 11, no. 3 (April 1978): 28–39, 99.

Du Bois, W. E. B. *The Souls of Black Folk: Essays and Sketches*. Chicago: A. C. McClurg, 1903.

Eades, J. S. *The Yoruba Today*. Cambridge: Cambridge University Press, 1980.

Elebuibon, Yemi. *The Healing Power of Sacrifice*. Brooklyn, NY: Athelia Henrietta Press, 2000.

Fadipe, N. A. *Sociology of the Yoruba*. Ibadan: University Press, 1970.

Falola, Toyin. "From Hospitality to Hostility: Ibadan and Stranger, 1830–1904." *Journal of African History* 26 (1985): 51–68.

———. *The Political Economy of a Pre-Colonial African State: Ibadan, 1830–1900*. Ibadan: University of Ife Press, 1984.

———. *Yoruba Historiography*. Madison: African Studies Program, University of Wisconsin–Madison, 1991.

Faluyi, Kehinde. "The Awori Factor in the History of Lagos." In *History of the Peoples of Lagos State*, edited by Babatunde Agiri, Ade Adefuye, and Jide Osuntokun, 222–230. Lagos: Lantern Books, 1987.

Farrow, Stephen. *Faith, Fancies and Fetich, or Yoruba Paganism: Being Some Account of the Religious Beliefs of the West African Negroes, Particularly of the Yoruba Tribes of Southern Nigeria*. New York: Macmillan, 1926.

Folayan, Kola. "Egbado and Yoruba-Aja Power Politics." MA thesis, University of Ibadan, 1965.

———. "Egbado to 1832: The Birth of a Dilemma." *Journal of the Historical Society of Nigeria* 4, no. 1 (1967): 15–34.

Fowler, W. "A Report on the Lands of the Colony District." In *Colonial Records Project*, 1–82. Oxford: Rhodes House Library, 1947.

Fyfe, Christopher. *A History of Sierra Leone*. London: Oxford University Press, 1962.

Gbadamosi, T. G. O. *The Growth of Islam among the Yoruba, 1841–1908*. Atlantic Highlands, NJ: Humanities Press, 1978.

Gleason, Judith. *Oya: In Praise of the Goddess*. Boston: Shambhala, 1987.

Greene, Sandra E. *Gender, Ethnicity, and Social Change on the Upper Slave Coast: A History of the Anlo-Ewe*. Portsmouth, NH: Heinemann, 1996.

Harley, George W. *Masks as Agents of Social Control in Northeast Liberia*. Millwood, NY: Kraus Reprint, 1975.

Hinderer, David. October 1, 1850, from journal ending September 25, 1851. Ca2/049/104.

"Historical Events, Otta District Court." St. James Church, Otta, Ogun State, 1962.

Hopkins, A. G. "Economic Imperialism in West Africa: Lagos, 1880–1892." *Economic History Review*, no. 21, no. 3 (1968): 580–606.

Houlberg, Marilyn. "Notes on Egungun Masquerades among the Oyo Yoruba." *African Arts* 11, no. 3 (1978).

Ibitokun, Benedict M. *Dance as Ritual Drama and Entertainment in the Gelede of the Ketu-Yoruba Subgroup in West Africa*. Ile-Ife: Obafemi Awolowo University Press, 1993.

Interview with Afolabi Oguntade. Oloolu compound, Ibadan, 2006.

Interview with Alagbaa Oyadolu. Akran Palace, Badagry, Lagos State, 2006.

Interview with Chief Abayomi Ojugbele. Osi ward, Otta, 2006.

Interview with Chief Abayomi Ojugbele. Otun ward, Otta, 2005.

Interview with Chief Abayomi Ojugbele and Nurudeen Ajiboga. Osi ward, Otta, 2006.

Interview with Chief Ifagbade Oduniyi and Chief Adedoyin Talabi Faniyi. Ibokun Road, Oshogbo, 2006.

Interview with Chief J. O. Akingbola, *Atokun* of Otta. Ijana ward, Otta, 2005.

Interview with Chief Keinde Odunlami. Akran Palace, Badagry, Lagos State, 2006.

Interview with Chief S. A. Asanbe, *Oloponda* of Otta. Itimoko compound, Ijana ward, Otta, 2005.

Interview with Chief S. A. Asanbe, *Oloponda* of Otta. Itimoko compound, Ijana ward, Otta, 2006.

Interview with Chief S. A. Matoro, *Onikosi* of Otta. Osi ward, Otta, 2006.

Interview with Chief Wadudu Deinde. Oruba ward, Otta, 2006.

Interview with Chief Wasiu Dada, *Ekiyo* of Otta. Ijesu compound, Ijana ward, Otta, 2006.

Interview with *Eshorun* of Oshogbo and Chief Adedoyin Faniyi. Ibokun Road, Oshogbo, 2006.

Interview with Oba M. A. Oyede III, *Olota* of Otta. Otun ward, Otta, 2005.

Interview with Oba M. A. Oyede III, *Olota* of Otta. Otun ward, Otta, 2010.

Interview with Oba of Ilogbo. Palace, Ilogbo, Ogun State, 2006.

Interview with the *Oloponda* of Ilaro and M. A. B. Ajayi. Ilaro, 2006.

Interview with Oyinade Ogunba. Olabisi Onabanjo University, Ago-Iwoye, 2006.

Interview with Prince Kunle Andrew. Otun ward, Otta, 2005.

Interview with Prince Wasiu Ashola Ojugbele. Osi ward, Otta, 2006.

Interview with Remi Ajala. Department of Archeology and Anthropology, University of Ibadan, 2006.

Interview with Salawu Abioru Olaniyan, *Olori* of Gelede in Otta. Oruba ward, Otta, 2006.

Ìsòòlá, Akínwùmí. *Madam Tinubu: The Terror in Lagos*. Ibadan: Heinemann Educational Books (Nigeria), 1998.

Johnson, Samuel. *History of the Yoruba: From the Earliest Times to the Beginning of the British Protectorate*. Lagos: C. M. S. Bookshop, 1921.

Kasfir, Sidney L. "Masquerading as a Cultural System." In *West African Masks and Cultural Systems*, edited by Sidney L. Kasfir. Tervuren: Musée Royal de l'Afrique Centrale, 1988.

———, ed. *West African Masks and Cultural Systems*. Tervuren: Musée Royal de l'Afrique Centrale, 1988.

Kasfir, Sidney Littlefield. "The Ancestral Masquerade: A Paradigm of Benue Valley Art History." In *Central Nigeria Unmasked Arts of the Benue River Valley*, edited by Marla C. Berns, Richard Fardon, and Sidney Littlefield Kasfir, 101–112. Los Angeles: Fowler Museum, 2011.

———."Masks from the Towns of the Dead." In *Igbo Arts: Community and Cosmos*, edited by Herbert M. Cole and Chike Cyril Aniakor. Los Angeles: Museum of Cultural History, University of California, Los Angeles, 1984.

Kopytoff, Jean Herskovits. *A Preface to Modern Nigeria: The "Sierra Leonians" in Yoruba, 1830–1890*. Madison: University of Wisconsin Press, 1965.

Kosebinu, Deji. *Alani Oyede: The People's Monarch*. Otta: Bisrak Communications, 2000.

Kosebinu, Deji, Dele Adeniji, and Rasheed Ayinde. *Millennium Egungun Festival in Ota Awori: Special Program Brochure*. Otta: Bisrak Communications, 2000.

———. *Odo Oje Otta: Launching and Commissioning of "Ege" Statue*. Otta: Bisrak Communications, 2000.

———. *2004 Egungun Carnival in Otta Aworiland*. Otta: Bisrak Communications, 2004.

Law, Robin. "The Career of Adele at Lagos and Badagry, c. 1807–1837." *Journal of the Historical Society of Nigeria* 9, no. 2 (1978): 35–59.

———. "The Gun Communities in the Eighteenth Century." Paper presented at the 34th Annual Meeting of the African Studies Association of the U.S.A., St. Louis, November 23–26, 1991.

———. "Historiography of the Commercial Transition in Nineteenth Century West Africa." In *African Historiography: Essays in Honour of Jacob Ade Ajayi*, edited by Toyin Falola. Harlow: Longman, 1991.

———. "How Many Times Can History Repeat Itself? Some Problems in the Traditional History of Oyo." *International Journal of African Historical Studies* 18, no. 1 (1985): 33–51.

———. *The Kingdom of Allada*. Leiden: CNWS, 1997.

———. "A Lagoonside Port on the Eighteenth-Century Slave Coast: The Early History of Badagri." *Canadian Journal of African Studies* 28, no. 1 (1994): 32–59.

———. "'Legitimate' Trade and Gender Relations in Yorubaland and Dahomey." In *From Slave Trade to "Legitimate" Commerce: The Commercial Transition in Nineteenth-Century West Africa*, edited by Robin Law, 195–214. Cambridge: Cambridge University Press, 1995.

———. *The Oyo Empire, c. 1600–c. 1836: A West African Imperialism in the Era of the Atlantic Slave Trade*. Oxford: Clarendon, 1977.

Lawal, Babatunde. *The Gelede Spectacle: Art, Gender, and Social Harmony in an African Culture*. Seattle: University of Washington Press, 1996.

———. "The Living Dead: Art and Immortality among the Yoruba of Nigeria." *Africa* 47, no. 1 (1977): 50–61.

———. "New Light on Gelede." *African Arts* 11, no. 2 (1978): 65–70, 94.

Layiwola, Dele. "Egungun in the Performing Arts of the Yoruba." In *Readings in African Studies*, edited by A. T. Oyewo and S. A. Osunwole, 147–162. Ibadan: Jator, 1999.

Lindsay, Lisa A., and Stephan Miescher. "Introduction: Men and Masculinities in Modern African History." In *Men and Masculinities in Modern Africa*, edited by Lisa A. Lindsay and Stephan Miescher, 1–29. Portsmouth, NH: Heinemann, 2003.

———, eds. *Men and Masculinities in Modern Africa*. Portsmouth, NH: Heinemann, 2003.

Lucas, Jonathan O. *The Religion of the Yorubas*. Lagos: C. M. S. Bookshop, 1948.

Lynn, Martin. *Commerce and Economic Change in West Africa: The Palm Oil Trade in the Nineteenth Century*. Cambridge: Cambridge University Press, 1997.

Mann, Kristin. *Marrying Well: Marriage, Status, and Social Change among the Educated Elite in Colonial Lagos*. Cambridge: Cambridge University Press, 1985.

———. *Slavery and the Birth of an African City: Lagos, 1760–1900*. Bloomington: Indiana University Press, 2007.

Mann, Kristin, and Richard Roberts. *Law in Colonial Africa*. Portsmouth, NH: Heinemann, 1991.

Matory, James. *Sex and the Empire That Is No More: Gender and the Politics of Metaphor in Oyo Yoruba Religion*. Minneapolis: University of Minnesota Press, 1994.

———. *Sex and the Empire That Is No More: Gender and the Politics of Metaphor in Oyo Yoruba Religion*, 2nd ed. Minneapolis: University of Minnesota Press, 2005.

McIntosh, Marjorie Keniston. *Yoruba Women, Work, and Social Change*. Bloomington: Indiana University Press, 2009.

Meyerowitz, Eva. L. R. "Notes on the King-God Shango and His Temple at Ibadan, Southern Nigeria." *Man* 46, no. 27 (1946): 25–31.

Morton-Williams, Peter. "The Egungun Society in South-Western Yoruba Kingdoms." In *Proceedings of the Third Annual Conference of the West African Institute of Social and Economic Research*, 90–103. Ibadan: University College, 1956.

———. "An Outline of the Cosmology and Cult Organization of the Oyo Yoruba." *Africa* 34, no. 3 (1964): 247–256.

———. "The Oyo Yoruba and the Atlantic Trade." *Journal of the Historical Society of Nigeria* 3, no. 1 (1964).

———. "The Yoruba Kingdom of Oyo." In *West African Kingdoms in the Nineteenth Century*, edited by Cyril Daryll Forde and Phyllis Mary Kaberry, 36–69. London: Oxford University Press for the International African Institute, 1967.

———. "Yoruba Responses to the Fear of Death." *Africa* 30, no. 1 (1960): 34–40.

Nigerian National Archives, Abeokuta. ED 309. "Otta District Council Meetings: Minutes of Proceedings of Meetings of the Otta District Council." Abeokuta, 1952.

———. ED 1146/6. J. Hinian Scott, "Otta District Council Chieftaincy Committee Meetings: Minutes of the Meeting Held at *Olota*'s Palace Otta on Wednesday the 10th of April." 1935.

———. "Otta Affairs: Brief History of Otta." Abeokuta, 1933.

Nigerian National Archives, Ibadan, Abe. Prof. 4, D33. "Abeokuta Province: A Report on the Otta District, Egba Division." 1936.

———. CSO 13, S2141/51, J. Hinian Scott, "Minutes of a Meeting Held at the Olota's Palace." 1935.

———. CSO 26, C. T. Lawrence. "Assessment Report on Otta District: Abeokuta Province." 1926.

———. CSO 26/2, 20629, F. C. Royce. "Assessment Report of Otta District, Egba Division, Abeokuta Province." 1927.

Nigerian National Archives, Ibadan. Otta District Court. "Population Census, Historical Events." 1962.

Nolte, Insa. *Obafemi Awolowo and the Making of Remo: The Local Politics of a Nigerian Nationalist.* Edinburgh: Edinburgh University Press, 2010.

Nunley, John W. *Moving with the Face of the Devil: Art and Politics in Urban West Africa.* Urbana: University of Illinois Press, 1987.

Nzewunwa, Nwanna, ed. *The Masquerade in Nigerian History and Culture.* Port Harcourt, Nigeria: University of Port Harcourt, 1980.

Odugbesan, Clara. "Feminism in Yoruba Religious Art." In *Man in Africa*, edited by Mary Douglas, Phyllis Mary Kaberry, and Cyril Daryll Forde. London: Tavistock Publications, 1969.

Ogundiran, Akinwumi, "Chronology, Material Culture, and Pathways to the Cultural History of Yoruba-Edo Region, 500 B.C.–A.D. 1800." In *Sources and Methods in African History: Spoken, Written, Unearthed*, edited by Toyin Falola and Christian Jennings. Rochester, NY: University of Rochester Press, 2003.

Ogunyemi, Wale. "Egungun Cult in Some Parts of Western Yorubaland: Origin and Functions." *African Notes* 21, nos. 1–2 (1997): 95–102.

Ojo, J. R. O. "Epa and Related Masquerades among the Ekiti Yoruba of Western Nigeria." MPhil diss., University of London, 1974.

———. "Ogboni Drums." *African Arts* 6, no. 3 (1973): 50–52, 84.

Okpewho, Isidoro. *African Oral Literature: Backgrounds, Character, and Continuity.* Bloomington: Indiana University Press, 1992.

Olajubu, Oludare, and J. R. Ojo. "Some Aspects of Oyo Yoruba Masquerades." *Africa* 47, no. 3 (1977): 253–275.

Olatunji, Olatunde. *Features of Yoruba Oral Poetry*. Ibadan: University Press, 1984.

Olutoye, O., and J. A. Olapade. "Implements and Tactics of War among the Yoruba." In *War and Peace in Yorubaland, 1793–1893*, edited by Adeagbo Akinjogbin, 199–218. Ibadan: Heinemann Educational Books (Nigeria), 1998.

Oni, Ademola. "Six Feared Dead as Egba, Awori Clash in Ota." *Nigerian Muse*, April 8, 2008. http://www.nigerianmuse.com/20080409063849zg/nigeria-watch/six-feared-dead-as-egba-awori-clash-in-ota/.

"Otta District Council Meetings: Minutes of Proceedings of Meetings of the Otta District Council." Abeokuta, 1952.

Oyewumi, Oyeronke. *The Invention of Women: Making an African Sense of Western Gender Discourses*. Minneapolis: University of Minnesota Press, 1997.

Peel, J. D. Y. "Gender in Yoruba Religious Change." *Journal of Religion in Africa* 32, no. 2 (2002): 136–166.

———. "Making History: The Past in the Ijesha Present." *Man*, n.s., 19, no. 1 (1984): 111–132.

———. *Religious Encounter and the Making of the Yoruba*. Bloomington: Indiana University Press, 2000.

Peterson, John. *Province of Freedom: A History of Sierra Leone, 1787–1870*. London: Faber, 1969.

Rea, William. "A Prevalence of Witches: Witchcraft and Popular Culture in the Making of a Yoruba Town." *Journal of Religion and Popular Culture* 18 (Spring 2008). http://ezproxy.carleton.edu/login?url=http://search.proquest.com/docview/232424839?accountid=9892.

Rea, William R. "Rationalising Culture: Youth, Elites, and Masquerade Politics." *Africa* 68, no. 1 (1998): 98–117.

Ryder, A. F. C. *Benin and the Europeans, 1485–1897*. Harlow: Longmans, 1969.

Salako, R. A. *Ota: Biography of the Foremost Awori Town*. Otta: Penink Publicity, 2000.

Salako, Ruhollah Ajibola. *Oba Moshood Oyede, the Olota of Ota: So Far So Good*. Otta: Penink Publicity, 2004.

Sanusi, Secretary Adesope. "Population Census 1982 Historical Events." Otta District Council, n.d.

Schiltz, Marc. "Egungun Masquerades in Iganna." *African Arts* 11, no. 3 (1978): 48–55, 100.

Semley, Lorelle D. *Mother Is Gold, Father Is Glass: Gender and Colonialism in a Yoruba Town*. Bloomington: Indiana University Press, 2011.

Shields, Francine. "Palm Oil and Power: Women in an Era of Economic and Social Transition in 19th Century Yorubaland (South-Western Nigeria)." PhD diss., University of Stirling, 1997.

Smith, Robert. "The Alaafin in Exile: A Study of the Igboho Period in Oyo History." *Journal of African History* 6, no. 1 (1965): 57–77.

———. *The Lagos Consulate, 1851–1861*. Berkeley: University of California Press, 1979.

Smith, Robert S. *Kingdoms of the Yoruba*. London: Methuen, 1969.

Soper, Robert C. "Carved Posts at Old Oyo." *The Nigerian Field* 43, no. 1 (1978): 12–21.

Stewart, Marjorie H. *Borgu and Its Kingdoms: A Reconstruction of a Western Sudanese Polity*. Lewiston, ME: E. Mellen, 1993.

Thomson, Robert Farris. *Black Gods and Kings: Yoruba Art at UCLA*. Bloomington: Indiana University Press, 1976.

Tonkin, Elizabeth. "Cunning Mysteries." In *West African Masks and Cultural Systems*, edited by Sidney L. Kasfir. Tervuren: Musée Royal de l'Afrique Centrale, 1988.

Usman, Aribidesi Adisa. "Precolonial Regional Migration and Settlement Abandonment in Yorubaland, Nigeria." In *Movements, Borders, and Identities in Africa*, edited by Toyin Falola and Aribidesi Adisa Usman. Rochester, NY: University of Rochester Press, 2009,

Uzoigwe, Veronica. "The Masquerade." In *Ibadan Mesiogo: A Celebration of a City, Its History, and People*, edited by Dapo Adelugba, Remi Raji, Omowunmi Segun, and Bankole Olayebi, 147–152. Ibadan: Bookcraft, 2001.

Verger, Pierre. "Grandeur et Decadence du Culte de Iyami Osoronga: Ma Mere La Sorciere Chez Les Yoruba." *Journal de la Societe des Africanistes* 35, no. 1 (1965): 201–219.

———. "Trance and Convention in Nago-Yoruba Spirit-Mediumship." In *Spirit Medium and Society in Africa*, edited by J. Beattie and J. Middleton, 50–66. London: Routledge and Kegan Paul, 1969.

Weil, Peter. "The Masked Figure and Social Control: The Mandika Case." *Africa* 41, no. 4 (1971): 279–293.

White, James. *Ca2/o87 Original Papers—Missionaries: Church Mission Society—Yoruba Missions*. Birmingham: University of Birmingham, 1879.

———. Annual letter to Major Hector Straith, January 1, 1857.

———. Annual letter to Major Hector Straith, December 31, 1857.

———. Annual letter to Rev. H. Venn, January 1, 1859.

———. January 9, 1866, from journal ending March 25, 1866.

———. January 10, 1852, journal of visit to Lagos.

———. January 10, 1857, from journal ending March 25, 1857.

———. January 13, 1857, from journal ending March 25, 1857.

———. January 13, 1871, from journal ending March 25, 1871.

———. January 15, 1871, from journal ending March 25, 1871.

———. January 27–30, 1858, from journal ending March 25, 1858.

———. February 8, 1857, from journal ending March 25, 1857.

———. February 9, 1857, from journal ending March 25, 1857.

———. February 10, 1857, from journal ending March 25, 1857.

———. February 12, 1871, from journal ending March 25, 1871.

———. February 14, 1857, from journal ending March 25, 1857.

———. February 17, 1857, from journal ending March 25, 1857.

———. February 18, 1862, from journal ending March 25, 1862.

———. March 3, 1857, from journal ending March 25, 1857.

———. March 7, 1855, from journal ending March 25, 1855.

———. March 23, 1863, from journal ending March 25, 1863.

———. March 25, 1863, from journal ending March 25, 1863.

———. March 27, 1872, from journal ending September 25, 1872.

———. May 23, 1870, from journal ending September 25, 1870.

———. May 25, 1870, from journal ending September 25, 1870.

———. June 7, 1855, from journal ending June 25, 1855.

———. August 8, 1861, from journal ending September 25, 1861.

——— . August 10, 1858, from journal ending March 25, 1859.

———. August 10, 1859, from journal ending September 25, 1859.

———. September 28, 1862, from journal ending March 25, 1863.

———. October 16, 1855, from journal ending December 25, 1855.

———. October 23, 1862, from journal ending March 25, 1863.

———. October 28, 1862, from journal ending March 25, 1863.

———. November 8, 1855, from journal ending December 25, 1855.

———. November 24, 1858 from journal ending March 25, 1859.

———. December 3, 1855, from journal ending December 25, 1855.

———. December 16, 1861, from journal ending March 25, 1862.

———. December 31, 1854, from journal ending March 25, 1855.

———. From journal ending March 25, 1857.

———. From journal ending September 25, 1865.

———. From journal ending September 25, 1867.

———. Letter, January 16, 1853.

———. Letter, May 4, 1863.

———. Letter, May 28, 1857.

Willett, Frank. "Investigations at Old Oyo 1965–7: An Interim Report." *Journal of Historical Society of Nigeria* 2, no. 1 (1960): 59–77.

———. "The Microlithic Industry from Old Oyo, Western Nigeria." *Actes du IVe Congres Panafricain de Prehistoire et l'etude du Quaternaire, Tervuren* 3 (1962).

Willis, John Thabiti. "Bridging the Archival-Ethnographic Divide: Gender, Kinship, and Seniority in the Study of Yoruba Masquerade." *History in Africa: A Journal of Method* 44 (2017). doi.org/10.1017/hia.2016.12.

# Index

Note: Page numbers in *italics* indicate figures and maps.

JOHN THABITI WILLIS is associate professor of African History at Carleton College. He earned a doctoral degree in African history from Emory University and is an associate editor of the *Journal of West African History*. His research interests include the history of the slave trade and changes in religious and political cultures in Africa.

Lightning Source UK Ltd.
Milton Keynes UK
UKOW06f0235241117
313270UK00007B/62/P